A
Chronology
of
Art

EDITED BY **Iain Zaczek**

A Chronology of Art

A Timeline of Western
Culture from Prehistory
to the Present

Thames & Hudson

Contents

Introduction

'Nothing can come of nothing,' declared Sir Joshua Reynolds in one of his *Discourses*. He was advising his listeners to work hard and research, but some of his words could apply just as well to the importance of history. 'It is indisputably evident that a great part of every man's life must be employed in collecting materials for the exercise of genius. Invention, strictly speaking, is little more than a new combination of those images which have been previously gathered and deposited in the memory.' In a similar way, no artist can entirely escape their own age. The most arcane artwork will still be affected to some degree by the environment that produced it, even if the artist in question has done his or her best to separate it from human experience and the natural world.

Often, the importance of contemporary events is not immediately apparent. In the public's mind, Impressionism is probably the most popular art movement of (fairly) recent times. It may seem to some that this style of painting could have happened at any time, but in fact its appearance in the late 19th century was shaped by a unique set of circumstances. Some of these, of course, were artistic. The Impressionists were influenced by the Barbizon painters who practised a limited form of *plein-air* painting in the Forest of Fontainebleau, by the independent stance of Gustave Courbet and, in particular, by the radical approach of Édouard Manet. Despite all this, the business of painting out of doors – the central tenet of the Impressionist movement – was made a great deal easier by certain external factors.

At the time, there were rapid advances in the field of paint production. It had previously been supplied in pig's bladders, tied with string. In order to use the paint, artists had to prick a hole in the bladder. Unfortunately, though, there was no practical way to seal it up again once the hole had been made and, to make things worse, the paints hardened very quickly when exposed to the air. In addition, bladders did not travel very well. On a bumpy ride, they would often burst open. Clearly, this kind of set-up was unsuitable for painting outdoors, and attempts were made to find a solution. In the 1830s experiments were made with a metal syringe. This was an improvement, but the cost of the syringe made it uneconomic.

The breakthrough was made by John G. Rand, an American portrait painter based in London. In 1841 he devised a collapsible tin tube with a screw cap. This eliminated all waste, as the tube did not leak and could be opened again and again without damaging the shelf-life of the paint. The tubes took a little while to become popular, as initially they raised the cost of the paints slightly, but the Impressionists accepted the innovation wholeheartedly. As Renoir commented, 'Without colours in tubes, there would be no Cézanne, no Monet, no Pissarro, and no Impressionism.'

The production of pigments was also undergoing a revolution. This had begun in 1856, when a young British chemist named William Henry Perkin stumbled on a new colour. He was trying to synthesize quinine when he noticed an unusual, brightly coloured residue in one of his flasks. After further experimentation, he managed to produce the first aniline dye – an intense purple colour which he called mauve. This proved an instant success, reaching the peak of its popularity in 1862, when Queen Victoria chose a mauve dress for her official visit to London's International Exhibition. Perkin made a fortune with his discovery, prompting chemists across Europe to follow his lead. Over the next few years, dozens of new synthetic pigments came on to the market. This meant that the Impressionists had a considerably larger range of colours to choose from than their predecessors.

In a very different context, pigment (or rather, the lack of it) can play an important part in the way we look at historical works of art. Some of the most intriguing examples are the tiny marble figurines produced in the Cycladic islands in the Aegean, in the 3rd millennium BC. These carvings are stylized almost to the point of abstraction. Their near-triangular heads look upwards, but they have no facial features apart from a nose. The women stand with their arms folded tightly across their torso, while the men are often seated and portrayed with a musical instrument. Artists in the early 20th century were fascinated by these figurines, attracted by the purity and simplicity of their forms. Picasso and Brancusi were both great admirers, and some of Modigliani's sculpture was directly influenced by them. Ironically, though, subsequent tests have shown that these figurines were originally highly coloured, with painted eyes and lips. The Modernists would have been far less impressed by this.

The same is true of much Classical sculpture. We have become conditioned to think of it as uncoloured, but in fact most of it was painted. In an attempt to demonstrate just how different the original sculptures would have looked, the Museum of Classical Archaeology at Cambridge painted copies of some of its best-known casts – most notably the Lady of Auxerre and the Peplos Kore – and displayed them

side by side with the unpainted versions. The contrast is striking. Something similar had already been attempted in the previous century, when in 1862 John Gibson showed his *Tinted Venus* at the International Exhibition in London. Not surprisingly, perhaps, it attracted somewhat mixed reviews. The *Sculptor's Journal* hailed it as 'one of the most beautiful and elaborate figures undertaken in modern times', while the reviewer in the *Athenaeum* snorted that it was nothing more than 'a naked impudent English woman'.

The lottery of survival has affected the way that entire branches of the arts are viewed. There are only tantalizing glimpses of the achievements that craftsmen must have made in fields such as basketry or textiles, which used perishable materials. It is intriguing to speculate, for instance, on the impact that they might have had on the intricate interlacing patterns that can be found on many early medieval artefacts, or on the decorative pages in illuminated manuscripts.

Conversely, some areas may have attracted added attention partly because the objects themselves are so durable. The Assyrians, Akkadians and Babylonians undoubtedly produced far greater artworks than their cylinder seals, but these are still fascinating because they have survived in considerable numbers and tell us so much about their respective civilizations. In a similar way, the vase-painting industry of ancient Greece may not have attracted the greatest artists of the time, but the objects themselves survived far better than other forms of painting. This is due in no small part to antiquarians and collectors such as Sir William Hamilton – husband of the famous Emma Hamilton, Lord Nelson's mistress – who eventually sold his enormous collection to the British Museum in London.

Sometimes, artists made a direct contribution to history itself. A few, such as Jacques-Louis David and Gustave Courbet, became closely involved in politics, not always with the happiest of consequences; many more assumed diplomatic roles, performing important services for their royal or princely patrons. In a few cases, the links with history are rather more unexpected. Vorticism, for example, was a short-lived, avant-garde movement in the early 20th century. Led by Wyndham Lewis and featuring other distinguished artists, such as David Bomberg, Edward Wadsworth and Christopher Nevinson, it owed its visual style to Cubism, but its bombastic, rebellious tone to the Futurists. Its most characteristic pictures were dizzying, kaleidoscopic whirlpools of interlocking, angular forms.

Vorticism was launched in 1914, but only one exhibition was held before the movement dissipated under the effects of the First World War. However, it was not forgotten. In 1917 German U-boats were causing devastation. In the space of three months, they sank about 500 merchant ships. At this stage, Norman Wilkinson – a talented but conventional marine painter – suggested to the British Admiralty a novel method of camouflaging the ships. It was impossible to hide the vessels, but by painting them with distorting, abstract designs, which broke up their form – similar in many ways to Vorticist pictures – it might be possible to confuse the commanders of the submarines. They would not be able to tell if the ships were coming or going, or even if they were sinking.

Wilkinson's suggestion was accepted, and the 'Dazzle Section' was set up at the Royal Academy, London. Teams of women from art schools produced the designs, while professional artists supervised the actual painting of the ships. One of these was the Vorticist Edward Wadsworth, who was based at the docks in Liverpool.

Eventually, thousands of merchant ships and hundreds of naval vessels were 'dazzled' in Britain, Canada and the United States. The contribution of these artists was recognized in 2014 on the centenary of the outbreak of the First World War, when five ships were dazzled by leading contemporary artists. These included Tobias Rehberger, who created a fine pastiche of Fernand Léger's 'tubist' style for HMS *President*, and Peter Blake, who produced a superlative Pop art design for *Snowdrop* (see p. 281).

A Chronology of Art highlights these links between art and history by placing key artworks and important events together on a central timeline to give an overview of the evolution of art in the Western world. By eschewing conventional divisions of the subject into historic periods, artistic schools and movements, it presents a fresh perspective on the history of art that produces many surprises – such as how the most illustrious Neoclassical painting, David's *Oath of the Horatii* (see p. 165), was executed just a couple of years after one of the best-known Romantic scenes, Fuseli's *The Nightmare* (see p. 164). Placing these works in context with contemporary social, political and cultural events, from the time of the earliest cave paintings to more recent mural installations by the mysterious Banksy, this book offers a deeper understanding of the influences behind some of the world's greatest artworks – and a new insight into the story of art itself.

1
—

ANCIENT
& MEDIEVAL

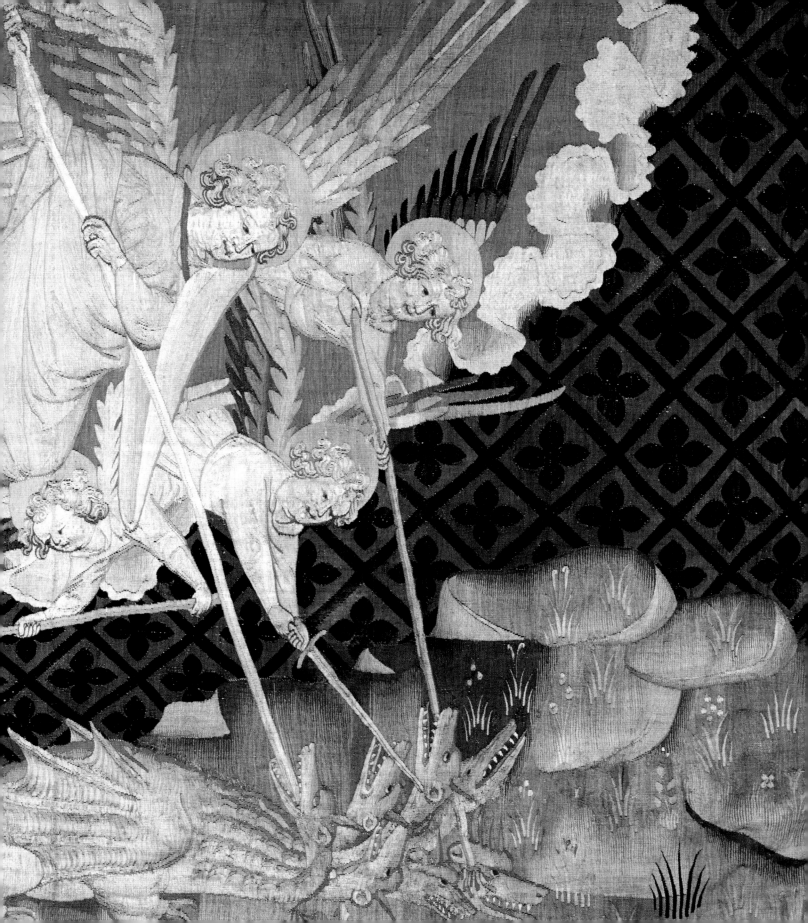

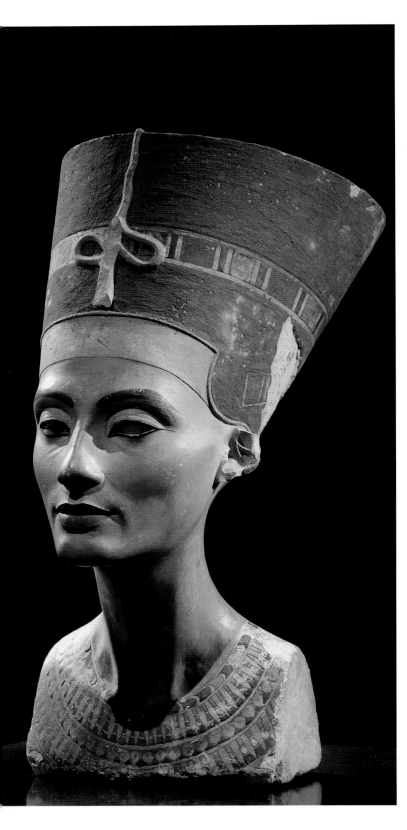

The ancients would probably not have been impressed by most modern forms of art. Certainly, any notions about individual expression or experimentation would have seemed very strange, because in most early societies, art was functional. It was produced for a particular purpose and, more often than not, that purpose had something to do with religion.

The status of a painter was also different – it was far closer to that of an artisan than a modern-day artist. Technical proficiency was expected as a matter of course, but originality of any kind was neither valued nor desired. Most ancient art is anonymous; if the identity of the artist was recorded, it has not come down to us.

Even among the ancient Egyptians, only a few artists' names are known. The most famous of these is Thutmose, who was the official royal sculptor at the court of the Pharaoh Akhenaten. He is renowned for one of the most beautiful artworks to have survived from ancient Egypt – the bust of Akhenaten's consort, Queen Nefertiti. This unfinished sculpture was discovered in 1912 by German archaeologists, in the remains of Thutmose's workshop. One eye is missing, and the other socket has a temporary wax filling, rather than the semi-precious stone that would normally have been used. Even so, the modelling of the head is exquisite. The core of the bust is limestone, but Thutmose added a very fine layer of plaster, which enabled him to create incredibly lifelike facial details. Historians have theorized that the bust was designed as a prototype – a model which Thutmose and his assistants used to make other artworks of the queen.

The bust of Nefertiti is not characteristic of most Egyptian art, which was normally heavily stylized. It dates from the Amarna period in the 18th Dynasty. This takes its name from the capital that was established by Akhenaten. He abandoned Egypt's traditional polytheistic system, preferring to worship a single god. He also promoted a more realistic style in the arts so that, for a brief interlude, there was a greater degree of individualism in royal portraits. Several other portrait busts were unearthed from Thutmose's workshop, although none of these can compare with that of Nefertiti.

With ancient Greece, the question of artistic identity is rather different. We have the names of many painters and sculptors, who were very famous in their day, but virtually nothing that can be attributed to them. We even have the names of specific artworks, which earned extravagant praise in Greek and Roman texts. Pliny, for example, recounts the anecdote of an artistic competition between Parrhasius and his celebrated rival, Zeuxis (*fl.* late 5th century BC). Parrhasius painted a bunch of grapes, which was so realistic that birds tried to peck at it. Triumphantly, Parrhasius went to draw back the curtain on his rival's entry, only to find that the curtain itself was the painting. Needless to say, Zeuxis won the competition.

The survival rate was better for painted vases. Here the most famous name is Exekias, who was active in the second half of the 6th century BC. He was a specialist in the black figure technique

(in which the figures were painted in black on a lighter background), designing both the pots themselves and their decoration. He was also versatile and inventive, equally adept at portraying scenes of pathos and moments of high drama. The Dionysus Cup (or, more correctly, *kylix*) is one of his finest creations. Everything about it is a celebration of wine. Dionysus, the god of wine, reclines in his boat while vines grow out of the mast, bearing bunches of grapes that act as a canopy above him. According to legend, Dionysus was once captured by pirates, who leapt overboard when he revealed his true identity and were instantly turned into dolphins. These are shown frolicking in the wine-red sea. The intricacies of this design would have been revealed only gradually to the drinker, as they drained the vessel.

Were it not for the chance survival of Pompeii, Herculaneum and nearby villas, our understanding of Roman painting might not be very different from that of Greece. In many cases the compositions of ancient paintings have come down to us in the more durable form of mosaic copies although, of course, we have no way of knowing just how accurate these copies are.

The wall paintings at Pompeii provide an interesting cross-section of the subjects and styles that were popular, together with the decorative motifs that accompanied them. The most elaborate examples are the depictions of the initiation rites at the Villa of Mysteries. They were also the most costly, making liberal use of cinnabar – a frighteningly expensive pigment.

To modern eyes, however, the Roman taste for more mundane subjects may be more appealing. From the Villa of Livia exists a charming fresco of a garden. It is lush and green, full of fruit, flowers and birds. This garden scene was painted as a frieze around the walls of a basement room, which the occupants of the villa would have used at the height of summer, to escape the stifling heat outside. The vernal freshness of the garden was designed to augment the cooling effect of the chamber.

Roman artists also enjoyed producing wall paintings with still life scenes. These appear deceptively simple, portraying everyday items such as peaches, figs, fish, eggs and beakers of water or wine, all arranged neatly on a shelf. Occasionally, there might be a small living creature, like a mouse, scurrying by. This type of picture was described as *xenia* ('hospitality') and displayed the kind of items that might be offered to a guest. Roman artists were skilled at painting the tiniest details – the glint of water in a glass, the sheen on the skin of a peach – and it would be hundreds of years before anyone painted still lifes as convincing as these again.

The Fall of Rome changed the course of Western art dramatically. The classical values of harmony, proportion and aesthetics, together with a fine understanding of the human form,

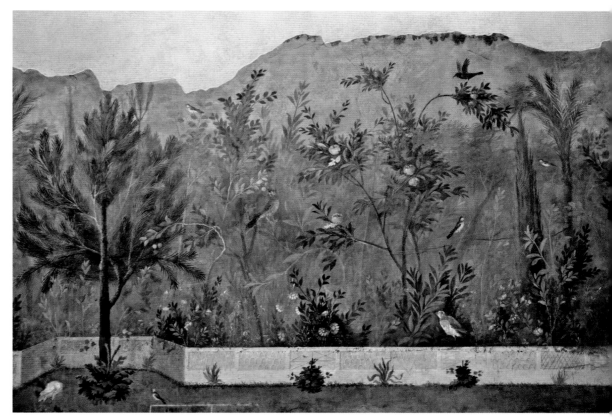

PREVIOUS PAGE. Apocalypse Tapestry, Angers – *St Michael Fighting the Dragon* (c. 1377–82)

FAR LEFT. Thutmose – *Bust of Nefertiti* (c. 1340 BC)

RIGHT. Detail from the Painted Garden fresco from the Villa of Livia (c. 30–20 BC)

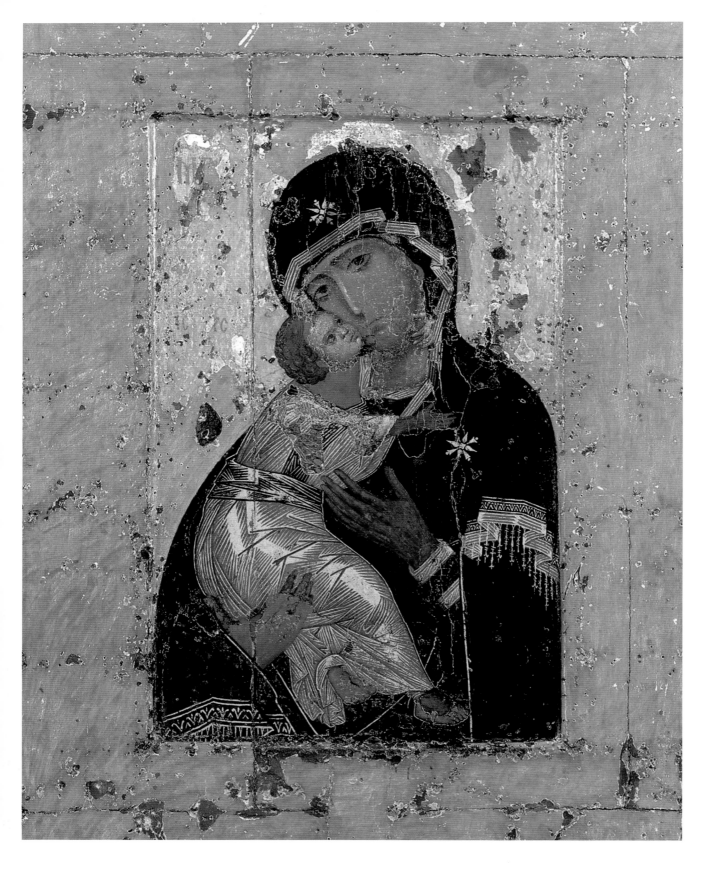

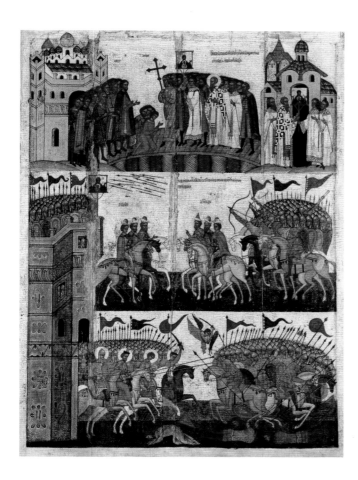

were gradually lost, and not rediscovered until the Renaissance. The various peoples that superseded the Romans had vibrant cultures of their own, but they were very different. In many cases, these peoples were nomadic and thus had no need of artworks destined for a home or a fixed place of worship.

The mantle of Rome's heritage passed to the Byzantine Empire in the east. Byzantine craftsmen excelled in many fields: they produced magnificent ivory carvings; they created glittering, golden mosaics; and they fashioned fine jewelry and textiles. Their painting, however, developed along very different lines to that in the West. In their religious icons they made no effort to produce images that were naturalistic or displayed any originality: quite the reverse. Artists were encouraged to copy the most famous icons as closely as possible. The most celebrated example is the Virgin of Vladimir, a beautiful image of the Virgin and Child painted in Constantinople by an unknown artist in about 1130. Over the years, this icon gained a reputation as the protectress of Russia, and it has been copied on countless occasions.

Icons were sacred images in their own right, to be venerated as an aid to contemplation. In some cases, they were deemed to have miracle-working powers, comparable with the holy relics of the Western Church. There are paintings that show an icon being carried into battle, or paraded around the walls of a city. In common with some other religions, the Orthodox Church was wary of portraying sacred figures too realistically. They were otherworldly beings, and depicting them in the same way as an ordinary person could seem disrespectful, almost blasphemous.

As it was, the use of icons remained controversial. There were lengthy periods when the iconoclasts ('image-breakers') took control (c. 726–87; 814–42). They argued that the veneration of icons was tantamount to idolatry, and thousands of the paintings were destroyed.

In the West, meanwhile, the revival of the arts proceeded gradually. There were high points during the Carolingian era, when Charlemagne and his successors attempted to restore some of the glories of Classical culture. Many wall paintings were commissioned for their churches and palaces, but few have survived. Instead, the contribution of the Carolingians is seen to best advantage in their illuminated manuscripts, their exquisite ivory carvings and their metalwork.

In the 10th century there was a similar revival in Germany during the Ottonian period (named after Holy Roman Emperor Otto the Great). This produced some fine examples of monumental bronze-casting and high-quality sculpture, typified by the life-size *Gero Crucifix*. In Anglo-Saxon England, meanwhile, the Winchester School created a series of outstanding illuminated manuscripts. The most impressive of these was the *Benedictional of St Ethelwold*, which features some extraordinarily ornate decoration. All of these revivals played a part in the development of the Romanesque style, which swept across many parts of Europe in the 11th and 12th centuries.

LEFT. Virgin of Vladimir (c. 1130)

ABOVE. Novgorod School – *The Battle Between the Novgorodians and the Suzdalians* **(c. 1450–75)**

30,000–15,000 BC

The earliest art. Prehistoric art usually represents social systems and beliefs, and during the Palaeolithic period some of the finest European art is made in vast cave complexes in southern France and northern Spain. Here, images of large animals are painted with tonal and textural effects using mineral and vegetable pigments. Rock paintings in India and Australia are also predominantly of animals, although Australian and African prehistoric art features more human figures than the art in other continents. Some of the earliest art is three-dimensional: small stone, ivory or bone female figurines are found in various parts of the world, but predominantly across Europe. All have similar features, including large bellies, breasts and thighs. As well as these humanoid objects, animal sculptures and pottery storage and cooking vessels are made in Asia, Australia and Europe. SH

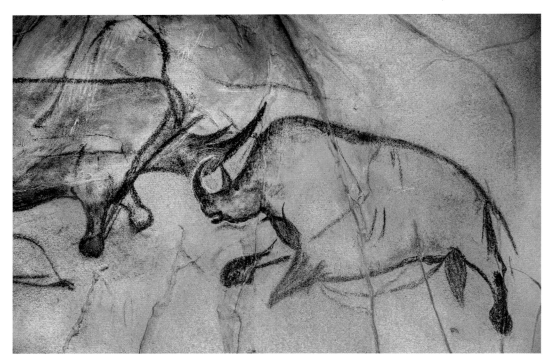

Chauvet – *Cave painting*
Dating to about 30,000 BC, these paintings in southern France are among the best-preserved figurative cave paintings in the world. In the first part of the cave, most images are red with some black and engraved pictures. In the second part, there are mostly black images. At least thirteen different animal species are depicted. Unusually, there are hand prints and stencils, part of a female body, and a volcanic eruption. Techniques used here are rarely found in other cave art. Artists scraped the walls for a smooth surface and suggested movement by incisions around some of the outlines, and some images show animals interacting with one another.

Parts of south-western Australia are inhabited by humans who use wooden rather than stone tools.

In Europe, tools made of stone, antler or bone become more sophisticated.

In Bhimbetka in India, artists paint in rock shelters.

Humans live longer; population grows.

Modern humans begin replacing Neanderthals.

Ovens are made for cooking.

New Guinea is populated by colonists from Asia or Australia.

The oldest-known twisted rope is made.

| 30,000 BC | 30,000–28,000 BC | 28,000–25,000 BC | 27,000–26,000 BC |

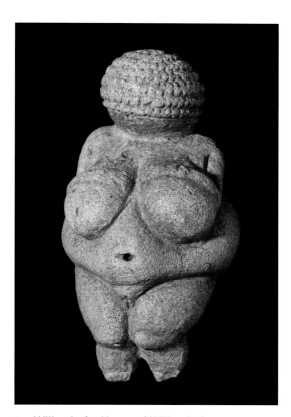

○ **Willendorf – *Venus of Willendorf***
In various parts of the world, small prehistoric statuettes have been found, all female, naked and voluptuous, possibly created as fertility symbols or mother goddesses, although some scholars propose that they were self-portraits. Known as Venus figurines after the later mythological goddess of love, beauty, fertility and victory, they are small enough to be hand-held, and the most famous is the 11 cm (4½ in.) Venus of Willendorf from Austria, estimated to have been made between 28,000 and 25,000 BC.

Altamira – *Cave painting*
Probably painted between 22,000 and 14,000 years ago, the caves at Altamira in northern Spain are so well preserved that their authenticity was doubted for years. Mainly featuring bison, but also deer, wild boar, horses, anthropomorphic figures, geometric symbols and hand prints, the subterranean complex is 270 m (885 ft) long, with twisting passages ranging from 2 to 6 m (7–20 ft) in height, in which more than a hundred animal figures are depicted, demonstrating quite astonishing technical skills for the period. Especially remarkable are the accurate proportions and the attempt at tonal differentiation.

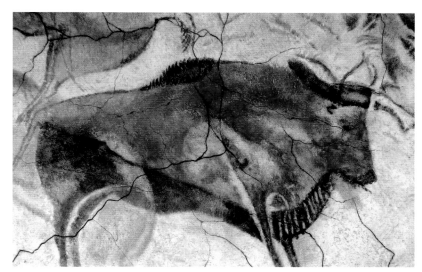

The oldest-known human permanent settlement is established in Moravia in the Czech Republic.

Artefacts suggest that human activity occurs in Canberra, Australia, at this time.

Near the Sea of Galilee in Israel, wild barley and other seeds are milled for bread.

The oldest-known pottery is made: a figurine rather than cooking or storage vessels. Around the world, people use fibres to make baby carriers, clothes, bags, baskets and nets.

Sea levels are approximately 137 m (450 ft) below current levels.

25,000–24,000 BC **23,000–20,000 BC** **22,000–14,000 BC**

15,000–3000 BC

Art develops. The Magdalenian era, from c. 15,000 to c. 10,000 BC, is named after 'La Madeleine' site in France, where some of the finest cave art in Europe is produced. Between about 13,000 and 10,000 BC, the Ice Age ends and a period of global warming begins. The region that later becomes the Sahara in North Africa is wet and fertile. During the Mesolithic period, from c. 10,000 to 5000 BC, more paintings are made outside on rocks than in caves, usually of human groups engaged in hunting or religious rituals. In c. 3500 BC the first wheels are made to help potters shape their vessels. The Minoan culture begins on Crete, and in Egypt stylized wall paintings are produced. SH

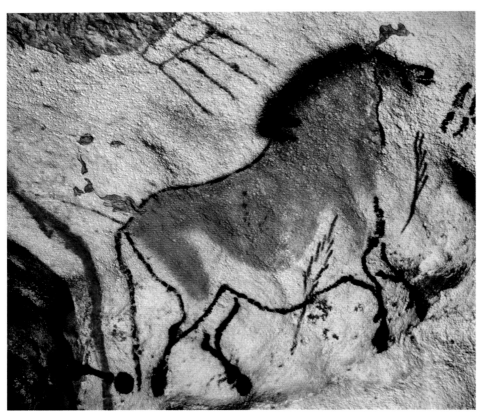

Lascaux – *Hall of the Bulls*

Among the best-known works of prehistoric art are large paintings in a series of interconnected underground caves at Lascaux in the Dordogne region of France. The most famous of these are in the Hall of the Bulls, named after four huge black bulls painted there among the many other animals. Created c. 16,000–14,000 BC, the images fill both sides of the length of the cave. There are hundreds of paintings of seemingly moving animals, including bulls or aurochs, horses, cattle and deer. Many are depicted from the side, with horns and antlers from the front, created with solid outlines and softly blended pigment over their bodies. The artists used various mineral and vegetable pigments, usually mixed with saliva, animal fat, groundwater or clay, swabbing or blotting it on, or sometimes blowing it on to the walls through hollowed-out bones.

Wisent, or European bison, are sculpted in clay deep inside a cave in the French Pyrenees.

The woolly rhinoceros becomes extinct.

The region that later becomes the Sahara Desert is a lush, fruitful grassland with plenty of rain.

| c. 16,000–14,000 BC | 15,000–13,800 BC | 8000–6000 BC |

Tassili n'Ajjer – *Rock paintings*

In Tassili n'Ajjer in Algeria, over 15,000 rock and cave paintings and engravings portray everyday life over a period of about 10,000 years. Images include humans and animals, many of which are now extinct, such as the giant buffalo. The paintings and engravings are usually divided into four chronological periods: the Round Head period: humans are portrayed with round, featureless heads; the Pastoral period: humans are shown herding animals and hunting; the Horse period: humans are riding horses or in horse-drawn chariots; and the Camel period: camels, cattle and goats frequently appear.

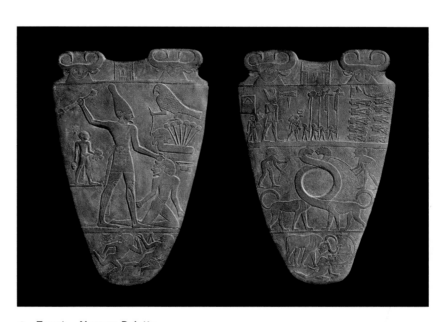

In northern Mesopotamia, now northern Iraq, barley and wheat are cultivated, initially used for beer and soup, and eventually for bread.

In the south-west of Egypt, settlers herd cattle, goats, pigs and sheep, and construct large buildings. They produce metal objects, tan animal skins, make pottery and weave.

Egypt – *Narmer Palette*

Also known as the Great Hierakonpolis Palette, this contains some of the earliest hieroglyphic inscriptions ever found. Made of siltstone, it is 63.5 cm (2 ft) high, and carved on both sides in low relief. It features a king called Narmer and other scenes that may represent the unification of Upper and Lower Egypt, or they may be a record of events, such as a military success. Egyptian conventions regarding the depiction of important figures are adhered to, while lesser figures are conveyed more freely.

4500 BC **3100 BC**

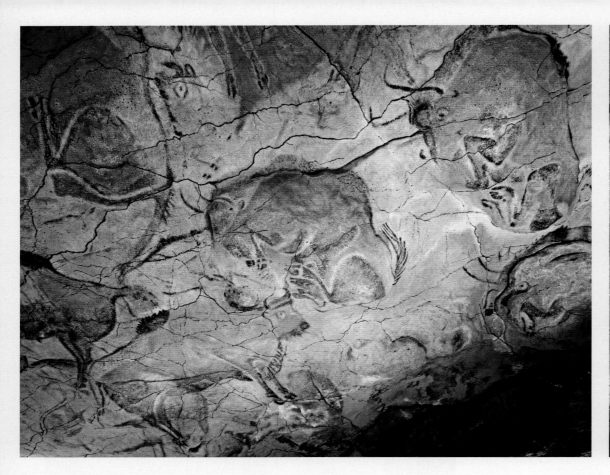

ANIMAL PAINTING

Animals have been depicted in art for thousands of years – in religious rituals, as mythical creatures and working beasts, and as companions. From caves in France to rock paintings in Australia, and from Franz Marc's horses to Picasso's bulls and doves, animals in paintings reveal much about the surrounding culture.

For instance, the earliest artists depicted images of species that they hunted or farmed, many of which have since become extinct, such as the cave lion, aurochs, sabre-toothed tiger and mammoth, although the most frequently depicted were horses, bison, deer, cattle and boar. Most caves feature only monochrome, flat-looking images, but those at Altamira in Spain are coloured and created with methods including scratching and blending to convey the appearance of texture and variations in tone. Even more unusually, the artists exploited the natural contours and protrusions of the cave surface to create a tangible sense of three dimensions. Finally,

there is an absence of the soot deposits left in other caves, which may indicate that these artists used more advanced methods of illumination.

Most European Palaeolithic paintings do not feature humans, and certainly not humans interacting with animals, which has inspired a great deal of speculation about the function of images such as that of a bison and a bird-man at Lascaux in France. With a bird's beak and a human torso, the figure could be a shaman in a mask performing a ritual. In shamanism, birds can occupy two realms – the earth and the heavens – and the bird on the pole could either be a staff or a spear. If a staff,

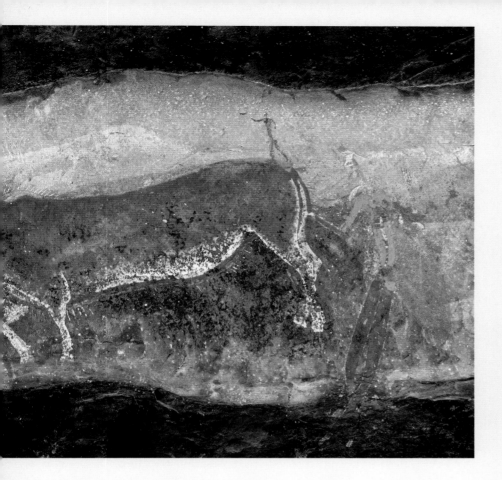

Drakensberg Paintings

Approximately 20,000 rock paintings by the
indigenous people of South Africa, the San
Bushmen, are in the Drakensberg Mountains,
the earliest about 2,500 years old, and the
most sophisticated and expressive made between
400 and 200 years ago. Subject matter includes
human figures, animals, and half-human,
half-animal hybrids, or therianthropes, who are
probably medicine men or healers. While most
animals are depicted in one colour – usually red or
black – elands are painted in several colours. They
are painted from various angles, in many natural
poses, embellished with fine details and enhanced
with sophisticated shading techniques to convey
three-dimensionality. As part of shamanistic rituals,
these paintings were created to harness the elands'
sacred spirits and pay them homage.

ABOVE LEFT. Altamira, bison
Although many animals are
depicted on the cave walls
at Altamira, images of bison
predominate. On the ceiling,
a herd of steppe bison are
depicted in different life-like
poses. They were painted
about 14,000 years ago.

**ABOVE. Drakensberg, eland
and human figures**
Known as the Rosetta Stone
of South African rock art, this
painting in the Game Pass
shelter led scholars to realize that
the art at Drakensberg was a
system of metaphors linked to
the San shamanistic religion.

it could be a shaman having a vision, or it
could be part of a myth or an omen. If it is
a spear, the image could be about the hunt.

Early societies in the Middle East
depicted animals working for humans, as
incarnations of gods, or to express a ruler's
authority. After 2000 BC horses became
the principal animal of transportation and
warfare in the Middle East and appeared in
paintings to demonstrate man's control over
the natural world. In Mesopotamia, animals
were domesticated almost 2,000 years
earlier than in Egypt, and depictions of small
cattle, goats, ibex, lions, snakes and birds
were common, as well as images of hunting.
For instance, the Palace of Ashurbanipal

at Nineveh, the capital of Assyria, contains
numerous animal paintings showing wild
asses and herds of gazelles running, in
flight from some threat. Animals appear
in Egyptian wall and papyrus paintings,
often showing everyday activities, such
as cows being milked or chewing on
bushes, goats being herded, men catching
fish or birds, and hunters spearing fowl
or crocodiles. Some deities were depicted
either as animals, or with both animal
and human attributes – such as Horus,
the sky god, as a hawk or falcon; Thoth,
the god of wisdom and learning, as a baboon
or ibis; and Anubis, the god of the dead,
as a jackal. SH

3000-2000 BC

Civilization begins. By 3000 BC in the Sumerian city of Uruk, cuneiform writing has been developed. Over the next century in Mesopotamia, huge religious monuments called ziggurats are constructed, such as the great Ziggurat of Ur, built c. 2100 BC. Between c. 2600 and 1100 BC, the Minoan civilization flourishes on the island of Crete, with vast palaces built specifically as forums for gatherings, for crop storage and as workshops for artists. The palaces are adorned with sculptures and frescoes, which feature stylized animals, plants, ceremonial figures, and bullfighting and court scenes. From c. 1700 BC the potter's wheel is used to create ceramics. Meanwhile, unlike the Minoans, the Egyptians paint frescoes on dry walls. Their first step pyramid is built at Saqqara for Pharaoh Djoser during the Third Dynasty. From c. 2575 to 2551 BC the Great Pyramids are built at Giza, as is the Great Sphinx approximately seventy-five years later. SH

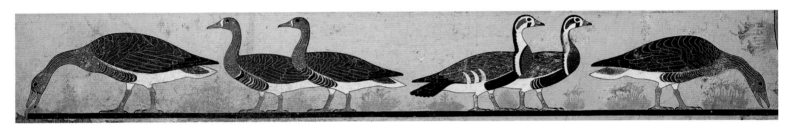

Meidum – *Geese*

This painting was on the wall of the tomb-chapel of Atet or Itet, the wife of Prince Nefermaat, at Meidum. Nefermaat was an Egyptian vizier and prince, the son of Pharaoh Sneferu, the founder of the Fourth Dynasty of Egypt, and his first wife. As members of the royal family, Atet and Nefermaat were given a large tomb decorated by skilled artists. These six geese are divided into two groups, and in each group, one goose bends down to eat grass while the other two are upright. Notable for its sensitive paint application and rendering of individual birds' feathers and plumage, the painting represents many geese, as in Egyptian writing the number three represents the plural.

In Egypt, the 365-day year is established based on the lunar cycle of twelve months, grouped into three seasons of four months, coinciding with the rise and fall of the waters of the Nile. The First Dynasty of Egypt ends and the Second Dynasty begins.

Simple ploughs are used, some of which are illustrated in pictographs in Uruk, an ancient city of Sumer, east of the present bed of the Euphrates river.

Farming develops in North Africa, Europe, Mesoamerica and Asia, food improves, and people live longer.

Troy is founded in Asia Minor.

The step Pyramid of Djoser is built.

The Fourth Dynasty of Egypt begins.

The Great Pyramids and Great Sphinx are built for pharaohs Menkaure, Khafre and Khufu at Giza.

The Indus Valley Civilization reaches its mature phase.

3000 BC	2900 BC	2700-2600 BC	2650 BC

Sumer – *Standard of Ur*

Because this small box was discovered near a soldier it has been called a standard, but it is more likely the sound-box for a musical instrument. The mosaic images, made of shell, lapis lazuli and red limestone set in bitumen, depict life in early Mesopotamia. On each side, the ruler is depicted, larger than other figures because he was both a warrior and an intermediary between the gods and the people. The 'War Side' of the box (below) shows wheeled wagons and onagers (donkeys) trampling on enemy soldiers, and the 'Peace Side' depicts men carrying produce and fish, and leading onagers, bulls and caprids (sheep and goats).

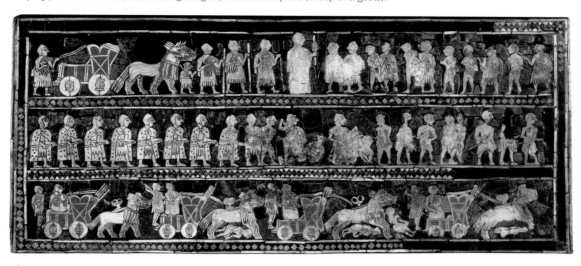

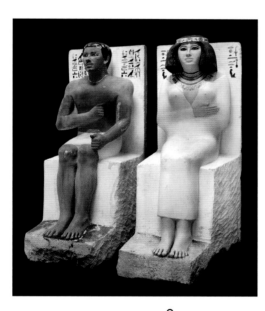

Meidum – *Rahotep and Nofret*

Found in a brick *mastaba* (ancient Egyptian tomb) at Meidum, these figures represent the married royal couple Rahotep and Nofret. Rahotep was probably a son of Pharaoh Sneferu, the founder of the Fourth Dynasty of Egypt, although some believe that his father was Huni, the last pharaoh of the Third Dynasty. Seated on high-backed chairs with foot rests, the figures follow Egyptian artistic convention, with Rahotep's male skin reddish-brown and Nofret's female skin creamy-white. On the backs of their chairs in hieroglyphs, the couple's titles are listed.

In Central Asia, spoked wheels are invented.

Semitic people arrive in Sumeria, probably from North Africa.

In Japan, the Middle Jomon Period starts. The people farm a wide variety of crops and decorate their pottery by impressing cords into wet clay.

The Old Kingdom ends in Egypt and the First Intermediate Period begins.

Stonehenge is constructed in Britain.

The first Sumerian literature is produced and the Akkadian Empire takes control of Sumer.

| 2600–2400 BC | 2570 BC | 2500–2200 BC | 2100–2000 BC |

2000–1000 BC

Art begins to flourish. As the Indus Valley Civilization declines, Egypt and Mesopotamia are the most powerful civilizations in the world, and rulers turn their attention towards creating elegant art and architecture. The first Mesopotamian civilizations, the Sumerians and the Akkadians, invent the wheel, the arch and the plough, and produce statues, reliefs and mosaics. In Anatolia by *c.* 2000 BC, the Hittites are creating stone reliefs, friezes and sculptures of warriors, lions and mythical beasts, while in the fertile Nile Valley, the Egyptians establish strict traditions of representation. From *c.* 1600 to 1046 BC, people of the Shang Dynasty cast highly decorated bronze jars and boxes using the lost-wax technique. They begin writing pictogram messages on these by *c.* 1200 BC. SH

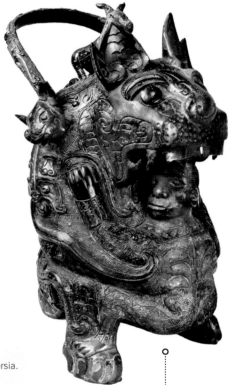

Shang Dynasty – *Tigress vessel*

The Shang Dynasty introduced a period of stability and several cultural advances, such as the calendar, writing and industrialized bronze casting. This is a bronze You vessel: a lidded container used for liquid offerings. As many were, it is zoomorphic, in the shape of a cat, appearing to clutch a small human in its front paws. This could represent an ancient story of a human baby being rescued by a tigress, or it could imply a child being sacrificed. It features animal and dragon motifs and square spirals, the back is in the shape of an elephant, the handle is decorated with animal masks, and a horned caprid (goat) appears over the lid. Used in ceremonies to nourish the dead, it would have been a symbol of status and power.

In Guatemala, the Mokaya bring cacao from the upper Amazon and create beverages with it; this is the precursor to chocolate.

Windmills are developed in Persia.

Babylon becomes the largest city in the world, taking over from Thebes in Egypt.

The last species of woolly mammoth becomes extinct on Wrangel Island in Russia.

The Indus Valley Civilization comes to an end.

In China, the Shang Dynasty begins.

Mycenaean culture becomes increasingly influential in the Peloponnese.

The Assyrians gain power in Mesopotamia and Queen Hatshepsut rules Egypt.

The Shang Dynasty creates China's first large cities, with twelve-month calendars, conscription, centralized taxes and outstanding artistic production.

| 2000–1000 BC | 1800–1600 BC | c. 1550–1050 BC | 1500–1300 BC |

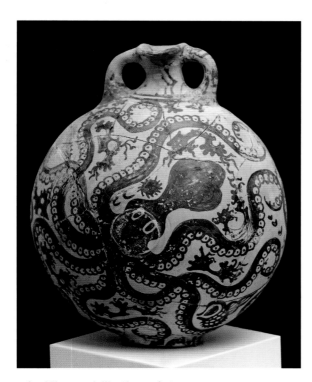

Minoan civilization – *Octopus vase*

Symbolizing wealth, protection, food and celebration
of the sea, the octopus appears often in Minoan
art. This anthropomorphic design that covers the
spherical vase or flask evokes a sense of freedom
that contrasts directly with the rigid conventions of
Egyptian art. Made in the late Minoan Bronze Age
during the period known as the Second or Marine
Style of pottery, this piece was part of a trend of
Cretan ceramic artefacts known as Kamares ware.
It would have been a prestigious object, owned
by a wealthy individual.

Thebes – *Nebamun hunting in the marshes*

Nebamun was a scribe in charge of grain collection for the Egyptian city
of Thebes. This is part of his tomb, in which he is shown hunting birds
in a small boat with his wife, Hatshepsut, and their young daughter.
Nebamun's striding figure dominates the image, which originally had
another side depicting him spearing fish with his young son. Although
traditionally Egyptian painting is seen as stylized and flat, the artists have
captured intricate details such as the shiny fish scales, the cat's tawny
fur, the birds' feathers and the papyrus fronds. As well as being a pet,
the cat represented the sun-god hunting the enemies of light and order.

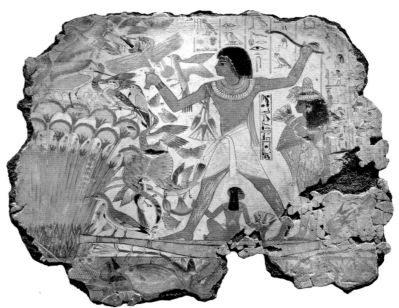

The earliest Chinese writing
is produced.

The Iron Age begins in the Near East,
eastern Mediterranean and India.

The Olmec culture begins to thrive
in coastal regions of the southern
part of the Gulf of Mexico.

The legendary Trojan War begins,
and lasts for a decade.

The Phoenician alphabet is invented.

The Linear B
Mycenaean script
develops; it becomes
the precursor of
Greek script.

1500 BC	c.1400 BC	1350 BC	1200–1000 BC

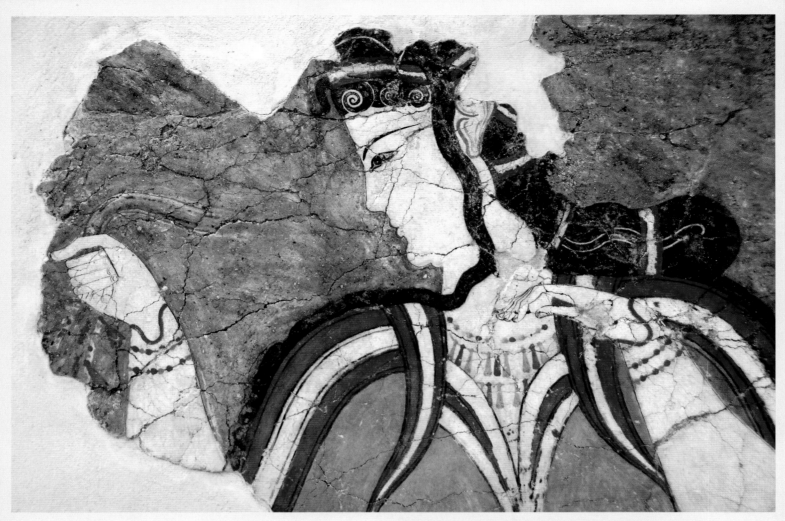

Heinrich Schliemann
(1822–90)

The first excavations at Mycenae were carried out in 1841, but the discoveries that brought the site widespread fame were made by Heinrich Schliemann, who began digging there in 1876. A multi-lingual German businessman, Schliemann became wealthy enough to give up commerce in the 1860s and devote himself to his passion for the ancient world – particularly the world of Homer's epic poems, which he thought were based on historical reality. In 1870 he began excavations at Hissarlik, on the Turkish Aegean coast, which has been plausibly identified with Homer's city of Troy. Later archaeologists have attacked his methods as crude (and sometimes dishonest), but Schliemann played an important role in making his subject an issue of wide public interest.

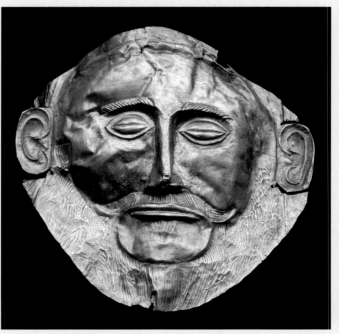

MYCENAEAN ART

Long before the classical age of ancient Greek culture, which peaked in Athens in the 5th and 4th centuries BC, the Mycenaean civilization flourished. However, its major cities were destroyed by invaders, and its treasures were not brought to light until the 1870s.

ABOVE LEFT. Fresco fragment from Mycenae (c. 1300–1200 BC) Discovered in 1970, this beautiful fragment has been dubbed 'The Lady of Mycenae'. It depicts a high-status woman (or perhaps a goddess) holding a necklace.

LEFT. Gold funeral mask from Mycenae (c. 1600–1500 BC) This mask covered the face of a buried king. Its discoverer, Heinrich Schliemann, named it the Mask of Agamemnon, but there is no evidence to connect it with this legendary ruler.

Mycenae was an important city in the early days of Greek civilization, located on a hill in the Peloponnese (the southern peninsula), dominating its immediate surroundings. According to legend, the city was founded by the hero Perseus, and in Homer's *Iliad* (dating from about the 8th century BC) it is the home of King Agamemnon, the leader of the Greek army during the Trojan War. After the remains of the city were excavated in the 19th century, the term 'Mycenaean' was used as a convenient label for Greek art and civilization as a whole in the late Bronze Age (c. 1600–1100 BC). The term includes the Greek islands as well as the mainland, with the exception of Crete (the largest island), which has its own distinctive Minoan culture. Apart from Mycenae itself, the major cities of the time included Pylos, Thebes and Tiryns (Athens had not yet risen to prominence).

Homer describes Mycenae as 'rich in gold', and the excavations there did indeed reveal a wonderful array of objects in precious metals, including goblets, masks, seals and weaponry, ornamented with superb craftsmanship. Among other luxury products are carved gems and glass, but Mycenaean art also includes everyday items of bronze and pottery. Some of these objects may have been imported, as there was widespread trade in the Mediterranean, but others were made in local workshops. There are also imposing architectural remains of Mycenaean culture, notably two famous structures in Mycenae itself: a large 'beehive' tomb called the Treasury of Atreus (also known as the Tomb of Agamemnon – both names are pure inventions); and the Lion Gate, which was the main entrance to the citadel. The two powerful figures of lions decorating the gate are the only surviving large-scale examples of Mycenaean sculpture. There are, however, numerous impressive fragments of wall paintings from the main cities.

In addition to works of architecture, art and craftsmanship, our knowledge of Mycenaean civilization is based on inscriptions on numerous clay tablets that have been unearthed. These are written in an early form of Greek in a script known as Linear B (also used on Crete), which was not deciphered until 1952. The inscriptions, made by palace officials, mainly deal with administrative matters such as accounts and inventories, suggesting a highly ordered society. The city of Mycenae was destroyed by invaders about 1200 BC, and for the next 3,000 years the Mycenaeans belonged more to myth than to history, until the dramatic results of excavations revealed their civilization to the world. IZ

1000-500 BC

Civilizations rise and fall. During the first millennium BC, iron working becomes widespread. The Celts dominate Central Europe and the Greeks, Carthaginians and Etruscans build city-states. The Phoenicians have been using their alphabet for some time, and many people learn the system. Soon the method is used in several languages, which leads to a greater dissemination of ideas, such as in astronomy and mathematics. Making their own modifications, the Etruscans and the Greeks adopt the alphabet, and Greek art begins developing in styles that are later called the Geometric and Archaic periods. During the 7th to 5th centuries BC, Greek artists produce black-figure pottery. Meanwhile, in Central America, the Olmec civilization, which produced colossal stone sculpture and traded widely, declines, replaced by the Maya. Rome is founded and the Persians build their capital, Persepolis. SH

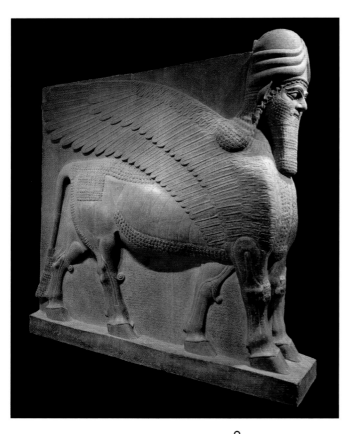

Assyrian Empire – *Winged bull*

When King Ashurnasirpal II (r. 883–859 BC) moved the Assyrian capital from Ashur to Nimrud in 863 BC, he built temples and a large palace. *Lamassu*, or royal guardians, were colossal stone reliefs of human-headed winged lions and bulls, which were put at the entrances. *Lamassu* were always made in pairs and, before Nimrud, were always lions. Bulls only appeared in Nimrud during Ashurnasirpal's reign, and ceased being made after his death. Bulls represented strength, while the wings symbolized speed, and the human head signified wisdom. Here, the bulls' bodies are realistically rendered, although each has five legs, so when seen from the front, they appear to be stationary and when seen from the side, they look as if they are walking. The wings are of a bird of prey, while the head is a man's, with a beard, thick eyebrows, expressive eyes and precisely modelled features.

The first Olympic Games are held in Greece to honour Zeus. The Greeks establish colonies in southern Italy and Sicily, and Homer composes the *Iliad* and the *Odyssey*.

David becomes king of the ancient united kingdom of Israel, followed by his son Solomon, who builds the first Temple in Jerusalem.

Rome is founded.

c. 1000 BC	*c.* 900–800 BC	*c.* 800–700 BC	776 BC	753 BC

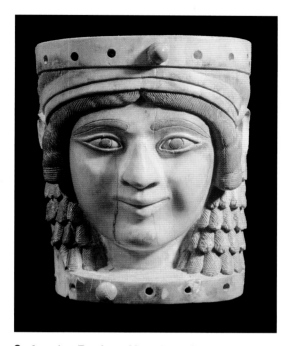

Assyrian Empire – *Mona Lisa of Nimrud*

When King Ashurnasirpal II made Nimrud the capital of Assyria, he held a ceremony to celebrate its architecture, art and other accomplishments. It became the centre of Mesopotamian achievement, and the art of ivory engraving reached a peak. This carved female head was found in a well in the palace, probably made as part of a piece of furniture. It is labelled the Mona Lisa of Nimrud for its enigmatic smile. The eyes appear to be laughing, and are surrounded by darkened eyebrows and hair in an elaborate style topped by a hat, perhaps indicating a high priestess.

Ancient Greece – *Bowl with gorgon's head*

According to Greek legend, anyone who looked upon the face of a gorgon – a woman with living, venomous snakes for hair – was instantly turned to stone. By looking only at the gorgon Medusa's reflection in his shield, the mythical hero Perseus cut off her head and gave it to the goddess Athena. Made early in the Archaic period (*c.* 800–479 BC) at a time of great changes in the language, society, art, architecture and politics of Greece, this bowl depicts Medusa's face. Believed to have the power to avert evil, gorgon heads became popular decorations for cups, bowls, friezes and frescoes.

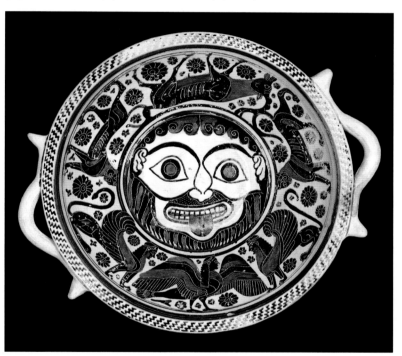

Nebuchadnezzar becomes king of Babylon. During his reign he creates the Hanging Gardens and sends the Babylonian army to sack Jerusalem, destroying the Temple.

The Athenian statesman **Solon** lays the foundation for democracy.

Gautama Buddha is born in Lumbini, in what is now southern Nepal. As an adult he attains Enlightenment and founds Buddhism in India.

Ancient Greek potter and painter **Exekias**, master of the black-figure technique, creates a series vases in Athens.

The Romans overthrow the Etruscan conquerors who had ruled over them for centuries, and establish a republic, electing their government to rule on their behalf.

| **625–600 BC** | *c.* **605 BC** | *c.* **574 BC** | *c.* **563 BC** | **550–525 BC** | **509 BC** |

500–1 BC

Across the world, empires develop: in China, the Chin and the Han dynasties; in Central America, the Maya and the Zapotec. The Carthaginians build theirs along the coast of North Africa and Sicily, and the unification of the Persian Empire brings stability to Central and West Asia. After 479 BC Athens dominates Greece politically, economically and culturally – monumentalized by the Acropolis. Dedicated to the city's patron goddess Athena, the Parthenon epitomizes Greek architectural and sculptural grandeur as Classical art reaches outstanding levels of harmony and Greece's influence spreads. In the Persian Empire glass is blown and knotted carpets are made. In China, the silk industry expands and newly invented steel needles are used to embroider silk robes. The terracotta sculptures depicting the armies of Qin Shi Huang (259–210 BC), the first emperor of China, are made and buried with him to protect him in the afterlife. SH

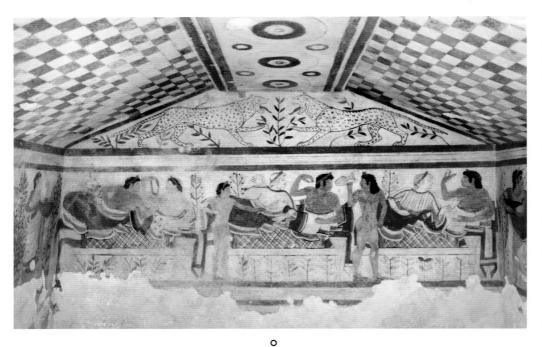

Etruscan Empire –
Tomb of the Leopards

Situated near Tarquinia in Lazio, Italy, the Etruscan Tomb of the Leopards is a single fresco-filled chamber. Demonstrating the festive nature of Etruscan funeral rites, the frescoes depict banqueting scenes, as the ritual of having a banquet with burials marked the transition of the deceased to the afterlife. The meal also included certain dishes and utensils which were then placed in the tomb, while games and other activities were performed to celebrate the dead person's life. Painted in only two colours of pinkish-red and blue, this depiction of elegantly dressed couples adheres to artistic convention – the women are fair-skinned, the men darker. Above them, two leopards flank a small olive tree.

The Nok culture flourishes in Nigeria. One of the earliest African centres of ironworking and terracotta figure production, it lasts until AD 200.

Democritus, the ancient Greek philosopher, proposes the existence of indivisible particles that he calls atoms.

Alexander the Great leads the Greeks in wars against the Persians, and after much bloodshed is ultimately victorious.

| c. 500 BC | c. 470 BC | c. 400 BC | 334–330 BC |

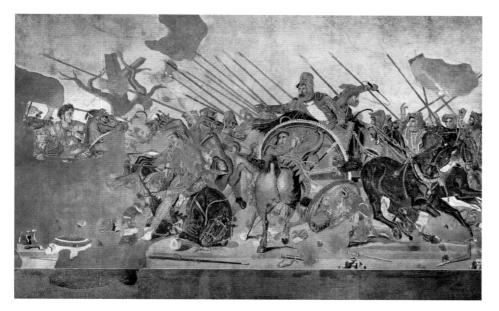

Ancient Greece – *Laocoön and his Sons*

This Hellenistic sculpture (probably a copy of a Roman bronze) epitomizes suffering and struggle. The work depicts the Trojan priest Laocoön and his sons Antiphantes and Thymbraeus. In a story told by Virgil in his *Aeneid*, Laocoön warned his fellow Trojans against taking in the wooden horse left by the Greeks outside the city gates. Athena and Poseidon favoured the Greeks, so they sent two sea-serpents to kill Laocoön and his sons. Made from seven pieces of marble, the sculpture has a monumentality and sensuousness that influenced Renaissance artists, including Michelangelo, and later Baroque and Neoclassical sculptors.

Pompeii – *Alexander Mosaic*

Originally from the House of the Faun in Pompeii, Italy, this was probably a copy of a Greek Hellenistic painting, or a late 4th-century BC fresco. An example of an early tessellated mosaic, it contains approximately four million tesserae (small mosaic tiles), each applied following the *opus vermiculatum* method (in which rows emphasize outlines). Depicting a battle between the armies of Alexander the Great and Darius III of Persia, this is the moment when Alexander attempted to capture or kill Darius. It is traditionally believed to represent either the Battle of Issus or Gaugamela, but is a general portrayal of Alexander's ultimate victory. Here Alexander storms in to attempt to engage Darius in battle, but Darius has already turned to run.

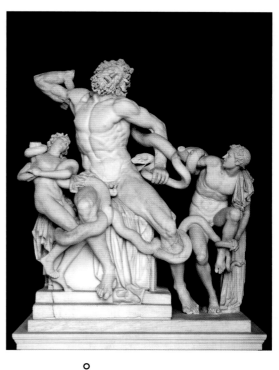

The Yayoi period starts in Japan, replacing the Jomon culture. It is characterized by the development of wet-rice cultivation and a new style of pottery with clean, functional shapes.

Euclid, the Greek mathematician, lays out the principles of geometry in *Elements*.

Emperor Shih Huang Ti of China orders the building of a great wall along China's northern border.

The Roman Empire is established, following the demise of the Roman Republic. Its first emperor is Augustus, who reigns from from 27 BC to AD 14.

Jesus, the central figure of Christianity, is born.

| *c.* 300 BC | *c.* 220 BC | 27 BC | *c.* 25 BC | *c.* 6–4 BC |

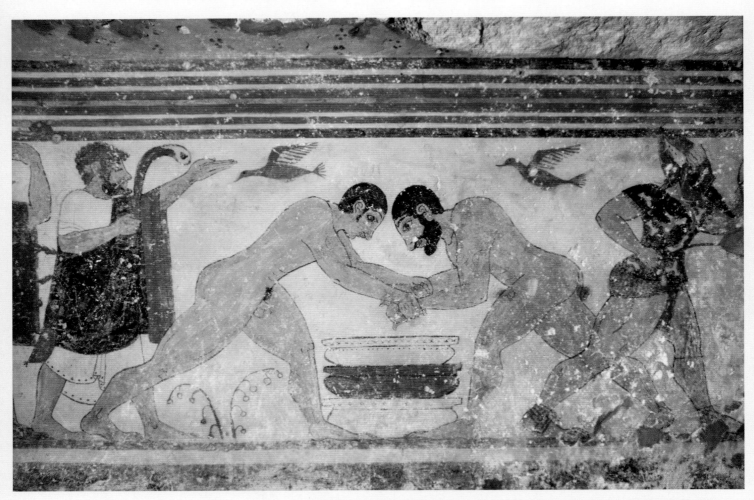

Vulca of Veii

Almost all Etruscan art is of anonymous authorship, but the name of one notable artist has survived – a sculptor called Vulca. He is mentioned in the writings of the Roman encyclopedist Pliny the Elder, who lived in the 1st century AD. According to Pliny, Vulca was summoned to Rome from the nearby city of Veii to make sculptures for the Temple of Jupiter, Juno and Minerva on the Capitoline Hill, which is said to have been dedicated in 509 BC. This was the most important building of its time in Rome. It was destroyed by fire, along with its sculptural decoration, in 83 BC, but a magnificent terracotta statue of Apollo discovered in Veii in 1916 has been plausibly attributed to Vulca.

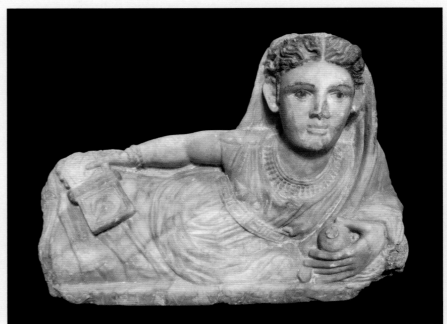

ETRUSCAN ART

The great precursors of the Romans were the Etruscans. They left no literature or historical records, but thousands of tombs reveal a wealth of art, including sculptures in painted terracotta, and some of the finest wall paintings from the ancient world.

The Etruscans were an ancient people who dominated central Italy before the rise of Rome. They did not form a unified nation, but rather a loose confederation of city-states, including Clusium (modern Chiusi), Perusia (Perugia), Tarquinii (Tarquinia) and Veii (Veio). The origins of the Etruscans are uncertain, although they are said to have migrated to Italy from Asia Minor about the 10th century BC. They were at the peak of their power in the 6th century BC, when they controlled much of the Italian peninsula and had colonies on Corsica, Sardinia and other Mediterranean islands (they were great seafarers). However, their empire declined under various pressures (including attacks by Gauls), and Rome's conquest of Veii c. 396 BC marked a shift in the balance of power. Thereafter the Etruscans were increasingly under Roman influence and by the 1st century BC they had lost their political and cultural independence.

The Etruscans excelled in various types of art, including sculpture, painting, pottery and metalwork (they were also notable builders). They were strongly influenced by Greek art, but Etruscan art is usually much less idealized, often showing a distinctive earthiness and sometimes an almost brutal vigour. It was largely concerned with commemorating the dead or honouring the gods, and most of the best works come from cemeteries or sanctuaries.

Although the Etruscans made use of local stone, their preferred materials for sculpture were terracotta and bronze. Clay is a common sculptural material throughout the world, but it is difficult to use for large works because of the problems of firing such pieces. However, the Etruscans were unusual in employing it to produce life-size (or even slightly larger) figures. They showed similar technical prowess in handling metal, creating some of the finest bronze sculpture of the ancient world. On a smaller scale, they were also expert goldsmiths.

The most remarkable remains of Etruscan art are the abundant wall paintings found in underground tombs. Thousands of such tombs have been discovered (more than 6,000 in Tarquinia alone), with hundreds of them decorated with paintings, the best of superb quality. These paintings are all the more significant because almost nothing comparable survives from contemporary Greece. They bear witness to the wealth and status of the people for whom the tombs were created, often depicting the continuation of earthly pleasures in the afterlife, with colourful scenes involving such subjects as banqueting, hunting and dancing. IZ

ABOVE LEFT. Wall painting, Tomb of the Augurs, Tarquinia (c. 550–500 BC)
The two powerful wrestlers shown here are taking part in funeral games. Other scenes in the tomb depict dancers, musicians and a banquet.

LEFT. Lid of cinerary urn from Volterra (c. 200–100 BC)
Cinerary urns (containing a dead person's ashes) have been found in many Etruscan tombs. This example is carved in alabaster.

RIGHT. Sarcophagus of the Spouses (c. 550–500 BC)
Found in a tomb in Cerveteri in 1845, this is considered one of the masterpieces of Etruscan sculpture, showing remarkable intimacy, with the couple reclining as if at a banquet.

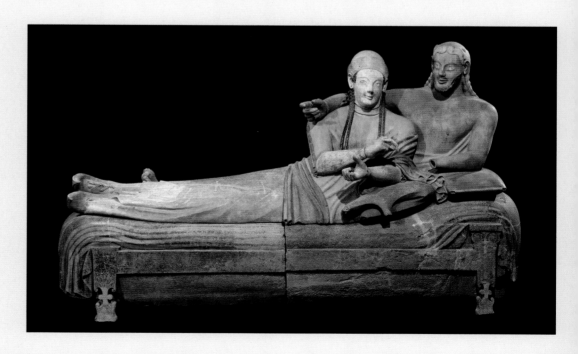

AD 1–100

The Christian era begins. The first part of the century coincides with the life and ministry of Jesus Christ. The precise dates are a matter of historical debate, but the Crucifixion is traditionally ascribed to c. AD 33. Most of the West is under the control of Rome. There are many successes – the Roman Empire reaches its greatest extent at the end of the century, under Trajan – but the period also includes the reigns of two of the most notorious emperors, Nero and Caligula. Much Roman art survives. The eruption of Vesuvius in AD 79 preserves fresco paintings in Pompeii, while in the Egyptian region of Fayum a unique tradition of portraiture is established. IZ

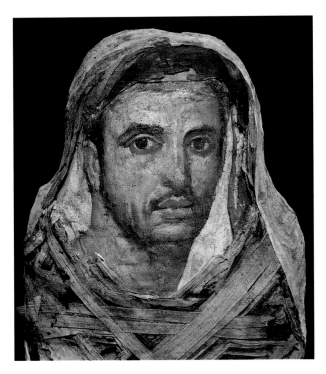

Fayum – *Portrait of a Man*
Egypt was under Roman rule at this time, leading to an unusual cultural mix in certain funerary practices. Some inhabitants retained the traditional Egyptian mummification process, but attached realistic, Roman-style portraits to the linen wrappings. There is evidence that mummies were kept in the household for quite some time before being buried, so the portrait would have been a poignant reminder of a departed relative. In this case, it may well have been a copy of an older portrait, since the body inside the wrappings was that of an elderly man. Fayum portraits were painted in encaustic, a durable medium which involved mixing pigments with molten wax.

Pompeii – *Portrait of a Couple*
This is probably the finest of the portraits that survived the destruction of Pompeii. It shows the baker Terentius Neo and his wife. They were probably Samnites (a defeated people), but socially they were on the rise. He wears a white toga and carries a scroll, suggesting that he may have been standing for political office, while she is dressed in the latest fashion. She holds a stylus and reckoning tablet, showing that she was active in their business.

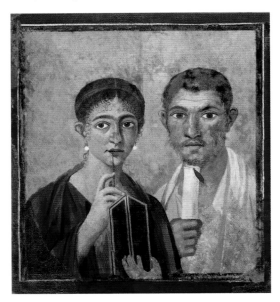

The Roman Conquest of Britain begins, when Emperor Claudius sends an invading army led by General Aulus Plautius.

c. 25–75 43 c. 50

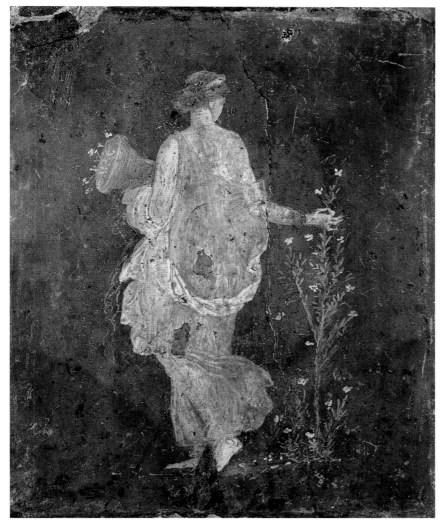

Villa Arianna, Stabiae – Fresco of Flora

This beautiful fresco was found in the Villa Arianna, a luxurious home near the seaside resort of Stabiae. It was situated a few miles south-west of Pompeii and was destroyed during the eruption of Mount Vesuvius. The villa overlooked the Bay of Naples and contained a wealth of fine frescoes and mosaics. Flora was found in one of the *cubicula* (bedrooms). She was a minor Italian deity – the goddess of flowers and Spring – but her festival at the end of April (Floralia) became a pretext for riotous celebrations. This is the same goddess who appears centuries later in some of Botticelli's most famous mythological paintings.

Pliny the Elder dedicates his monumental *Natural History* – the first great encyclopedia – to the future emperor Titus. He will die two years later, while trying to observe the eruption of Vesuvius at close quarters.

The Great Fire of Rome destroys much of the city and takes six days to bring under control. Emperor Nero uses this opportunity to build a huge new palace, the Domus Aurea ('Golden House').

The First Jewish-Roman War. A major rebellion breaks out in the province of Judea. Much of the revolt is centred on Jerusalem, where the Second Temple is destroyed (AD 70).

Boudicca, the queen of the Iceni tribe, leads an uprising in Britain against the Roman occupying forces.

Mount Vesuvius erupts, burying the city of Pompeii in ash. The nearby towns of Herculaneum and Stabiae are also destroyed.

| 60 | 64 | | 66-73 | 77 | 79 |

100-200

Roman wars. Roman power is at its zenith. During the first part of the century, the empire is governed by the so-called 'five good emperors' (Nerva, Trajan, Hadrian, Antoninus Pius and Marcus Aurelius) – a nickname coined by the Renaissance historian Niccolò Machiavelli. This era of stability ends with the 'Year of the Five Emperors' in 193, which follows the murder of Emperor Commodus. This troubled period will also see the start of the Great Migration, as barbarian tribes put pressure on the empire's eastern borders. Roman art flourishes, though much of it is based on ancient Greek models. Both the *Capitoline Venus* and the *Centaur Mosaic* are copies of lost Greek originals. IZ

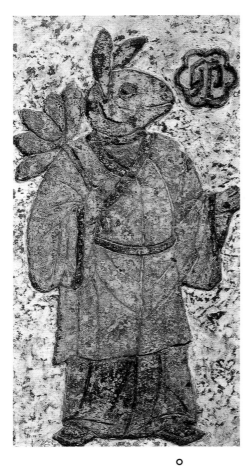

Han Dynasty – *Painted Tiles: Guardian Spirits of Night and Morning*

Some of the earliest examples of Chinese painting can be found on the decorative tiles and bricks that were used in tombs. There, they served a protective function, representing guardian spirits. These examples are zoomorphic (part human, part animal) and they wear the lavish silk robes that were popular during the Han era. The animals themselves are traditional zodiac symbols, and their protection covers different times of the day. The rabbit is the guardian spirit of part of the morning (5 a.m. to 7 a.m.).

Trajan's Column in Rome is completed. This monumental structure, with spiralling decorations, celebrates Emperor Trajan's victories over the Dacians.

Hadrian's Wall is constructed in the north of England. It is designed to keep the Picts and other northern raiders out of Roman territory.

Rome wages war against the Parthians (a powerful people in modern-day Iran and Iraq). They are competing for control of Armenia and Upper Mesopotamia.

| 113 | c. 120-130 | 122 | 161-66 |

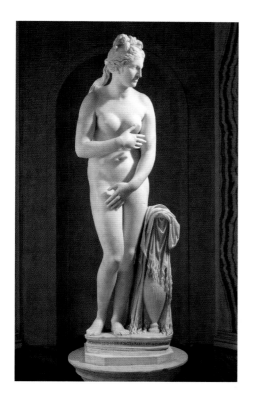

Hadrian's Villa – *The Centaur Mosaic*

This dramatic mosaic was discovered in the *triclinium* (dining room) of a luxurious villa, which the Emperor Hadrian built for himself near Tivoli. It is the *emblema* (central panel) of a much larger mosaic, which once covered the entire floor. The unknown artist or artists have captured a dramatic moment. A centaur is about to hurl down a rock on the tiger, which has killed his female companion. At the same time, he glances nervously to his right at a leopard, which is about to leap down on him. A leopard's pelt is slung over his left arm, indicating that the centaur was no stranger to this kind of struggle. The violence of this scene contrasted with other artworks in the villa, which showed animals living together in harmony.

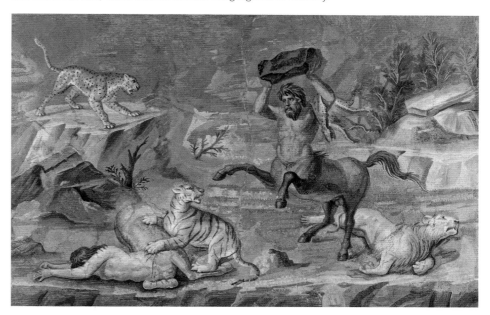

Rome – *The Capitoline Venus*

This statue of Venus takes its name from the Capitoline Museums in Rome, where it has been housed since the 18th century. It is a Roman copy of the *Aphrodite of Knidos,* a Greek statue from the 4th century BC by Praxiteles, which has not survived. The *Aphrodite* was one of the most famous statues of antiquity. Although sculptures of male nudes were common, this was the first life-size female nude. It is also known as the *Venus Pudica* ('Modest Venus'), because of the way in which the woman is covering herself. The statue was much copied – more than fifty versions have survived – and it also proved an inspiration to painters. Botticelli's *The Birth of Venus* (see p. 104) was clearly modelled on it.

The Marcomannic Wars break out along the north-eastern border of the Roman Empire. The Marcomanni are a confederation of Germanic tribes.

The Yellow Turban Rebellion begins in China. This peasant uprising will last until 205 and heralds the end of the Han Dynasty (206 BC–AD 220).

The Antonine Plague begins to spread across Europe. The sickness, brought back by Roman troops serving in the Near East, may have been smallpox. It soon becomes a pandemic, killing about 5 million people.

165 **166** **184** **c. 200**

La Tène

The high watermark of Celtic culture occurred during the La Tène era (*c.*450–*c.* 50 BC). This takes its name from a major archaeological site, near Lake Neuchâtel in Switzerland. Here, the Celts would make offerings to their gods by casting objects of value into the watery depths. When the site was drained in 1868, it revealed a veritable treasure trove of objects. In all, more than 3,000 items have been recovered, including 270 decorated spears, 170 swords and 385 brooches, along with a variety of tools, horse-trappings and chariot parts. Archaeologists also found the remains of wooden platforms, which were probably used to deposit the offerings and, on a more sinister note, a large number of human and animal bones.

CELTIC METALWORK

The Celts developed one of the great civilizations of the ancient world, which lasted for over a thousand years and produced artworks of astonishing beauty. They were a nomadic people, composed of many different tribes, and their history can be traced from about the 6th century BC to the late 1st millennium AD. Initially, they were based in Central Europe but, as the Roman Empire expanded, they gradually migrated to the western fringes of the continent.

ABOVE LEFT. The Battersea Shield (c. 350–50 BC)
This decorative shield-cover was found in the Thames near Battersea in London, deposited there as a votive offering.

ABOVE. Basse-Yutz Flagons (late 5th century BC)
These bronze wine flagons were discovered in eastern France. They are decorated with coral and enamel.

LEFT. The Gundestrup Cauldron (c. 150 BC–AD 1)
This remarkable silver vessel was discovered in 1891 in a Danish peat bog, where it had been carefully dismantled.

The nomadic lifestyle of the Celts meant that their style absorbed many influences. These came from Greece and Etruria in the Classical world, from Scythia and Persia to the east, and from the Iron Age culture at Hallstatt (in Upper Austria). The decoration on Celtic artworks is highly varied, but there are a couple of common factors. There was no interest in naturalistic representations of the human form, and when people or animals were depicted, they were heavily stylized. Instead, Celtic craftsmen were fascinated with intricate pattern-making. They were particularly fond of using spirals, interlacing, knotwork and triskeles. The patterns that they assembled from these elements were perfectly transferable and can be found on metalwork and stonework, and in illuminated manuscripts.

The greatest artworks produced by the ancient Celts were made from metal. The smith held an important place in their society – there seemed something magical about the way he could transform dull ores into gleaming weapons. In some areas, they even worshipped a smith-god, similar to the Roman deity Vulcan.

As a warlike people, the Celts placed their main focus on weapons. These came in two kinds. There were the arms that were used for fighting and there was the parade gear, which was used on ceremonial occasions and for sacrificial offerings. The Battersea Shield falls into the latter category – it was certainly too flimsy to take into battle. Made from sheet bronze with *repoussé* work in the centre, the decoration is typical of the La Tène style. The scrolls, with their red glass inserts, seem to hint at half-hidden faces. Viewed from different angles, the scrolls can resemble elaborate horns or drooping moustaches.

Cauldrons also played a significant role in the Celtic world. Essentially, they were large feasting vessels, though they were occasionally used as cremation containers and they also had magical associations. The Gundestrup Cauldron is unique. Most authorities agree that the workmanship is Thracian (from present-day Romania or Bulgaria), but the imagery is unmistakably Celtic. A cross-legged figure with antlers is Cernunnos, a Celtic deity who was lord of nature and animals. In one panel, soldiers march into battle carrying long-necked war-horns (a Celtic instrument known as a *carnyx*), while in another scene a giant figure places a dead soldier into a cauldron. This seems to echo a popular Celtic legend, in which a king owned a magic cauldron that could bring dead warriors back to life, if they were cooked in it overnight. IZ

200-300

The spread of Christianity. The Roman Empire undergoes a crisis after the murder of Severus Alexander. Over the next fifty years there are at least twenty-six claimants to the throne, many of whom are assassinated shortly after staking their claim. Order is restored with the rise of Diocletian.

The Christian faith is taking root. The Roman catacombs contain some of the earliest examples of Christian art. The archaeological remains of Dura-Europos include the oldest-known Christian church, as well as a remarkable synagogue. Monasticism is born as the first of the 'Desert Fathers' found a community in the Upper Nile Valley, near Thebes. IZ

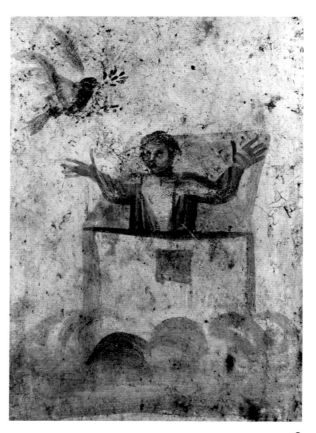

Roman Catacombs – *Noah and the Dove*

This is one of a number of biblical scenes that decorate the catacombs of Marcellinus and Peter. Noah was a relatively common theme in Early Christian art, and the Old Testament subjects often focused on the idea of salvation. Typical subjects included the Hebrews in the Fiery Furnace, Daniel in the Lion's Den, and Jonah and the Whale. Noah's salvation from the Flood is emphasized by the dove, which returns with a sprig of olive, showing that the waters have abated.

The imagery has two unusual features. In later Christian art, Noah was always shown as an old man, but here he is portrayed as a beardless youth. He is also depicted in the *orant* ('praying') position, with his arms upraised in prayer. This pose did not survive for long in Western art, but it remained commonplace in the Eastern Church for many centuries (see *The Virgin Orans*, p.61).

The Edict of Caracalla grants the right of citizenship to all free Roman men. Previously, this privilege had been open only to Italian inhabitants, but now it is extended to Romans throughout the empire.

The Battle of Hormozdgān marks the final defeat of the Parthians. The victor, Ardashir I, founds the Sassanian Dynasty – the last imperial power to rule Persia, prior to the rise of Islam.

Severus Alexander is assassinated. The death of this unpopular ruler causes chaos in the Roman Empire.

212 224 235 c. 244

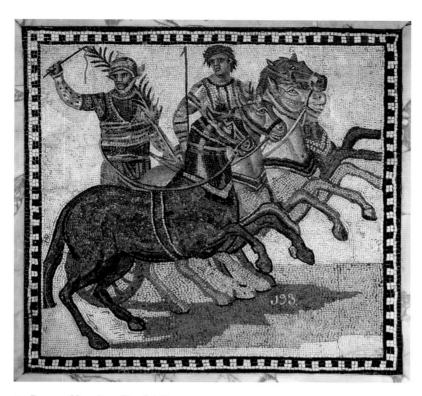

Roman Mosaic – *Chariot Race*

Scenes of gladiatorial combat and chariot racing were popular choices for Roman mosaics. This example comes from a set of small mosaics representing *quadriga* (four-horse) races. It depicts a member of the green faction (team). He has just won the race – the victor receives a palm frond – and is acknowledging the applause of the crowd. There were generally four factions (red, white, green and blue), recognizable by the colour of their tunics. Each faction generally consisted of three chariots, which operated as a team. It was a perfectly legal tactic to hinder the opposition, causing them to crash.

Dura-Europos – *The Vision of Ezekiel*

This extraordinary fresco is part of the earliest-known cycle of Old Testament paintings. It was executed in a synagogue in Dura-Europos (now Qalat es Salihiye in Syria), a border town at the edge of the Roman Empire. This scene depicts an apocalyptic vision, which the prophet Ezekiel experienced during his exile in Babylon. It represents the Valley of Dry Bones, where he witnessed Jesus bringing the dead back to life, clothing their bones in flesh (Ezekiel 37:1–14).

Emperor Valerian is taken captive by the Sassanians at the Battle of Edessa. He is the first Roman emperor to suffer this indignity.

Diocletian is proclaimed emperor by the army. He restores order within the Roman Empire after a long period of instability.

Cyprian, the Bishop of Carthage, is martyred. He is beheaded, as part of Valerian's persecution of the Christians.

c. 250 258 260 284

300–400

Constantine the Great. The fortunes of Christianity rise dramatically during the 4th century. Initially, they are at a low ebb, as Emperor Diocletian begins his persecutions in 303. These vary in intensity, but are particularly severe in Palestine and Egypt. This trend is reversed by Constantine, who grants freedom of worship and is baptized a Christian on his deathbed. The official acceptance of the religion leads to an improvement in its artworks, commissioned by wealthy, powerful converts.

Constantine's other momentous decision is to shift his capital. His 'new Rome' is Constantinople, in the East. This offers commercial and strategic advantages, though it will eventually cause the empire to split. IZ

Villa Romana del Casale, Sicily – *The Coronation of the Victor* (detail)
The official title of this famous mosaic is *The Coronation of the Victor*, but it is better known by its nickname, *The Bikini Mosaic.* It shows ten female athletes competing in a variety of sports. The winner receives a palm frond and a crown. This unique design is just one of a huge array of mosaics at this villa, which has been designated as a UNESCO World Heritage Site. The luxurious villa was part of a large agricultural estate, and probably belonged to a wealthy landowner, perhaps even the emperor. Its mosaics are thought to have been made by North African craftsmen.

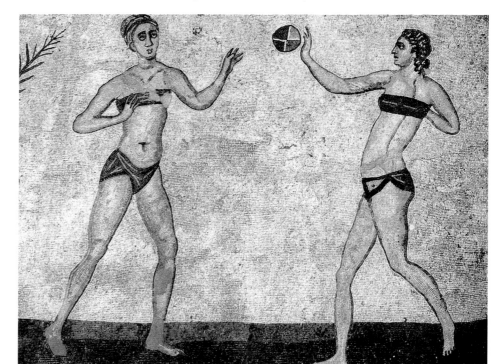

Armenia is the first country to adopt Christianity as its state religion.

In the Edict of Milan, Emperor Constantine the Great grants freedom of worship to Christians throughout the Roman Empire.

Eusebius, the Greek historian and Bishop of Caesarea, completes his *Ecclesiastical History*, a pioneering survey of the early development of the Christian Church.

Constantine the Great creates a new capital in the East. This is based on the city of Byzantium, which is renamed Constantinople.

| 301 | 313 | c.324 | | 330 |

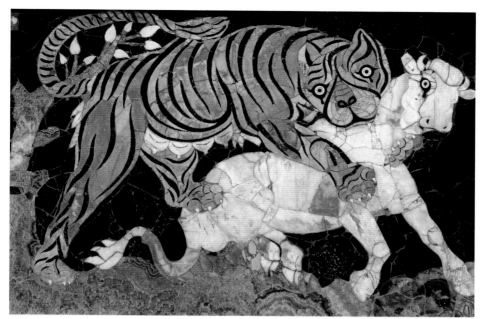

Basilica of Junius Bassus, Rome –
Tiger Attacking a Calf

This is a spectacular example of *opus sectile* ('cut work'), a luxurious alternative to mosaic that was popular in the ancient world. The design was formed by cutting, polishing and shaping large pieces of material – usually coloured marble, although mother-of-pearl and glass were sometimes employed. The technique originated in Egypt and Asia Minor, but was taken up enthusiastically by the Romans. This superb piece comes from a house in Rome, which was built in 331 by a high-ranking politician, Junius Annius Bassus.

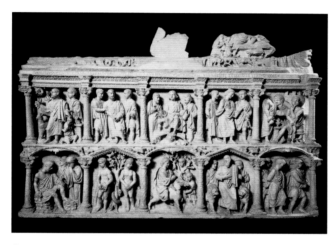

Old St Peter's, Rome –
Sarcophagus of Junius Bassus

This ornately carved sarcophagus illustrates the rise of Christianity. Once Constantine had granted freedom of worship, it began to gain converts at every level of society. One of the most distinguished figures was Junius Bassus, the son of Junius Annius Bassus (see above). He held the post of urban prefect (effectively the Mayor of Rome), and his sarcophagus is a fine example of Early Christian art, though its imagery is still in a Classical vein. Christ is seated in the centre flanked by St Peter and St Paul, with his foot on the head of a pagan god.

The Empire divides, following the death of Emperor Theodosius.

At the Battle of Adrianople (Edirne in modern-day Turkey), the Goths defeat the Romans and Emperor Valens is killed.

c. 331–50 359 378 395

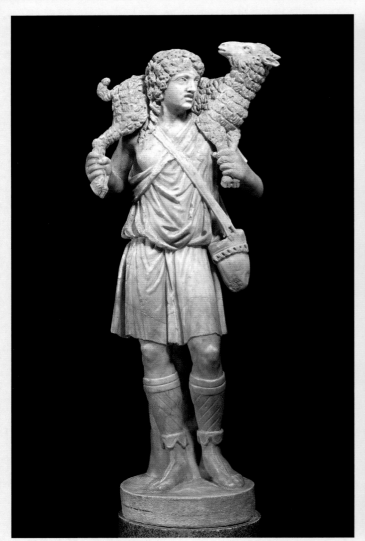

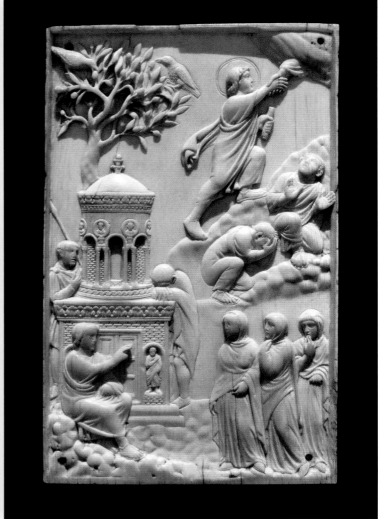

Old St Peter's

The greatest church of the Early Christian period was St Peter's in Rome, now known – to distinguish it from the building that replaced it – as Old St Peter's. It was begun in about 320 by the Emperor Constantine (on the site where St Peter is said to be buried) and was probably still unfinished when Constantine died in 337. The huge building (over 100 m/330 ft long) was renovated many times, but by the 15th century it had become badly decayed, and Pope Julius II took the bold decision to demolish it (horrifying many people, as it was hallowed by more than a thousand years of use) and erect a new church in its place. The foundation stone of this, the present St Peter's, was laid in 1506.

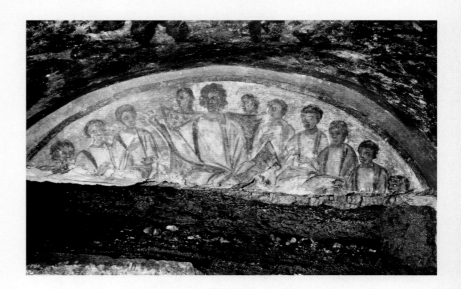

EARLY CHRISTIAN ART

Over the centuries Christian art developed a large and complex repertoire of themes and images, and by the Middle Ages many of these had become standardized. The events shown were familiar episodes from the Bible; the main participants were instantly recognizable, either by their physical appearance or by the attributes (objects) that they were holding.

The largest selection of Early Christian art has survived in the catacombs (underground cemeteries) at Rome. These date back to the end of the 2nd century. Romans respected the sanctity of the dead, so Christians were able to bury their followers here with impunity. By about 217 the Church owned and administered many of the catacombs. Several of the early martyrs were buried there, and tomb-slabs were often used as makeshift altars, to say Mass on the anniversary of the martyrs' death. The most extensive catacombs were at Rome, but similar examples were constructed at Naples (see *San Gennaro*, p. 44), Syracuse, Canosa and Chiusi, and in Malta, Sardinia and North Africa.

There were many paintings on the walls of the catacombs, though the quality of these was generally poor. In part, this was due to the fact that, during the persecution era, most converts were either poor or slaves. The quality of Christian art improved dramatically after Constantine introduced his policy of toleration. In the West, the religion could now attract wealthy Romans, such as Junius Bassus (see p. 41). Similarly, in the East, Christian imagery could be found on a wide range of expensive items, made of silver or ivory. These included caskets, marriage chests, book covers and combs.

The earliest Christian artists copied aspects of Classical art. In many scenes, Christ and his followers are dressed in togas and, in some, he is even attired in purple robes (the colour reserved for emperors). Often, there was an overlap with pagan themes. This kind of ambiguity was prudent during the era of persecutions. Depictions of Christ as the Good Shepherd could easily be confused with images of Orpheus or Mercury (see *The Good Shepherd*, p. 45). Equally, sheep were common sacrificial animals in several faiths, so a painting or sculpture of a young man carrying a lamb on his shoulders would not have appeared exclusively Christian.

Conversely, there were some subjects which Early Christian artists specifically avoided. The most important of these was the Crucifixion, which was rarely depicted before the 6th century. The earliest-known version dates from *c.* 430. Before its abolition, crucifixion was regarded as a humiliating and degrading punishment, so depictions of it were unlikely to attract new converts. Even when the subject did become acceptable, the treatment of it was rather different. In the East, artists preferred to portray the theme as 'Christ Triumphant', with Jesus appearing alive and imperious on the Cross, triumphing over death. The idea of depicting Christ as suffering or dying was a later development, which first emerged in the West. IZ

ABOVE LEFT. The Good Shepherd (c. 300–50)
Jesus is shown as the Good Shepherd, who is prepared to lay down his life for his sheep. In the earliest Christian art, Jesus is always depicted as a beardless youth; the familiar image of a more mature, bearded man developed later.

ABOVE RIGHT. The Ascension (c. 400)
This small, exquisitely carved ivory panel was perhaps originally part of a casket. Jesus grasps the hand of God as he enters heaven. At the bottom, the three Marys approach his tomb, where an angel sits.

LEFT. Christ Teaching the Apostles (c. 300)
Some of the earliest Christian art is found in catacombs in Rome. This example, in the Catacombs of Domitilla, is indistinguishable in style from secular Roman painting of the time.

400-500

The Fall of Rome. Rome finally succumbs after repeated barbarian attacks. Many of these tribes are nomadic, pushed westwards by the invading forces of the Visigoths under Alaric, and Attila and the Huns. The latter, in particular, cause immense devastation, sweeping through the Balkans, Gaul (now France) and Italy. Their threat only diminishes after the death of Attila in 453.

As Rome declines, imperial power shifts to the East. The western capital is moved first to Milan and then, in c. 402, to Ravenna. This soon becomes the most important Byzantine outpost in the West. Emperor Honorius and his half-sister Galla Placidia both begin major building projects there. IZ

Catacombs of San Gennaro, Naples – *San Gennaro*
Catacombs were not exclusive to Rome. There were three in Naples, dating back to the 2nd century. This fresco comes from the Catacombs of San Gennaro (also known as St Januarius). He was a bishop of Benevento who was martyred in Pozzuoli in 305. In the 5th century, his remains were transferred to Naples and he became a patron saint of the city. His tomb in the catacombs was revered as a pilgrimage site. In later art, Januarius was usually portrayed in a bishop's robes, but here he is shown wearing a classical toga.

Rome is sacked by the Visigoths. This marks the start of Rome's final decline. St Augustine of Hippo writes his *City of God* to deny the claim that Rome's rejection of paganism had caused its weakness.

The Vandals capture Carthage. This east Germanic tribe then proceeds to take Sicily, Corsica and Malta, before sacking Rome itself in 455.

| 410 | 439 | c. 440 |

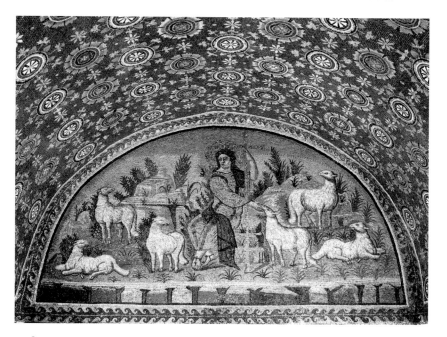

Mausoleum of Galla Placidia, Ravenna – *The Good Shepherd*

The image of Christ as the Good Shepherd comes from the New Testament ('I am the good shepherd; the good shepherd giveth his life for the sheep' – John 10:14). The theme was often used in frescoes in the catacombs, though its ultimate source was Classical art. Here, for example, the composition was loosely based on depictions of Orpheus playing his lyre and charming the animals. This fine mosaic is one of the most elaborate versions on the theme, but probably also one of the last. The subject was later banned entirely in the Eastern Church, for fears that it might lead to accusations of animal worship.

Vergilius Romanus (Roman Virgil) – *Portrait of Virgil*

This is one of the oldest surviving examples of an illustrated codex (book). It contains several of the works of the Roman poet Virgil: the *Eclogues,* the *Georgics* and the *Aeneid.* It dates from the late Antique period and shows the first signs of a break with Classical tradition. The figures are crudely drawn, with none of the realism associated with Roman art. The manuscript's history can only be traced back to the 15th century, when it was in France, but its origins are obscure. Its style is provincial, leading some to believe that it stemmed from the Alexandrian tradition in Egypt, while others consider that it came from the West and might even have been produced in Britain.

Rome falls. Romulus Augustulus, the last Roman emperor, is deposed by Odoacer. His rule is recognized by the emperor in Constantinople.

At the Battle of Châlons, an alliance between the Romans and the Visigoths brings a temporary halt to the Huns' invasion of Gaul.

Clovis I becomes king of the Western Franks. He will eventually unite all the Frankish tribes.

The Battle of Mount Badon: the supposed date of King Arthur's victory over the invading Saxons.

451 476 481 c. 490

500-600

Shift to the East. Following the fall of Rome in the previous century, the balance of imperial power shifts to the eastern Mediterranean. Under Justinian (r. 527–65), the Byzantine Empire reaches its greatest extent, encompassing parts of Spain, North Africa and Persia. Its western capital is in Italy, which becomes a conduit for Byzantine art. The conversion of pagan Europe, meanwhile, continues to gather pace.

During this period Christianity becomes the official religion throughout the empire. The incorporation of the rapidly spreading belief system into the fabric of the state is both reflected in and reinforced by an ambitious construction programme. Naturally, the ecclesiastical buildings are extensively adorned with religious art, much of it magnificent by any standards. At the same time, municipal edifices were built on a grand and often triumphalist scale. The project was recorded in rich detail in *De Aedificiis* ('On Buildings'), an outstanding book by Justinian's court chronicler, Procopius of Caesarea (*c.* 500–60). IZ

Church of San Vitale, Ravenna – *The Emperor Justinian and His Entourage*
Located prominently in the apse of San Vitale, two celebrated mosaic panels portray Emperor Justinian and his consort, Theodora. Neither of them ever visited Ravenna, but these majestic images were designed to emphasize their political and spiritual authority. This is symbolized by their haloes and their imperial purple robes.

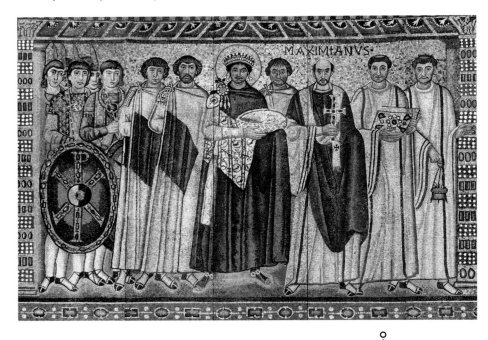

Justinian founds St Catherine's Monastery, at the foot of Mount Sinai. Its huge, fortresslike walls are designed to protect the hermits who had settled in this holy place. The monastery houses many early icons, and its collection of ancient manuscripts is second only to that of the Vatican.

The Byzantine province of Spania is established by Justinian's forces in modern-day southern Spain.

Work begins on Hagia Sophia, the magnificent church which Justinian commissioned as the showpiece of his capital at Constantinople.

Justinian sends General Belisarius to expel the Ostrogoths from Ravenna. This city now becomes the seat of his Exarch (Governor) in the West.

522 527 532 540 547

Rossano Gospels – *Christ's Entry into Jerusalem*
This lavish Greek manuscript was written in gold and silver lettering on purple parchment. During this era purple dye was a rare and expensive commodity, and was usually reserved for imperial clients. The Rossano illustrations were designed to accompany passages from the Gospels, which were read aloud during Lent. In line with Eastern tradition, Christ is portrayed sitting side-saddle on an ass.

St Catherine's Monastery, Sinai –
The Virgin Enthroned with Two Saints
This is one of the oldest surviving icons. It shows the Virgin and Child flanked by two warrior saints, Theodore and George. Behind them, two angels look up in wonder, as the hand of God appears in a beam of light above Mary's head. The icon is a fine example of encaustic painting, which involved mixing pigments with molten wax. This was a slow, painstaking process, but it produced very durable results.

St Columba founds a monastery on the Scottish island of Iona. In time, many famous illuminated manuscripts will be created here, among them the *Book of Kells*.

Pope Gregory the Great sends Augustine, a Benedictine monk, to convert the English to Christianity. Augustine gives Ethelbert, king of Kent, a number of artworks, including the *Gospels of St Augustine*. Ethelbert adopts Christianity and gives Augustine land to found an abbey.

c. 563

597

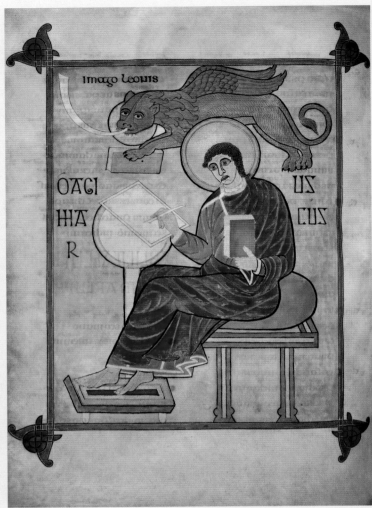

GOSPEL BOOKS

Gospel books played a vital role in the conversion of pagan Europe. They were specifically designed as tools for the missionaries who undertook this work, and this governed the format of the books. Transporting manuscripts with the entire text of the Bible would have been an onerous business, and it was felt that the Gospels alone were all that was required to convey the message of Christ.

Insular gospel books ('Insular' in this context means produced in Britain or Ireland) contained three main areas of decoration: the portraits of the Evangelists and their symbols; the calligraphy at key passages in the text; and pages of pure decoration known as 'carpet pages'. These decorative elements served two distinct purposes. On one level, they were designed to impress the potential convert, but they also had a more prosaic function. At this stage, the biblical text had not yet been divided up into chapters and verses, so any kind of decoration helped the priest to find the passage he required.

A portrait of the relevant Evangelist was normally placed at the start of each Gospel; this idea stemmed from the author portraits in Classical manuscripts. The artist of the Lindisfarne Gospels had clearly seen something

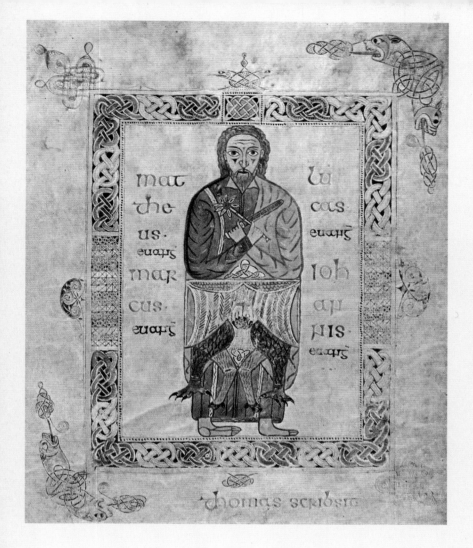

The *Book of Kells* is widely regarded as the finest of all the Insular gospel books. Dating from about 800, it was a colossal undertaking. It has more illustrations and its decoration is more elaborate than any other manuscript of its kind. Sadly, it was never completed, and the precise details surrounding its creation are unknown. However, the likeliest scenario is that it was produced in the scriptorium of the monastery on Iona, in Scotland. This was the period when the island was coming under attack from Viking raiders. Sixty-eight monks were killed in the raid of 806, and this may have been one of the reasons why the project was abandoned. The entire community moved to the safe haven of Kells in Ireland shortly afterwards.

ABOVE LEFT. Tunc Crucifixerant – *Book of Kells* (c. 800)
This marks the passage in St Matthew's Gospel which begins: 'Then they crucified with Christ two thieves.'

ABOVE CENTRE. Portrait of St Mark – *Lindisfarne Gospels* (c. 700)
Attired in Classical robes, Mark is accompanied by his traditional symbol, the lion.

ABOVE RIGHT. Tetramorph – *Trier Gospels* (8th century)
Artists came up with many different ways of depicting the Evangelists' symbols, but this is perhaps the most bizarre.

of the kind, for the hair, the robes and the sandals of his Evangelists are all loosely based on Classical models.

In the more elaborate manuscripts, the symbols of the Evangelists were sometimes also displayed separately. The origins of these symbols were rather mystical. They came from two passages in the Bible, one describing a vision of the prophet Ezekiel (Ezekiel 1:5–14) and the other from an account of the Apocalypse (Revelation 4:6–8). The supernatural appearance of these creatures gave artists the scope to exercise their imaginations. The version found in the *Trier Gospels* is one of the strangest examples. Here, the artist merged all four symbols into a single figure – the Tetramorph.

In Celtic manuscripts, the calligraphy was often the most impressive feature. Certainly,

in the *Book of Kells*, there was nothing to match the splendour of the Monogram Page (see p. 53). The Tunc Crucifixerant page was inserted in Matthew's Gospel, opposite the passage which describes the Crucifixion (Matthew 27:38). Fittingly, the shape of the letters in the lower half of the page forms a diagonal cross. However, the most striking aspects of the design are the two fierce, dragonlike beasts which appear to be chasing their own tails. There are further tiny creatures within the border, while a feline head appears attached to the 'T'. The bodies of the beasts are filled with intricate geometric and interlacing patterns that were borrowed from Celtic metalwork. The artists working on the *Book of Kells* felt no compunction about including motifs from pagan artefacts in the most sacred parts of their text. IZ

600-700

The Heraclian Dynasty. In the East, the accession of Heraclius ushers in a new dynasty, which will rule the Byzantine Empire for most of the century (610–95). There is success against the Sassanians, but a new enemy threatens the status quo. The Arab conquests begin, as Muslim armies sweep across much of the Middle East. They seize Palestine, Armenia and Egypt and, by 674, they are laying siege to Constantinople itself. In the West, efforts are being made to gain new converts to Christianity. St Willibrord, the so-called 'Apostle to the Frisians', undertakes one of the most successful missions. He establishes the Abbey of Echternach in Luxembourg in 698. Lavish gospel books play an important part in his evangelical work. IZ

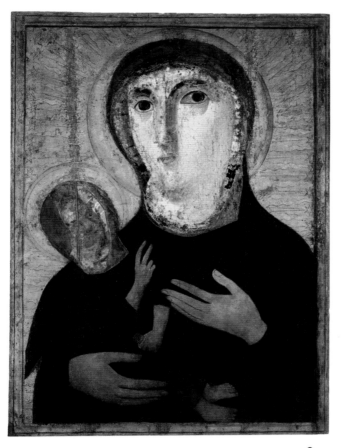

Santa Francesca Romana, Rome – *Virgin and Child*

This may well be the oldest surviving icon in the West. It is in a poor state of repair – the face has been overpainted clumsily on several occasions, and the hands are a later addition. However, the original sections are very old – some have even suggested that they could date back to the 5th century. The icon's early history is hard to determine. The painting was certainly displayed in Santa Maria Nova (later renamed Santa Francesca Romana), but it may originally have come from a much older church, Santa Maria Antiqua, which was built in the 5th century. This was abandoned in 847, after it was damaged during an earthquake.

Heraclius becomes Byzantine emperor after the overthrow of Phocas. He changes the official language of the empire from Latin to Greek.

The Hegira marks the Prophet Muhammad's move from Mecca to Medina. The Islamic calendar begins.

Samo founds the first political union of the Slavs.

Arab forces capture Alexandria and destroy its famous library.

610 | 622 | 623 | 642

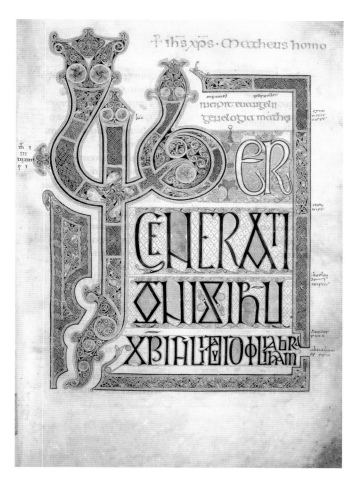

Lindisfarne Gospels – *Decorative Calligraphy*

This is an *incipit* page – one that shows the opening few words of a text. This example is from the beginning of St Matthew's Gospel. It reads *Liber Generationis* … ('The Book of the Generation of Jesus Christ' …). *Incipit* pages served a practical purpose, as well as a decorative one. Early versions of the biblical text were not divided into chapters and verses, so this would have helped the priest to locate the passage he needed. The calligraphy, with its swirling patterns, interwoven with beasts and birds, was inspired by the intricate designs on Celtic metalwork. The Lindisfarne manuscript also featured birds that were local to the area of northeast England.

Echternach Gospels – *Evangelist Symbol*

In decorated manuscripts, each gospel was usually prefaced with a portrait of the Evangelist or his symbol. Matthew's symbol was a man, shown here (*imago hominis* means 'image of the man'). Normally the symbol was portrayed with wings, to resemble an angel, but in this case he was depicted as a monk. Significantly, he wears a Roman tonsure (a distinctive shaving of the head). This was one of the issues that was discussed at the Synod of Whitby.

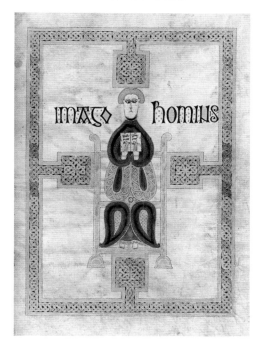

The Synod of Whitby is an important ecclesiastical council, held in Northumbria, to reconcile the differences between the Celtic Church and Rome.

'Greek fire' is developed in the Eastern empire. This secret, incendiary weapon is particularly effective at sea and will be used to destroy the Arab fleet in 677.

664

c. 672

700-800

Art under threat. The early part of the century witnesses the continuing rise of Arab power. Under the Umayyad caliphs, Muslim forces launch successful campaigns into India, North Africa, Spain and Gaul. These lose some of their momentum after the defeat at Tours in 732.

Elsewhere, Christian art comes under threat from different sources. In the East, thousands of artworks are destroyed during the first iconoclastic period (726–87), when religious images are banned. In the West, the Norsemen of Scandinavia present a new danger. They pillage vulnerable coastal sites in northern Europe. Monasteries, with their rich stores of precious metalwork, are a prime target. IZ

The first iconoclastic period begins, after the Byzantine emperor Leo III destroys an icon of Christ above the Chalke Gate – the ceremonial entrance to Constantinople.

Aberlemno, Scotland – *Pictish Cross Slab*

The Picts were a Celtic people who flourished in northern Britain. They produced remarkable stonework with unusual imagery, which influenced the artists working on contemporary manuscripts. The unique decoration on this stone is thought to depict the crucial victory at the Battle of Nechtansmere (685), when the Picts defeated the Anglians of Northumbria. On the left, the bare-headed Picts advance while, in the bottom corner, the corpse of the helmeted Anglian leader is pecked by a crow. In the centre, the strategy of the footsoldiers is indicated. The leading warrior attacks while, behind him, the figure with the long spear and the raised shield covers him. To their left, a third soldier stands ready to join the shield-wall when required.

The Venerable Bede completes his *Ecclesiastical History of the English People*.

At the Battle of Tours, Charles Martel and the Franks win a crucial victory against the Moors. This halts the Arab advance into northern Europe.

726 731 732

Stockholm – *Codex Aureus*

During the 8th century the Classical and Celtic styles began to merge. This *codex aureus* ('golden book') was probably made at Canterbury, but the elaborate calligraphy shows the Celtic influence. The notes around the text record its history. It was stolen by Viking raiders, but then ransomed by ealdorman (chief magistrate of a district) Aelfred and his wife, Werburg. They donated it to Christ Church, Canterbury. The manuscript eventually returned to Scandinavia, when it was purchased for the Swedish royal collection in 1690.

Book of Kells – *Monogram Page*

This is the most spectacular page in the *Book of Kells*, devoted to Christ's sacred monogram. This is the Chi-Rho (written as 'XP'), the first two letters of Christ's name in Greek. Throughout the Early Christian era, this monogram held an almost magical significance. Constantine the Great instructed his soldiers to daub the emblem on their shields before the Battle of the Milvian Bridge (AD 312), after seeing it in a vision. His subsequent victory is said to have inspired his tolerant policy towards Christianity. The mystical aura surrounding the monogram explains the elaborate decoration on this page. Hidden away in the swirling interlacing are angels, cats, mice, and an otter with a fish.

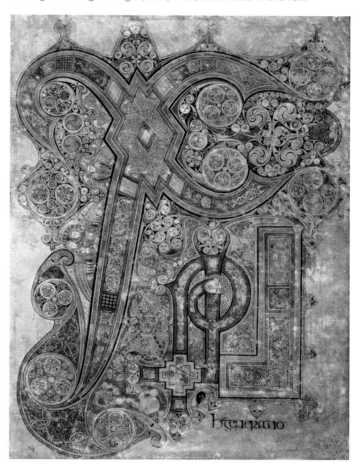

Offa becomes king of Mercia. He will reign for almost forty years, becoming the most powerful Anglo-Saxon ruler before Alfred the Great.

Charlemagne becomes king of the Franks. He rapidly expands his power and influence, with successful campaigns against the Lombards and the Saxons, and will be crowned emperor in 800.

Viking raiders plunder Iona for the first time.

757 768 795 c. 800

800-900

Carolingian Renaissance. Charlemagne, king of the Franks, engineers the first genuine revival in the West since the fall of Rome. With his coronation in 800, he becomes the first ruler of the Holy Roman Empire. Alongside his military conquests, Charlemagne also reinvigorates the arts. He brings Alcuin of York – the greatest scholar of the era – to his court, and promotes a golden age of manuscript illumination. A fine, new script (the Carolingian minuscule) becomes standard throughout the empire, while the Ada School of artists ushers in exciting new styles. IZ

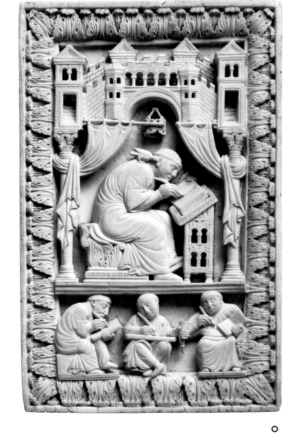

Charlemagne is crowned as 'Emperor of the Romans'. This title rebuffs the claims of the Byzantine emperor, ensuring that the two territories remain separate.

Norsemen strike again at the island of Iona, killing sixty-eight monks. The monastic community will soon move to a new home at Kells, in Ireland.

Carolingian School – *St Gregory Writing, with Scribes Below*
This delicate ivory carving was designed as a book cover, presumably for one of Gregory's own books. St Gregory (c. 540–604), also known as Gregory the Great, was one of the four Latin Doctors of the Church (along with St Ambrose, St Augustine and St Jerome). This image celebrates his achievements as a theologian and author, but he was also a distinguished pope and a pioneer of church music (Gregorian chant is named after him). Here he is shown writing in the Lateran Palace (the papal residence). The Holy Ghost, taking the form of a dove, perches on his shoulder and whispers divine inspiration into his ear. Below, three scribes copy out the saint's text.

The Battle of Pliska is a series of engagements between the Byzantines and the Bulgars; it ends in defeat for the Byzantines and the death of their emperor Nicephorus I.

The Treaty of Verdun confirms the division of the Carolingian Empire into three separate kingdoms, inherited by the surviving sons of Charlemagne.

| 800 | 806 | 811 | 843 | c. 850–75 |

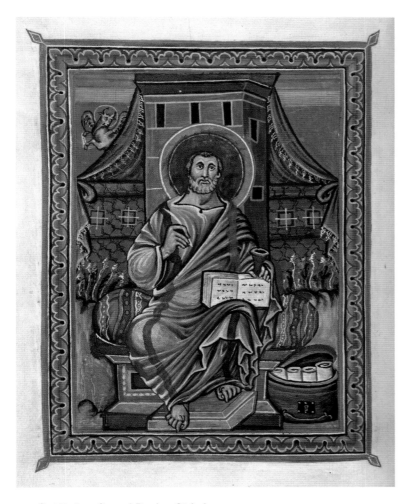

Rheims Gospel Book – *St Luke*

This comes from a lavish gospel book, written in gold. St Luke is shown with his traditional symbol, the winged ox. By his feet, there is a basket full of scrolls, for writing, and he wears a Roman toga. This was not unusual in manuscripts of the period, as Charlemagne and his successors aimed to promote themselves as the cultural heirs of ancient Rome.

Rheims was an important monastic centre in the Carolingian era. This manuscript was produced when it was under the control of Hincmar, Archbishop of Rheims, who was a close friend and adviser of Charles the Bald, king of Francia Occidentalis.

Anglo-Saxon – *The Alfred Jewel*

This beautiful little item, made of gold and cloisonné enamel, is probably an aestel – a pointer for reading manuscripts. Originally, there would have been a tiny rod, perhaps made of ivory, attached to the mouth of the dragonlike head at the base of the jewel. The inscription around the edge translates as 'Alfred ordered me to be made'. This accords well with one of the king's policies. In c. 890, he sent a copy of *St Gregory's Pastoral Care* to every monastery, together with an aestel.

Basil I accedes to the throne. He is the founder of the Macedonian Dynasty, which will rule the Byzantine Empire until 1056.

Alfred the Great defeats the Danes at the Battle of Ethandun. Guthrum, the leader of the Danes, is converted to Christianity.

c. 860 867 878

LEFT. The Sutton Hoo helmet (*c.* 625)
The most famous of the Sutton Hoo artefacts, the helmet, made of iron decorated with other metals, was found in hundreds of tiny rusted pieces that had to be painstakingly reassembled.

ABOVE. Gold belt buckle from Sutton Hoo (*c.* 625)
The superbly vigorous interlace ornament is characteristic of Anglo-Saxon art. At first sight it appears to be completely abstract, but in fact it incorporates tiny animal motifs.

ABOVE RIGHT. Purse lid from Sutton Hoo (*c.* 625)
Decorated in gold and enamel, this is the most impressive lid of its type ever found. It would originally have covered a leather pouch for holding gold coins, attached by straps to a waist belt.

SUTTON HOO

The discovery of a unique ship-burial at Sutton Hoo in Suffolk was both the greatest and the most mysterious archaeological find in British history. The treasures found within the tomb were of supreme quality, indicating that the deceased was a high-status figure, probably a king. Yet his identity remains uncertain and the exotic mixture of grave-goods poses many questions.

In the summer of 1939, not long before the outbreak of the Second World War, an archaeologist working on a private estate at Woodbridge, near the Suffolk coast, made a miraculous discovery. Underneath a shallow mound, he found the remains of an Anglo-Saxon ship-burial. The timbers of the 27-m (89-ft) long vessel had rotted away, but the rivets were still in place and there was a ghostly imprint of the ship in the compacted sand – detailed enough to show that it had been a working vessel. A small burial chamber was constructed in the centre of the ship, where the dead man lay, surrounded by his treasures.

These treasures included a remarkable helmet, decorated with images of warriors and beasts. The face is adorned with a fierce, dragonlike creature. The nose is its body, while the eyebrows are its outstretched wings. There were other military items – a sword, a shield, a coat of chain mail – but also a number of more ostentatious pieces that were designed to underline the owner's exalted status. The most spectacular of these is a fabulous belt-buckle made of gold. Its complex interlacing features tiny, ribbonlike bird and snake motifs. The buckle also contains a tiny,

secret compartment, which would have held a precious keepsake. Some have suggested that this might have been a relic.

There were also a number of foreign items, which may have been acquired through trade, as booty or possibly even as diplomatic gifts: a set of silver bowls from the Byzantine world, a large silver platter that was over 100 years old, a pair of spoons with Greek inscriptions, and a pair of aurochs drinking horns from the Mediterranean area (an aurochs is a large ox). The bowls and the spoons are particularly intriguing, as their decoration could suggest a Christian connection, which would be surprising in a pagan burial.

Among the finds there were also a number of coins, which helps to place the burial at around AD 625. This in turn has raised questions about the identity of the dead man. For many, the favourite candidate is Raedwald, who was a king of East Anglia (r. *c.* 599–625). According to Bede, he was converted to Christianity but later, under the influence of his wife, reverted to paganism. The chronicler described him as 'noble by birth but ignoble in his deeds'. Even so, he was powerful, exerting his authority over both Kent and Mercia. Could this be the potentate who was buried at Sutton Hoo? IZ

900–1000

Heyday of the Ottonians. Like the Carolingians in the previous century, the Ottonians try to recapture the glory of the old Empire. They unite the German tribes and invade Italy. When Otto II marries the Byzantine princess Theophanu (972), links with the East are rekindled. Ottonian artists emulate the Carolingian tradition in their illuminated manuscripts, but on an even more opulent scale. Elsewhere in Europe, the Vikings are turning from raiders into settlers. They establish permanent bases in northern France, on the eastern seaboard of Ireland and in the Danelaw in England. IZ

Liber Evangeliorum Cum Capitulare – *The Ascension*

Ottonian artists aimed to revive the outstanding quality of manuscript illumination that was achieved during the Carolingian Renaissance, though their style was rather different. The compositions are simpler, with few background details, and the colours are brighter. Purples, violets and mauves are commonplace. Figures are slightly elongated and they have large, expressive hands, typified by the angels in this scene. These are the 'two men in white' mentioned in the biblical account (Acts 1:10–11). Below, the Virgin and the disciples watch in wonder while Christ is raised up in a *mandorla* (an almond-shaped halo). The manuscript was produced by the Reichenau School – the style that takes its name from the famous island monastery on Lake Constance.

The Abbey of Cluny is founded by William I, Duke of Aquitaine. This rapidly expands into one of the greatest Benedictine monasteries and becomes an important centre for Church reform.

Rollo and his Viking followers settle in northern France. He becomes the 1st Duke of Normandy.

Gorm the Old becomes the first king of Denmark.

910 911 936

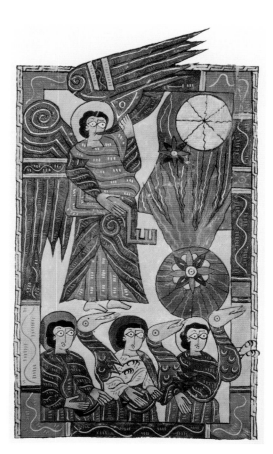

The Menologion of Basil II – *The Seven Sleepers*

A *menologion* is a church calendar and service book. This miniature comes from an exceptionally lavish example, which was produced in Constantinople for Emperor Basil II. It has many unusual features, including a section on the lives of the saints, and scores of illustrations – more than 430 in all. Eight artists worked on the project, and their figures display a solidity that was unusual in Byzantine art of the time. The majority of the images depict individual acts of martyrdom, but there were also a number of historical scenes.

According to legend, the Seven Sleepers of Ephesus were a group of Christian youths who hid in a cave during the persecutions of Diocletian. Their attackers walled it up and they fell asleep. Miraculously, they woke up around 200 years later, during the reign of Theodosius II.

The Escorial Beatus – *The Sounding of the Fifth Trump*

In this scene from the Book of Revelation (Revelation 9:1–10), the angel sounds the fifth trump (trumpet call), which sends a huge star plummeting into the pit of hell. This unleashes a plague of monstrous locusts, with human faces and scorpionlike tails. The brightly coloured, naïve composition is a typical example of the Mozarabic style, from Arab-occupied Spain.

Beatus (died *c.* 798) was an abbot at the monastery of Liébana, in northern Spain. In 775–6 he wrote a hugely influential *Commentary on the Apocalypse*.

Otto I is crowned as the Holy Roman Emperor by Pope John XII. During its brief tenure of office (936–1002), the Ottonian Dynasty does much to restore the power and splendour of Charlemagne's empire.

Viking incomers establish a permanent settlement at Dublin. Although there had been other, smaller settlements here, this date is recognized as the official foundation of the Irish capital.

Vladimir I of Kiev marries Anna, the younger sister of Emperor Basil II, in the Crimea. This creates an important diplomatic alliance in the East. Vladimir converts to Christianity.

962 *c.* 985 988 989

1000–1050

The flowering of Anglo-Saxon art. In the field of manuscript production, the only serious competition to the Ottonians comes from England. Ottonian and Anglo-Saxon artists form the last distinctly national schools of painting, before the emergence of the Romanesque. The Anglo-Saxon nation of England had grown out of the kingdom of Wessex. Its capital was at Winchester, so it is not surprising that the Anglo-Saxon style of illumination is often described as 'the Winchester School'. This is not the only centre of production, however, as many manuscripts are also created at Canterbury. The artists of the Winchester School draw much inspiration from Carolingian art, most notably in their taste for heavy, ornamental borders, decorated with acanthus leaves. IZ

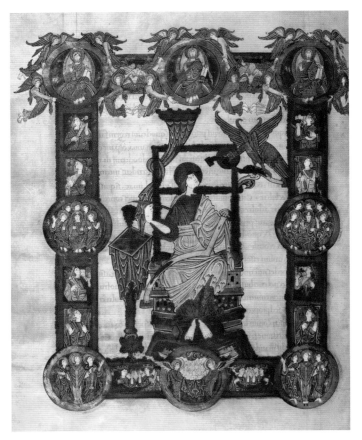

The Grimbald Gospels, Canterbury – *St John the Evangelist*

In Anglo-Saxon manuscripts, the profuse border decoration sometimes overshadowed the main subject. Here St John is about to write in an enormous book, while looking up at his traditional symbol, the eagle. However, the eye is drawn to the wealth of detail in the large roundels that surround him. In the upper row, the three figures of the Trinity are seated in majesty, supported by groups of angels. Below them, various worshippers gaze up adoringly. These include kings in golden crowns, the disciples (in the central medallions), and a number of churchmen and angels.

The manuscript is thought to have been produced at Christ Church, Canterbury. This attribution is based on the identity of the scribe – Eadwig Basan – who was active there from about 1012 until 1023.

Leif Eriksson sails close to the coast of North America. He establishes a settlement at Vinland, which may have been on the tip of Newfoundland.

At the Battle of Clontarf, Brian Boru, the High King of Ireland, defeats an alliance led by Norsemen and the king of Dublin. However, Brian himself is killed.

Yaroslav the Wise becomes Grand Duke of Kiev, after defeating his rivals with the aid of Novgorodian allies.

Canute claims the throne of Norway. He now rules three kingdoms – England, Denmark and Norway.

c. 1001 c. 1010–20 1014 1019 1028

Ottonian manuscript, Regensburg –
The Entry into Jerusalem

Not every Ottonian miniature was a masterpiece. The
use of gold leaf is typical – they liked their manuscripts
to appear opulent – but the draughtsmanship is clumsy.
The *Entry* was traditionally the first scene in the
Passion – the cycle of illustrations which depict the
events leading up to the Crucifixion. Christ is shown
riding a donkey (in Byzantine versions, he is pictured
riding side-saddle). The disciples follow him, led by
Peter. On the right, a man cuts down a palm frond,
to lay in Christ's path; Palm Sunday takes its name
from this episode. This image is from a manuscript
produced at the monastic centre of Regensburg.

St Sophia's Cathedral, Kiev – *The Virgin Orans*

This gigantic mosaic (more than 6 m/20 ft high) dominates the
vault of the central apse. The cathedral, designated a UNESCO
World Heritage Site, was built partly as a political statement.
Medieval Rus had only recently adopted Orthodox Christianity as
its state religion, and this was its principal place of worship. It was
originally founded by Vladimir I, but completed by his son, Yaroslav
the Wise. In keeping with their close ties with the Eastern Empire,
the sumptuous decoration of the church is entirely Byzantine in
character. Both the pose and the attire of the Virgin, with her hands
raised in prayer, are closely modelled on Byzantine icons.

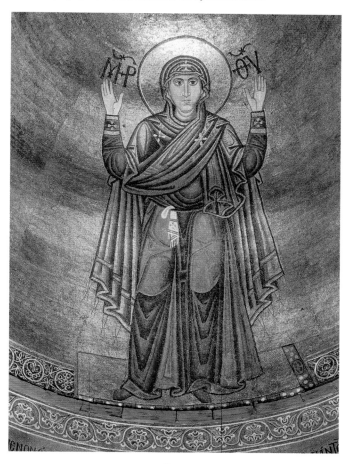

Ferdinand, Count of Castile,
becomes king of Léon, after
defeating Vermudo III at the
Battle of Tamarón.

Macbeth becomes king of
Scotland, after Duncan I
is killed in battle.

| 1030-40 | 1037 | 1040 | c. 1043-46 |

1050–1100

The Rise of the Normans. The Normans – descendants of the Norsemen who had ravaged Europe in previous centuries – begin to extend their influence. They move into Italy, helping the Lombards to expel their Byzantine rivals, and, towards the end of the century, they capture Malta and Sicily from the Saracens. In England, William the Conqueror seizes the throne from the Anglo-Saxons. In the East, they fight as mercenaries and also participate in the First Crusade, eventually carving out a Norman principality in Antioch. IZ

Salzburg Lectionary – *The Presentation of the Virgin in the Temple*

This strange miniature, taken from a book of readings for the Mass, illustrates the transitional phase between the Ottonians and the emergence of the Romanesque style. The subject is unusual, taken from the so-called Infancy Gospels in the Apocrypha. It shows the Virgin as a child, standing between her parents, Joachim and Anne. The bizarre figures on the columns relate to the miracle of her birth, as her mother had been childless until late in life. The Spinarios ('thorn-pullers') were often confused with images of Priapus (an ancient fertility god), while the figures at the base recalled the infertile women who embraced the column of Simeon Stylites (an ascetic saint, who lived on top of a pillar), in the belief that this would improve their fertility.

The Norman Conquest of England begins. Harold II is killed at the Battle of Hastings and William, Duke of Normandy, seizes the throne.

Seljuk Turks capture Jerusalem from the Byzantines. They also sever the main pilgrim routes.

c. 1050　　　　**1066**　　　　**1074**

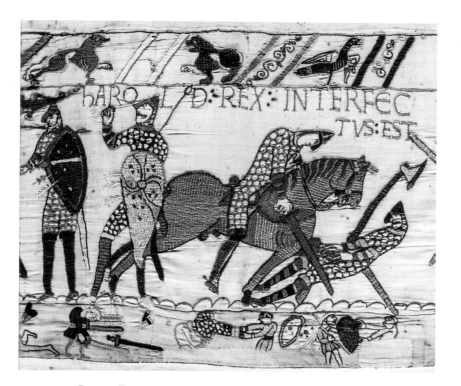

Bayeux Tapestry – *King Harold is Slain*

The Bayeux Tapestry is a unique combination of historical document and monumental artwork. It records the Norman invasion of England in great detail, in a 70-m (230-ft) frieze composed of eight long strips of linen. Technically, it is a fine specimen of embroidery rather than a tapestry. The workmanship is English, but the political spin is Norman. It was probably commissioned by Odo, who was both the Bishop of Bayeux and Earl of Kent. It provides many fascinating insights – about how the fleet was constructed, for instance – but there are also areas of controversy, such as the identity of Harold.

The Homilies of St John Chrysostom – *Emperor Nicephorus III*

This glittering miniature illustrates the opulence and sophistication of the Byzantine court. It comes from a book of homilies (commentaries) that were written by St John Chrysostom, one of the early Church Fathers. In a conventional conceit, the author is pictured presenting his book to the reader – the emperor – while the Archangel Michael stands in attendance. The figures are elegant, slightly elongated and dressed in rich attire.

Behind this golden façade, however, there is a tale of treachery and deceit. The book had been made for Emperor Michael VII but, before delivery, his throne was usurped by Nicephorus III. Four of the miniatures were swiftly altered, to reflect this change of ownership.

Nicephorus Botaneiates launches a successful uprising against Michael VII, proclaiming himself Emperor. Michael abdicates and becomes a monk.

The University of Bologna is founded. This is the oldest university in the West.

El Cid, the Spanish national hero, takes possession of the city of Valencia, following a lengthy siege.

Pope Urban launches the First Crusade, urging Western nations to help recapture Jerusalem and the Holy Land.

c. 1077 *c.* 1078 1078 1088 1094 1095

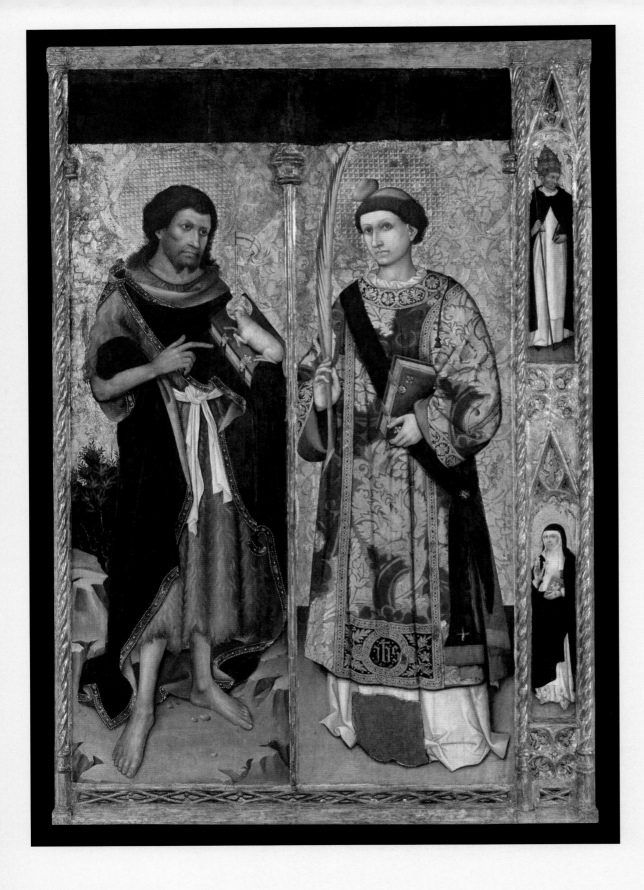

IMAGES OF SAINTS

The depiction of saints has always been a mainstay of Christian art. The term 'saint' was in use from the earliest days of the religion, but it took time for the formal process of canonization to evolve. The imagery also developed gradually, as the demand for pictures grew, from churches and private patrons.

The term first appeared in the New Testament. Here, it was used in the plural and referred rather vaguely to 'good people' or Christians in general. Apart from the Apostles, the first individuals to be described as saints were the early martyrs. They were recorded in martyrologies, or the Byzantine equivalent, the *menologion* (see *The Seven Sleepers*, p. 59).

Early sainthoods were agreed by acclamation, but the papacy eventually exerted more control. In about 1170 Pope Alexander III decreed that only the papacy had the authority to canonize saints (i.e. to enter them into the 'canon', or catalogue, of saints). Once a saint was officially recognized, their image could be venerated on an altarpiece or in a private chapel; churches could be dedicated in their name; and their relics could be displayed, becoming a focal point for pilgrimages.

Saints were seen as intermediaries, who could intercede on behalf of the faithful. St Cecilia, for example, was the patron saint of musicians; St Christopher offered protection for travellers; while those suffering from ergotism (also known as St Anthony's Fire) could pray to St Anthony himself.

Paintings would often illustrate a scene from the saint's life or an episode from the Bible. John the Baptist, for instance, may be shown holding a lamb as a reference to his comment about Christ: 'Behold the Lamb of God'. In some cases, the image had a more symbolic meaning. St Michael, for example, was an archangel. He mainly features in paintings of the Last Judgement or the Apocalypse (see *St Michael Fighting the Dragon*, p. 84). St George, by contrast, was a genuine martyr, but he never fought a dragon. In this celebrated theme, popular in both the East and the West, the dragon is regarded as a symbol of Satan or paganism.

The tale of St George was loosely based on the Classical myth of Perseus. In the Middle Ages this gained very wide currency through *The Golden Legend*, a hugely popular collection of saints' lives. These stories were very colourful, but often highly inaccurate. The legend of St Ursula is a typical example. She was said to have been martyred, along with 11,000 virgins, on her return from a pilgrimage. This is the fable recorded on Hans Memling's beautiful shrine. However, historians believe that the improbable numbers resulted from the misreading of an old inscription (which actually mentioned eleven virgins) and they have questioned the existence of Ursula herself. IZ

LEFT. Catalan School –
St John the Baptist and St Stephen (c. 1450)
This panel was probably produced for the Convent of St Dominic in Puigcerdà, in northern Spain.

RIGHT. Russian Icon –
St George and the Dragon (15th century)
This fine example of the Novgorodian school of painting is the most famous icon of George and the Dragon. The saint was revered equally in the West and the East.

FAR RIGHT. Hans Memling –
The Shrine of St Ursula (c. 1489)
Memling was commissioned to decorate this ornate shrine, which is shaped in the form of a Gothic chapel, when the saint's relics were transferred in 1489.

1100–1150

Twelfth-century Renaissance. The Church plays an increasingly active role in the West. It becomes more involved in political affairs, pitting its influence against the authority of secular rulers, but also oversees a cultural and spiritual revival. The Cistercians, led by Bernard of Clairvaux, spearhead Church reform. Architecture becomes grander, as the first hints of the Gothic style appear, and there is an upsurge in the translation of Greek and Arabic texts. The first universities are thriving, giving rise to new forms of teaching, pioneered by controversial figures such as Peter Abelard. IZ

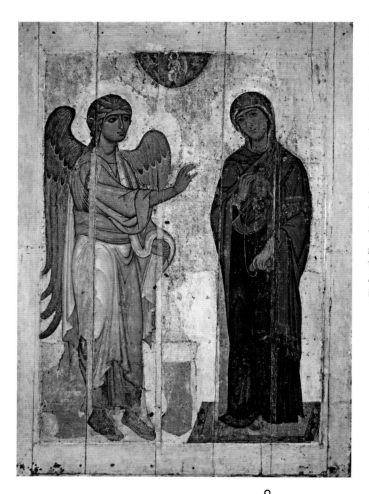

Novgorod, Russia – *The Ustyug Annunciation*

This is one of the oldest Russian icons, one of the very few that survived the Mongol invasions in the 13th century. It was made in Novgorod, taking its name from St Procopius of Ustyug. According to legend, he prayed in front of the painting when his home town was threatened by a tornado. The Virgin is holding a skein of wool as the golden-haired angel approaches her. This refers to the legend that she grew up in the Temple, helping to weave the priests' vestments. Across her chest, there is an image of Christ, her future son.

Baldwin of Boulogne, one of the leaders of the First Crusade, is crowned king of Jerusalem on Christmas Day.

The military order of the Knights Templar is founded. Their stated aim is to protect pilgrims.

| 1100 | 1119 | c. 1120–30 | c. 1130 |

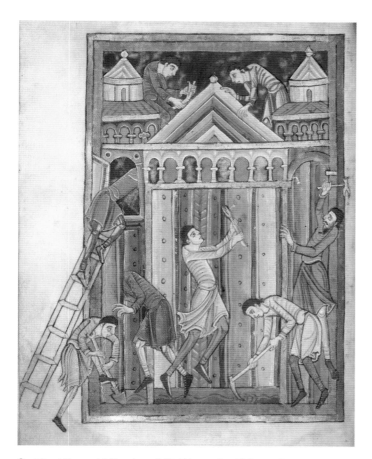

○ **The Life and Miracles of St Edmund** – *Thieves Breaking into the Shrine of St Edmund*
Based on an account by Abbo of Fleury (a French monk who spent two years in England, 985–87), this is one of the miracles surrounding St Edmund. Eight thieves break into the abbey at Bury St Edmunds and start to dismantle his ornate shrine. Suddenly, through the saint's intervention, they are paralyzed. In the morning, their crime is discovered and the bishop orders them to be hanged.

Eadwine Psalter – *Eadwine the Scribe*

This is the finest depiction of a medieval monk at work on a text. It comes from a psalter produced at Canterbury and, in its scale and detail, it is on a par with the portraits of the Evangelists featured in contemporary gospel books. The Latin inscription surrounding the image adds to this effect. It begins: 'The prince of scribes am I: neither my praises nor my fame shall ever die … ' This boastful tone has raised doubts about the identity of the figure. It may be that this is not Eadwine – the scribe who produced this psalter – but a commemorative portrait of a great scribe of the past.

The Treaty of Mignano finally signals an end to the war in southern Italy. In it, Pope Innocent II recognizes Roger II as the king of Sicily.

The Almohads, a Berber dynasty in North Africa, capture Marrakesh and overthrow the Almoravids of Morocco. They will later extend their power into the Iberian Peninsula.

Abbot Suger embarks on the reconstruction of the Church of St Denis. It is often cited as the first major building in the Gothic style.

Peter Abelard, the philosopher and theologian, is ex-communicated by Pope Innocent II.

| 1136 | 1139 | 1141 | 1147 | c. 1150 |

1150-1200

The power of the papacy. The papacy wields increasing influence over secular affairs. Using their dual weapons of interdict and excommunication, which bar groups and individuals from participating in Church rites, the popes play a leading role in international politics. They put pressure on the Holy Roman Emperor and national rulers to take part in the Crusades, and they form alliances that are designed to strengthen their own authority. These trends reach a peak during the administrations of Celestine III (1191–98) and Innocent III (1198–1216). IZ

The Morgan Leaf – *Scenes from the Life of David*

This has been described as the finest English painting of the 12th century. There are strong indications that it was planned as an illustration for the *Winchester Bible*, but that it was never actually inserted into the volume. It would undoubtedly have been intended as the frontispiece for the Book of Samuel. In the upper row, David attacks a suitably gigantic Goliath, while Saul and his soldiers look on. In the middle register, Saul hurls a spear at David, who, on the right, is anointed by Samuel. Finally, at the bottom, Joab kills Absalom, one of David's sons, and David mourns when he receives the news.

Winchester Bible – *Initial Letter*

The *Winchester Bible* is widely regarded as the finest example of Romanesque illumination produced in England. A team of at least five artists worked on it over more than twenty years. Early images were by the Master of the Leaping Figures and the Apocrypha Drawings Master; later ones were by the Master of the Morgan Leaf, the Master of the Genesis Initial and the Gothic Majesty Master.

The Treaty of Benevento finally seals the peace between the papacy and the Norman kings of Sicily after many years of conflict.

1156

c. 1160–85

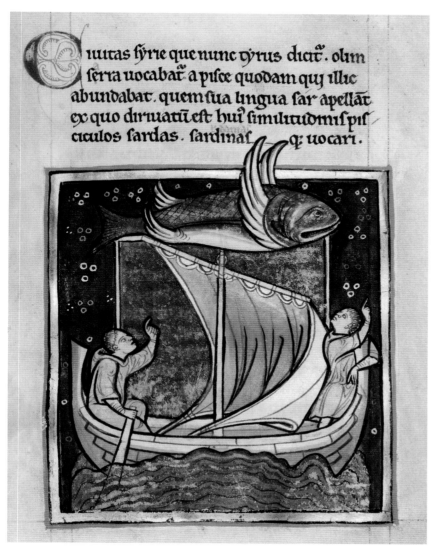

Ciuitas fyrie que nunc tyrus dicit. olim
ferra uocabat a pifce quodam qui illic
abundabat. quem fua lingua far apellat
ex quo diriuatū eft huj fimilitudinis pif
ciculos fardas. fardinas ꝙ uocari.

Bestiary – *Sawfish and Ship*

Bestiaries were medieval books which used animals – both real and imaginary – as a way of preaching lessons in morality. This miniature comes from one of the earliest illustrated texts. It was made in England, probably in Lincoln. In most bestiaries, the sawfish was portrayed as a monstrous flying fish, which liked to race against ships. It soon tired of the effort, however, and plunged back into the sea. The moral of this was that the sailors were like the righteous, keeping to the true path, however much they might be buffeted by waves or storms. The sawfish, on the other hand, resembled those who eagerly engaged in good works for a time, but were soon led astray and brought crashing down by sin.

The Norman invasion of Ireland begins. This move is sanctioned by both Henry II of England and Pope Adrian IV.

Archbishop Thomas Becket is murdered in Canterbury Cathedral. He will be canonized by Pope Alexander III in 1173.

The Muslim forces of Saladin win a notable victory at the Battle of the Horns of Hattin. This eventually leads to the surrender of Jerusalem.

Richard I of England defeats Saladin at the Battle of Jaffa. This is the final battle of the Third Crusade, after which the two parties negotiate a truce.

1169 **1170** **1187** **1192**

1200-1250

The mendicant orders. The Crusades continue to dominate the foreign policy of Western nations, but the sacking of Constantinople in 1204 brings the entire project into disrepute. By contrast, there is a new emphasis on piety in domestic religious circles. This is promoted by two new orders – the Franciscans (founded 1209) and the Dominicans (founded c. 1215). These are mendicant orders of friars, who preach out in the community. They survive by begging, emulating the life of poverty experienced by Christ and his followers. IZ

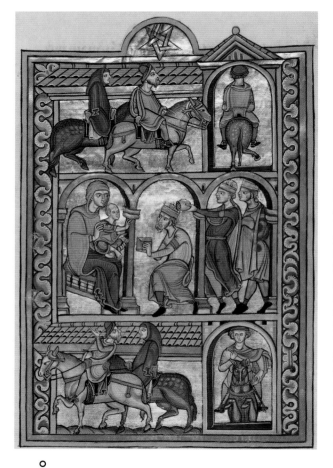

Berthold Sacramentary –
Adoration of the Magi
This manuscript takes its name from its patron, Berthold von Hainburg. He commissioned it for the Benedictine monastery of Weingarten in Swabia, where he served as abbot from 1200 to 1232. It is a fine example of German Romanesque illumination. The artist is unknown, but he displays a very distinctive approach. The Adoration is usually portrayed as a single scene, but he expanded the narrative, showing the Magi travelling to and from Bethlehem. Their guiding star is included in a lunette at the top.

Constantinople is captured and looted during the Fourth Crusade, which has been diverted from the Holy Land by Venetian interests. The sacking of a Christian city by other Christians creates a huge gulf between the Eastern and Western Churches.

Rebellious barons compel King John to approve *Magna Carta*, a document limiting his power. It has come to be regarded as a milestone in English constitutional history.

Building starts at Amiens Cathedral, the main fabric of which is completed by 1270. It marks the summit of the Gothic style in France.

Francis of Assisi dies in the small central Italian town from which he takes his name. He is canonized only two years later and Assisi quickly becomes a major pilgrimage site.

| 1204 | 1215 | 1215-17 | 1220 | 1226 |

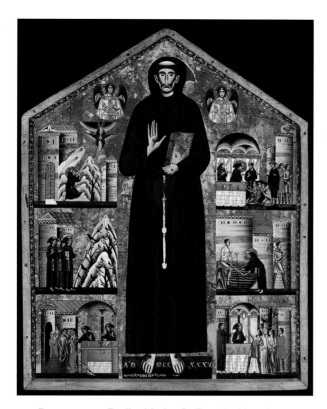

Bonaventura Berlinghieri – *St Francis Altarpiece*
This is the earliest dated image of the saint, produced for the Church of San Francesco in the Tuscan city of Pescia, where it can still be seen. Berlinghieri's painting is firmly in the Byzantine mould. The life-size figure is elongated, hieratic and strictly frontal. It is not meant as an accurate portrait – its purpose is to underline the ascetic lifestyle of Francis. His expression is gaunt and severe, and he bears the marks of the stigmata (echoing the wounds of Christ on the Cross) on his hands and feet. The smaller images depict scenes from his life, including the famous episode in which he preached to the birds (centre, left).

Crusader Bible – *Old Testament Scenes*
This action-packed page comes from an outstanding manuscript, known as the *Crusader Bible* or the *Maciejowski Bible*. It was traditionally said to have been produced at the court of Louis IX – the French crusader king. This link is uncertain, but the Bible was certainly produced in Paris and is widely regarded as one of the finest examples of French Gothic illumination. Originally, the manuscript had no text, but over the years inscriptions have been added in a variety of languages, including Latin, Persian, Arabic and Hebrew.

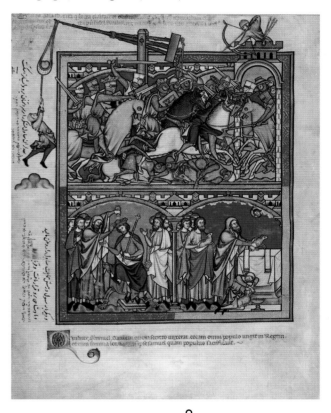

The Hanseatic League, a trading alliance of north German cities centred on Lübeck, is founded. It eventually has about a hundred member towns and dominates trade in northern Europe in the later Middle Ages.

Prince Alexander Nevsky, one of Russia's greatest heroes, is victorious against invading Teutonic Knights at the Battle on the Ice, on the frozen surface of Lake Peipus.

1235 **1241** **1242** **c. 1245**

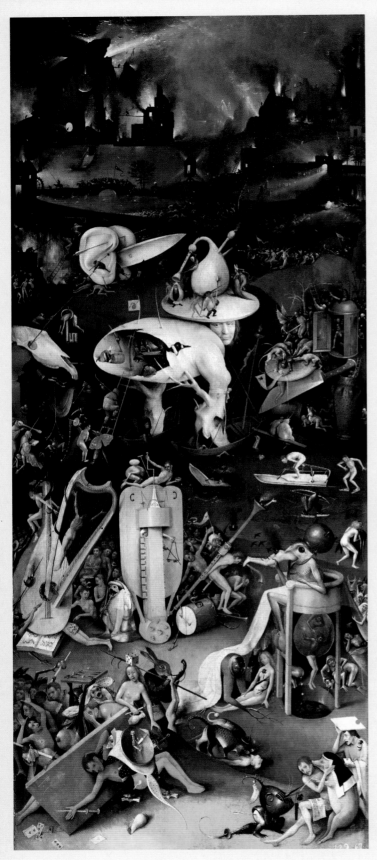

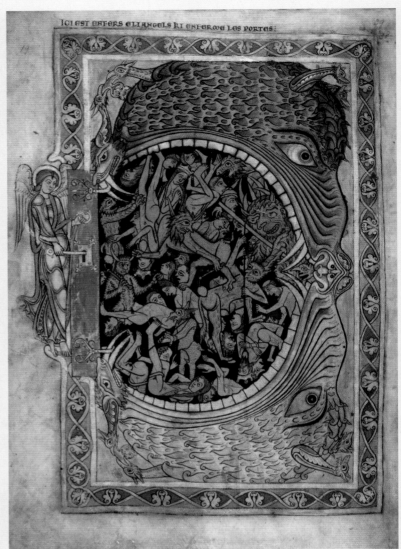

The Harrowing of Hell

This popular subject shows Christ rescuing Adam and Eve. According to medieval belief, they were trapped in limbo – a place situated on the outskirts of hell – together with all the other righteous people, who had died before Christ redeemed the souls of humanity through the Crucifixion. The episode was first recorded in the apocryphal Gospel of Nicodemus and was later retold in books such as the *Golden Legend* (13th century). The theme was popular in the Eastern Church, where it formed part of the *Anastasis* ('Resurrection') cycle of paintings. In visual terms, the Harrowing usually shows Christ trampling on the gates of hell, chasing away demons, and extending a hand to Adam and Eve, or other figures from the Old Testament.

IMAGES OF HELL

While Hell had long been a subject of Christian iconography, there was a distinct shift in the Medieval period towards a more graphic depiction of its torments. For a largely illiterate population, these artworks were a vivid warning of the fate that could befall the faithless.

The belief in an afterlife is common to many cultures and faiths. Its nature is open to speculation, but in Christian art the afterlife evolved into two opposing concepts: a place of perfection located high above, and a place of torment located far below. Painters found it hard to visualize perfection, and there are very few pictures that offer a satisfying view of heaven. Hell, on the other hand, was much easier. It allowed artists to give full rein to their imagination.

Some aspects of the Christian hell were drawn from other cultures. In the Classical world, the dead resided in the underworld, which was known as Hades. This was reached by crossing the River Styx. Within Hades, there was a place of punishment called Tartarus. Here, special torments were devised for those who had offended the gods. In a similar vein, the Hebrew scriptures described *Sheol*, a realm of darkness cut off from the world of the living and from God. They also mentioned *Gehenna*, the 'lake of fire', which was the destination of the wicked.

Christian accounts of hell appear in the Book of Revelation and, more fleetingly, in the Gospels. However, they were described in greater detail in some apocryphal texts. The most graphic example was the *Apocalypse of Peter,* a 2nd-century narrative which took the form of a discourse between the risen Christ and his disciple. In it, the punishments for specific sins were listed: blasphemers are hanged by their tongues; adulterers are dangled over bubbling mires with their heads dipped in the boiling filth; and the oppressors of Christians are flogged and burned, while worms devour their entrails.

The vindictive nature of the punishments appealed to the members of a persecuted minority sect, but accounts of this kind remained popular, even when Christianity had become the dominant religion in the West. The idea of making the punishment fit the crime provided considerable inspiration. In Bosch's *Hell*, musicians are tortured on their own instruments. One man is impaled on a harp, while another is imprisoned inside his drum. A slothful man is tormented in his bed by demons, while a vain woman is forced to stare at her reflection on a monster.

The landscape of hell altered over time. Both Bosch and Pieter Bruegel portrayed it as a nocturnal city, on fire and under attack from nightmarish forces. The Italian poet Dante Alighieri devised a more systematic topography for the place. In his *Divine Comedy* (c. 1308–20), he divided his Inferno ('hell') into nine distinct circles or layers, each housing a different type of sinner. Dante's verses proved a popular subject for artists until well into the 19th century. IZ

1250–1300

The end of the Crusades. Enthusiasm for the Crusades gradually begins to wane as the century wears on. In spite of some successes, the Seventh (1248–54), Eighth (1270) and Ninth (1271–72) crusades all end in failure. In part, Western rulers are distracted by problems at home, but the internal squabbles between the Christian forces in the East are even more damaging. The ongoing hostilities between the Venetians and the Byzantines weaken the cause still further. The Fall of Acre in 1291 signals the end of the Crusader states. IZ

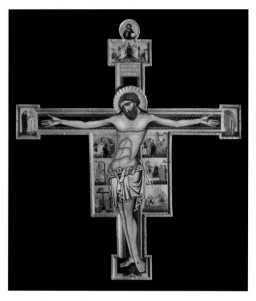

Tavèrnoles Baldachin – *Christ in Majesty*

Very little is known about this remarkable example of Romanesque art from Catalonia. It was discovered in 1906 at the Benedictine monastery of Sant Serni de Tavèrnoles. The church had been in a ruinous state for many years and the painting was found propped up, half-hidden and forgotten, behind a Gothic altarpiece. It shows Christ enthroned in majesty, encircled by a huge halo. This is supported by four large angels. The format is typical of contemporary versions of the Ascension. It seems certain that the panel was designed as a baldachin or canopy, which would have been displayed horizontally above an altarpiece.

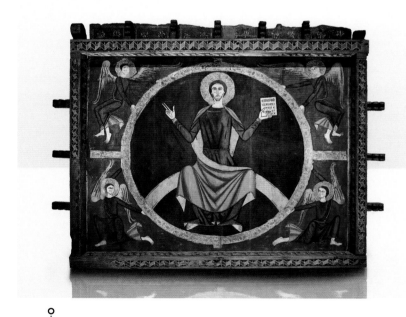

Coppo di Marcovaldo – *Crucifix*

This harrowing version of the Crucifixion is generally attributed to Coppo di Marcovaldo, who is regarded as one of the founding fathers of the Sienese School of painting. The stylizations of the figure and the loin-cloth are typically Byzantine, but the pain-filled features of Christ's face are strikingly different. Coppo had been a soldier in the Florentine army at the Battle of Montaperti (1260), which had been a particularly brutal encounter. There were 10,000 casualties and the local river ran red with blood. It has been suggested that the anguish in Coppo's painting reflects his traumatic wartime experiences.

Lisbon becomes the capital of Portugal, following the reconquest of the country from the Moors.

Constantinople is recaptured and restored as the capital of the Byzantine Empire. It remains as such until 1453, when the city is captured by the Turks.

c. 1250 1255 1261 c. 1265

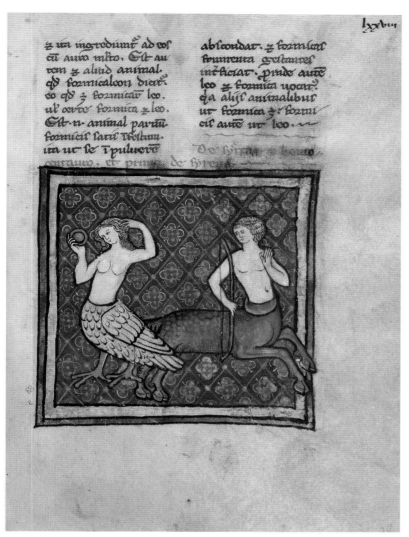

Flemish bestiary – *A Siren and a Centaur*
This comes from a Flemish bestiary that was probably produced at Thérouanne (now in France). Both creatures were borrowed from Classical mythology, but were modified considerably in Christian manuscripts. Sirens represented temptation. They lured sailors to their death with their irresistible, magical songs. A siren was usually portrayed as half-woman and half-bird, but medieval artists often conflated the creature with a mermaid, showing her as half-woman and half-fish. This confusion is evident here, as the siren holds a mirror – a symbol of vanity – which was the traditional attribute of a mermaid. The centaur was another composite creature, and here his human half is plainly falling victim to the siren's allure. In bestiaries, he sometimes represented hypocrisy or adultery, because of his contradictory nature.

In Palermo, Sicily, there is a successful uprising against harsh French rule; the insurrection has become known as the Sicilian Vespers since it broke out as Vesper bells were ringing.

Florence Cathedral is begun under the direction of the architect and sculptor Arnolfo di Cambio. It is structurally completed by Filippo Brunelleschi's celebrated dome (1420–36).

The Venetian merchant Marco Polo begins more than two decades of travel in Asia, which he later recounts in a book about his experiences.

King Edward I issues a decree expelling all Jews from England; this is not overturned until 1657, when Oliver Cromwell allows Jews to return.

c. 1270 1271 1282 1290 1296

1300–1325

The Scots fight for freedom. The Scottish struggle for independence reaches a peak during these years. William Wallace and Robert the Bruce both enjoy some success against the English, culminating in Bruce's victory at Bannockburn. The Declaration of Arbroath (1320) is the formal expression of the Scots' aspirations. These are turbulent years for the papacy, too, which opts to leave Rome and begin a period of exile in Avignon. IZ

Rüdiger and Johannes Manesse – *Codex Manesse*

The *Codex Manesse* is one of the most delightful manuscripts produced during this era. It takes its name from Rüdiger Manesse, a town councillor in Zürich, and his son Johannes. They are thought to have compiled the book in the early 14th century. The *Codex* is a unique collection of songs and poems by the *Minnesinger* – the German minstrels – whose work was popular at the time. The manuscript features verses from about 140 poets, accompanied by charming illustrations. Four different artists were employed; their names are unknown, but their style is typical of Gothic illuminators in the Upper Rhine region. The chief subject of the songs is courtly love, with amorous knights trying to win the hand of their fair ladies. This example illustrates a love poem by Konrad von Altstetten.

The Battle of the Spurs, fought at Courtrai (Kortrijk in present-day Belgium), is a major defeat for France, halting Philip IV's attempt to overrun Flanders.

William Wallace is executed in London on 23 August. The gruesome manner of his death, which involved hanging and mutilation, makes him a legend in Scotland.

1302 **c. 1304** **1305** **c. 1306**

Duccio di Buoninsegna – *The Raising of Lazarus*

This panel once formed part of Duccio's best-known painting, the *Maestà* ('Virgin in Majesty'). It was probably part of the back *predella* (a boxlike base underneath the main picture). This was devoted to scenes from Christ's ministry. The Raising of Lazarus was one of his most famous miracles (John 11:1–44). Duccio's treatment of the theme is entirely Byzantine in character. Eastern icons traditionally showed the body being entombed in an upright position in a cave. Intriguingly, though, there are signs of a compositional change. In the lower, right-hand section of the painting, it appears there was once a horizontal sarcophagus.

Giotto – *Ognissanti Madonna*

Giotto was one of the founding fathers of Western art. Early Italian painting had been heavily dependent on the traditions of Byzantine art, but Giotto adopted a more naturalistic approach. The movements and expressions of his figures appear real, and they are anchored in a credible pictorial space. Mathematical perspective had not been discovered, but the recession of the figures on either side of the throne is entirely successful. By obscuring parts of their faces with the throne and the haloes of the other angels, Giotto lends a genuine sense of depth to the scene.

The Great Famine begins. Brought on by bad weather and crop failures, it extends over most of Europe until 1317, causing millions of deaths.

The papacy moves to Avignon (now in southern France) because of unstable political conditions in Rome. Seven successive popes live in Avignon before the papacy returns to Rome in 1377.

Robert the Bruce wins a crushing victory against Edward II of England at the Battle of Bannockburn, securing Scottish independence.

Thomas Aquinas (*c.* 1225–74), the greatest philosopher of the medieval Christian world, is canonized. His ideas have had a huge influence on Roman Catholic teaching.

1309 **1310-11** **1314** **1315** **1323**

ART AND CHIVALRY

During the High Middle Ages many of the most important manuscripts were produced for members of the aristocracy. These included religious works for their private devotions, but they also wanted books that reflected the mood of the times, as well as their own secular interests.

Chivalry and courtly love were two of the most fashionable concerns. The orders of chivalry were originally inspired by the military orders that had arisen during the Crusades (the Knights Templar, the Knights Hospitaller and the Teutonic Knights). They did not serve the same military purpose, but were highly prestigious. The two most celebrated examples are the Order of the Garter and the Order of the Golden Fleece. The latter was founded in 1430 by Philip the Good, Duke of Burgundy, as part of the celebrations

for his marriage to Princess Isabella of Portugal. Rogier van der Weyden produced a fine series of portraits of the members, each displaying the emblem of the order around their neck.

The literal meaning of chivalry is 'horsemanship', but in this period the term also implied a knightly code of conduct that was popularized in contemporary literature. This included the troubadour songs, which were featured in the *Codex Manesse*, as well as courtly romances. The most famous

ABOVE LEFT. Illustration from *The Book of Hunting* by Gaston Phoebus (c. 1410)
Hunting was not just a favourite aristocratic diversion, but was also suitable training for war. Treatises on the pursuit were popular subjects for illuminated manuscripts, such as this one by Gaston Phoebus.

ABOVE CENTRE. A knight bidding farewell to his lady from the *Codex Manesse* (c. 1310–40)
Named after a former owner, the richly illustrated *Codex Manesse* is a famous German manuscript containing an unrivalled collection of courtly lyric poetry by more than a hundred different authors.

ABOVE RIGHT. Jousting scene from the Royal Armoury manuscript (1448)
This illustration depicts an Englishman, John Chalons, jousting with a Frenchman, Louis de Bueill, at Tours in 1446, in front of an audience including King Charles VII. De Bueill was accidentally killed.

of these – the *Roman de la Rose* – was copied in more than 200 manuscripts.

The equine activities that were most closely associated with chivalry were jousting and hunting. Jousting scenes were not uncommon in medieval manuscripts. Some, such the Royal Armoury manuscript, illustrated real events, while others were entirely fictional. Perhaps the most spectacular example was the tournament in the *Romance of Guiron Le Courtois*. This showed a pitched battle fought out between two groups of knights, while the female audience looked on.

The most celebrated hunting book of the period was the treatise written by Gaston III, Count of Foix and Béarn. He adopted the name 'Phoebus' because of his golden hair (meaning 'radiant', it was also the nickname of the sun god, Apollo). Gaston's text was hugely popular. It was translated into various languages and copied in numerous manuscripts. It covered every aspect of the pastime, right down to the veterinary care of the hunting pack. **IZ**

The Order of the Garter

Of the many orders of chivalry that still survive throughout the world, the most famous is probably the Order of the Garter, instituted by King Edward III of England, probably in 1348. According to a well-known but dubious story (first recorded in the late 15th century), the order got its name and motto when Edward gallantly picked up a garter that had slipped from the leg of a woman dancing at a ball and silenced tittering bystanders by declaring, '*Honi soit qui mal y pense*' ('Shame on anyone who thinks badly of it'). The motto is also used on the British royal coat of arms and by several regiments in the British Army.

1325–1350

Instability and plague. Against a backdrop of political instability, frequent warfare and the dominance of Christianity, a deeper interest in nature, a credit economy and humanistic learning come to the fore. Art focuses mainly on Bible stories for the largely illiterate populace, while less common works of secular art express chivalry, knightly crusades and courtly love. For three years from 1348, the Black Death (bubonic plague) ravages Western Europe, killing over a third of the population, and the ideal of salvation through faith prevails. Art mostly follows the established Gothic styles, although in Italy and Bohemia (the present-day Czech Republic), artists introduce new ideas, and in some Italian states a number of artists become known by name. SH

Simone Martini – *Guidoriccio da Fogliano*

A powerful Italian leader of Padua, Verona and Siena, Guidoriccio da Fogliano conquered the castles of Montemassi and Sassoforte. In 1328 Simone Martini commemorated these and other Sienese victories in a lively fresco cycle. Wrapped in a coat embroidered with his family's heraldic insignia, Guidoriccio rides his horse between the *bastita*, or fortifications, built by the Sienese during the siege, and a camp of tents. While the image provides facts about the siege, it also portrays stark truths about the destruction caused by warfare. Harmony, delicacy and bold colour became characteristics of the Sienese School, and this was probably the first Sienese artwork that did not serve a religious purpose. With his graceful and rhythmical lines, Martini spread the influence of Siena's art across Italy and beyond.

In England, fourteen-year-old Edward III is crowned king after a *coup d'état* against his father, Edward II.

The Holy Roman Emperor Louis IV invades Italy and deposes Pope John XXII.

1327 1328 c. 1335

Bernardo Daddi – *Virgin with Saints*

Probably intended for a small chapel, this triptych depicts the Virgin Mary flanked by St Thomas Aquinas on the left and St Paul on the right, holding a sword, his symbol of martyrdom. Her extended right hand over the marble parapet symbolizes her power and mercy. In his large church altarpieces and small devotional panels, Bernardo Daddi became influential for amalgamating his own graceful curves with elements of the art of Giotto di Bondone and of Sienese painting.

Bohemian Master – *Glatzer/Kłodzko Madonna*

A Bohemian panel painting dating from 1343–44, this Enthroned Madonna was originally the central part of a larger winged altarpiece in an Augustinian monastery in Kłodzko, Poland, commissioned by the monastery's founder, Archbishop Arnošt of Pardubice (depicted in the bottom left-hand corner). Originally this included another four painted panels with scenes portraying the life of Christ. Surrounded by angels, the dark-skinned Madonna wears a veil and a crown of leaves. Coupled with the receding perspective lines and rich fabrics, the image displays artistic influences from northern Italy, France and the Rhineland. More specifically, the soft modelling of the faces and the emphasis on smooth surfaces and solid forms suggest that the work was produced by an artist known as the Master of Vyšší Brod, or the Master of Hohenfurth.

The Italian painter Giotto di Bondone dies. Renowned in his lifetime for taking painting beyond the traditional, stylized forms of Byzantine and medieval composition, his innovations help to initiate the Renaissance.

Provoked by French attacks on his French territories, Edward III retaliates, launching the Hundred Years' War between France and England, which lasts until 1453.

The Black Death – or bubonic plague – reaches Europe, probably carried by the fleas on black rats on Asian merchant ships. Over the following three years, the plague kills approximately 30–60% of the European population.

In Europe, persecutions rise over the Black Death. Throughout the continent, Jews, friars, beggars, lepers and foreigners are expelled or killed.

1337 **1343–44** **1348** **1350**

1350–1375

Bohemia takes centre stage. The spotlight falls on Central Europe when Charles IV becomes the first Bohemian king to be crowned Holy Roman Emperor (1355). He is also king of Italy and king of Burgundy. Charles makes Prague his imperial capital, rebuilding it on a grand scale. It becomes the third-largest city in Europe, after Rome and Constantinople. He also establishes a university there – the first in Central Europe. IZ

Francesco d'Antonio da Ancona – *Madonna and Child with Saints*

This polyptych has fourteen separate sections. On the left, St Laurence holds the symbol of his martyrdom – the gridiron on which he was roasted alive. Next to him, St Francis bears the stigmata (see the *St Francis Altarpiece*, p. 71), with a wound visible on his side, while the man wearing the animal skins is St John the Baptist. The most unusual figure, perhaps, is St Stephen on the right. There are two bloodstained stones on his head – a reminder that he was stoned to death.

Pedro (Peter) the Cruel becomes the king of Castile and Leon; he reigns until killed by his half-brother and successor Henry II in 1369.

c. 1350

1350

Russia – *Icon of St Boris and St Gleb with Scenes from their Lives*

While artists in the West were gradually adopting a more naturalistic approach, icon painters in the East remained wedded to their traditional style. The figures of the saints are elongated and stereotypical, with simplified frontal poses, while the landscape and architectural elements in the smaller scenes are still heavily stylized. Boris and Gleb were Russia's most popular saints, with many churches dedicated in their honour. They were sons of Vladimir the Great, who had converted the country to Christianity, but were murdered after his death in 1015. They were the first Russian saints to be canonized (1071).

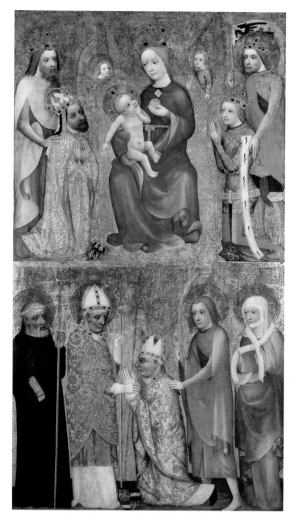

Bohemia – *Votive Panel of Jan Očko of Vlašim*

This fine example of Bohemian art was commissioned by Jan Očko, who succeeded Arnošt of Pardubice as the Archbishop of Prague. Očko can be seen on the lower register, kneeling in front of St Adalbert, the patron saint of Bohemia. Above them, Charles IV and his son, the future Wenceslaus IV, kneel on either side of the Virgin. The picture was probably commissioned for a new chapel dedicated to the Virgin at the archbishop's residence, Roudnice Castle. Očko was a statesman as well as a cleric. He was an adviser to Charles IV and acted as regent when the king was out of the country. This might explain the nationalist emphasis in the painting. All the saints in the picture have some connection to Bohemia – either by birth, or because their relics were displayed there. The artist is unknown, but probably came from the circle of the court painter, Theodoric of Prague.

The Black Prince wins a great English victory over the French at the Battle of Poitiers. The French king, John II, is captured and dies in London in 1364.

Marino Faliero, the Doge of Venice, is executed for plotting against the state. His story later inspires a play by Byron, an opera by Donizetti and other works.

The Ming Dynasty is established in China, following the overthrow of Mongol rulers. It lasts until 1644 and marks a golden age of prosperity and culture.

1355 1356 1368 c. 1370–71

1375–1400

The Hundred Years' War. Western Europe is still dominated by the Hundred Years' War (1337–1453), the seemingly interminable struggle between England and France. During this phase of the conflict, both sides are hampered by underage monarchs. Richard II of England is ten when he gains the throne (1377), while Charles VI of France is eleven (1380).

This period also witnesses the rise of the International Gothic style. Characterized by an air of aristocratic elegance and refinement, it affects many branches of the arts, including painting, sculpture, tapestries and illuminated manuscripts. IZ

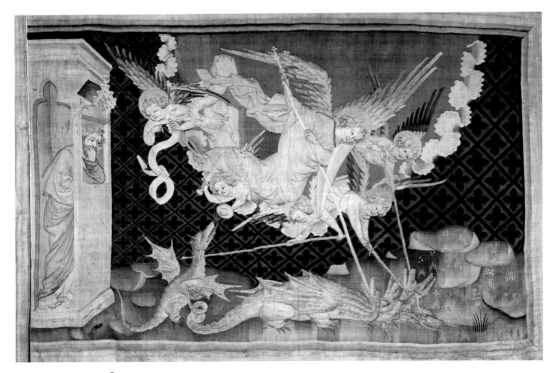

Apocalypse Tapestry, Angers – *St Michael Fighting the Dragon*

This image depicts the Apocalypse from the Book of Revelation. It was commissioned in the late 1370s by Louis I of Anjou, who planned to display it in the chapel of his ducal palace at Angers, in northern France. He hired a Netherlandish artist, Jean Bondol, to produce the cartoons (preparatory drawings), which were then woven into tapestries in the Paris workshop of Nicholas Bataille. The designs were loosely based on a manuscript Louis had borrowed from his brother, King Charles V of France. There were ninety scenes, over a length of more than 100 m (330 ft). This episode shows St Michael and his angels defeating the dragon (Revelation 12:7–9). Its seven heads symbolize the Seven Deadly Sins.

The nave of Canterbury Cathedral (finished *c.* 1403), one of the masterpieces of the Perpendicular style, is begun in what will be the final phase of English Gothic architecture.

The Peasants' Revolt, an uprising against unpopular legislation, results in London being pillaged by a mob; the rebellion collapses after the leader, Wat Tyler, is killed.

The Swiss victory against Duke Leopold of Austria at the Battle of Sempach is a major stepping stone on the way to establishing Switzerland as a unified nation.

c. 1377–82　　1378　　1381　　1386

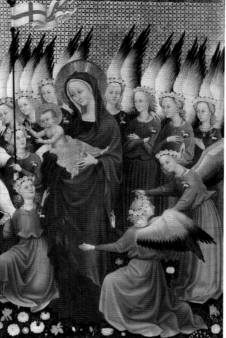

Netherlandish – *The Annunciation*

This panel is one of the earliest paintings of the Netherlandish School. It was part of a small, folding altarpiece, which can be traced back to the Chartreuse de Champmol. This monastery was founded by Philip the Bold, Duke of Burgundy, and housed his magnificent art collection. The name of the painter is unknown, but his style suggests that he came from the Guelders region, in the northern Netherlands. He was certainly adventurous, as this is one of the first pictures to feature oil paint which, at the time, was still an experimental medium.

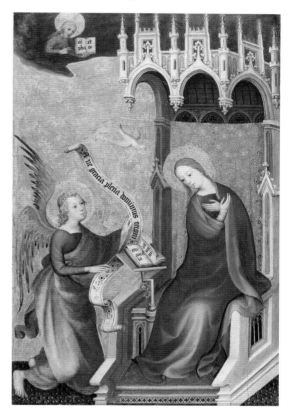

England – *Wilton Diptych*

The *Wilton Diptych* is one of the chief glories of the International Gothic style of painting. It shows Richard II of England kneeling before the Virgin. He is accompanied by John the Baptist and two saintly English kings, Edward the Confessor and Edmund. The artist has taken pains to make this scene resemble a private audience. Richard is wearing his personal emblem – a white hart – around his neck, while, on the right, each of the angels is wearing this same emblem as a badge. The banner with the red cross is both the English flag and the traditional symbol of the Resurrection. Even the Christ child appears to be reaching out to the king. Only the ground, carpeted with flowers, emphasizes that the Virgin is on a different spiritual plane, in Paradise. The diptych (a painting with two parts) is a portable altarpiece. It is hinged and could be closed, to protect the inner panels. The unknown artist was probably either English or French.

Richard II is deposed and succeeded as king of England by Henry IV. Richard dies in captivity the following year, the cause of death being uncertain.

c. 1395–99 1399 c. 1400

2
—

RENAISSANCE
& BAROQUE

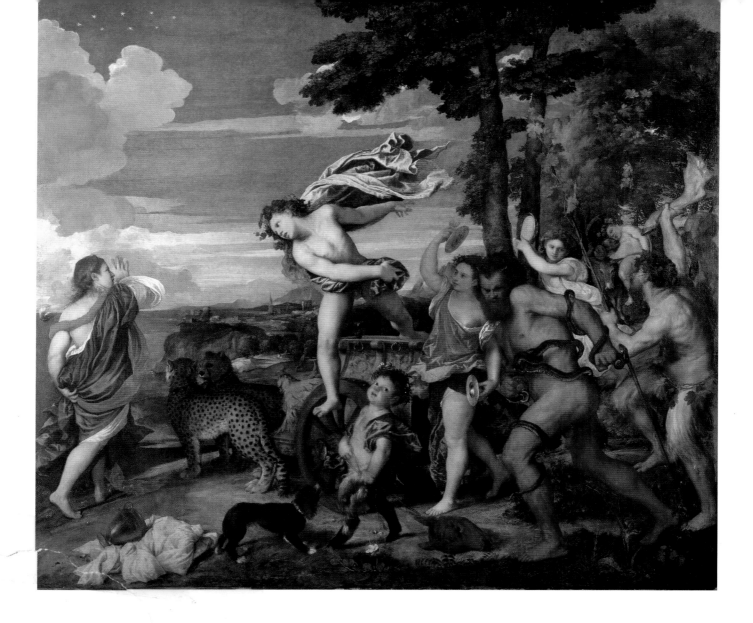

The term Renaissance means 'rebirth'. It refers primarily to the upsurge of new cultural styles and values which began in Italy in the 14th century, and eventually spread to other parts of Europe. The idea of a revival implied, of course, that something had previously been lost. This stemmed from the widespread view that the arts had reached a peak of perfection during the Classical era, swept away when the Roman Empire collapsed.

This view was not uncommon at the time. In his ground-breaking book *The Lives of the Artists* (1550), Giorgio Vasari divided the period into three stages: in the first, dating from about 1250, Giotto and his contemporaries led the move towards naturalism; the artists of the 15th century built on these foundations, making great strides in the fields of anatomy and perspective; while in the third stage, often referred to as the High

Renaissance (c. 1500–20), the artistic triumvirate of Raphael, Leonardo and Michelangelo surpassed the works of the ancients.

Historians have backtracked over some of these claims. To lift the genius of Giotto out of his own era, they argue, is to undervalue the energy and variety of the medieval period. By the same token, the so-called 'Dark Ages' were nothing like as dark as has been claimed. There were revivals of learning in the 10th and 12th centuries, and the various cultures of the 'barbarian' peoples, while very different from Classical values, had many positive features that are now greatly admired.

Nevertheless, the continuing rediscovery, translation and reinterpretation of ancient texts, together with the unearthing of more Classical statuary, did give Renaissance philosophers and artists a much clearer vision of the pre-Christian world. This is

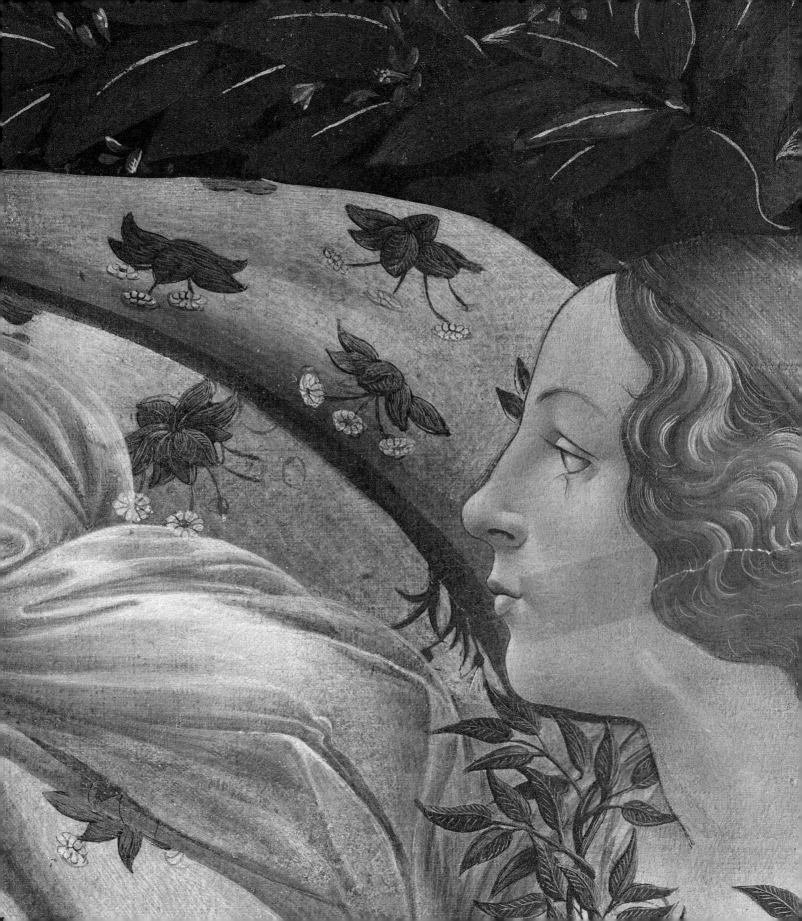

plainly evident in some of the paintings and sculpture of the time. Dürer's *Adam and Eve*, for example, carries echoes of the *Apollo Belvedere*, which was discovered at the end of the 15th century. Similarly, Titian's *Bacchus and Ariadne* was partly inspired by *Laocoön* (see p. 29), the Hellenistic marble group that was found in a Roman vineyard in 1506. The influence of Classical texts was equally pervasive, particularly when viewed through the prism of commentaries by the philosophers Marsilio Ficino and Giovanni Pico della Mirandola. The mythologies of Botticelli bear the imprint of ideas of this kind, although many may feel that their incomparable beauty can be better assessed through the perfection of their formal qualities, rather than through the tortuous Neo-Platonic iconography that lies behind them.

Italy was not a unified country at this time. It was a collection of independent city-states, which were often at war with one another. They developed different stylistic preferences, which interacted with one another, giving impetus to the movement as a whole. The Sienese School came to the fore in the late medieval period, blending elements from Gothic and Byzantine art. Duccio, Martini and Lorenzetti were among its greatest artists.

Venice had strong political and trading links with the Eastern Empire – it was administered in its early days by the Exarchate of Ravenna – so it is hardly surprising that its earliest painting style had a distinctly Byzantine flavour. By the 14th century, however, the Venetian Republic had become a wealthy maritime power, and its art had changed direction. During the Renaissance its greatest painters included the Bellini family – especially Gentile and Giovanni – and Vittore Carpaccio.

The artists of the Venetian School became renowned as fine colourists, while in Florence the chief emphasis was on line (i.e. drawing). The Florentine School pioneered many of the key developments of the Renaissance. It was here that the main principles of perspective were established, and Vasari set up his Accademia del Disegno – the first formal art academy in Italy. Masaccio, Uccello, Botticelli, Ghirlandaio and Lippi were just a few of the great names who forged their careers in the city.

The real driving force behind the rise of Florence was the Medici family. This dynasty of merchants and bankers ruled the city and its environs for much of the period between 1434 and 1737. They were ruthless at acquiring and maintaining power, but they were also bountiful patrons of the arts, commissioning many of the greatest paintings of the Renaissance. Their most celebrated member was Lorenzo the Magnificent, who was a poet and scholar, as well as a collector of Classical antiquities.

The Medici were not the only great patrons of the period. The d'Este family from Ferrara, the Sforzas in Milan, the Gonzagas in Mantua and the Montefeltro family in Urbino all maintained lavish princely courts. These were cultured individuals, who wanted to surround themselves with artworks that reflected their learning, their refinement and their appreciation of beauty.

PREVIOUS PAGE. Sandro Botticelli – *The Birth of Venus* (detail; *c.* 1485)

LEFT. Titian – *Bacchus and Ariadne* (1520–23)

BELOW. Leonardo da Vinci – *The superficial anatomy of the shoulder and neck* (c. 1510–11)

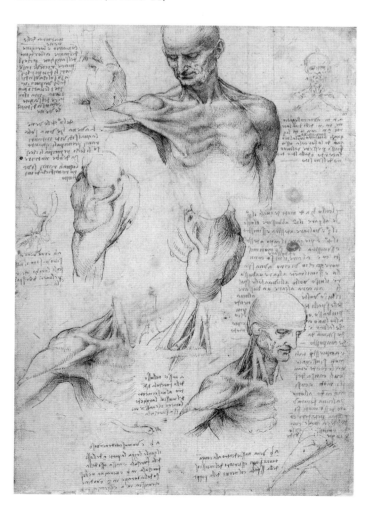

This important new source of secular patronage undermined the dominance of religious art. Instead, there was an increasing tendency to place humankind rather than God at the centre of the artistic universe. This was fuelled by the Renaissance brand of humanism, though there were also important technical developments. The invention of perspective enabled painters to place figures much more realistically into their surrounds. This key development was pioneered by Filippo Brunelleschi and publicized by Leon Battista Alberti in his *De pictura* (On Painting; 1445). The first artist to enjoy the benefits of this discovery was Masaccio, in his frescoes in the Brancacci Chapel in Florence.

The trend towards naturalism was also aided by a new interest in the human form. This had been a major feature of Classical art, but was a much lower priority in medieval and Byzantine painting. There, the figures had been either elongated or heavily stylized. A detailed study of the human anatomy was not without its difficulties at this time, as dissections sometimes had to be carried out covertly. Once he became famous, however, Leonardo da Vinci found it easier to gain access to corpses – usually of executed criminals. He conducted more than thirty dissections, often collaborating with Marcantonio della Torre, the anatomist at the University of Pavia. In the course of his studies,

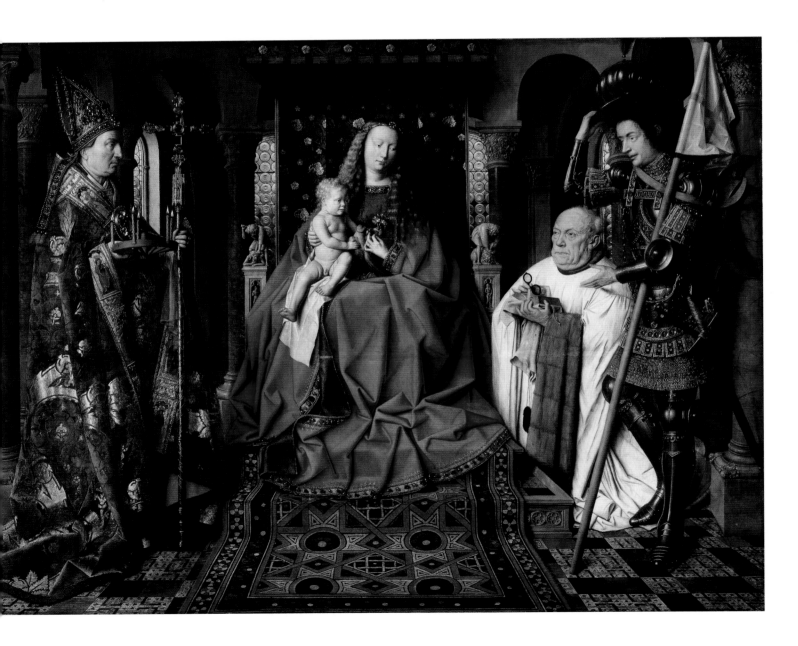

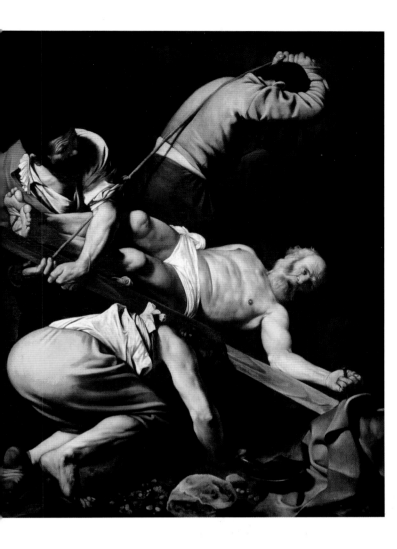

Leonardo produced hundreds of anatomical drawings, along with detailed notes.

The lessons of the Renaissance were transmitted far beyond the shores of Italy by the greatest invention of the period – printing. Developed in Mainz by Johann Gutenberg, this process enabled artists to disseminate their work around Europe with phenomenal speed. One of the most prolific craftsmen in this field was Marcantonio Raimondi. He devised a simplified cross-hatching technique, which proved ideal for making accurate copies of paintings. Raimondi is best known for popularizing the work of Raphael through this medium.

The other major technical advance of the time was oil painting. Vasari attributed its invention to Jan van Eyck. Historians have generally discredited this idea, though there is no doubt that he was the first to realize its full potential. By using its capacity to render minute details, brilliant colours and a wide range of tones, van Eyck was able to achieve astonishingly naturalistic effects. His *Madonna with Canon van der Paele* (1436) is so realistic that physicians have diagnosed the old man's medical condition.

The Northern Renaissance describes those artists in northern Europe who absorbed some of the new ideas from Italy. The term has been variously applied to such figures as Albrecht Dürer, Jan van Eyck, Rogier van der Weyden, Pieter Bruegel the Elder and Hans Holbein the Younger. Each of these artists acquired different traits from their knowledge of Italian developments. However, the movement in the north had a very different character, as it evolved against the background of the Reformation.

The style that succeeded the High Renaissance was Mannerism. Deriving from the Italian word *maniera* ('stylishness'), the term was used by Vasari as a compliment, believing that it indicated gracefulness and sophistication. Later generations were less impressed, criticizing the Mannerists' apparent taste for strained poses, bizarre viewpoints and rampant emotionalism. Much later, the tide of academic opinion turned back to a more positive assessment.

The origins of the term Baroque are unclear, although it is often associated with *barocco*, a Portuguese word for an irregularly shaped pearl. The movement sprang up in Rome, where it was swiftly adopted as the chief cultural weapon in the armoury of the Counter-Reformation – the Catholic Church's response to the rise of Protestantism. In stylistic terms, the Baroque was characterized by dynamic movement, intense spiritual emotion and an air of theatricality. In Italy, the key figures were Caravaggio, Carracci and Bernini.

The Baroque also flourished in some northern areas. In Catholic Flanders, the greatest exponent of the style was Peter Paul Rubens, while in France it attracted the interest of the monarchy rather than the Church. Louis XIV recognized the propaganda value of employing such a dramatic and grandiose style, and used it in the decorations at his palace in Versailles.

LEFT. Jan van Eyck – *Madonna with Canon van der Paele* (1436)

ABOVE. Caravaggio – *Crucifixion of St Peter* (1601)

1400–1420

Private devotion. At the beginning of the 15th century, religious figures are the predominant subject matter in northern European art in what came to be called the International Gothic style. At the dawn of the new century society begins to recover from the ravages of the Black Death, but mortality and the afterlife are still on people's minds. The Great Western Schism undermines papal authority, leading to a religious crisis: there is an emphasis on personal piety, and the affluent are drawn to use artworks for their private devotions. These are in the form of small painted panels and illuminated manuscripts, often depicting the natural world and everyday life, sowing the seeds for landscape and genre painting. Some of the finest manuscript painting is produced by Flemish artists working under the patronage of the Dukes of Burgundy. Innovations such as aerial perspective, with colours softened to show distant objects, enable greater naturalism. CK

Upper Rhenish Master – *The Little Garden of Paradise*

Painted on oak, this painting was intended for private devotional purposes. It shows Mary reading a book, the infant Jesus playing, and an angel and saints in the idyllic setting of a *hortus conclusus* (enclosed garden). It depicts nature in exquisite detail, showing fish, butterflies, dragonflies, nineteen different plants and twelve kinds of bird. Viewers would have been familiar with its symbolism, such as the small dragon indicating St George.

Deaths from the plague in Asia, North Africa and Europe reach 20 to 30 million by 1400. This means that agriculture suffers from a lack of labour, and trade has declined. Christians see plague as a punishment for sin.

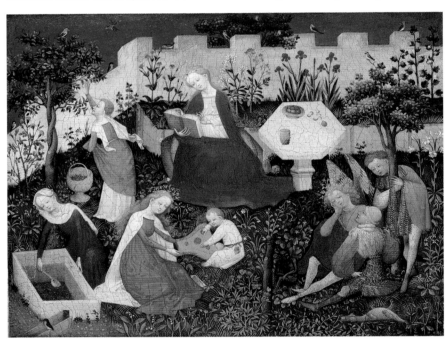

A copy of the *Geographia* **atlas** by the ancient geographer and astronomer Ptolemy (*c.* 100–170) is translated from Greek into Latin. It reintroduces longitude and latitude as measurements, and changes mapmaking and the concept of geographical identity.

The Wycliffe Bible (1380), the first English version of the Bible, is in circulation in London. A synod of clergy in Oxford bans it and issues an order against unauthorized translation of the Bible into English.

1400	1407	1408	c.1410–20

Limbourg Brothers – *Month of May*

This miniature illuminated manuscript comes from *Les Très Riches Heures du Duc de Berry*. It is an example of a medieval book of hours, a devotional book including text for each liturgical hour of the day, as well as a calendar, Masses for Holy Days, prayers and psalms. The illustration is from the most famous part of the book, the calendar. A French noble, Jean, Duc de Berry, commissioned the Flemish Limbourg brothers, Paul and Jean, to paint the miniatures. The brothers died in 1416, before the book was finished.

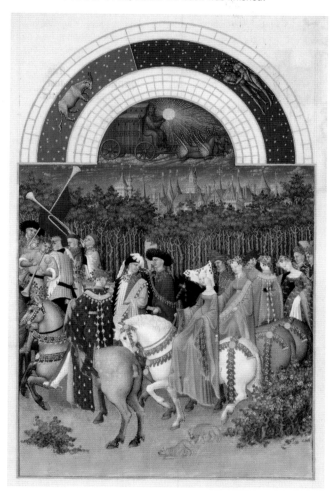

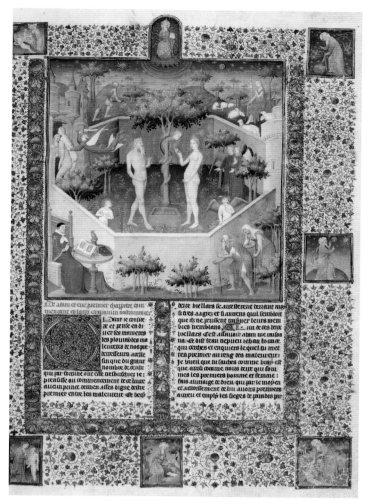

Boucicaut Master – *The Story of Adam and Eve*

In the early 1400s the Franco-Flemish Boucicaut Master was the leading master of manuscript illumination in Paris. This work depicts the biblical story of Adam and Eve. The Temptation – when they eat the fruit from the Tree of Knowledge – is shown at the centre, and subsequent events including their expulsion from the garden are shown around the walls. The sky is shown lighter towards the horizon in what is thought to be the earliest-known example of aerial perspective.

Czech religious reformer Jan Hus is burned at the stake after being convicted of heresy at the Council of Constance, provoking religious wars in Bohemia. His work anticipates that of the Lutheran Reformation a century later.

The Great Western Schism in the Roman Catholic Church ends when Pope Benedict XIII is excommunicated. The Church is united after thirty-nine years of division and three rival popes, which damaged the prestige of the papacy.

| 1412–16 | c. 1413–15 | 1415 | 1417 |

1420-1440

The winds of change. The Gothic is superseded by the Early Renaissance, and the early 14th century witnesses intellectual change as the city-state of Florence comes to the fore. The Council of Florence aims to join Eastern and Western Christendom, and its examination of their common roots is the watershed for the Renaissance. Religious subjects continue to dominate, as artists seek to convey human emotion in their narratives. Secular subjects make an appearance too, sometimes including portraits of rich patrons. Their wealth signifies the rise of bankers, the merchant class and craft guilds, as trade in Europe thrives. This leads to an exchange of ideas about religion, philosophy, science and art, as well as craft skills and artistic techniques. CK

The first recorded patent for an industrial invention is granted in Florence to the architect and engineer Filippo Brunelleschi. The patent gives him a three-year monopoly on the manufacture of a barge with hoists used to haul marble.

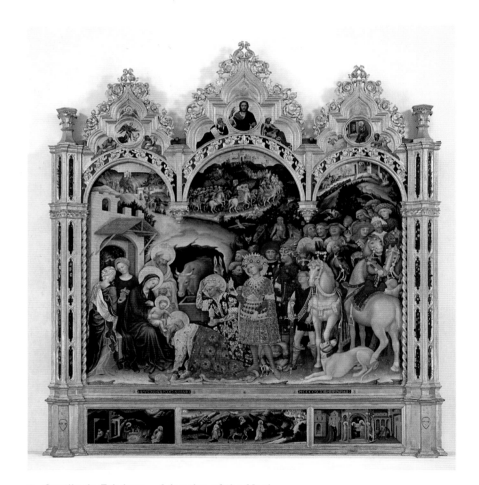

○ **Gentile da Fabriano – *Adoration of the Magi***
Gentile da Fabriano painted this altarpiece for the Cappella Stronzi in the Santa Trinità Church in Florence. It depicts the biblical story of the Adoration of the Magi, with the Madonna and Child on the left. Paying homage is a line of chivalrous figures including knights and hunters. The procession recedes into the distance towards a castle in the hills. The Florentine banker who commissioned the work, Palla Strozzi, is shown in a red hat behind the young king at the centre.

1421 · 1423 · 1425-27

Andrei Rublev – *Old Testament Trinity*

Rublev was the greatest of the Russian icon painters and this large work is his supreme masterpiece. The nature of the Holy Trinity (Father, Son and Holy Ghost) was a vexed question, both for theologians and for artists. Western artists tended to distinguish between the three aspects of the Trinity, depicting the Holy Ghost as a dove. In the East, there was uneasiness about portraying God in human form. Normally he was only shown as a single hand emerging from the sky (see *The Ascension*, p. 42). The Trinity itself was represented by three identical figures. These are based on the three otherworldly visitors (not angels), who appeared to Abraham and Sarah. This episode is traditionally viewed as a prefiguration of the Holy Trinity.

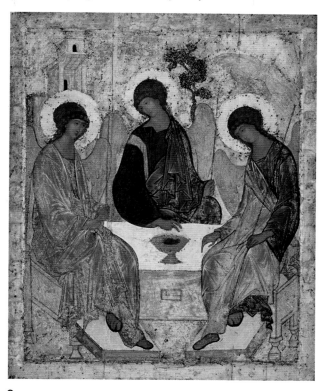

Rohan Master – *Lamentation of the Virgin*

This illumination comes from the *Grande Heures de Rohan* (Rohan Hours) painted by the anonymous artist the Rohan Master of Anjou. It shows the Virgin Mary grieving over Christ's bloodied corpse at the foot of the Cross. She is held by the Apostle John, who tries to console her while he looks up accusingly at an all-seeing, sombre God. The artist attempts to convey the figures' emotions and create a sense of drama, prefiguring the expressive art of the High Renaissance.

Joan of Arc defeats the English at the Battle of Orléans in May, having been told through visions to aid Charles VII and recover France from English domination in the Hundred Years' War. In August she enters Paris in triumph. Within two years, she is burned at the stake as a heretic.

King Alfonso V of Aragon, ruler of Naples and Sicily, orders Jews throughout Sicily to attend sermons and convert to Catholicism.

Cosimo de' Medici, head of a Tuscan banking family, becomes ruler of Florence. The House of Medici starts to dominate the city politically, and eventually wields similar influence across Italy and Europe.

1428 1429 1430–35 1434

Pietro Perugino
(d. 1523)

One of the earliest Italian practitioners of oil painting, Pietro Perugino was a precursor of the High Renaissance and a formative influence on Raphael. Born near Perugia, he was possibly taught by Fiorenzo di Lorenzo and Piero della Francesca. According to Vasari he was also taught by Andrea del Verrocchio alongside Leonardo, Domenico Ghirlandaio, Lorenzo di Credi and Filippino Lippi. He worked in Rome, Florence, Venice and beyond, and became an early international success. He painted frescoes in the Sistine Chapel in Rome for Pope Sixtus IV and in the Florentine Palazzo della Signoria. His light style comprises tightly controlled sculptural figures, a sense of space and economy of formal elements, all gracefully composed in simple architectural settings.

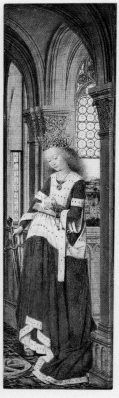

THE INVENTION OF OIL PAINTING

The adoption of oil painting in the 15th century marked a major turning point in European art. The medium allowed a greater range of brushstrokes and could be worked while still wet, giving artists the ability to create new depths of textural variation in their work.

FAR LEFT. Antonello da Messina – *St Sebastian* (1477–79)
Antonello painted two Venetian altarpieces, one for the Church of San Cassiano, and a triptych for the altar of the Scuola di San Rocca in the parish church of San Giuliano. Forming part of that triptych, this work is an overt tribute to Venice.

ABOVE LEFT. Jan van Eyck – *Triptych of Mary and Child* (1437)
Van Eyck's profound impact on the development of oil painting emerged from his detailed, naturalistic portraits and religious subjects, which also contained underlying symbolism.

Powdered pigments mixed with oil and used as paint date to at least the 7th century AD, when artists in Afghanistan mixed ground natural pigments with walnut or poppyseed oil, and used the mixture to decorate an ancient cave complex in Bamiyan. In Europe, oil as a painting medium was first recorded in the 11th century, but was not used widely until after 1400, when improvements were made in the refining of linseed oil. Artists in Flanders were the first Europeans to paint with oils. In his handbook on art, *Il Libro dell'Arte*, written in the late 1390s, the Italian painter Cennino Cennini mentioned that the 'Germans' (artists north of the Italian Alps) used oil paint. By then tempera – paint made with powdered pigment and egg – was the standard medium for European painters. Pioneers of oil painting included the brothers Jan and Hubert van Eyck, Robert Campin, and Rogier van der Weyden. Due to his proficiency with the medium, for many years Jan van Eyck was mistakenly attributed with oil painting's invention. He initially worked in The Hague for John of Bavaria-Straubing, ruler of Holland, Hainault and Zeeland, but after John's death in 1425 he was employed in Lille as court painter and diplomat to Philip the Good, Duke of Burgundy. In 1429 he moved to Bruges, where

he remained for the rest of his life. His elegant, meticulous style evolved from manuscript illuminations, such as the detailed, decorative work of the Limbourg brothers: Herman, Paul and Jean, whose art reflected the International Gothic style. Van Eyck's expertise soon became known beyond Flanders and first the Dutch and then the Italians began using oils rather than tempera.

Explorations into the slow-drying, jewel-bright, translucent qualities of oil paint had a profound effect on Early Renaissance painting, as successive layers of thinly applied oils enabled greater experimentation and meant that lighter and more versatile linen canvases could replace wooden panels. In Italy, some of the most accomplished Early Renaissance artists who worked with oils were Gentile da Fabriano, Fra' Filippo Lippi, Piero della Francesca, Giovanni Bellini, Antonello da Messina and Andrea Mantegna. The chronicler Giorgio Vasari credited the Sicilian artist Antonello da Messina with introducing oil paint to Venice when he stayed there from 1475 to 1476. From that time, Venetian painting changed considerably. The city's artists of the 16th century such as Titian, Tintoretto and Veronese went on to exploit the rich possibilities of colour with the medium. SH

1440–1460

Spread of the arts. As Italian city-states become rich from trade, more money is spent on the arts. Merchants commission artists and fund the building and decoration of churches and civic buildings. Rulers of several city-states, such as the Medici family in Florence, also fund and provide artistic study and production, using art to increase their political power, and artists are encouraged to experiment and innovate. Meanwhile, in the Holy Roman Empire about 1440, the printing press is invented by Johannes Gutenberg, enabling mass book production and the dissemination of knowledge across Europe. In 1455 the *Gutenberg Bible* is printed – the first major book produced with movable type in the Western world. All this occurs as the plague wipes out swathes of the population, resulting in a pessimistic view of humanity. SH

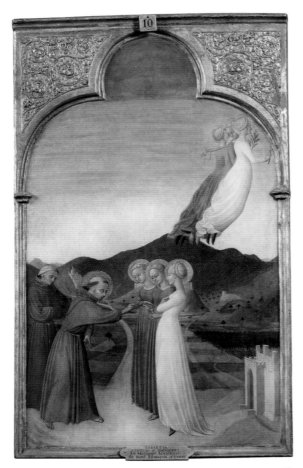

Sassetta – *Mystic Marriage of St Francis*

Made for the church of the Convent of San Francesco at Borgo San Sepolcro, this is set in an idyllic landscape, with little care for perspective and realism. Portraying a vision experienced by St Francis of Assisi as he travelled to Siena, it depicts him meeting the three Theological Virtues of Faith (white), Hope (green) and Charity (red). St Francis and his companion Fra' Leone wear their brown monk's habits. Symbolizing the saint's mystic 'marriage' to the Virtues, here he places a ring on Hope's finger. In the same image, the Virtues float up to heaven holding their attributes, and Hope glances back at her 'husband'. Sassetta is famed for building on the Sienese Gothic style. The elegant contours, elongated figures and delicate colours show an influence of the contemporary Florentine artists Gentile da Fabriano and Masolino.

The construction of the Palazzo Medici begins in Florence. Designed by Michelozzo di Bartolomeo for Cosimo I de' Medici, it is an architectural expression of the power of the banking dynasty.

Johannes Gutenberg develops the movable type printing press in Germany. It prints books and newspapers efficiently on a large scale.

1440

1444

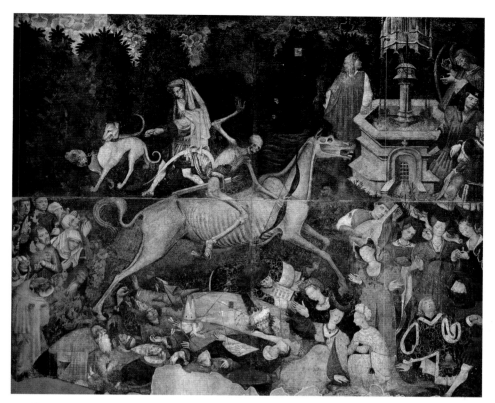

Italy – *The Triumph of Death*

Painted *c.* 1446 by an unknown artist, this fresco exemplifies late Gothic painting in Italy, with its emphasis on flowing lines, minute details, complex compositions and lack of perspective. Across Europe, the theme of the Triumph of Death was widespread, but the emphasis here on the macabre was more common in northern Europe than in Italy. In the 15th century death was a constant, fearsome and indiscriminate spectre. In the centre of a garden, Death rides an emaciated horse and has just fired an arrow into the neck of a young man in the lower right-hand corner, which leads the eye to figures including emperors, popes, bishops, friars, poets, knights and maidens – all also dead or dying. On the left, a group of poor people are either supplicating with Death to end their suffering – or alternatively they may be plague survivors who have evaded Death.

Rogier van der Weyden – *Last Judgement* (detail)

In Brussels, Rogier van der Weyden established a highly personal painting style that ensured his international fame. Comprising fifteen panels, this is part of his largest work. It was made for the Hospices de Beaune, founded by the rich and powerful chancellor Nicolas Rolin and his third wife, Guigone de Salins, and it depicts the Christian tradition of the Last Judgement: the moment when all souls will be judged by God. In the lower part of the painting, the dead rise and the Archangel Michael (shown in this detail in white) weighs their souls.

The *Gutenberg Bible* is published, revolutionizing European literacy.

In England, the two noble families of York and Lancaster begin fighting for the throne – the start of the Wars of the Roses.

Venetians occupy Iraklion, the capital city of Crete, and use the surrounding forests of cedars and firs to build their powerful fleets.

The Ottoman conquest of Constantinople: many Greek thinkers escape to Western Europe, taking ancient Greek documents with them.

c. 1446 | 1448–51 | 1453 | 1454 | 1455

1460–1480

Chivalry and virtue prized. In England, the Wars of the Roses (1455–85) cause civil strife as the rival descendants of Edward III, the House of Lancaster and the House of York, fight for the throne. Despite the turmoil – or perhaps because of it – there is a strong revival of interest in chivalric romance and Britain's past, the evidence of which is seen in contemporary literature and art. The advent of the printing press means old masterpieces from England, France, Spain and Italy find a vast new audience. The Renaissance is emerging in Italy, and there is a similar shift in art in northern Europe. The use of slow-drying oil paints allows artists to create durable paintings with fine detail, realistic precision and a lustrous, hard-wearing finish. The introduction of the easel also enables artists to create portable works more easily. CK

Sir Thomas Malory completes his *Le Morte d'Arthur*, about the legendary King Arthur, the Knights of the Round Table and their quest for the Holy Grail. Malory worked from a late 14th-century French poem and added material from other sources to produce his English prose translation. The chivalry of King Arthur's world contrasts with that of Malory's, as England was torn apart by a dynastic civil war.

Barthélémy d'Eyck –
Livre du Cœur d'Amour Espris
This illuminated page comes from the manuscript *Livre du Cœur d'Amour Espris* (The Book of the Love-Smitten Heart) written by René, Duke of Anjou and King of Naples. Although he was an amateur painter, many artworks were falsely attributed to him because they bore his coat of arms; his court painter, Barthélémy d'Eyck, illustrated this courtly allegorical romance. The image shows a young knight standing solemnly before a gravestone, while his servant sleeps on the ground beside their horses.

1465

1470

Leonardo da Vinci – *Ginevra de' Benci*

This portrait of the daughter of a Florentine banker, Ginevra de' Benci, shows her face framed by the leaves of a juniper bush in reference to her name (which is Italian for juniper) and her chastity, and was probably commissioned to celebrate her engagement. It is one of the earliest oil paintings by Leonardo da Vinci, and this choice of medium indicates the wealth and sophistication of the patron. Unusually, Leonardo depicts her in an open setting when women were usually portrayed within the confines of their homes. In another innovation, he employs a three-quarter pose, one of the first in Italian portraiture, and his sitter looks towards the viewer – signalling both her beauty and Leonardo's ability to add psychological depth to a portrait.

Hugo Van der Goes – *Portinari Altarpiece* (detail)

The Italian banker Tommaso Portinari was working for the Medici Bank in Bruges when he commissioned the Ghent painter Hugo Van der Goes to complete this triptych for the church in the hospital of Santa Maria Nuova in Florence. Portinari and his two sons, Antonio and Pigello, are portrayed on the left panel kneeling in front of their protectors, St Thomas and St Anthony. The image served to remind Florentines of Portinari. After the painting was shipped from Bruges to Florence, Van der Goes' use of oils, chiaroscuro and rich colour, as well as his depiction of lifelike figures, proved highly influential on Italian artists.

Members of the Pazzi family lead a conspiracy to displace the Medici family as rulers of Florence. They attempt to assassinate Lorenzo de' Medici and his brother Giuliano. Lorenzo is injured but survives, while Giuliano dies of his stab wounds. The murder heralds two decades of political strife in Florence.

Ferdinand II succeeds his father as king of Aragon. He and his wife, Isabella of Castile, share power. The union of Aragon and Castile creates a single political unit – Spain.

*c.*1474–78 *c.*1475–76 1478 1479

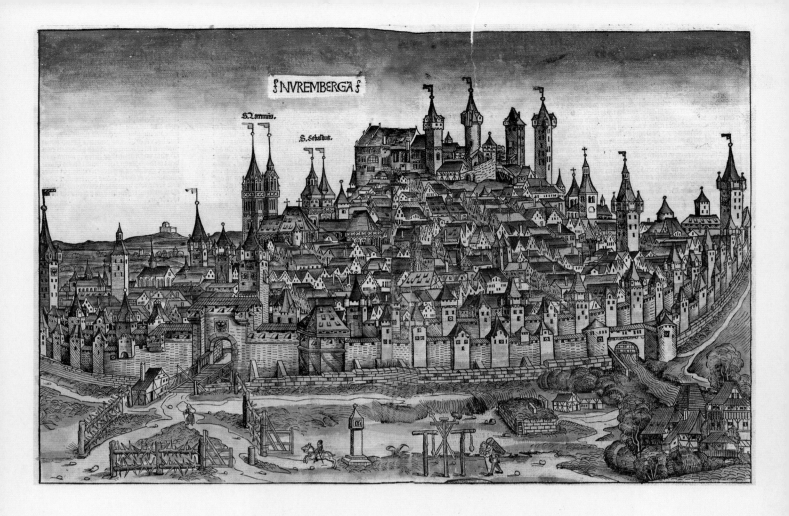

THE GROWTH OF PRINTING

The printed book was one of the most significant inventions in the history of civilization, revolutionizing the spread of ideas. Initially Germany and Italy were the main centres of printing in Europe, but the technology was soon taken up in other countries. The art of illustrating books with woodcuts also developed quickly.

Printing as we now understand the term – using movable metal type that could be cast in large quantities – was invented in Germany around the middle of the 15th century. The key figure was Johannes Gutenberg, a metalworker who began making experiments with printing in the 1430s in Strasbourg. By 1448 he had established a workshop in his native city of Mainz, and by 1455 he had completed a magnificent Bible (now usually called the *Gutenberg Bible*), the first substantial printed book produced in Europe (he may have issued a few, slighter publications earlier on). His invention quickly spread and by the 1480s there were printing presses in most European countries (the first in England was established by William Caxton in 1476). By 1500 it is estimated that about a thousand presses were in operation.

ABOVE LEFT. View of Nuremberg from Hartmann Schedel's *Weltchronik* (1493) The woodcut has been coloured by hand, as many book illustrations were at the time.

ABOVE CENTRE. Illustration to Sebastian Brant's *Das Narrenschiff* (The Ship of Fools) (1494)
This comes from the original edition (published in Basle) of a popular satirical work that was much reprinted and translated into several languages, including English (1509).

ABOVE RIGHT. Albrecht Dürer – *Adam and Eve* (1504)
Dürer's print shows the fine detail and rich effects of texture that could be created in engraving – qualities that led it to succeed woodcut as the main technique for book illustrations.

Copies of the *Gutenberg Bible* and many other early printed books were often decorated by hand to make them resemble illuminated manuscripts, but printed illustrations also came into use. Individual woodcut prints were being produced in Europe by the end of the 14th century, and the first record of such prints illustrating a book dates from 1461. Many books had just one illustration, on the title page, and they were often of mediocre quality. However, a major turning point in the history of book illustration came in 1493 with the publication of Hartmann Schedel's *Weltchronik* (World Chronicle), sometimes known in English – from its place of publication – as the *Nuremberg Chronicle*. This was unprecedented in its use of more than 600 illustrations. It was the first printed book in which the illustrations do not merely embellish the text, but actually determine the character of the publication.

The woodcut illustrations in the *Chronicle* were produced in the workshop of Michael Wolgemut, who taught Albrecht Dürer, and the book was published by Anton Koberger, Dürer's godfather. Dürer himself produced numerous woodcut book illustrations, but he also made copper engravings, which eventually superseded woodcuts for most illustrative purposes. Woodcuts were in some ways better suited to illustrations than engravings: they were cheaper and could be printed on the same press as was used for the typography. Engravings required a heavier press, and therefore had to be printed separately from the text, but they had the great advantage of producing more detailed and subtle images, and this proved the decisive factor. By the end of the 16th century engraving had become so dominant that woodcut was generally used only for low-grade and ephemeral jobs such as playbills, rather than for serious illustrations. IC

1480–1500

Italian culture. Arising mainly from the rediscovery of Classical texts and artefacts, culture across much of Italy follows the ideals of antiquity and promotes the study of the liberal arts, especially literature and fine art, while huge innovations are also made in the fields of mathematics, medicine, engineering and architecture. Largely through the funding of the powerful Medici family, Florence rises above all other European cities as the centre of art, humanism, technology and science. Significant artistic developments occur in certain other Italian city-states, including Siena, Padua, Mantua and Urbino, which also have powerful rulers. SH

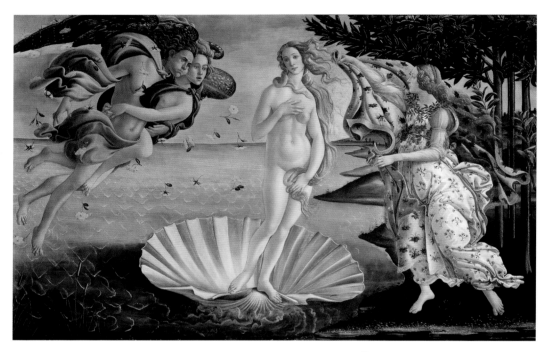

Sandro Botticelli – *The Birth of Venus*

Botticelli painted this interpretation of the Birth of Venus from Ovid's *Metamorphoses*, combining classical and Christian subject matter. Venus, the Roman goddess of love and beauty, emerges from the sea on a shell and sails to the shore of the island of Cythera. With her tilted head and classical contrapposto stance, her pose was modelled on an ancient Greek statue of Aphrodite (see *The Capitoline Venus*, p. 35). Commissioned by the Medici, probably to celebrate a marriage, this is the first full-length nude since antiquity and the first example in Tuscany of a painting on canvas. Unusually, Botticelli used alabaster powder to give the skin an ethereal glow.

The Tribunal del Santo Oficio de la Inquisición, or the Spanish Inquisition, set up to maintain Catholic orthodoxy, becomes particularly active after having been established for two years.

Edward IV of England dies and his brother Richard, Duke of Gloucester, keeps Edward's two young sons Edward and Richard in the Tower of London, where they are probably murdered.

England's Richard III, the last Plantagenet king, is killed in the Battle of Bosworth and replaced by the Tudor Dynasty – ending the Wars of the Roses.

In Toledo in Spain, approximately 750 lapsed Christians are made to walk through the streets and be reconciled to the Christian faith. Jews are forced to renounce their faith, fined and forbidden to dress respectably or hold office.

| 1480 | 1483 | c.1485 | 1485 | 1486 |

Geertgen tot Sint Jans – *The Glorification of the Virgin*

This painting was originally part of a diptych. It illustrates a story in the Book of Revelation, 'The Woman and the Dragon', which describes a vision: 'And there appeared a great wonder in heaven; a woman clothed with the sun, and the moon under her feet, and upon her head, a crown of twelve stars.' This is Mary holding Jesus and surrounded by circles of angels. In the inner circle are cherubs and seraphs (six-winged angels); in the second, angels carry instruments from the Passion: a nail, a cross, a spear, a pillar. In the third circle, the angels play musical instruments. Even the infant Jesus plays bells.

Tapestry – *Unicorn in Captivity*

Elaborate tapestries were common during the late medieval period and the Renaissance. Richly hand-stitched in fine wool and silk, with gilded threads, this depicts the elusive, magical unicorn that in medieval times was seen as a symbol of Christ. It was probably created in Flanders, as by 1500 Flemish tapestries were the most sophisticated being made, and they became status symbols as well as investments. Flowers and fruit have been used for their symbolism: lilies for faithfulness, carnations for marriage, and wild orchids, thistles and ripe pomegranates for fertility. The unicorn is tethered to a tree and encircled by a fence, but could escape if it wanted to. It is probable that the work was made to celebrate a marriage.

Ferdinand and Isabella expel all Jews from Spain, except those willing to convert to Christianity. Approximately half of the population of 80,000 convert.

Christopher Columbus encounters the Americas and lands on San Salvador Island in the Bahamas.

*c.*1490 1492 *c.*1495–1505

1500–1520

The *cinquecento*. The art and culture of 16th-century Italy are known as the *cinquecento*, and the early years are particularly productive, nurturing numerous artists who surpass their forbears in technique and harmony of design. Oil paint has become the medium of choice, and printed imagery and literature encourage a rapid exchange of ideas. Interest in the natural world increases and landscapes are often used as backgrounds for religious paintings, while the notions of humanism spread. Florence remains culturally important, but other city-states, led by powerful rulers, gain wealth and prestige, underpinned by artistic patronage. In Rome, several popes become fervent patrons of the arts, and the city becomes the hub of the High Renaissance. **SH**

Antwerp Cathedral is completed after 148 years.

Pope Alexander VI calls for a crusade against the Turks.

Azerbaijan becomes the power base of the Safavid Dynasty.

Raphael – *Madonna in the Meadow*

After spending his formative years surrounded by the court life of Urbino, Raphael moved to Florence, where he studied the art of Michelangelo and Leonardo, and later became the most respected artist in Rome. His art epitomized the ideals of the High Renaissance. Commissioned by the cloth merchant Taddeo Taddei and set against a Tuscan landscape, this tranquil and tender moment shows the Virgin Mary holding her little boy as he leans towards his cousin, St John the Baptist. In a premonition of his crucifixion, Jesus clutches St John's cross. The blue of Mary's mantle symbolizes the Church, and the red of her dress signifies Christ's death. Raphael's clarity of form, pyramidal composition, subtle chiaroscuro and aerial perspective are interpretations of the ideas of Leonardo and Michelangelo, while the graceful curved lines and light palette were inspired by Perugino.

Peter Henlein of Nuremberg constructs a portable timepiece, probably the first ever watch.

Spanish armies invade North Africa in a crusade against the Muslim rulers of Tripoli, Oran and Bougie.

Vasco da Gama establishes a Portuguese colony at Cochin in China.

| 1500 | 1502 | 1505–06 | 1509 |

Albrecht Dürer – *Melencolia I*

This is one of three large prints by Dürer known as his *Meisterstiche*, or master engravings. During the Renaissance it was believed that creative genius was coupled with a melancholy spirit so this is often described as an allegorical self-portrait. Melancholy sits with her head on her hand, surrounded by tools associated with carpentry. A ladder leans against a building that supports a balance, an hourglass and a bell. A putto sits on a millstone writing on a tablet and an emaciated dog sleeps between a sphere and a polyhedron. In the background, a blazing star or comet illuminates an ocean under a rainbow. The figure is referred to as 'she' but seems androgynous, and the wings are a metaphor; she aspires to fly, yet is too heavy for the wings to lift.

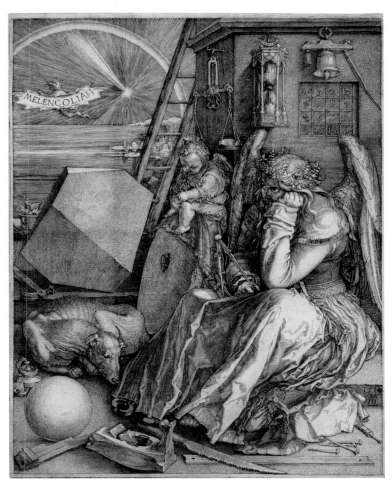

Vittore Carpaccio – *Young Knight in a Landscape*

Although the knight remains unidentified it has been assumed that this is a posthumous portrait, and one of the earliest full-length portraits in European painting. Originally thought to be St Eustace, a knight who saw a stag with antlers in the form of a crucifix, the figure is now believed to be Francesco Maria della Rovere, Duke of Urbino. Looking out of the painting with a troubled expression, he is about to draw his sword: a knight ready for heroic action.

Portuguese sailors reach the islands of Mauritius, Réunion and Rodrigues, where they discover the dodo and kill many for sport. Malacca (Melaka), the centre of the East Indian spice trade, is captured by the Portuguese, but soon taken over by the Dutch.

Giovanni di Lorenzo de' Medici becomes Pope Leo X.

Spanish explorer Juan Ponce de León finds a land he names Pascua Florida, or 'feast of the flowers'.

| 1510 | 1511 | 1513 | 1514 |

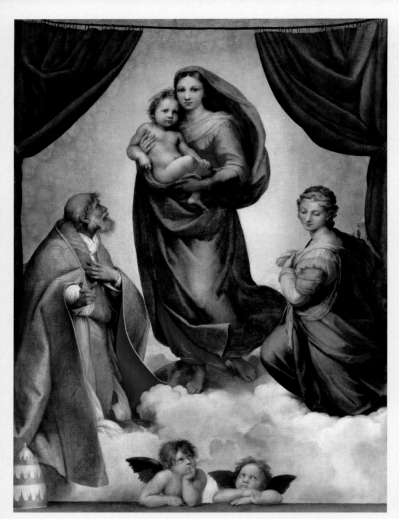

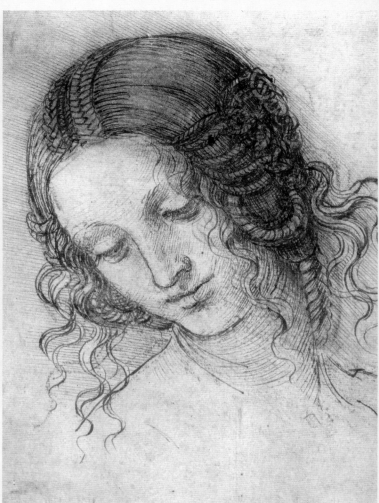

THE HIGH RENAISSANCE

Roughly spanning the period from 1500 to 1520, the High Renaissance is generally perceived as the pinnacle of Renaissance art, when it became especially ambitious in scale and complexity.

During this period momentous discoveries and political and religious conflicts shook accepted beliefs about the world. In 1492 Christopher Columbus reached the Americas, and in 1522 Ferdinand Magellan circumnavigated the world. In 1494 Charles VIII of France invaded Italy, and this evolved into a series of conflicts known as the Italian Wars that lasted until 1559, involving several European countries and the Ottoman Empire. In 1512 Nicolaus Copernicus claimed that the Sun, rather than the Earth, was at the centre of the universe. Meanwhile, across Europe political and religious tension was escalating. In 1517 the whole of Europe was plunged into religious turmoil when a German priest, Martin Luther, printed his Ninety-Five Theses, rejecting certain teachings and practices of the Roman Catholic Church. This triggered the Reformation, which led to widespread and prolonged discord, and ended in 1527 with the Sack of Rome.

The term High Renaissance was originally used by Giorgio Vasari in 1550, and he described the artists' attainment as 'absolute perfection'. High Renaissance artists blended realism with the emulation of the Classical art of ancient Greece and Rome, above all aiming to attain beauty and harmony of form and colour. The term is often criticized by art historians for oversimplifying the artistic developments and historical context, but it is traditionally accepted as a period of creative genius that occurred particularly in Italy. While the Early Renaissance had taken place mainly in Florence and was largely paid for by the Medici family, the High Renaissance was mostly funded by popes in Rome. In 1505 Pope Julius II began rebuilding St Peter's Basilica and set a precedent for papal patronage. He employed Donato Bramante as his architect and commissioned Michelangelo and Raphael to paint frescoes in the Vatican. Along with Leonardo da Vinci, these were the most celebrated artists of the High Renaissance, who epitomized the ideals of humanism, innovation and technical prowess.

Meanwhile, Venice had grown rich on maritime trade and also developed into a great centre of art. Principally through the work of Giovanni Bellini, the Venetian Renaissance became known for its intense colour and light, extended notably by Bellini's pupils, including Giorgione, Sebastiano del Piombo and Titian. The Venetian emphasis on colour contrasted directly with the earlier Florentine focus on line. By the 1520s several artists began exaggerating aspects of High Renaissance painting in a style later known as Mannerism. SH

FAR LEFT. Raphael – *Sistine Madonna* **(1512)**
Framed by heavy curtains, and standing on a bed of clouds, this was one of Raphael's last paintings of the Madonna before his death. Commissioned by Pope Julius II as a decoration for his own sepulchre, it was instead installed on the high altar of the Benedictine abbey church of San Sisto in Piacenza.

LEFT. Leonardo da Vinci – *The Head of Leda* **(1503–7)**
This three-quarter view of a young woman is a study by Leonardo for his painting (now lost) of Leda and the Swan. The story, from Greek mythology, describes how Zeus, king of the gods, turns himself into a swan and seduces Leda, daughter of the Aetolian king Thestius.

RIGHT. Michelangelo – *Doni Tondo* **(1504–6)**
The *tondo* (roundel) was a popular picture shape for private patrons, and images such as the Holy Family were often chosen to hang on the wall above the marriage bed. The painting was commissioned by a wealthy banker, Agnolo Doni, probably at the time of his marriage to Maddalena, of the important Strozzi family.

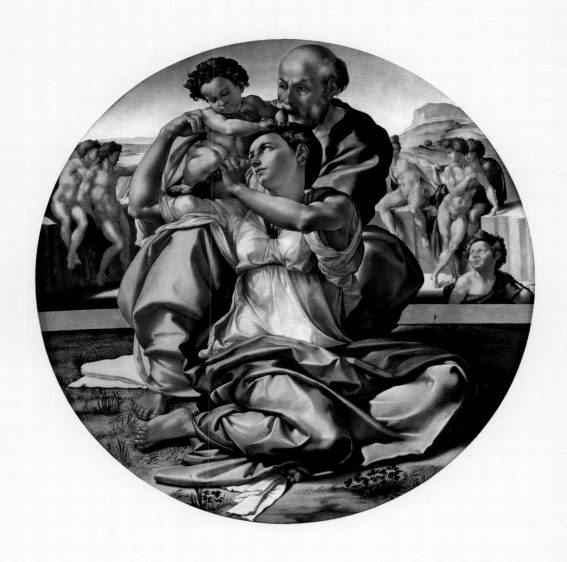

1520–1540

The Reformation. By the mid-16th century the Protestant Reformation, a religious, intellectual, political and cultural movement, engages much of Europe. It calls into question the Catholic Church's right to define Christian practice, and challenges the authority of the pope. This has a profound effect on Catholic imagery in art, as portrayals of Jesus, Mary and the saints are disapproved of – sculptures and large-scale paintings deemed idolatrous are damaged or receive a hostile reception. In Protestant countries, secular forms of art take their place, and artists diversify into types such as landscape, still-life, portrait and historical painting. AH

Lucas Cranach – *Martin Luther and Katharina von Bora*

Katharina von Bora was the wife of the reformer Martin Luther, and little is known about her, except that she was a nun before she was married. She is thought to have played a key role in the Reformation owing to her commitment to clergy marriages and Protestant family life. This diptych in oil demonstrates Cranach's Northern Renaissance style, with its clarity of detail and realism. It is the first of his works signed with the serpent device (on the far left).

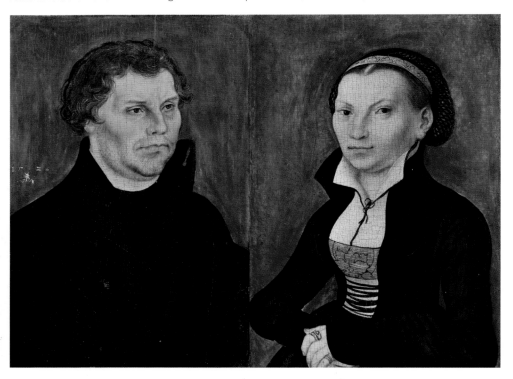

Suleiman the Magnificent becomes Sultan of the Ottoman Empire. Over the course of his forty-six-year reign, he greatly expands his empire and oversees important developments in the fields of law, literature, art and architecture.

The Peasants' War, a popular revolt, arises in Switzerland, Germany and Austria, with class structures in flux and the burghers' power on the increase.

| 1520 | 1524–25 | 1526 |

Hans Holbein the Younger – *The Ambassadors*

This vibrant picture depicts two learned young men: on the left is Jean de Dinteville, French ambassador to England; to the right is Georges de Selve, Bishop of Lavaur, who acted as ambassador to the Holy Roman Emperor. They pose next to symbols of learning and culture, but the anamorphic skull (bottom centre), which appears normal when viewed from the side, shows that this is a *vanitas* (a picture illustrating the transience of worldly achievements). A tiny crucifix (top left), barely visible behind the curtain, shows the true path.

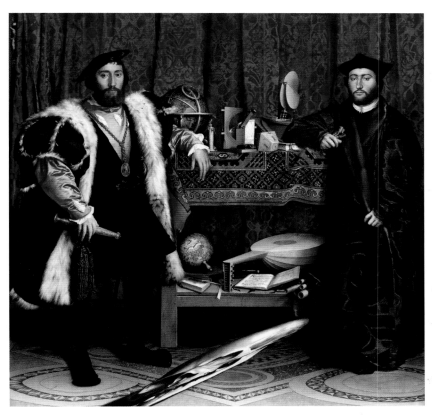

Master of Messkirch – *Wildenstein Altarpiece*

Although it was believed that the Master of Messkirch was an anonymous German Renaissance painter who studied in a circle close to Albrecht Dürer, this famous altarpiece, one of eleven, is now thought to have been executed by Peter Strüb, a master of the Late German Renaissance. He was commissioned by the von Zimmerns, a Catholic family of Messkirch, a Protestant region, to portray the family. The design used lavishly decorated pillars to frame its painted panels.

The Inca Emperor Atahualpa is executed by the Spanish conquistadors and the Inca Empire falls apart.

The Sack of Rome by the armies of the Holy Roman Emperor Charles V marks the beginning of the end of the Italian Renaissance.

Henry VIII passes the Act of Supremacy, declaring himself the head of the Church of England and breaking with the papacy of Rome.

1527 **1533** **1534** **1536**

1540-1560

The Rise of Mannerism. Even though the High Renaissance has now passed it peak, artists in Italy continue to be revered as masters of their practice. The artistic centres of Florence and Rome continue to flourish, while in Venice, painters such as Bellini, Titian and Giorgione are developing a distinct school based on their innovations with colour. Later Renaissance art gives way to the Mannerists, whose attention to the artifice of painting marks a break from the visual harmony of the High Renaissance. Elsewhere in Europe the economy is booming, with the Netherlands becoming one of the most commercially prosperous countries on the Continent. With its international appeal and prosperity, Antwerp becomes a hub for artists and patrons alike, and the work being produced in this trade city reflects its growing and diversified economy. ED

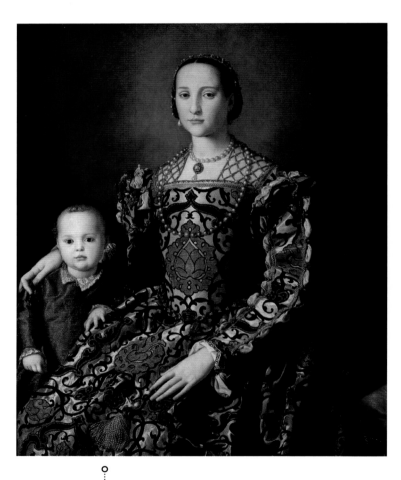

Bronzino – *Portrait of Eleonora of Toledo*

Bronzino was court painter to the wealthy and influential Cosimo I de' Medici, Duke of Florence. One of the many portraits he completed of the powerful Florentine family, here he painted the Duke's wife, Duchess Eleonora of Toledo, with her young son Giovanni de' Medici. Her nonchalance and cool demeanour were typical of Mannerist portraiture. A master of texture and light, Bronzino accentuated the wealth of the Medici family through the Duchess's richly textured dress and glistening jewelry – as well as the continued power of the family line as represented by her young son.

The Council of Trent is held between 1545 and 1563 in Italy, an important event that gives shape to the Counter-Reformation. It is prompted by the establishment of Protestantism as a religion distinct from Catholicism, sparking years of civil war between the two Christian sects.

Giorgio Vasari publishes his historic *Lives of the Most Eminent Painters, Sculptors and Architects*.

1544-45 **1545** **1550**

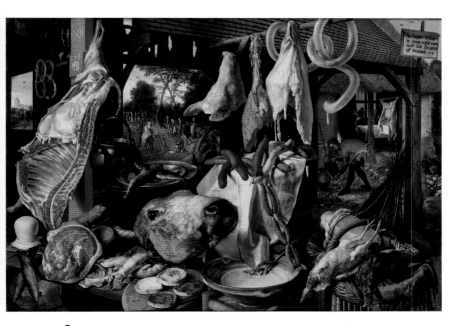

Pieter Aertsen – *A Meat Stall with the Holy Family Giving Alms*

Mannerist painters took delight in novelty, often portraying familiar subjects from unconventional viewpoints. The Dutch painter Pieter Aertsen was a still-life and genre specialist, but his pictures often contain religious scenes, half-hidden in the background. Aertsen painted four near-identical versions of this bizarre market scene depicting the interior of a butcher's stall. Heavy with symbolism, the painting's central moral message is conveyed through the pointed contrast between the almost obscene profusion of food in the foreground and the Virgin offering bread to a beggar in the distance.

Titian – *Diana and Actaeon*

Titian took inspiration from Ovid's *Metamorphoses* for this impressive canvas. Commissioned by King Philip II of Spain, the work is the fifth of six large-scale mythological paintings. It depicts the young hunter Actaeon intruding on the bathing Diana, goddess of the hunt, who struggles to cover herself. Together with the sixth work depicting Diana and Callisto, the paintings were conceived of as a pair, and took Titian over three years to complete. Despite moving between royal collections in Madrid, France and England, the two canvases have always stayed together.

Charles V abdicates as king of Spain in favour of his son, Philip. One of the most powerful monarchs in history, he controlled the Habsburg possessions in Europe as Holy Roman Emperor, as well as ruling over the growing Spanish empire in the New World. After divesting himself of office, he retires to his home at the monastery of Yuste in Spain.

Cosimo I de' Medici commissions Giorgio Vasari to begin building work on the Uffizi complex, where important works from the family's art collection continue to be exhibited.

| 1551 | 1556 | 1556–59 | 1560 |

ABOVE. Carolus-Duran – *Mademoiselle Croizette on Horseback* **(1873)**
Sophie Croizette, an actress, was Carolus-Duran's sister-in-law. The picture was painted at Trouville in Normandy, a seaside resort popular with artists.

ABOVE RIGHT. Sir Anthony van Dyck – *Charles I with Monsieur de St Antoine* **(detail; 1633)**
St Antoine was Charles's riding master. The painting was probably hung to give the appearance of Charles riding into the room.

FAR RIGHT. Jacques-Louis David – *Napoleon Crossing the Alps* **(1801)**
This stirring equestrian painting was so admired that David and his studio produced four replicas of the work.

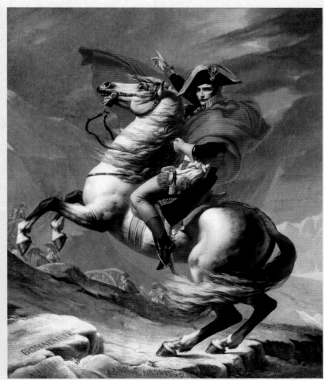

EQUESTRIAN PORTRAITS

From the Renaissance onwards equestrian portraits helped to define the idea of royal dignity and power. The artists who painted such works often flattered their subjects, and some of the greatest examples show wonderful imagination in transforming prosaic reality into breathtaking visual drama and poetry.

Equestrian statues were made in ancient Greece and Rome, and one major example still survives – the famous over-life-size bronze of the Emperor Marcus Aurelius (r. AD 161–80). The form was revived in the Renaissance, notably in two of the greatest masterpieces of 15th-century sculpture, Donatello's Gattamelata monument in Padua (1443–53) and Verrocchio's Colleoni monument in Venice (1481–96). Two major 15th-century Italian painters produced imposing fresco memorials imitating equestrian sculptures, both of them in Florence Cathedral – Paolo Uccello's *Sir John Hawkwood* (1436) and Andrea del Castagno's *Niccolò da Tolentino* (1455–6). However, the tradition of the painted equestrian portrait really begins a century later with Titian's *Emperor Charles V on Horseback* (1548), commemorating his victory at the Battle of Mühlberg the previous year.

In Titian's painting Charles exudes calm authority, and it is easy to understand why later rulers and generals wanted to have themselves portrayed in a similar manner. In reality, Charles – who suffered badly from gout – was carried to the battle on a litter, and many other painters of equestrian portraits similarly altered the facts to create a suitably heroic image. Charles I's

court painter, Anthony van Dyck, was a master of flattery. Charles was dignified in manner but short in stature, and van Dyck cleverly disguised his lack of height by depicting him from a low viewpoint, with the viewer seeming to look up at him. Even more pointedly, Jacques-Louis David's *Napoleon Crossing the Alps* is a brilliant exercise in propaganda rather than an accurate depiction of a historical event. When he invaded Italy in 1800, Napoleon actually crossed the Alps on a mule, led by a guide, but he said he wanted to be shown 'calm, mounted on a fiery steed', and David followed his directive superbly.

By the time David painted this masterpiece, the equestrian portrait was no longer confined to images of royalty, aristocracy and military leaders. Rembrandt painted such a portrait of a wealthy Amsterdam merchant in 1663, and although this was unusual for the time, during the 18th century it became fairly common for gentlemen to be depicted on horseback. Generally, however, these paintings were much smaller than the majestic life-size images of Titian, van Dyck or David. During the 19th century the broadening of scope continued, with portraits such as Carolus-Duran's *Mademoiselle Croizette* being more about glamour than power. **IC**

1560-1580

A time of change. Europe in the 16th century is undergoing many changes: public religious imagery is outlawed, and the middle class is growing apace. There is fast advancement in learning, and an emphasis on knowledge acquired by observation and experimentation. Painters have to change to reflect the times and become more inventive, turning to portrait or genre painting depicting ordinary people and everyday life, or adapting biblical stories and substituting uncontroversial figures for saints. Artists begin to take more interest in achieving accurate anatomy in their paintings and develop new, realistic techniques for subjects. AH

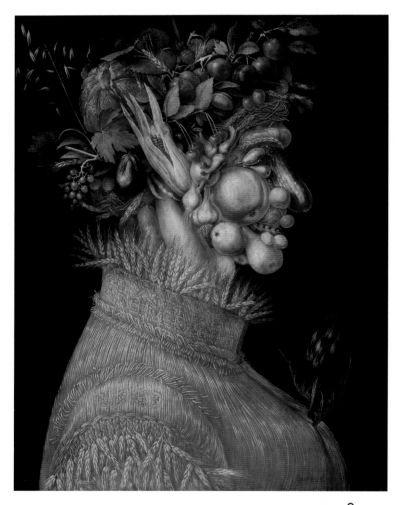

Giuseppe Arcimboldo – *Summer*

As part of the innovative series that depicted the four seasons, *Summer* was painted for Emperor Maximilian. It is a head made up of fruits and vegetables: the cheeks are rosy peaches, the mouth is a pear, and an opened pea pod forms the teeth – all symbolizing summer. Despite the unusual construction, it is a smiling face and represents happiness. Arcimboldo's unusual subject-matter later attracted the interest of the Surrealists.

Philip II of Spain establishes his permanent court at Madrid, in the centre of the Iberian Peninsula. Previously, the court moved to wherever the monarch happened to be.

1561 **1563**

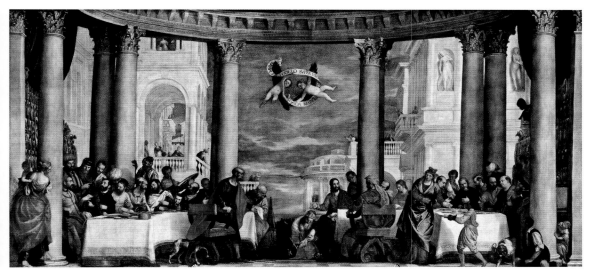

Paolo Veronese – *The Feast in the House of Simon the Pharisee*
Created for the monastery of St Sebastian, this magnificent painting depicts a supper at which Christ was present. Veronese often took stories from the Gospels and created scenes of opulence and luxury with elaborate, theatrical perspectives, with the guests dressed in rich and elegant clothing.

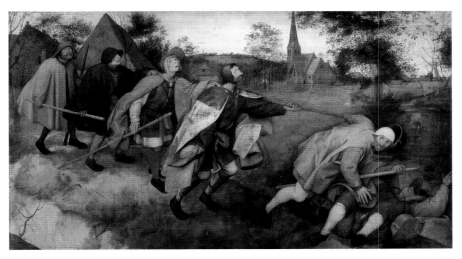

Pieter Bruegel the Elder – *The Blind Leading the Blind*
This monumental work was painted towards the end of Bruegel's life. It reflects his despair at the religious conflict that was tearing his homeland apart. He blamed both Catholics (symbolized by the man with the rosary) and Protestants (symbolized by the lute, a punning reference to Lutheranism). The extremists from both sides were leading the country away from the Church (top) and into a ditch.

The St Bartholomew's Day Massacre – a wave of violence against French Huguenots (Protestants) – occurs in Paris on 24/25 August. Plotted by Catherine de' Medici and carried out by Roman Catholic nobles and other citizens, it takes the lives of the Protestant leader Gaspard de Coligny and 3,000 Huguenots. The violence spreads to other cities, resulting in up to 30,000 further deaths and plunging France into civil war.

The victory of Dutch rebels over the Spanish army at Heiligerlee marks the start of the Eighty Years' War, the long struggle for Dutch independence that would end in 1648 when the Spanish formally recognized the Dutch Republic.

Oda Nobunaga, the lord of Owari, seizes control of the imperial capital at Kyoto and begins the unification of Japan.

The English explorer Francis Drake embarks on a three-year voyage around the world aboard his small flagship, the *Golden Hind*.

1568 **1570** **1572** **1577**

1580–1600

The Late Renaissance. Hovering on the threshold of the modern era in art, science, philosophy and politics, the Late Renaissance occurs against a background of growing prosperity and political stability. The printing press improves communication and makes it available for all; a new system of astronomy is developed; and new continents are explored. Literature, philosophy and particularly art are also flourishing, and there is massive interest in the beauty of the natural world. With new knowledge of scientific classification, specimens of exotic fruits and flowers are celebrated in paintings. Natural objects are now beginning to be appreciated as worthy of study, and there is a move to break away from the spiritual and mythological connotations of the subjects depicted. Artists in Europe begin to produce illustrations of nature and still-life paintings in their thousands. AH

Vincenzo Campi – *The Fruit Seller*

Campi is best known for being one of the first northern Italian artists to work in the Flemish style of realist genre painting. *The Fruit Seller* depicts a woman selling an abundance of fruit presented in baskets, with the occasional vegetable. Naturalistic paintings of domestic scenes were popular for economic reasons; the production and preparation of food were central to daily life.

Spain takes control of Portugal, following a decisive victory at the Battle of Alcantara in August.

The Gregorian calendar is adopted in Catholic Europe (Italy, Spain, Portugal and Poland), a change instituted by Pope Gregory XIII in order to correct the date of Easter.

1580 *c.***1580** **1582**

John White – *Roanoke Indians*

John White was an artist attached to the first colonists sent to Roanoke Island in the New World in 1587. He produced many portraits of the local Indians, providing a unique visual record of their lives and the clothes they wore. His watercolours and maps are the most instructive illustrations of a Native American group in North America, predating artists who sailed with Captain Cook in the 18th century.

Marcus Gheeraerts the Younger – *Captain Thomas Lee*

Probably commissioned by his cousin Sir Henry Lee, Queen Elizabeth I's champion, this portrait shows the captain in the regalia of an Irish footsoldier, bare-legged to allow him to walk comfortably through bogs. Later in his career, Lee became involved in the Essex rebellion. He was tried for treason and executed at Tyburn.

Philip II of Spain launches the Spanish Armada in an attempt to challenge the Protestant rule of Elizabeth I of England, but is defeated.

Henry IV of France issues the Edict of Nantes, granting religious liberties to the Huguenots and ending the French Wars of Religion.

The Globe Theatre opens in London and becomes the city's biggest and most sensational playhouse. It hosts the first performances of many of William Shakespeare's plays, including *Hamlet*, *Othello* and *King Lear*.

| 1585–93 | 1588 | 1594 | 1598 | 1599 |

The Art of Limning

In about 1600 Nicholas Hilliard wrote a treatise on miniature painting, *The Art of Limning*, in which he reveals much about his social and aesthetic outlook as well as his working methods. He thought that his art was suitable to be practised only by gentlemen, and he stressed the importance of a calm and clean working environment, advising the artist to wear silk clothes, 'such as sheddeth least dust or hairs', and even to take care that no dandruff fell on the delicate picture. He usually painted on very fine vellum (calfskin), stuck to a piece of card. Some later miniaturists preferred ivory.

PORTRAIT MINIATURES

Emerging as a distinctive art form in the early 16th century, the portrait miniature flourished in Elizabethan and Jacobean England. In particular, the work of Nicholas Hilliard has never been surpassed for delicacy of technique.

FAR LEFT. Isaac Oliver – *A Young Man Seated Under a Tree* **(c. 1595)**
Oliver was French by birth, but he was brought to England as a child and was apprenticed to Nicholas Hilliard, becoming his most distinguished pupil and, after the turn of the century, his most serious rival.

ABOVE LEFT. Nicholas Hilliard – *Young Man Among Roses* **(c. 1588)**
This work is acknowledged as Hilliard's masterpiece – an image of a melancholic youth that brings to mind the sonnets and lute songs about the pains of love that were so characteristic of the Elizabethan age.

LEFT. Lucas Horenbout **–** *Henry Fitzroy, Duke of Richmond and Somerset* **(c. 1534)**
Horenbout was a respected member of Henry VIII's court. The sitter in this miniature was Henry's son with Elizabeth Blount – the only illegitimate child the king acknowledged.

In art-historical contexts the word 'miniature' is applied to two different types of picture: illustrations in illuminated manuscripts, and very small portraits. The term does not derive from the tiny ('minute') size of such images, but from the Latin word *minium*, describing a paint (also called red lead) that was often used in manuscripts. Small portraits were sometimes included in manuscripts, and the idea of creating such an image as an independent work seems to have caught on during the 1520s (probably influenced by the portrait medals that had become popular from the mid-15th century).

The first certain reference to portrait miniatures dates from 1526, when Marguerite d'Alençon, sister of Francis I of France, sent a gift of two lockets to Henry VIII of England; they opened up to reveal portraits – one of King Francis, the other of his two sons. Unfortunately the lockets have not survived, but the earliest-known miniatures date from about the same time. The first notable specialist in the field was Lucas Horenbout. He was Flemish by birth but spent the last two decades of his life in England, working at Henry VIII's court.

Horenbout is said to have taught miniature painting to the German-born Hans Holbein, far and away the greatest artist to work for Henry.

He completely outclassed Horenbout, creating images that have extraordinary strength and dignity considering their tiny size. His work was an inspiration to the most famous of all miniaturists, Nicholas Hilliard, who was largely responsible for making miniature portraiture a speciality that was particularly associated with English artists. His sitters included several of his most famous contemporaries, notably Elizabeth I, Sir Francis Drake and Sir Walter Raleigh.

Most miniature portraits are round or oval in shape, head-and-shoulders or bust-length in format, and not much bigger than a large coin. However, miniaturists sometimes used rectangular shapes and occasionally slightly larger sizes suitable for full-length figures such as Hilliard's *Young Man Among Roses*. Miniatures were sometimes kept in little boxes or cabinets, but often they were meant to be worn as jewelry – around the neck, for example, attached to a gown or even in the hair. Such intimate works made ideal love tokens. Few later exponents could approach Hilliard's visual poetry, but miniatures continued to be popular in Europe (and also America) until small photographic portraits generally superseded them in the mid-19th century. IC

1600–1620

The decline of Spain. At the beginning of the 17th century Spain still rules large areas of Italy and northern Europe (as well as vast territories in the American colonies), but its mighty empire is starting to crumble, as finances weaken, resources are overstretched and subject states fight for their freedom. In spite of this political decline, Spain begins to enjoy a golden age in culture, but Italy remains the dominant nation artistically. In particular, Rome is unchallenged as the artistic capital of Europe. Painters and sculptors flock there from far and wide to see the wonders of ancient and Renaissance art, and to seek work decorating the many churches and palaces that are being created or improved during a building boom. IC

Caravaggio – *The Sacrifice of Isaac*

In the first two decades of the 17th century, Caravaggio was the most influential painter in Europe, with his powerful style – combining earthy realism with dramatic contrasts of light and shade – inspiring many followers, known as the Caravaggisti. He worked mainly in Rome, and imitators of various nationalities carried his innovations to their own countries. This characteristically intense biblical scene was probably painted for Cardinal Maffeo Barberini, who later became Pope Urban VIII.

Giordano Bruno, a philosopher and astronomer whose views anticipate modern science, is burnt at the stake as a heretic in Rome.

The Gunpowder Plot, an attempt to blow up the House of Lords in London as a prelude to a Catholic uprising, is foiled.

The Dutch Republic's freedom from Spain is marked by the beginning of a twelve-year truce, although Spain does not officially acknowledge independence until 1648.

| 1600 | c. 1603 | 1605 | 1609 |

El Greco – *Laocoön*

The greatest Spanish painter of his time, El Greco worked mainly on religious subjects, which dominated the country's art. However, he was also a superb portraitist and occasionally ventured into other fields. This is his only known painting based on Classical mythology. The subject became familiar in art after a magnificent ancient sculpture depicting it was unearthed in Rome in 1506 (see p. 29). El Greco would have seen the sculpture when he lived in Rome from about 1570 to 1576, before settling in Spain.

Artemisia Gentileschi – *Judith Slaying Holofernes*

It was difficult for a woman to pursue an independent career as an artist in the 17th century, but Artemisia Gentileschi had formidable strength of character in addition to great talent, and she worked successfully in Rome (where she was born), Florence, Venice, Naples (where she died) – and, for a few years, England. She often painted subjects showing strong women in central roles, as in this powerful scene (influenced by Caravaggio) of the biblical heroine Judith killing an enemy general.

Henry IV of France is assassinated. He restored stability to France after a period of civil war and had begun transforming Paris into a handsome modern city.

A revised English text of the Bible is published, known as the Authorized Version or King James Bible (as it was done at the order of James I). It is regarded as a landmark in English literature.

The Thirty Years' War begins in Bohemia. This series of conflicts eventually involves most of the major European powers, in a complex pattern of shifting aims and alliances.

c.1610　1610　1611　c.1615　1618

1620-1640

The Dutch Republic flourishes. After gaining hard-won independence from Spain, the Dutch Republic (today known as the Netherlands) develops in only a few decades into one of Europe's major powers, with a superb navy and a strong economy based on worldwide trade. In cultural matters, the nation's flowering is equally remarkable, as it transforms from an artistic backwater into a country where painting flourishes with unrivalled vigour and variety. Several towns develop their own distinctive traditions in painting, and the capital Amsterdam becomes one of the chief centres of the international art market. In other countries, the Church and the aristocracy continue to be leading patrons, but in the Dutch Republic their place is taken by the prosperous middle classes, who generally favour fairly modest subjects that express pride in their country and their own achievements. IC

Frans Hals – *Singing Boy With Flute*

This painting exemplifies the feeling of movement and life typical of Hals's work. He ranks as the first great master of 17th-century Dutch art, and his early paintings have a buoyant optimism that captures the spirit of his newly independent country. Although Dutch paintings are generally concerned with everyday life, they often have underlying meanings, and this one – as well as being an enchanting portrait of a young musician – was perhaps originally part of a series illustrating the five senses, in this case hearing.

The Schildersbent (Band of Painters), a fraternal organization of expatriate Dutch and Flemish artists, is founded in Rome; it lasts until 1720.

Maffeo Barberini becomes pope as Urban VIII; he reigns until 1644 and is one of the outstanding art patrons of his time.

Cardinal Richelieu is appointed chief minister to Louis XIII. In this role he virtually becomes the ruler of France and is the chief architect of the country's growing political power.

*c.*1620 1623 1624 *c.*1625

Balthasar van der Ast – *Still Life of Flowers, Fruit, Shells and Insects*

Still-life painting became a significant speciality in Dutch painting. It often reflects the affluence of the nation and a desire to show the benefits of success. One of the most popular types of still-life showed a table, as here, laden with food and other objects that express prosperity. However, paintings such as this could also have a deeper meaning, reminding the viewer of the brevity of life, for the most succulent fruits and beautiful flowers will soon decay.

Sir Peter Paul Rubens – *The Judgement of Paris*

The leading artist of his time in northern Europe, Rubens had an international career but worked mainly in Antwerp in the Southern Netherlands (modern Belgium). The Southern Netherlands remained subject to Spain after its neighbour the Dutch Republic won its freedom, and Rubens worked in very different circumstances to those of most Dutch painters: his patrons included some of the most eminent men and women of his day, and his subjects were usually remote from everyday life, as in this splendid mythological painting.

Galileo Galilei is forced by the Inquisition in Rome to recant his 'heretical' belief that the Earth is not at the centre of the universe and revolves around the Sun.

c. 1629 1633 c. 1635

The Last Great Expression

The familiar title of Rembrandt's *The Night Watch* is misleading: the painting does not represent a night scene, but by the late 18th century dirty varnish made it appear so, and it was at this time that the name was given to the piece. *The Night Watch* was one of six civic guard groups painted (by six different artists) for the Amsterdam militia headquarters in the early 1640s. This commission represented the last great expression of the tradition, for in 1648 Spain formally acknowledged the Dutch Republic's independence, and the civic guards consequently lost much of their significance.

DUTCH MILITIA PORTRAITS

Group portraits were a distinctive feature of Dutch art during its golden age in the 17th century, as a means of expressing national, civic or institutional pride and duty. Among such portraits, those of militiamen – citizen soldiers – include celebrated works by illustrious masters.

The majority of the paintings produced in the 17th-century Dutch Republic were of modest size – suitable for display in middle-class houses rather than palaces or churches. However, there was one great exception to this trend, for large group portraits found favour in the Republic in a way that was unmatched elsewhere. Such paintings were commissioned by groups of citizens of various kinds, representing particular professions, for example, or charitable institutions, and typically they would be displayed in meeting places. These assignments were prized by Dutch artists, who otherwise had little opportunity to create imposing, multi-figure compositions.

The most distinctive type of Dutch group portrait depicts militiamen (sometimes called civic guards) – citizens who undertook military training so that they could be ready to defend their homeland. Such militiamen assumed a new importance after the Dutch rebelled against oppressive Spanish rule in 1568, effectively achieving independence in 1609. However, in paintings the guards are usually shown in celebratory rather than warlike mood, particularly at their annual banquets. As the country's prosperity increased and the danger of war receded, the groups of militiamen functioned more like social clubs than serious fighting units, and their banquets could be very lavish affairs.

The earliest militia portraits date from the 1520s. They are usually rather stiffly posed and mechanical, showing the participants arranged in rows, as in an old-fashioned school photograph, but by the early 17th century they had become livelier. In this respect, the most important artist was Frans Hals, who worked in Haarlem, which together with Amsterdam had the strongest tradition of such portraits. Between 1616 and 1639 Hals painted five large groups for Haarlem militia companies (to one of which he belonged himself), and in 1633 he was commissioned to paint one for an Amsterdam company. However, he left this picture unfinished after a dispute with his patrons and it was completed by another artist, Pieter Codde, in 1637. Rather than posing formally, Hals's figures interact with convincingly spontaneous gestures and expressions, and exude good humour.

The most famous depiction of Dutch militia groups is Rembrandt's *The Night Watch*, completed in 1642. Here Rembrandt showed even more originality than Hals, for he made a dramatic, sweeping composition, full of lively incidental detail, from an insignificant moment, as a group of militiamen prepare to march. **IC**

1640-1660

The rise of France. In 1648 the Treaty of Westphalia marks the end of the Thirty Years' War. France emerges from the war as the most powerful European country, and by this time it is also building a strong independent tradition in art, breaking free from Italian influence. Sweden also comes out of the war well. For a time it ranks among the major European states, and Queen Christina's court in Stockholm becomes a renowned centre of culture. The Dutch Republic continues to prosper, but Spain has significantly declined in status. The greatest loser of the war is Germany, which was the main scene of fighting and suffered widespread destruction. It takes decades for the country to recover, and it goes through a largely stagnant period in the arts. IC

Nicolas Poussin – *Landscape with the Ashes of Phocion*
Poussin spent almost all of his mature career in Rome, but he is regarded as the pre-eminent French painter of the 17th century and the most important figure in establishing the classical tradition in his country's art. This painting, depicting a sombre story from the history of ancient Greece, exemplifies the qualities of clarity, harmony and dignity for which he was renowned, and which made him a guiding light for future generations of French artists.

The Académie Royale de Peinture et de Sculpture is founded in Paris – the first official art academy outside Italy.

Portugal achieves independence after sixty years of Spanish rule; Spain's unwieldy empire continues to decline.

Cardinal Richelieu dies; his protégé Cardinal Mazarin succeeds him as chief minister of France and continues to guide the country to dominance.

Charles I of England is executed. Most of his superb art collection is sold by Oliver Cromwell's new republic, to the benefit of some of the leading princely collectors of Europe, including Philip IV of Spain.

1640 **1642** **1648** **1649**

Carel Fabritius – *A View of Delft*
Fabritius was Rembrandt's most brilliant pupil, but he died aged only thirty-two in the devastating explosion of Delft's gunpowder magazine in 1654, leaving a tiny body of work (about a dozen paintings). The exaggerated sense of perspective in this example suggests that it was originally used in a peep-show box – a kind of cabinet in which a painted interior was viewed through a small aperture so as to create a vivid sense of three dimensions.

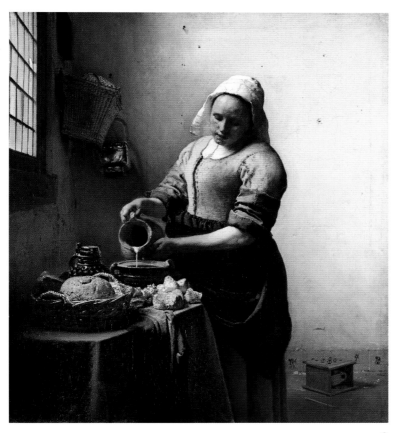

Johannes Vermeer – *The Milkmaid*
Vermeer's paintings express the peaceful prosperity of the Dutch Republic in images that make exquisite poetry from the everyday world. By the time of his death in 1675, however, the Republic's brief golden age was already coming to an end. A series of wars against England (1652–74) greatly damaged the country's economy, and in 1672 it was invaded by France, after which time much of the vigour and originality of Dutch art disappeared, as French influence increasingly prevailed.

The first of three wars breaks out between England and the Dutch Republic, the two greatest sea powers of the time. The wars, which end in 1674, are inconclusive but leave both sides exhausted.

A devastating outbreak of plague sweeps Naples, killing virtually a whole generation of artists in the city. Genoa also is badly hit.

| 1652 | 1656 | c. 1658 |

1660–1680

The Sun King. In 1661 Louis XIV, who became king aged four in 1643, assumes personal rule in France, which during his long reign to 1715 continues its aggressive expansionist policies. He is not a connoisseur of art, but he appreciates its propaganda value, using it to promote his grandiloquent image as the 'Sun King' and to glorify the military triumphs of the country. His greatest artistic monument is the Palace of Versailles, which becomes a giant symbol of his wealth and power. The most important artist of his reign is Charles Le Brun, whose flamboyant, ceremonial style is ideally suited to Louis's taste for pomp and splendour, and whose organizational skills are used to direct the huge workforce involved at Versailles and on other royal projects. IC

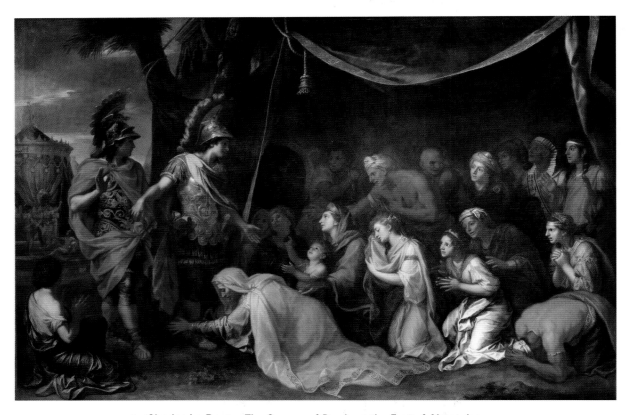

Charles Le Brun – *The Queens of Persia at the Feet of Alexander*
This was Le Brun's first commission from Louis XIV, who liked to identify himself with Alexander the Great, the most illustrious general of the ancient world. In this sumptuous and colourful scene, Alexander is depicted as a magnanimous conqueror, showing mercy to the family of the defeated King Darius of Persia. Le Brun later painted several other scenes from Alexander's life for Louis, some of them of enormous size.

Charles II (son of the executed Charles I) becomes king of England, after an eleven-year period in which England is governed as a republic. His return from exile inspires national rejoicing.

1660　　**1661**　　**1664**

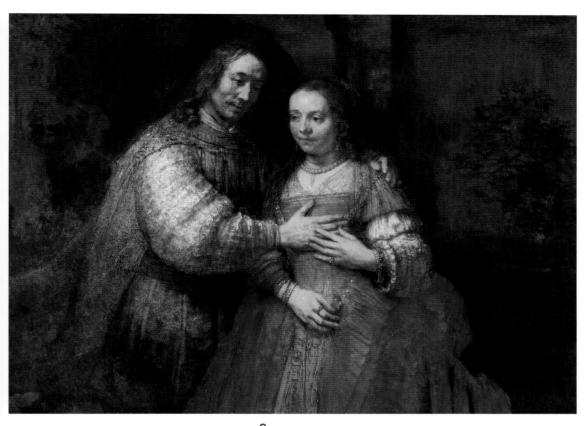

Rembrandt van Rijn – *The Jewish Bride*
Rembrandt's career reached a low point in 1656 when he was declared insolvent – a result partly of his extravagance, and partly of the damage the war against England caused to the Dutch economy. He never regained his former prosperity, but his work continued to grow in depth of feeling and richness of technique. This is one of his most glorious late works. The subject is uncertain (the title is a 19th-century invention), but it perhaps represents the biblical couple Isaac and Rebecca.

New Amsterdam, the main Dutch settlement in the Americas, is seized by the British and renamed New York (after the Duke of York, later James II).

Gian Lorenzo Bernini, the most famous artist of the day, visits Paris. His designs for the Louvre are rejected in favour of the work of French architects, reflecting growing independence from Italy in artistic matters.

Bartolomé Esteban Murillo – *The Virgin and Child in Glory*
Murillo was the most famous and successful Spanish painter of the late 17th century. He specialized in religious scenes that have a sweetly emotional appeal. This characteristic example was painted for the private chapel of the Archbishop of Seville, the city where Murillo spent virtually all his life. It was one of the most prosperous cities in Europe, mainly because it was the chief port for Spain's lucrative trade with its American colonies.

The Popish Plot, a conspiracy to murder Charles II and replace him with his Catholic brother, James, causes widespread panic in England before it is discredited.

1665 **c. 1666** **1673** **1678**

1680-1700

The balance of power. Louis XIV's wars win him territory and prestige, but they also weaken the French economy and encourage other countries to join forces against him. The leader of the resistance to French imperialism is the Dutch prince William of Orange, who in 1689 becomes king of England as William III. Although the Grand Alliance (England, the Dutch Republic and various other states) turns the tide militarily against Louis, France continues to be expansionist in cultural matters, especially after persecuted Huguenots (French Protestants) flee the country in large numbers. By the end of the century Paris rivals Rome as the most significant and innovative centre of art in Europe. Another important Italian art centre is Venice. After a relatively undistinguished period during most of the 17th century, its glorious tradition in painting is beginning to revive. IC

Meindert Hobbema – *The Avenue at Middelharnis*

This celebrated painting is often described as the swansong of the golden age of Dutch art, for by this time all the greatest figures of the period had died and the earthy naturalistic tradition was giving way to French-inspired elegance. Like many Dutch artists, Hobbema had another profession. In 1668 he took a job with Amsterdam customs and excise, and thereafter he seems to have painted mainly as a hobby.

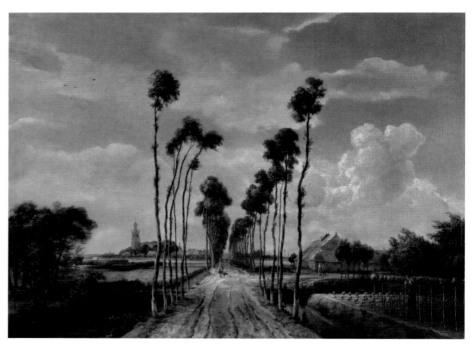

A Turkish army is defeated after besieging Vienna for two months. This marks the Muslim Ottoman Empire's last major threat against Christian Europe.

Louis XIV revokes the Edict of Nantes (1598), which had granted certain rights to Huguenots. In consequence, thousands of Huguenots flee to other countries (including England), which benefit from their renowned skills in various crafts.

Isaac Newton publishes his *Principia Mathematica*, one of the most important books in the history of science, in which he gives a mathematical explanation of the laws of mechanics and gravity.

Peter the Great seizes power in Russia. His reign is to be marked by many reforms and the Westernization of the country's art and architecture, but also by barbaric cruelty.

1683	1685	1687	1689

○ **Manuel de Arellano – *The Virgin of Guadalupe***
In 1531 a vision of the Virgin Mary is said to have
appeared at Guadalupe (now a suburb of Mexico
City). A church built on the site is one of the most
popular Catholic shrines in the world. It displays
an image of the Virgin that is said to have been
miraculously imprinted on the cloak of an Indian
who experienced the vision. It has been much
copied and adapted, as in this version by a leading
Mexican painter of his time.

Sebastiano Ricci – *Bacchus and Ariadne*
Ricci is associated particularly with Venice, but he travelled
widely and was a leading figure in spreading the ideas of
Italian art to other countries (he worked in England, Flanders,
France and Germany). The colourful mythological story of
Bacchus and Ariadne was a favourite with Ricci, who treated
it several times. In this example he is beginning to develop
from a vigorous Baroque idiom to a lighter style characteristic
of the 18th century.

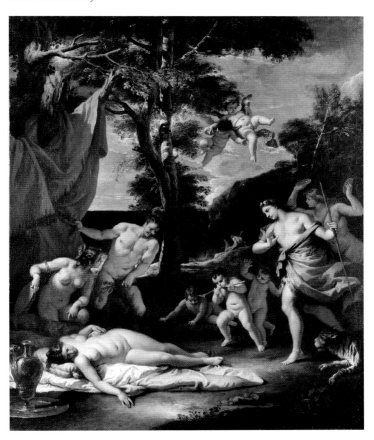

The Bank of England is founded. Its
immediate purpose is to raise money
to lend to the British government to
finance war against France.

Charles II of Spain, mentally
and physically infirm, dies
childless, bringing to an end to
the Spanish Habsburg dynasty.
He is succeeded by Philip V, a
grandson of Louis XIV.

|||||||| **1691** |||||||||||||||||||||||||||||||||| **1694** |||||||||||||||||||||||||||||||||| **c.1700** ||||||||||||||| **1700** ||||||||||||||||||||||||||||||||

3

—

ROCOCO & NEOCLASSICISM

The Rococo is a highly decorative style of art and architecture, which began to supersede the Baroque at the start of the 18th century. The term is said to have originated as a jokey fusion of *rocaille* and *barocco*. *Rocaille* referred to the ornamental shellwork and rockwork, which was used to adorn fountains and grottoes, while *barocco* was a source-word for Baroque. Initially, Rococo was used as a term of ridicule, but it no longer carries any pejorative overtones.

At the outset the Rococo developed as an antidote to the grandiose pretensions of the Baroque. The walls and ceilings of great palaces and mansions were covered in complex allegories, designed to glorify the aspirations and achievements of the patron. Giambattista Tiepolo – the greatest of the Rococo decorative artists – was also required to tackle unpromising material of this kind. However, with his lightness of touch and

his playful flights of fancy, he transcended the limitations of his subjects. He dazzled the princes of Europe with his sumptuous decorative schemes in Venice, Udine, Madrid and, above all, at the *Residenz* (palace) of the prince-bishop of Würzburg in Germany.

On a smaller scale, the Rococo was light-hearted, elegant, playful, sometimes even erotic. The pioneering genius of the style was Jean-Antoine Watteau. His love of the theatre led him to create an entirely new genre of painting – the *fête galante*. This was an idyllic party, set in beautiful parkland and attended by elegant young people. They are dressed in fine clothes – ball gowns, historical costumes, outfits from thee Commedia dell'Arte (Italian Comedy) – and they dance, make music and engage in flirtatious conversations. These fêtes often resembled scenes from a play and, indeed, Watteau's most famous picture – *The*

Embarkation for Cythera – was precisely that. The artist transformed the closing moments of a long-forgotten play into a dreamlike fantasy, in which lovers pair off in homage to Venus.

At the start of his career, Watteau had worked for a time for Claude Audran III. He was a leading decorative artist who provided paintings and tapestry designs for several of Louis XIV's palaces. Under his supervision, Watteau executed many of the decorative details – Chinoiseries, arabesques, singeries and grotesques. This underlined two of the key requirements for the successful Rococo artist – versatility and decorative appeal.

This trend became even more evident during the reign of Louis XV. It played a significant role in the career of François Boucher, who was both the most prolific and the most successful exponent of the Rococo style. In terms of painting, he is probably best known for his mythological scenes. These are significantly different from most earlier versions of the theme. During the Renaissance and the Baroque eras, artists had frequently used mythological figures in an allegorical context, or else as illustrations of a story in a classical text. Even when the subject was light-hearted, they tended to refer to a specific legend. Boucher made no attempt to do this. His mythologies were simply pretexts for decorous depictions of the nude. In *The Triumph of Venus* (1740; see p. 152), for example – a theme that bears very little resemblance to any passage from the ancient world – the goddess is wafted across the waves in a shell-like throne, covered with rich fabrics. Draperies flutter above her head, borne aloft by circling putti, while in the frothing waves naked sea-nymphs and tritons frolic around her.

Painting was only one of the activities carried out by Boucher. His chief patron was Madame de Pompadour, Louis XV's *maîtresse en titre*, and she involved him in many of her pet projects. In particular, he designed many of the decorative elements for articles produced at the Sèvres porcelain factory, with which she was closely associated. His drawings of mythologies, pastorals and putti were reproduced on enamel dinner services, while his series *Jeux d'Enfants* (Children's Games) was used to create a range of soft-paste biscuit figurines. These little statuettes of rustic infants – which proved enormously popular – were modelled by the sculptor Etienne Falconet.

Along with his work at Sèvres, Boucher also had a growing reputation as a tapestry designer. He created a set of fourteen on the theme of *Les Fêtes Italiennes* for the Beauvais tapestry factory, while also winning acclaim for his Chinoiserie compositions, which were partly inspired by Watteau's designs. It is a measure of his success that Boucher was also employed by rival concerns such as the Gobelins, becoming their *Surinspecteur* in 1755. While working for them, he produced two of his most famous tapestries – *The Rising of the Sun* and *The Setting of the Sun*. The full-scale cartoons for these are as well known as the tapestries. They were shown at the Salon, and Madame de Pompadour displayed them at her château at Bellevue.

PREVIOUS PAGE. Jean-Baptiste Oudry – *Swan Attacked by a Dog* (detail; 1745)

LEFT. Jean-Antoine Watteau – *The Embarkation for Cythera* (1717)

BELOW. François Boucher – *Are They Thinking about the Grape?* (1747)

One of the keys to Boucher's success was the ease with which his designs could be transferred from one medium into another. The same putto that featured in a painting, as one of Venus's attendants, for example, could be used as a symbol of one of the seasons on a porcelain vase.

One of the most popular subjects for Rococo artists was the pastoral. Boucher's *Are They Thinking About the Grape?* (1747) is typical of the genre. A pretty young shepherdess cossets her lover and ties ribbons in his hair, while well-behaved sheep doze happily at their feet. This idyllic view of the countryside was very fashionable at the time, though it appealed to the type of people who knew nothing about the hardships of rural life. It fell out of favour as the French Revolution drew nearer, largely because of its associations with the Ancien Régime. In 1783 Marie Antoinette famously built her Hameau de la Reine ('Queen's Hamlet') in the grounds of Versailles. In this sanitized version of the countryside – with its dairy, mill and barn – she and her friends could relax by dressing up as shepherdesses and pretending to live the simple life, away from the court. Unintentional though it may have been, this indulgence typified a monarchy that was dangerously out of touch with its subjects.

The other aspect of the movement that fell out of favour was its attitude to love and sex. No picture epitomizes the Rococo more completely than Fragonard's painting of *The Swing* (1767). The mood is joyous and carefree – but it is, in its own way, a paean to adultery and deceit. A young woman shows off her legs to her lover, while her husband is oblivious to their secret, in spite of the yapping dog and the alarmed expressions of the statues. This kind of immorality was frowned on in the stern new ethos of the Revolutionary era. When conflict broke out, the painting was confiscated and its owner ended up on the guillotine.

Neoclassicism became the visual accompaniment to the French Revolution. Interest in the style had been growing for some time. In part, it was stimulated by the excavations at Herculaneum and Pompeii. These caused great excitement, although there was some disappointment at the quality of the paintings discovered there. These were probably more useful to designers such as Robert Adam than to mainstream artists. Joseph-Marie Vien's *The Cupid Seller* (1763) – based on a fresco found at a villa in Stabiae – was one of the few paintings directly inspired by an example from the recent excavations.

Rome itself was a greater influence. The city was the highlight of the Grand Tour, attracting hordes of visitors eager to explore its ancient heritage. This provided work for many artists. Giovanni Battista Piranesi produced spectacular etchings of the ruins for tourists, while Pompeo Batoni painted portraits of wealthy clients posing beside their favourite landmark. The Scottish artist Gavin Hamilton took things a stage further. He settled in Rome, joining the circle of distinguished figures, led by Anton Mengs and Johann Winckelmann, who formulated the key principles of Neoclassicism. Hamilton's paintings, typified by his *The Death*

ABOVE. Jean-Honoré Fragonard – *The Swing* (1767)

RIGHT. Gavin Hamilton – *The Death of Lucretia* (1763–7)

of Lucretia (1763–7), were fine examples of the style. However, he probably earned more from his activities as an archaeologist and art dealer. He made important finds at the excavations in Hadrian's Villa at Tivoli, and was in close contact with the agents of serious collectors. Two of the most important connoisseurs of the time were Charles Townley, whose collection is now on display in the British Museum, and the architect Sir John Soane, best known for designing the Bank of England. His enormous collection was stored in his London home, which has since become a museum.

Jacques-Louis David won the Prix de Rome in 1774, after four failed attempts. The prize in this competition for budding artists was a period of study in Rome at the State's expense. David was sceptical at first, vowing that 'the antique will not seduce me', but he could not have been more wrong. He was overwhelmed by the Classical art that he witnessed there, and this shaped the rest of his career. After his return to Paris in 1780, David rapidly established himself as the leader of the Neoclassical movement. He tended to prefer themes drawn from ancient history rather than mythology but, unlike those of the Rococo artists, his pictures were noted for their high moral content. For his contemporaries, they seemed to carry a message about honour, courage and self-sacrifice, beckoning them towards revolution.

1700–1710

Life is on the move. As the 18th century dawns, the first decade in Europe is overshadowed by the War of the Spanish Succession (1701–14), but it also brings the stirrings of fundamental changes in people's lives. At the start of the century much of everyday life is still rooted in old social patterns and agricultural economies, but already movement is afoot towards increasingly mechanized production, people moving from country to city, and money migrating towards the middle classes. Interesting mixtures are at play in art, too. Rachel Ruysch's work of the 1700s combines the fine technical draughtsmanship enshrined in much 17th-century still-life painting with an elegantly fluid 18th-century approach. Nicolas de Largillière melds earlier traditions of grand Baroque portraiture practised by Anthony van Dyck and Peter Paul Rubens, and the warm colouring of northern European realism, with a relaxed approach that reflects the lightness of touch in early 18th-century French painting. AK

The Great Northern War (1700–21) breaks out; Sweden's dominance in the Baltic is challenged by Russia, Denmark–Norway, Poland and Saxony.

The War of the Spanish Succession (1701–14) begins when Charles II, the Spanish monarch, dies without an heir. Much of Europe spends the first decade of the 1700s embroiled in a struggle to stop France and Spain having too much power.

Rachel Ruysch – *Still-Life with Bouquet of Flowers and Plums*

The successful Dutch artist Ruysch was one of the finest practitioners of the still-life. Her work shows a progression from the best traditions of 17th-century Dutch Golden Age painting into a freer style for the new century. Ruysch's signatures were movement, refined colouring, lighting effects that create three-dimensionality, and delicate brushwork that perfectly captures a fragile petal or the soft bloom on fruit. This is a typical Ruysch: a deftly composed bouquet in a vase, on a ledge and against a plain backdrop.

Peter the Great founds St Petersburg. The city will grow into a grand centre for sumptuous Baroque and Rococo art and architecture.

1700 **1701** **1703** **1704**

Nicolas de Largillière – *Self-Portrait of the Artist with His Family*

Paris-based Largillière was a prolific, wealthy and much sought-after painter famed for being able to turn his hand equally skilfully to any genre, but known best for his many portraits (about 1,500 in number). These featured well-to-do middle-class and court sitters. He also painted several self-portraits, some showing himself with his family and featuring trappings of luxury and plenty, such as the extravagantly draped plush fabrics and the apple in this image.

Marco Ricci – *Rehearsal of an Opera*

The Italian artist Ricci was also a stage designer with a particular interest in opera. His landscape works reveal influences from Dutch art, as shown in the seascape shown on the back wall of this painting. Theatre- and opera-going boomed throughout the 1700s, fuelled as the century progressed by the rise of a wealthy middle class. Portraits of actors were popular, as was introducing a whimsically Rococo theatrical or masque element into a picture.

The astronomer **Edmond Halley** publishes his groundbreaking *Synopsis astronomia cometicae* (A Synopsis of the Astronomy of Comets), identifying what is now called Halley's Comet and correctly predicting its reappearance in 1758.

The first true 'hard-paste' porcelain is made in Germany, by the alchemist Johann Friedrich Böttger, after a major ingredient, kaolin, is discovered in Europe at the start of the 1700s. The first factory in Europe to make this porcelain is founded at Meissen the following year.

c. 1704 **1705** **c. 1709** **1709**

1710-1720

The face of Europe changes. In 1713–14 a body of treaties often collectively called the Peace of Utrecht brings to an end the long and bitter War of the Spanish Succession. Treaties are also signed in 1714 at Rastatt and Baden, and others in the years following, and the Austrian Charles VI gives up his claims to the Spanish throne. All of this establishes five major international powers – Britain, France, the Hapsburg Empire, Russia and Spain – and makes Britain a leader in world trade. For artists, historical and religious subjects expressed with Baroque flourishes still have high status, as they did in the 1600s. They are now joined, however, by the more delicate Rococo style from about 1700 in France, as perfected in Watteau's hugely successful romantic follies. AK

Paolo de Matteis – *Self-Portrait in the Act of Painting: An Allegory of the Peace of Utrecht (1713) and the Peace of Rastatt (1714)*

De Matteis here places his own image centre-stage, dressed informally in housecoat and cap – considered unseemly at the time for depicting such a momentous historical occasion. He is at work on a canvas showing Spain and Austria as queens shaking hands, their respective symbols of a lion and double-headed eagle at their feet. This reflects agreements made between the two powers at this time. Allegorical figures such as Peace, Plenty, Faith, Hope and Charity fill the image.

The first successful steam engine is built at a coal mine in Staffordshire. This is the first recorded version of the British engineer Thomas Newcomen's 'atmospheric steam' design.

The Peace of Utrecht (or the Treaty or Treaties of Utrecht) finally ends the War of the Spanish Succession. It confirms the French Bourbon Philip V as Spain's monarch and brings back a more even sharing of power and lands across Europe.

| 1712 | 1713-14 | c. 1714 |

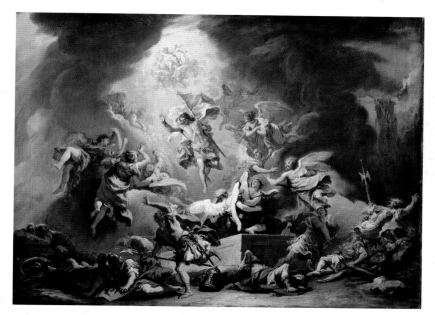

Sebastiano Ricci – *The Resurrection*

This oil sketch is linked with a fresco Ricci painted for London's Royal Hospital, Chelsea. Christ soars upwards attended by angels, two of which have lifted the slab from his tomb. The Resurrection often appeared in contemporary hospital paintings as a powerful symbol of recovery. Here the dramatically portrayed scene – with bold lighting, movement and billowing fabric – has a Baroque feel. However, a delicacy in the colours and technique are Rococo in style and echo the work of Venetian Renaissance artists such as Paolo Veronese.

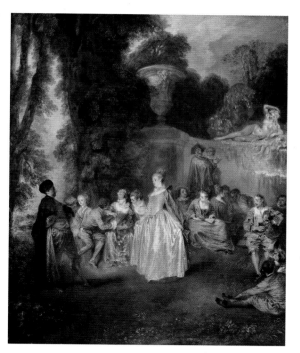

Jean-Antoine Watteau – *Fêtes Vénitiennes*

This picture's title may refer to an opera-ballet of the time. Watteau has become synonymous with Rococo art, through excelling at frivolous, wistful scenes of people enjoying gently amorous and idle pursuits, painted with a light touch and beautiful colouring. This painting is a fine *fête galante* (courtship party) – a form he is credited with inventing that showed beautifully dressed young people in parkland settings. The central dancer may be the famous actress Charlotte Desmares, while the seated musician (right) is a self-portrait of the artist.

Louis XV comes to the French throne – the start of a reign that will bring a golden age for French Rococo art, in painting, decorative arts and architecture, and in schemes that blend all three forms.

The pirate Blackbeard starts his infamous reign of terror along the American coast and in the Caribbean with the capture of a French slave ship called *La Concorde*.

The Mongols are driven out of Tibet by the Kangxi emperor (Qing Dynasty), helping to quell Tibetan/Chinese fighting for the next couple of centuries.

| 1715 | c. 1715–16 | 1717 | 1718–19 | 1720 |

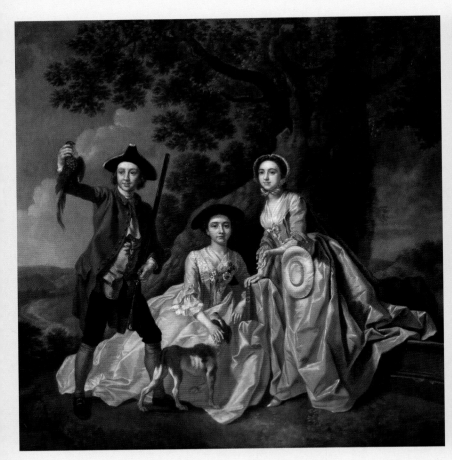

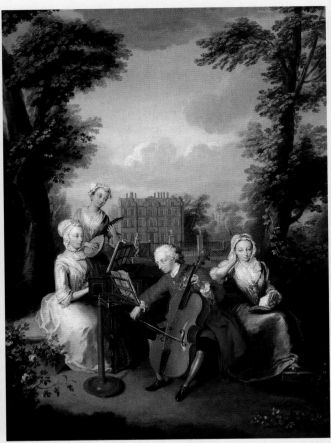

THE CONVERSATION PIECE

Some of the most delightful portraits of the 18th century are conversation pieces, showing family or friends at leisure. These paintings are usually small and unpretentious, suitable for display in middle-class homes, although they were sometimes commissioned by aristocracy or even royalty.

It is difficult to give a precise definition of a conversation piece, but the term refers to a type of portrait, usually fairly small, showing two or more full-length figures in an informal, everyday setting, indoors or outdoors. The people depicted are not necessarily (or even usually) shown actually talking to one another: the term derives from now obsolete senses of the word 'conversation', meaning a circle of acquaintance or social intimacy. There are various early precedents for this kind of painting, for example Jan van Eyck's famous Arnolfini portrait (1434), showing a couple in their home, but it flourished particularly in the 18th century, most notably in England.

The earliest-known occurrence of the phrase 'conversation piece' dates from 1706, in Bainbrigg Buckeridge's *An Essay Towards an English School*, the first attempt to write a history of English painting. Buckeridge used the term in connection with the work of Marcellus Laroon, a multitalented man of Dutch extraction who seems to have painted mainly as a hobby. However, the figures in Laroon's small group pictures are usually of generalized types rather than identifiable individuals, and another painter of foreign extraction, the German-born Philip Mercier, is generally regarded as the pioneer in England of the conversation piece as the term is now understood. He settled in England

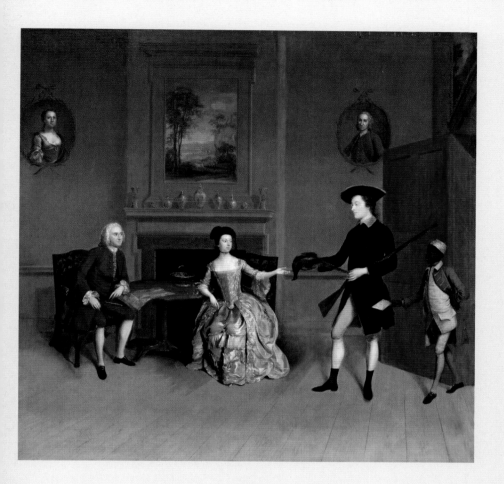

Arthur Devis
(1712–87)

The most prolific of all exponents of the conversation piece was Arthur Devis, who painted more than 300 works of this type. One of a family of artists, he worked in his home town of Preston in Lancashire and also in London. His sitters were mainly from the rising middle classes (to which he belonged himself). For many years after his death he was virtually forgotten, but his work was rediscovered in the 1930s and is now admired for its engaging charm, as well as for the wealth of social observation it contains.

ABOVE LEFT. Francis Hayman – *George Rogers with his Wife and Sister (c. 1750)* Rogers married a daughter of one of Hayman's main patrons.

ABOVE CENTRE. Philip Mercier – *Frederick, Prince of Wales, and his Sisters (1733–50)* The royal siblings are making music in front of Kew Palace.

ABOVE RIGHT. Arthur Devis – *John Orde, His Wife, Anne, His Eldest Son, William, and a Servant (1754–56)* John Orde was a landowner in Morpeth, in northern England.

in about 1716, painted his first-known, dated conversation piece in 1725 and was appointed principal painter to Frederick, Prince of Wales (son of George II), in 1739.

The first major artist to create conversation pieces was William Hogarth, who in the early 1730s painted several depicting the families of noblemen or gentlemen. They helped to establish his reputation, but he found that they involved a lot of work for insufficient remuneration, so he moved on to different fields. However, other painters quickly followed in his path, among them Francis Hayman, the growing popularity of the conversation piece reflecting the expansion of a middle-class clientele. Hayman's pupils

included Thomas Gainsborough, who in his early career painted some of the most beautiful of all conversation pieces.

Artists outside Britain who painted conversation pieces included Cornelis Troost (sometimes called 'the Dutch Hogarth') in Amsterdam and Pietro Longhi in Venice. Such paintings were also produced in America. The tradition continued into the 19th century, but the rapid growth of photography in the 1840s brought about a sharp decline. However, certain modern painters have created works that revive the spirit of the conversation piece in a contemporary vein, for example David Hockney in his celebrated *Mr and Mrs Clark and Percy* (1970–71). IC

1720-1730

Playfulness and luxury. The 18th century sees a number of innovations in art. Breaking with the drama and grandeur of 17th-century Baroque styles, a more playful approach develops. In France, the aristocratic elite reigns over the social, cultural and economic trends that come to define the period. Louis XV or 'Louis the Beloved' is easing into his reign in this period of absolute monarchy. His mistress, Madame de Pompadour, is a dedicated patron and heavily involved in architecture, fine and decorative arts, and interior design. The early Rococo style exemplifies the excess and decadence of the French aristocracy, and pervades all areas of the arts. From palatial interiors to painted canvases, the playful luxury of the style rules the day, and salon culture brings the upper-crust of the French aristocracy together on a regular basis. ED

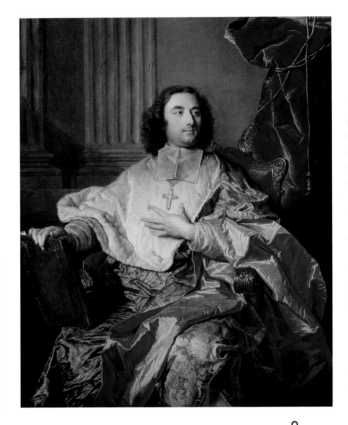

Hyacinthe Rigaud –
Charles de Saint-Albin
Charles de Saint-Albin commissioned this portrait to commemorate his appointment as archbishop of Cambrai in 1723. The illegitimate son of a duke and a dancer, Saint-Albin nevertheless rose through the ranks of the Church and is here depicted accordingly. The robes, the prominent gold cross around his neck, and the gesture of his left hand held up to his chest portray him as a powerful man of the cloth. Commissioning Hyacinthe Rigaud, who was portraitist to the court of Louis XIV, ensured that the resulting portrayal was quite literally fit for a king.

The Dutch navigator **Jacob Roggeveen** reaches Easter Island while on a quest to find Australasia.

Afghan forces carry out a seven-month siege of Isfahan, overthrowing the Safavid Shah Sultan Hussein and toppling the Persian Empire.

Johann Sebastian Bach's *Brandenburg Concertos* set new standards in orchestral and chamber music.

Louis XV reaches the age of maturity and begins his personal reign following the regency of Philippe d'Orléans.

1721 1722 1723

Canaletto – *Bucentaur's Return to the Pier by the Palazzo Ducale*

Canaletto's majestic scene pictures the Doge of Venice's golden barge, or *Bucentaur*, returning to the pier in one of the city's busy canals. The state vessel was used once a year to take the Doge to the Adriatic in order to perform an ancient ritual celebrating the union between Venice and the Adriatic Sea. The ritual was performed annually on the Feast of the Ascension until 1798. Canaletto has painted identifiable Venetian landmarks into the scene: the Doge's Palace, St Mark's Cathedral and the bell-tower all stand tall amid the Doge's industrious fleets.

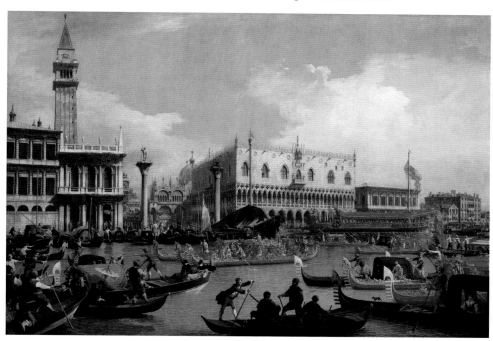

Nicolas Lancret – *The Swing*

Lancret's charming canvas depicts an amorous scene between two elegantly dressed young lovers. He learned the basics of the *fête galante* genre from the master Rococo painter Watteau, and brings it to life here. Luxury, refinement and the idyllic outdoors set the stage for the playful excesses of the French aristocracy in these genre scenes. Thanks to Watteau, the swing was a popular motif in French Rococo painting, and Lancret experimented with it many times in his own work.

Nicola Salvi wins the commission to renovate the Trevi Fountain in Rome. The Baroque fountain is one of the most famous in the world.

François Boucher leaves his native France to study in Italy, where he is influenced by the art he encounters in Venice.

c. 1724 **1727** **1728–29** **1730**

1730–1740

Romance and Realism. Artistic trends overlap interestingly as the 1700s progress. Baroque styles persist, especially for weighty projects such as Lemoyne's *Apotheosis*, whose grand Baroque air catches Rococo subtleties from the artist's lightness of touch and colouring. Eighteenth-century Neoclassicism is seen in Panini's subject matter, but the whimsy of his fantasy ruins scene shown here has the Rococo blend of light-heartedness tinged with melancholy. Ruins are reminders of life's transience for contemporary viewers, and this is also seen in Chardin's bubbles. A key cultural development is the burgeoning of 'experimental philosophy' in the 1730s, which elevates experimentation based on real life as being vital to thought about all kinds of matters. **AK**

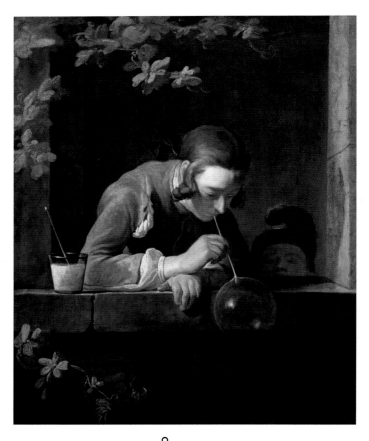

Jean-Baptiste-Siméon Chardin –
Soap Bubbles

Chardin's image focuses on a boy concentrating on blowing a large bubble, as a smaller boy next to him looks on, transfixed. The viewer's attention is also focused skilfully – by the light catching the bubble, the simple triangular composition and the strong framing device of a window. Chardin excelled at still lifes and genre scenes, and Netherlandish influences are clear here. But another layer of meaning is at work: for Chardin's contemporaries, bubbles were potent symbols of life's transience.

The Danish explorer Vitus Bering
– who in the late 1720s had sailed through the strait between North America and Asia that would bear his name – sets off on the Great Northern Expedition. This trip maps much of Siberia's Arctic coastline.

The New York journalist
and printer John Peter Zenger is acquitted in a landmark libel case that establishes a vital precedent for freedom of the press.

Johann Sebastian Bach,
German Baroque composer and organist, becomes Royal Court Composer to the Elector of Saxony.

1733 **1733–34** **1733–36** **1735** **1736**

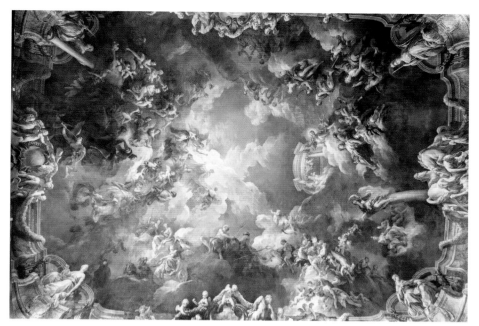

François Lemoyne – *The Apotheosis of Hercules*

Lemoyne painted this spectacular work on a canvas that was glued across the vast vaulted ceiling of the 'Hercules Salon' in the Palace of Versailles. The theme of Heracles/Hercules being elevated to the status of a god by Zeus/Jupiter, his father, is powerfully expressed by a soaring pyramid-shaped composition. Featuring 142 figures, this great achievement won Lemoyne the coveted role of First Painter to the French king.

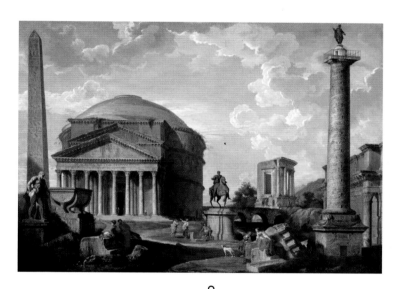

Giovanni Paolo Panini – *Fantasy View with the Pantheon and Other Monuments of Ancient Rome*

Panini, the master of 18th-century *vedute* (views) of Rome, had a talent for depicting Classical ruins and monuments. *Vedute* were popular topographical studies typically featuring architectural elements, often in an imaginary setting. Here Panini brings together real objects from different locations: the *Farnese Hercules* sculpture; the ancient Egyptian Thutmose III obelisk; the Pantheon; the equestrian statue of Emperor Marcus Aurelius; the Temple of Vesta from Tivoli; Trajan's Column; and the Forum of Nerva.

William Kent, a leading landscape gardener linked with 18th-century Picturesque visual art, starts his highly influential four-year remodelling project for the gardens at Rousham, Oxfordshire.

The Treaty of Vienna ends the War of the Polish Succession, a European conflict over who should rule Poland. One outcome is that Russia gains more power over Polish affairs.

The 'Stono' slave rebellion takes hold in South Carolina. It is the largest slave revolt in Britain's mainland colonies prior to the American Revolution but is ultimately quashed. It results in the passing of measures that restrict slaves' freedoms even more.

1737 **1738** **1739**

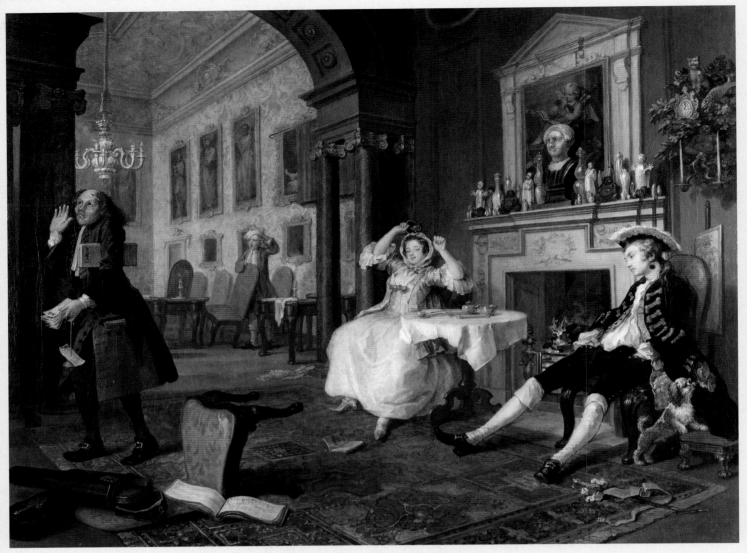

Johann Kaspar Lavater
(1741–1801)

One influence on the development of visual satire and
caricature in European art was the work of the Swiss
writer and theologian Lavater, famed as the founder
of a systematized approach to physiognomy. His
work stressed links between mind and body such that
people's characters could be read in their faces. He
gained an international reputation in the late 1700s
that lasted into the 1800s (when phrenology became
popular, especially in America and Britain). Lavater's
most famous work is his *Physiognomische Fragmente*
(Essays on Physiognomy) of 1775–8. The artist Henri
Fuseli made an English translation of his *Aphorisms
on Man* (1788).

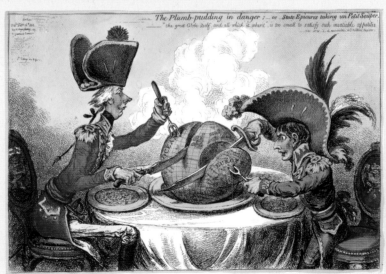

ART AND SATIRE

The 18th century proved a golden age for visual satire. With major political turmoil in Europe and America and the philosophical upheavals of the Enlightenment, the time was ripe for sharing outspoken comment. Britain was a focal point for the trend, but satirical works appeared in other parts of Europe and in America too.

ABOVE LEFT. William Hogarth – *Marriage à-la-Mode, Scene 2: The Tête à Tête* **(c. 1743)**
Hogarth's multiple-image series narrates the marriage between a viscount and a merchant's daughter. In this scene, the house is in disarray and the viscount slumps after a night out, probably in a brothel.

LEFT. James Gillray – *The Plumb-pudding* [sic] *in Danger* **(1805)**
Gillray's famous cartoon about the Napoleonic Wars shows French Emperor Napoleon and British Prime Minister William Pitt greedily vying to get their portion of the globe. Gillray's 'Boney' caricatures were much copied.

ABOVE. Honoré Daumier – *The Pears* **(1831)**
The tradition continued in these images of the overweight French king, Louis-Philippe, published in the political journal *La Caricature*. Daumier drew these after a sketch by Charles Philipon, founder of the journal.

Turbulent times meant that a vast range of opinions were found wherever people gathered. In the later 1700s this began to be expressed in satirical forms ranging from sobering morality tales to outrageous caricature. Eighteenth-century satire firmly established the political cartoon and paved the way for publications such as *Punch* magazine in the 1800s and the satirical trends of the 20th and 21st centuries.

This century saw multiple wars and its later years brought revolutions in France and America. In Britain, King George III's reign (1760–1820) was filled with instabilities, charges of corruption and accession uncertainties. In this atmosphere Whig and Tory party political rivalry gained a grip, as did a certain freedom of speech in the press. The scene was set for outspoken controversy. Getting this into print, accompanied by lampooning imagery, was further aided by the late 18th-century growth of publishing ventures and print-shops. The rise of the political satirical print brought ideas to an ever-wider audience. With industrialization came the steady expansion of cities, an increasingly urbanized outlook and the advance of an educated middle class – creating a larger market for debating issues.

All of this, however, would have meant little without artists who could rise to the occasion.

Politically satirical prints can trace a tradition back to those by artists such as Lucas Cranach the Elder in the 1500s. The 18th and early 19th centuries, however, produced a constellation of experts in the field, led by William Hogarth, James Gillray, Thomas Rowlandson, George Cruikshank and later Honoré Daumier. William Hogarth had a genius for a particular type of satire: modern morality tales that revealed the human weaknesses and vices of contemporary society. Engravings of his work ensured that huge numbers of people saw his narratives. His main works in this field were *A Harlot's Progress* (1731–32), *A Rake's Progress* (1733–35) and *Marriage à-la-Mode* (c. 1743), considered his triumph. In contrast, the colourful prints of Gillray and Rowlandson established a line of satire more blatantly based on brilliantly exaggerated caricature. Gillray was the ultimate political satirist, whose characters included his John Bull everyman, whereas Rowlandson leaned more towards social satire.

Other art forms also held up a mirror to folly by using satire, for example Henry Fielding's novels including *Joseph Andrews* (1742). Fielding linked his mode of using satire to promote good behaviour with classical ideas – another strand of 18th-century Neoclassicism. AK

1740-1750

The heyday of Rococo. Louis XV continues his reign as the king of France, though the political situation under his control heats up. In the 1740s France invades and occupies the Austrian Netherlands. The Age of Enlightenment emerges in Europe, with explosive advancements in social, political, scientific and artistic thought. As mid-century approaches the late Baroque and Rococo styles continue to develop, and their influence spreads across Europe. François Boucher continues to attract commissions from the French elite, including an impressive number of portraits of Madame de Pompadour, the notorious mistress to the king. ED

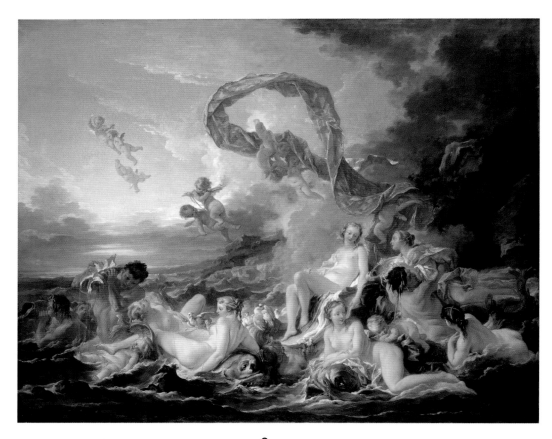

François Boucher – *The Triumph of Venus*

Venus, the goddess of love, is one of the most painted figures in the canon of Western art history. Here she appears emerging from her sea-foamed shell, attended by mythological creatures including naiads, tritons and flying cupids. Boucher paints a swirling composition that reaches its peak in the shimmering, translucent drapery billowing away from Venus. The strings of pearls, cool jewel-tone colours and eroticism of the scene are typical of the high Rococo style.

Madame de Pompadour becomes the official mistress to King Louis XV, a position she held for six years, during which time she had a great deal of influence over the King.

Frederick the Great becomes the king of Prussia in 1740, and reigns for a staggering forty-six years.

The British artist William Hogarth embarks on his series of satirical paintings entitled *Marriage à-la-Mode*, for which he is famous.

1740

1743–45

Jean-Marc Nattier – *Marie Adelaide of France as Diana*

Jean-Marc Nattier was born to a family of artists. Under the influence of his father, who was a portraitist, and his uncle, who painted history scenes, Nattier worked on a composite genre that married these two styles. His portrait of Marie Adelaide, third daughter to King Louis XV and Queen Marie Leczinska of France, portrays a striking likeness of her face, while her pose, bow and arrows, and the idyllic outdoor setting, allude to the figure of Diana, goddess of the hunt.

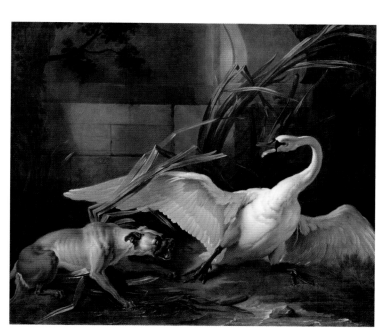

Jean-Baptiste Oudry – *Swan Attacked by a Dog*

Another of Louis XV's artistic quirks was his penchant for commissioning portraits of his various hunting dogs. To this end he enlisted the talents of Jean-Baptiste Oudry, whose dramatic animal scenes he admired. The skill of Oudry's rendering in this painting is visible in the hyper-realism of the stone wall, and the intense details of the swan's plumage – no small feat against the stark white of the underlying canvas. A third animal, hanging from the tree in the background, which Oudry later painted out, may account for the uneven lighting painted into the stone wall.

The Battle of Culloden is fought on 16 April between the depleted Jacobite army of Prince Charles Edward Stuart (Bonnie Prince Charlie) and the Hanoverian force led by the Duke of Cumberland. The decisive victory against the Jacobites – with over 1,200 dead in just one hour – puts a final end to the Jacobite risings, and Culloden is the last battle to be fought on British soil.

A full-scale excavation of the buried Roman city of Pompeii is ordered by the Bourbon king of Naples, Charles III, following its discovery in 1738 by a peasant digging a well near Herculaneum.

1745 **1746** **1748**

1750–1760

Taste for the exotic. The 1700s witnesses a flourishing curiosity about science, the wider world, and exploring and colonizing 'new' lands. This fuels what has often been called a 'cult of the exotic'. So-called Orientalism – a fashion for the culture of the Near and Middle East and North Africa, but also other regions – builds towards great popularity in the 1800s. Popular Rococo artworks by Carle Vanloo portray people in Turkish and Spanish dress; the exquisitely detailed fabrics in Jean-Étienne Liotard's Turkish-themed works promote interest further. Tiepolo's epic Baroque–Rococo stairwell ceiling at Würzburg, with its portrayals of the four continents, nevertheless shows that interest in the exotic often revolves around a certainty that European values should rule. AK

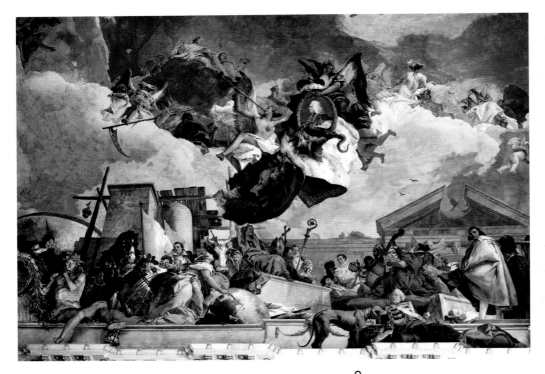

Giambattista Tiepolo –
***Europe* (detail)**

Europe is part of Tiepolo's vast ceiling fresco over the stairwell of the Prince-Bishop's Würzburg Residence. While the fresco also features exoticized images for America, Asia and Africa, it sought ultimately to elevate Europe's culture and global expansionism and depicts the Würzburg court as a central player in artistic accomplishment. This detail shows the Residence's architect, Balthasar Neumann, seated on a cannon, and its stucco artist, Antonio Bossi, in a swirling cape (right), in among the classical architectural detail that was becoming so prevalent.

A great population boom starts in Europe, with the number of people doubling by 1850.

Carolus Linnaeus's *Species Plantarum* is published, following on from his groundbreaking work classifying the natural world in the 1730s. *Species Plantarum* provides the first consistent method for naming plants, introducing a two-word approach that will underpin the system used in the modern world.

c. 1750

1752–53

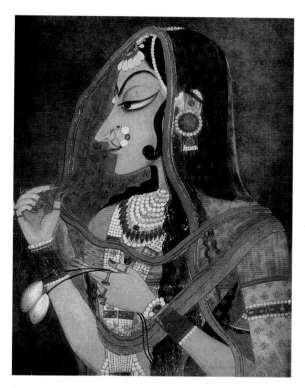

Nihal Chand – *Bani Thani as Radha* (detail)
This image is believed to represent Radha, mistress of the Hindu god Krishna. In the mid-1700s the Kishangarh School of painting (named after a city and royal state in Rajasthan) was at its height, famed for a lyricism coupled with beautiful detailing. The court painter Nihal Chand was a master of this school. His idealized women bear the elegantly elongated and curved forms typical of Kishangarh. Such faces may have been modelled on the poet–singer Bani Thani.

Jean-Étienne Liotard – *Portrait of Marie Adelaide of France in Turkish-style Clothes*
The Swiss-born artist Liotard was a leading Enlightenment portraitist, who depicted royalty, high society and the affluent middle class from all over Europe. He began sporting Turkish-style dress after a long spell in Constantinople, earning the nickname 'the Turk'. He is well known for images of life in the Ottoman Empire and of wealthy European sitters in Turkish clothing – as in this portrait of a daughter of Louis XV.

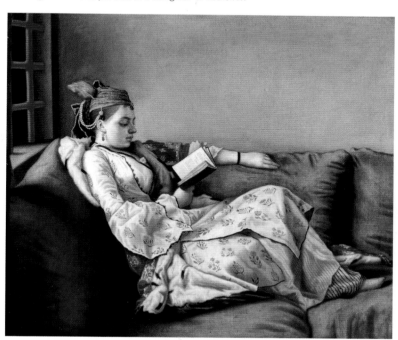

The Seven Years' War breaks out. It is a major conflict ultimately fought by Russia, Austria, Sweden, Spain, Saxony and France against Prussia, Hanover and Britain.

The Lisbon Earthquake, one of history's worst natural disasters, kills about 60,000 people in Portugal's capital. Portrayed in the arts for many years afterwards, the event etches itself deeply on European culture.

Samuel Johnson's *Dictionary of the English Language* is first published, listing 40,000 words. It has taken about eight years to compile, with the aid of six helpers.

Voltaire's novel *Candide* is **published.** Influenced by events such as the Seven Years' War and the Lisbon Earthquake, the philosopher satirizes the science, reason and optimism of the Enlightenment age, as well as the worlds of religion and politics.

| 1753 | 1755 | 1756 | 1759 |

THE GRAND TOUR

Flourishing particularly during the 18th century, the Grand Tour was a leisurely journey made by wealthy young men (and a few intrepid women) to round out their education by visiting some of the great cultural centres of Europe. Many such travellers spent lavishly on art and antiquities.

Young aristocrats and gentlemen from various countries made the Grand Tour, but it is associated above all with travellers from Britain. Its origins go back to the 16th century, when travel was regarded as a way in which future members of the ruling class could gain useful knowledge about foreign states (potential allies or enemies). However, such travel gradually became more concerned with culture than diplomacy, and the major art centres of Italy were the chief attractions for Grand Tourists. Rome was the main goal for most of them, with Florence, Naples and Venice also very popular. The outward or return journey usually took them through France (a stay in Paris was almost obligatory), and sometimes the Low Countries or Central Europe. From about 1770 some Grand Tourists also visited Greece.

Typically these travellers were in their late teens or early twenties. Often they were accompanied by a tutor and sometimes by servants. The journey generally took about a year, but some travellers were abroad for much longer (and a few returned to make second tours). In Rome particularly, these wealthy visitors were catered for by a network of artists, dealers, guides and so on. For example, Pompeo Batoni, the leading portraitist in Rome, painted many British aristocrats, and Canaletto, the great Venetian view-painter, similarly had a large British clientele. Numerous expatriate British artists also earned at least part of their living by working for the same market. The Scottish painter Gavin Hamilton spent most of his career in Rome, where he was an art dealer and archaeologist as well as an artist. The wealth of Italian paintings and Classical antiquities in British country houses and museums is in large part a legacy of the Grand Tour.

In the middle of the 18th century foreign travel was for a time severely curtailed by warfare. The War of the Austrian Succession (1740–48) hit Canaletto's business so badly that he moved to England (the home of his best customers) in 1746 and lived there for most of the next decade. Further disruption came with the Seven Years' War (1756–63), which involved most of the major European powers. When it ended, foreign travel resumed, and the next two decades marked perhaps the peak of the Grand Tour's popularity. However, the French Revolutionary Wars and Napoleonic Wars then virtually stopped Continental travel for most of the period from 1792 to 1815. When peace was restored, the Grand Tour returned, but it was now in decline, and the rapid development of railways from about 1840 fundamentally changed foreign travel, opening it up to the middle classes. IC

1760–1770

Enlightened times. Names such as 'The Enlightenment' and 'The Age of Reason' will come to be applied to the 1700s, thanks to this century's constant quest for new ideas and ways of doing things. Empirical enquiry, causes and effects, and careful observation of the natural world are key. There is a great flourishing of the sciences and shifts are felt across all areas of life. These range from the development of more productive methods and machinery in agriculture and industry to medical advances and the birth of fresh concepts about governance. Voltaire's *Dictionnaire philosophique* of 1764 captures the spirit of the times in its promotion of tolerance over organized religion and entrenched ideas. Art can hardly fail to reflect this brave new world, with painters such as Joseph Wright of Derby recording it in vividly admiring detail. Other art trends include a continuing craze for the Grand Tour portrait, which Pompeo Batoni makes his own. AK

Jean-Jacques Rousseau presents radical ideas in his *Social Contract* that speak to the 18th century's revolutionaries in France and America.

Catherine the Great starts her reign as empress of Russia. A well-read patron of the arts, she makes her court a leading cultural centre and amasses an impressive art collection.

John Singleton Copley –
A Boy with a Flying Squirrel (Henry Pelham)
Copley was a successful portraitist in colonial Boston when he sent this picture of his half-brother Henry and pet to London for exhibition to see how he measured up against European standards. The picture won some praise, and its reflections, lights and darks, and touches such as the echo of the pet's pale underside in the boy's adjacent cuff make it an impressive promotional tool. His colouring has a Rococo beauty; his detailing betrays a love of realism suited to his age.

The Peace of Paris brings the Seven Years' War to an end, with Russia, Prussia and Britain enjoying especially good outcomes.

Thomas Bayes's important paper on probability is published posthumously and will in the future give rise to a formulation called Bayes's Theorem.

Britain's Stamp Act attempts to raise revenue from colonists in America, whose angry opposition to this tax helps to fuel moves towards independence.

1762 1763 1765

Pompeo Batoni – *Colonel William Gordon*

Batoni achieved great wealth and acclaim painting those on the Grand Tour (see p. 156) and was also much admired for his portrayal of Classical remains. Here these illustrate the popular motifs of Neoclassical art while lending a semi-Baroque grandeur to the portrait. Gordon's confident pose in vivid tartans is an act of defiance – in the wake of the Jacobite uprising (1745), Scotsmen were prohibited from wearing kilts and tartan in their native land. This act – the Dress Act 1746 – was not repealed until 1782.

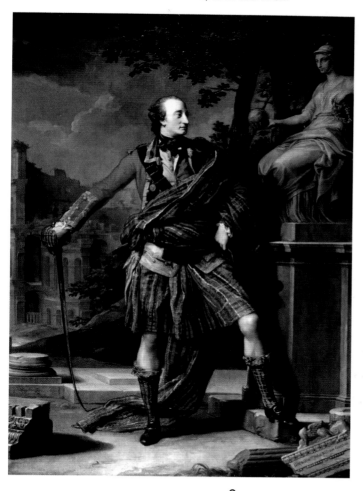

Joseph Wright of Derby – *A Philosopher Giving That Lecture on the Orrery, in Which a Lamp Is Put in the Place of the Sun*

Wright has become well known for works that combine his dramatic chiaroscuro with topics linked to the scientific and philosophical interests of the later 1700s. Here a 'philosopher' uses a model named after the Earl of Orrery to demonstrate the movement of the solar system. An oil lamp deployed to represent the sun illuminates the faces of the onlookers. In this post-Newtonian world everyone is enlightened by new, exciting knowledge.

The Royal Academy of Arts is founded in London and becomes a huge influence on European art. Its first president is Joshua Reynolds.

1766

1768

1770–1780

The rich and noble at play. Eighteenth-century artists excel at capturing the wealthy and aristocratic: dressed in closely observed sumptuous finery; indulging in civilized exchanges in the popular 'conversation pieces' of the day (see p.144); or enjoying cultural pursuits on a Grand Tour (see p.156). The Rococo mastery of painters such as Fragonard is perfect for such subjects. His famed and frivolous *Progress of Love* scheme is commissioned by Louis XV's mistress, Madame du Barry. Du Barry is a woman with a love for the arts but whose lavish expenditure makes her generally unpopular. Elsewhere at this time, other regimes are toppling and horizons expanding. America declares its independence, while James Cook charts seas and coasts from the Pacific to Antarctica. AK

Jean-Honoré Fragonard – *The Progress of Love: The Lover Crowned*

Decorative schemes for noble patrons formed an important aspect of 18th-century art. Fragonard's *Progress of Love* series was his greatest work in this area, created for Madame du Barry's pavilion at Louveciennes. *The Lover Crowned* is one of four principal scenes, the others being *The Meeting*, *The Pursuit* and *Love Letters*.

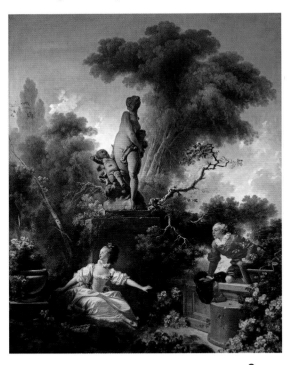

Tilly Kettle – *Dancing Girl*

The portraitist Kettle was in India from the late 1760s until 1776 and was notable among European artists for spending such a long spell there. This dancer is among some Indian genre scenes he produced while also enjoying prosperous success painting Indian princes and officials, including those in the British East India Company. The Company had acquired considerable power in India by the 1770s.

Easter Island in the Pacific is reached by a Spanish expedition.

Captain James Cook undertakes his second voyage, designed to circumnavigate the globe and determine the existence of a great southern land mass.

| 1770 | 1771–72 | 1772 | 1772–5 | 1772–77 |

Thomas Gainsborough – *The Honourable Mrs Graham*

When this portrait went on show at the Royal Academy in London in 1777, it attracted great praise – for the artist's talent and his sitter's beauty. It shows an eighteen-year-old Mrs Graham, daughter of the 9th Baron Cathcart, Ambassador to Catherine the Great. It is easy to see how Gainsborough's elegant, fluid approach made him a leading portraitist of English Georgian society.

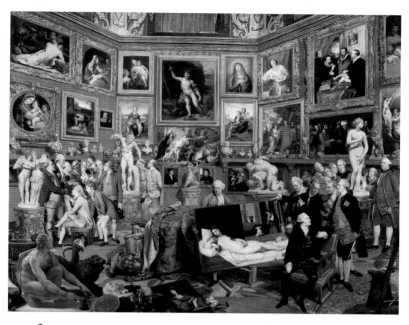

Johan Zoffany – *The Tribuna of the Uffizi*

Zoffany won international repute as a portraitist of the upper classes and king of the conversation piece. With a witty Rococo theatricality, he manipulated content to bold effect, often using multiple figures. Here he gathered numerous actual treasures of the Grand Duke of Tuscany fictitiously into one room. The reception was mixed. To a modern eye the strange perspective, scale and overwhelming detail – each element fighting for equal attention – seems like a computer-generated collage.

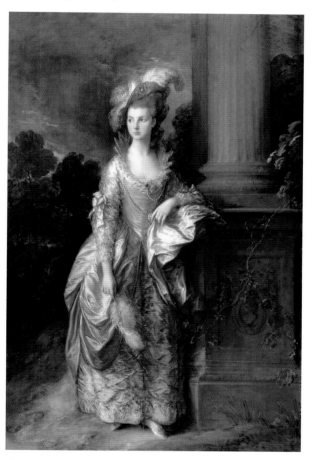

Louis XV dies and Louis XVI becomes the last king of France before the Revolution. The term 'Louis XVI style' will often be used to refer to the great interest in the Antique that feeds the Neoclassicism of the later 1700s.

The American Revolution breaks out as Great Britain's colonies start their battle for independence.

The American Declaration of Independence is formally adopted on 4 July in Philadelphia. The American Revolution will continue until 1783.

Adam Smith's *Wealth of Nations* is published. It argues for a semi-unregulated approach to trade and economics.

| 1774 | 1775 | 1775–77 | 1776 |

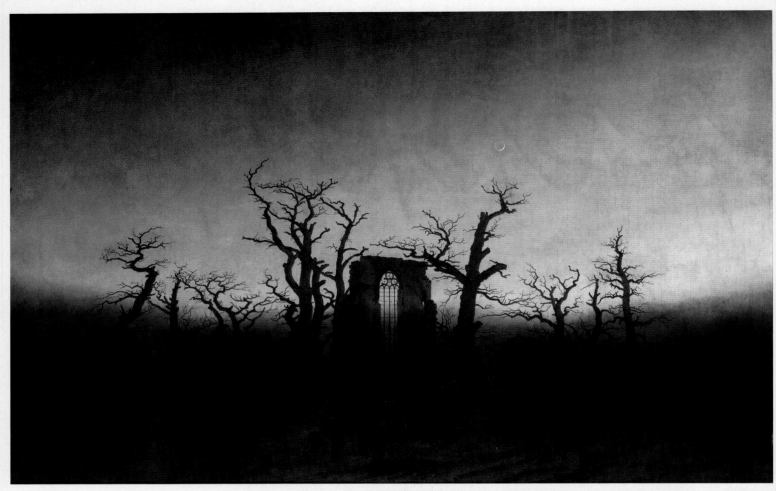

Science or Fiction?

Eighteenth-century Gothic culture is often seen as a precursor to science fiction, and 'science' is a key term here. Gothic art and writing feed on the unknown, on superstitions, mysteries and uncertainties. The popularity of the Gothic at this time gives an insight into a significant reaction in the 1700s to the scientific rationalism of the Enlightenment, which was increasingly pervading everyday life. Many people felt unsettled by the startling new ideas of science and logic that seemed to run counter to comfortably established traditions bound up with Church and court. The uneasiness of Gothic culture expressed this anxiety while allowing its consumers to retreat back into the medieval 'Dark Ages' from which contemporary scientists urged them to emerge.

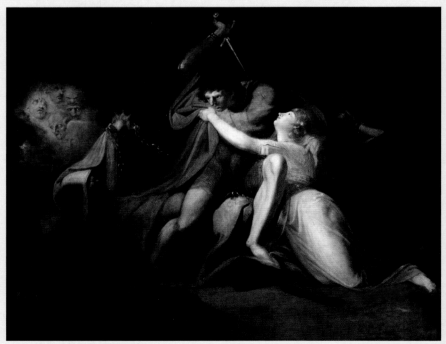

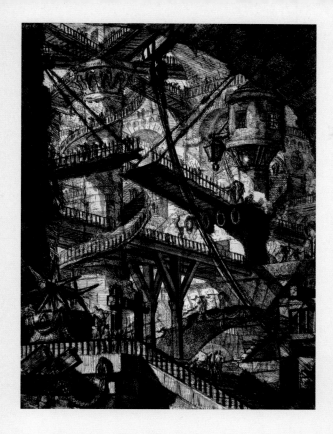

GOTHIC HORROR

A heightened supernatural sensationalism became an important cultural force in art and culture in the second half of the 1700s, persisting into the early 1800s – and, in different forms, beyond that. Ideas that circulated about the appeal of variety, romance and the unexpected remained tame and restrained at one end of the scale, but dramatically extreme at the other.

ABOVE LEFT. Caspar David Friedrich – *Abbey in the Oakwood* **(1809)**
Here an ecclesiastical 'Gothic' ruin rises darkly against an eerie sky. A tiny line of monks bearing a coffin makes its way past an open grave – is this a message about death or transcendence?

LEFT. Henry Fuseli – *Percival Delivering Belisane from the Enchantment of Urma* **(1783)**
Swiss-born Fuseli admitted to fabricating this tale of Percival and Belisane. Damsels in distress were a common Gothic theme but Fuseli was forward-looking in marrying psychologically intense imagery with a potent sexuality.

ABOVE. Giovanni Battista Piranesi – *The Drawbridge, from Imaginary Prisons* **(c. 1749–61)**
Piranesi used his acute architectural understanding to produce a series of strikingly dreamlike printed images, said to represent visions he had when delirious with fever.

'Gothick' culture in 18th-century art took its name from the medieval ruins and buildings that inspired some of its tendencies. The genre had various forms. These included dramatic renderings of grand ruins, breathtaking alpine landscapes and sensationalized scenes from literature. Thinkers of the day were much engaged with ideas about the 'picturesque', the 'beautiful' and the 'sublime', sparked by writings such as Edmund Burke's influential *A Philosophical Enquiry into the Origin of Our Ideas of the Sublime and Beautiful* (1757). A taste arose for having the imagination stimulated by interesting irregularity; the term 'sublime' was attached to things that created a feeling of awe.

These ideas were closely bound up with the landscape. For example, picturesque grottoes and false 'ruins' appeared in grand gardens designed by masters such as Humphry Repton. Painters in turn depicted these kinds of scenes and garden-owners sought inspiration from paintings. People on the Grand Tour looked out for views of dangerous mountain passes and pondered how humans became a speck when set against nature's grandeur. All this provoked intense and altered mind-states –

be this the hallucinatory prison etchings of the Italian artist–architect Giovanni Battista Piranesi or the spiritual landscapes of misty infinity by the German Romantic painter Caspar David Friedrich. Much of J. M. W. Turner's work, such as his dramatic sea paintings, continues the sublime tradition.

Another aspect of the Gothic was an often macabre supernaturalism with sexual undertones – an early form of 'horror' that would later influence Surrealism and horror movies. Henri Fuseli was a central practitioner and his best-known work, *The Nightmare* (see p. 164), made an impact when it appeared at the Royal Academy in the 1780s. It is easy to see that he was an influence on William Blake's work. Fuseli also sought inspiration in Shakespeare's plays, and suspensful literary tales were a strong crossinfluence on Gothicism in art. Horace Walpole's *Castle of Otranto*, first published in 1764 and a hit across Europe, is often seen as the first true Gothic novel. Such stories were filled with secret passages and trapdoors, mistaken/mysterious identities, wild and remote 'historical' locations such as castles, and heroines fleeing the grasp of an evil man. **AK**

1780-1790

Revolution is in the air. The American War of Independence draws to a close, and peace is sealed with the Treaty of Paris in 1783. In France the political situation deteriorates, culminating in the Revolution of 1789. In art Neoclassicism holds sway. The paintings of Jacques-Louis David and his colleagues conjure up the glories of ancient Greece and Rome, but they are often interpreted as thinly veiled comments on current events. Alongside this highly politicized art, there is also a growing taste for escapism. While the reading public devours the Gothic novels of Horace Walpole, William Beckford and Ann Radcliffe, painters like Henry Fuseli and William Blake explore the darker side of human nature, conjuring up visions of demons, ghosts, witches and sinister fairies. IZ

Henry Fuseli – *The Nightmare*

This painting created a sensation when it was shown at the Royal Academy in London, appealing to the contemporary taste for Gothic horror. It has been interpreted in several ways, but the original inspiration may have come from a visual pun. The woman's dream is caused by the incubus, or mara, which perches on her chest, while a spectral horse (a 'night mare') peers around the curtain. As so often with Fuseli, the picture exudes an air of disturbing sexuality.

The British General Charles Cornwallis surrenders to American forces at Yorktown, Virginia. This proves to be a decisive victory in the struggle for independence.

Thomas and William Reeves are awarded the Silver Palette of the Society of Arts for their invention of watercolour cakes. Previously, watercolours had been sold in shells.

The Iron Bridge over the River Severn is completed. This is the first bridge of its kind to be built from cast iron, a landmark achievement in the Industrial Revolution.

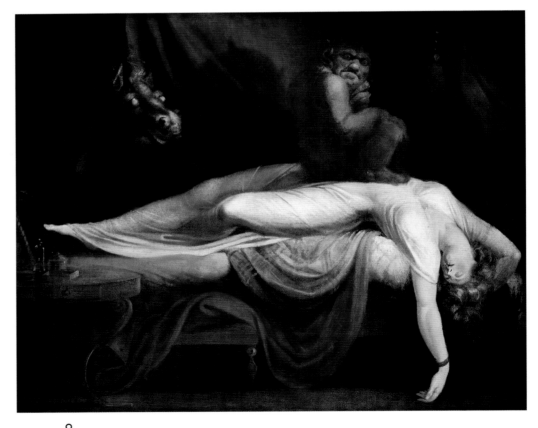

1781

1782

Antonio Carnicero – *Ascent of a Montgolfier Balloon in Aranjuez*
Following successful test flights in France, demonstrations of the Montgolfier balloon were staged at many European venues. This flight took place on 5 June 1784, when a Frenchman called Bouclé piloted the balloon in front of the Spanish royal family, near their palace at Aranjuez. Events such as this sparked off a craze for images of balloon flights, not only in paintings, but also on chair-backs, clocks and even crockery.

Jean-Jacques Rousseau's controversial *Confessions* is published four years after his death. Rousseau was a founding father of the Enlightenment, and his political philosophy inspired leaders of the French Revolution.

Charles Willson Peale opens an exhibition gallery next to his studio in Philadelphia, Pennsylvania. This houses many of his portraits of heroes of the American War of Independence, including several of George Washington.

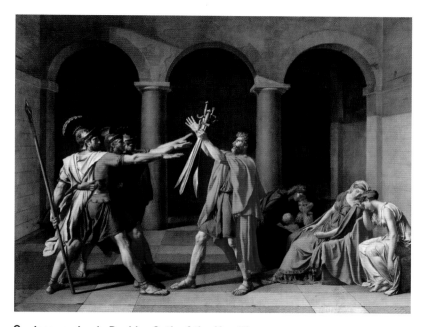

Jacques-Louis David – *Oath of the Horatii*
This painting had an incendiary effect when it was exhibited at the Paris Salon. The theme is taken from ancient history, when two families – the Horatii and the Curatii – find themselves on opposing sides in a war between Rome and Alba. The sons in both families were required to fight each other, even though they were closely linked by marriage. In the days leading up to the French Revolution, this blend of heroism and self-sacrifice was viewed as a call to arms.

The French Revolution begins with the storming of the Bastille on 14 July. It leads to the overthrow of the monarchy and the establishment of a republic based on principles of natural rights and 'liberty, equality and fraternity'.

1784

1789

1790–1800

Revolution and unrest. In France the storming of the Bastille in 1789 marks the beginning of the French Revolution. With mounting pressure from the populace, this is the beginning of the end for the monarchy. Elisabeth Vigée Lebrun's skilled portrayals of Marie Antoinette attempt to elevate the desperate status of the Queen in the public eye – to little avail. Ushering in the Neoclassical style that will define the era, Jacques-Louis David's sobering political canvases will also change the course of Western art. In England the Industrial Revolution is well underway as technological advancements develop into increasing mechanization. In the United States the young country is in the first decade of its independence, and its artists are concerning themselves with the development of a distinctively American style. ED

Elisabeth Vigée Lebrun – *Lady Hamilton as a Bacchante*

This portrait represents a remarkable collaboration between two fascinating female figures in 18th-century Europe. Though she spoke begrudgingly of the free-spirited and often scandalous figure of Lady Hamilton, Elisabeth Vigée Lebrun painted her multiple times. Vigée Lebrun was one of the only successful professional female artists of the 18th century, and was the favoured portraitist of Marie Antoinette during her controversial reign as queen of France. In this more light-hearted commission, Vigée Lebrun pictures the frivolity of Lady Hamilton as a Bacchante, a companion to the god of wine.

Jacques-Louis David, the Neoclassical painter, unveils his famous work *The Death of Marat*, depicting the brutal murder of the Revolutionary leader Jean-Paul Marat.

King Louis XVI is executed by guillotine on 21 January. His death inaugurates the bloodiest phase of the French Revolution, which culminates in the Reign of Terror from September 1793 to July 1794. Intended to purge France of enemies of the Revolution and protect the country from foreign invaders, it results in the execution of about 17,000 people, including Marie Antoinette.

Joshua Reynolds, famed British portraitist and the President of the Royal Academy, dies in London.

1792

1793

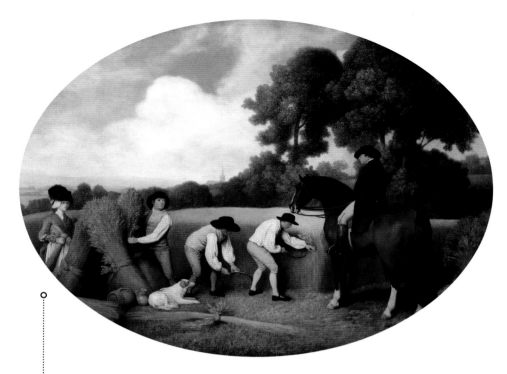

George Stubbs – *Reapers*

The British artist George Stubbs painted the original version of this work together with its counterpart, *Haymakers*, in 1785, and exhibited both canvases at the Royal Academy, London, the following year. Both compositions picture a figural group engaging in the rural environment that surrounds them. In the 1790s he adapted the subjects to three oval versions painted in enamel, as shown here. Though Stubbs was best known for the anatomical exactitude of his paintings of horses, the labouring rural class in the throes of the Industrial Revolution is the primary focus here.

Charles Willson Peale – *Staircase Group*

This portrait is a masterclass in early illusionism. The painting pictures Peale's two sons climbing a flight of stairs. An actual step emerges from the base of the painting, and is nearly indistinguishable from the painted steps that follow. The constructed doorframe surrounding the piece further tricks the eye. Just below one son's foot lies a ticket to Peale's museum; Peale exhibited this painting in celebration of the first art school in the country, founded in 1795, and to indicate to audiences that the future was bright for art in the United States.

Edward Jenner discovers that inoculating patients with cowpox provides immunity from the deadly smallpox virus, thus inventing the first vaccination.

George Washington publishes his farewell address as US President, a final letter to the nation in which he calls for everyone to work together for the common good.

Lyrical Ballads by William Wordsworth and Samuel Taylor Coleridge is published, marking the start of the Romantic movement in literature.

1795 1796 1798

4
—

ROMANTICISM
& BEYOND

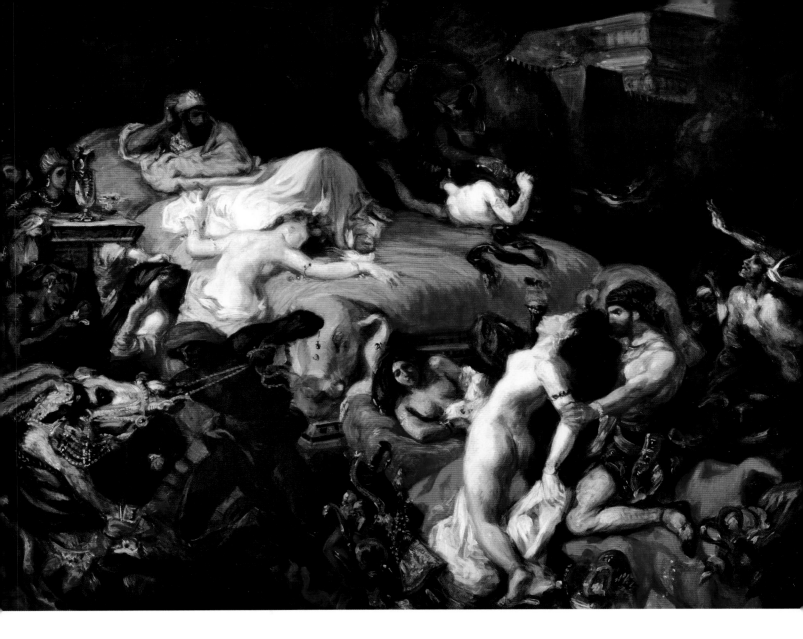

Romanticism was a complex, multifaceted movement, which flourished in most parts of Europe. It emerged in the late 18th century and blossomed in the first half of the 19th century. In its most basic sense, Romanticism developed as a reaction against the clarity, logic and order that were the guiding values of the Enlightenment and the Neoclassical movement.

This reaction manifested itself in many different ways. In some cases, it focused on the importance of the individual. For Neoclassical artists, stoicism and self-sacrifice were the order of the day, but the Romantics had a rebellious spirit, ready to embrace a worthy cause or struggle. Equally though, the Romantics recognized how small and insignificant the individual could be when pitted against the vast size and power of nature,

and many landscape artists chose to concentrate on this. The reaction could also have been against reason itself; during the Romantic era, there was a taste for the irrational – subjects drawn from horror, fantasy, the exotic or even madness itself.

In another sense, Romanticism had an element of escapism. The term has its origins in the medieval 'romances' – the tales of love and chivalry that had been spread by the troubadours. This helps to explain the nostalgic taste for medieval subjects, which was a recurrent theme throughout the 19th century. However, this trend was not limited to a single period. It represented a desire to escape from the more unpleasant aspects of the present day – the 'satanic mills' of the Industrial Revolution, mass urbanization and the industrialization of the countryside itself.

Given the broad scope of the movement, it is hardly surprising that there is no visual style which links the various strands. Romanticism developed in a different way in each country. In France, it is chiefly associated with the 'Romantic versus Classic' debate, which took place in the battleground of the Salon in the 1820s. The leaders of these two camps were Delacroix and Ingres. Trouble erupted in 1824 when the former exhibited his *Massacre at Chios* at the Salon. This gory episode was part of the Greek War of Independence, which was the great *cause célèbre* of the Romantic movement, because Greece was regarded as the fount of Western civilization. However, the painting raised the hackles of the critics for two reasons: firstly, it breached the conventions of the Salon by representing a modern-day subject – an area that was deemed to be the province of a journalist, rather than a serious artist. In addition, Delacroix's fiery handling and uninhibited use of colour made the picture seem unfinished in the eyes of conservative commentators, who preferred the smooth, detailed aesthetic that was expected at the Salon.

Three years later, Delacroix hit the headlines again, when he showed *The Death of Sardanapalus*. Based on a play by Lord Byron, the painting was a disturbing orgy of violence. Sardanapalus, a quasi-mythical ruler of Assyria, has lost his kingdom in battle, so he chooses to commit suicide. Before dying, however, he decides to destroy everything that has ever given him pleasure – his concubines, his horses and his treasure. The critics were appalled, partly because of the chaotic composition, but mainly because of the king's apparent relish, as he watched the slaughter taking place before his eyes.

In Britain, the standard-bearers for Romanticism worked in a variety of different fields. Henry Fuseli (Swiss-born but mainly active in England) was drawn to fantastic or supernatural subjects, which were often spiced with elements of horror, cruelty and thinly veiled eroticism. By contrast, his friend William Blake used a blend of mysticism and a personalized mythology to express his deeply felt religious views.

Blake had a group of followers known as the Ancients, who shared many of his ideals. Taking inspiration from their mentor's illustrations for *The Pastorals of Virgil* (c. 1821) they conjured up a bucolic golden age of plenty. Edward Calvert's engravings emphasized the pagan side of this vision – he even erected an altar to Pan in his garden. Meanwhile Samuel Palmer's approach was more biblical, echoing the theme of fertility and abundance in the Book of Psalms: 'Thou crownest the year with thy goodness … The Pastures are clothed with flocks; the valleys also are covered over with corn; they shout for joy, they also sing'

PREVIOUS PAGE. Claude Monet – *Poppy Field* (1873)

ABOVE LEFT. Eugène Delacroix – *The Death of Sardanapalus* (1827)

RIGHT. Samuel Palmer – *The Shearers* (1833–34)

(Psalm 65). In his watercolours and drawings, Palmer portrayed shepherds in the moonlight, sleeping next to their flocks, or magical trees with an impossible profusion of blossoms or fruit.

Britain's most famous landscape painters, John Constable and J. M. W. Turner, were also associated with the movement. Early in his career, the latter painted classical landscapes that were very much in the spirit of Claude, but after 1800 he began to aim at more dramatic effects. *Snow Storm: Hannibal and his Army Crossing the Alps* (1812) was one of his first major efforts in this vein, showing a famous army looking helpless and insignificant when confronted by the cataclysmic forces of nature.

In Germany, Caspar David Friedrich ploughed a similar furrow. In his *The Wreck of Hope* (1823–4), for example, a naval vessel has met with disaster in its efforts to find a way through the Arctic wastes. Indeed, nature's triumph is so complete that the remains of the ship can barely be seen amid the jagged shards of ice. The subject was loosely based on William Parry's expedition to find the Northwest Passage. Friedrich often portrayed human figures dwarfed by vast panoramas but, in keeping with his deep religious faith, he usually added a symbol of salvation. This could take many forms – a distant cross in the mountains, a ship on the horizon or a church spire swathed in mist.

Also in Germany, there was an influential group of young artists known as the Nazarenes. Led by Friedrich Overbeck, Franz Pforr and Peter Cornelius, they formed a community called the Brotherhood of St Luke, aiming to recapture the spirit and working practices of the Middle Ages. For the most part, they opted for medieval subjects and styles and made efforts to revive the taste for monumental fresco painting.

There were a number of affinities between the Nazarenes and the Pre-Raphaelite Brotherhood (see p. 187). The Pre-Raphaelites also had a taste for early historical themes, though they preferred to execute these in a painstakingly detailed manner. Their influence also extended far longer, through a second generation of Pre-Raphaelites, such as William Morris, who was a pioneer of the Arts and Crafts Movement (see p. 204), and Edward Burne-Jones, who was a major exponent of Symbolism.

In the middle years of the century, the dominant movement was Realism. In France, this was spearheaded by Gustave Courbet and Jean-François Millet, who shocked Salon-goers with their oversized paintings of peasants. In part, the authorities were concerned that these pictures were politically subversive – and indeed Courbet was later jailed for his activities during the Paris Commune – but the movement was also part of a broader

LEFT. Caspar David Friedrich – *The Wreck of Hope* (1823–4)

ABOVE RIGHT. Claude Monet – *Water Lilies* (1916)

reaction against the power of official exhibiting bodies. Across Europe, artists increasingly resented the restrictions imposed by juries and selection committees. This culminated in the Salon des Refusés – an exhibition of works that had been rejected by the main Salon. The idea had been to mock the 'refused', but as these included a number of artists who later became very famous – Whistler, Pissarro, Cézanne and, above all, Manet – the event actually undermined the authority of the Salon.

Instead, artists began to organize their own exhibitions and used dealers to market their works, rather than relying on the selling power of the official shows. This trend was pioneered by the Impressionists, who staged eight exhibitions between 1874 and 1886. At the first show, the group was pilloried in the press, but, ironically, one of the attacks gave the movement its name. A painting by Claude Monet, *Impression: Sunrise* (1872), was singled out for particular criticism and its title was used mockingly to dismiss the 'Impressionists' as a whole.

One of the guiding principles of the Impressionists was the practice of painting in the open air, rather than in the studio. They wanted to capture the most transient effects of nature – reflections rippling in the water, shadows forming on a cloudy day, sunlight filtering through the leaves on a tree. In order to do this, they had to work quickly, and this led them to adopt their revolutionary technique. They used short dabs of complementary colours, which fused in the spectator's eye, rather than painstakingly mixing their pigments beforehand. For contemporary critics, who were accustomed to the detailed finish of Salon pictures, the results seemed sketchy and slapdash. However, they gradually became accustomed to it and, by the time of the final Impressionist exhibition, the style was widely accepted.

The gospel of Impressionism spread beyond Europe, reaching as far as Australia and the United States. In Australia, for example, the groundbreaking '9 by 5 Impression Exhibition' (so-called because the pictures were painted on cigar boxes measuring 9 by 5 inches) took place in 1889. By this stage, some artists in France were looking to move on. They had experimented with Impressionism, but wanted to tackle subjects that were weightier and more lasting. Led by the four great giants of the style – Paul Cézanne, Georges Seurat, Paul Gauguin and Vincent van Gogh – the Post-Impressionists laid the foundations of modern art.

1800–1810

Napoleon as emperor. Napoleon Bonaparte's armies spread across Europe, and in 1800 they enter Italy, winning a notable victory against the Austrians at Marengo. Napoleon then achieves even greater success at the Battle of Austerlitz (1805), where he overcomes a coalition of Russian and Austrian forces, though the naval defeat at Trafalgar (1805) is a setback. Undeterred, he launches an invasion of the Iberian Peninsula (1807), initially posing as Spain's ally. In 1804 Napoleon is crowned Emperor of the French at Notre Dame Cathedral in Paris. The title distances him from the discredited kings of the Ancien Régime, linking him instead to the glorious memory of Charlemagne's empire. In the arts these imperial pretensions are reflected in the new Empire style, which is particularly evident in furniture, fashion and the decorative arts. IZ

Antonio Canova – *Napoleon as Mars the Peacemaker*

There was a terrible irony in describing Mars, the Roman god of war, as a 'peacemaker'. No less ironic was the ultimate destination of this enormous (3.3 m/11 ft high) statue. Napoleon had it commissioned for the Foro Bonaparte, a new forum in Milan, which was to be a focal point of his empire in Italy. However, the scheme was never built and the statue languished in a storeroom, until it was seized by the British. It was then donated to the Duke of Wellington, Napoleon's conqueror at the Battle of Waterloo (1815), who placed it in his London home, Apsley House. It is still on view there today.

Thomas Jefferson is elected as the third President of the United States.

The Louisiana Purchase is agreed. Through this transaction, the United States acquires the Louisiana Territory from France for 68 million francs. The Territory includes land from fifteen of the present-day states.

Napoleon is crowned emperor at Notre Dame Cathedral in Paris.

| 1801 | 1802–6 | 1803 | 1804 |

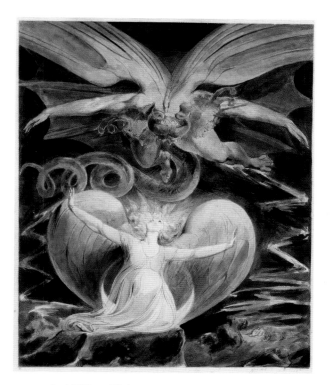

William Blake – *The Great Red Dragon and the Woman Clothed with the Sun*

This striking image comes from a large series of pen-and-watercolour illustrations of the Bible, which Blake produced for his patron, Thomas Butts. It relates to a passage in Revelation (12: 12–17) describing the Apocalypse. A huge dragon with seven heads and eleven horns (the Devil) confronts the Woman (symbolizing both the Virgin Mary and the Church). Blake tackled this section of the narrative with particular gusto, as it had close affinities with his own prophetic writings. His images played a major role in Thomas Harris's 1981 novel *Red Dragon*, in which they inspired a series of murders.

Antoine-Jean Gros – *Napoleon on the Battlefield of Eylau*

In February 1807 Napoleon's forces won a narrow victory over the Russian army at Eylau, in East Prussia. Losses were heavy, but Napoleon was anxious to capitalize on the propaganda value of his success. Artists were invited to enter a government competition to commemorate the triumph, and this was the winning entry. Gros's painting was unusually realistic for the time, with a large pile of corpses displayed very prominently in the foreground.

The Battle of Jena marks a significant upturn in the fortunes of the French. Napoleon's army inflicts a decisive defeat on the Prussians.

The Battle of Trafalgar is a serious setback to Napoleon's plans. The combined fleets of France and Spain are defeated by the British navy, under the leadership of Admiral Horatio Nelson.

The invasion of Spain heralds a new phase in the Napoleonic Wars. French forces occupy the country, initiating the Peninsular War.

c. 1805 | 1805 | 1806 | 1807 | 1808

1810–1820

The tide turns. Napoleon's grand project begins to go off the rails when, after initial successes, his invasion of Russia (1812) turns into a humiliating retreat. This is followed by another defeat, at the Battle of Leipzig (1813), and in the following year Napoleon is exiled to the Mediterranean island of Elba. He escapes in 1815 and embarks on his final campaign – the 'Hundred Days' – which ends in ignominious defeat at the Battle of Waterloo. This time he is sent to the much more remote island of St Helena in the South Atlantic, where he ends his days. IZ

Francisco de Goya – *The Third of May 1808*

On 2 May 1808 there was a popular uprising in the Spanish capital, Madrid, against the occupying French army. It was swiftly quelled and, on the following day, the French carried out brutal reprisals. Six years later, when the war was over, Goya produced two dramatic scenes to commemorate these events. The one shown here underlines the savage inhumanity of war. The daytime executions have been transformed into a sinister nocturnal scene, with all eyes focused on the figure in white, whose raised arms echo the pose of the crucified Christ. He is also huge. He is shown kneeling; if he stood up he would tower over his killers. The official response to the painting was lukewarm, partly because during the conflict, Goya had accepted an award from the French emperor.

The French retreat from Moscow proves a humiliating setback for Napoleon. The Russians' scorched-earth policy leaves the French hungry and exhausted during a freezing winter.

Pride and Prejudice, Jane Austen's most famous novel, is published.

Napoleon is exiled in Elba, after being forced to abdicate.

Defeat at the Battle of Waterloo finally ends Napoleon's dreams. He is exiled to the remote island of St Helena.

| 1812 | 1813 | 1814 | 1815 |

Théodore Géricault – *Riderless Racers at Rome*

In many ways Géricault was the archetypal Romantic artist, drawn to themes of violence, madness and despair. His most famous picture was *The Raft of the Medusa*, an enormous depiction of a shipwreck, filled with graphic images of the dying and the dead. *The Race of the Riderless Horses* was meant to be an equally monumental project, and Géricault hoped to capture the turbulent spirit of this event – which was staged annually in Rome as the climax of the Spring Carnival – in a huge 9.1-m (30-ft) wide canvas. In the end, the sheer scale of the scheme defeated him, leaving only a series of preparatory paintings such as this. Géricault had a passion for horses, which contributed to his early death. In 1824, aged thirty-two, he fell from his mount and developed an abscess, which turned septic after he cut it open with his knife.

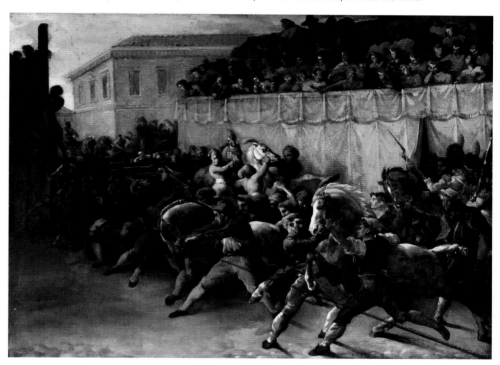

Benjamin West – *Benjamin Franklin Drawing Electricity from the Sky*

This tiny painting was a study for a larger portrait, which West intended to donate to Pennsylvania Hospital – an institution that Franklin had founded. Both men were natives of Pennsylvania, and West was keen to honour the memory of the famous statesman and scientist (Franklin had died in 1790). The scene is a strange, allegorical representation of the experiment the latter is said to have carried out in 1752, demonstrating that lightning is a form of electricity. Franklin is seated in the heavens, assisted by a group of angels, one of whom is dressed as a Native American.

The Peterloo Massacre takes place in Manchester, England, when cavalrymen disperse a crowd of protesters demanding parliamentary reform.

c. 1816

1817

1819

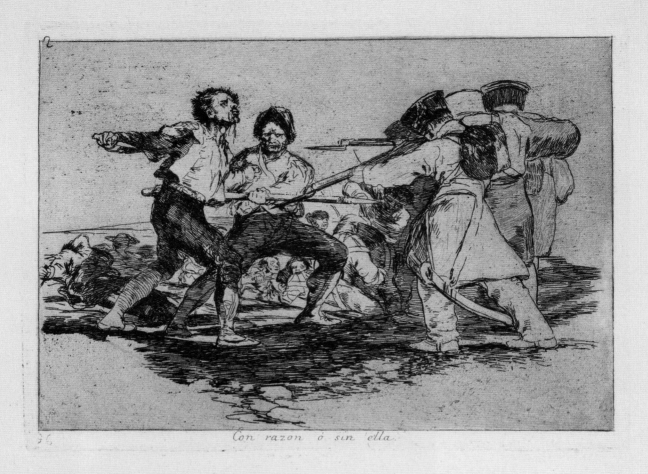

Con razon ó sin ella.

The Peninsular War (1808–14)

At the height of Goya's career, his homeland was torn apart by a terrible conflict, as Spain was drawn into the Napoleonic Wars. The two countries had been allies – they fought side by side at the Battle of Trafalgar (1805) – so there was no real concern when French troops entered the country. Ostensibly, they were coming to aid Spain against the Portuguese, who were allies of the British. However, it soon became obvious that this was an army of occupation. There were popular uprisings, but these were suppressed, and the Spanish king (Charles IV) abdicated in 1808. In his place, Napoleon installed his brother, Joseph Bonaparte, who ruled Spain until it regained its independence. This was the struggle that Goya so graphically portrayed in his *Disasters of War*.

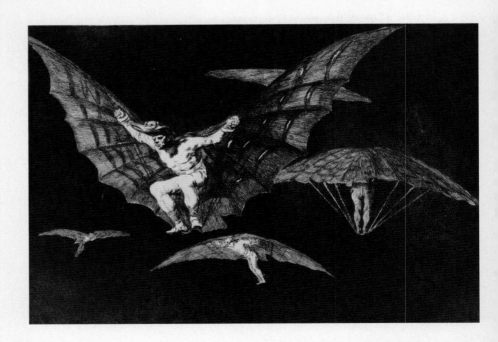

GOYA'S ETCHINGS

There are intriguing, contradictory elements in Francisco Goya's career as an artist. On the one hand, he enjoyed great success in official circles, gaining important commissions from the court, the aristocracy and the Church. He also won significant honours, becoming Painter to the Royal Household and Director of the Academy of San Fernando. At the same time, he also had a dark side, producing nightmarish images of witchcraft, violence and death. In many cases, he found the best outlet for these in his graphic work.

The pessimistic strain in Goya's art seems to have been triggered by a near-fatal mystery illness in the winter of 1792–93. During his convalescence, he produced a series of small pictures on subjects drawn from his imagination. Goya found this a welcome change from his normal routine, because it enabled him to make observations about life that he could never make in his commissioned works, 'where caprice and invention are not permitted'.

Goya was able to develop these ideas further in his first great set of prints, *Los Caprichos* (the 'Caprices'), published in 1799. It consisted of eighty plates, a combination of etchings and aquatints. Each of the images was accompanied by a cryptic caption and a brief commentary. In advertising the series, Goya described the subjects as a satire on 'the follies and blunders common to every society … together with the vulgar prejudices resulting from custom, superstition, and ignorance'. The *Caprichos* proved very popular, enhancing Goya's reputation, even if many commentators insisted on interpreting the etchings as caricatures of specific public figures.

The most famous plate in the series is *The Sleep of Reason Produces Monsters*, in which sinister owls and batlike creatures crowd around a sleeping figure. Goya had originally intended this to be his frontispiece. In an early pen-and-ink drawing, the figure was a self-portrait, hunched over an etching press, and the surrounding details were the follies that he was dreaming of satirizing. Later,

he provided a more conventional frontispiece and moved this plate to the middle of the series. He also removed the element of self-portraiture, making the plate far more ambiguous and disturbing.

Towards the end of his life, Goya produced another series of 'Follies' (*Los Disparates*, c. 1816–24). Here the imagery was even more perplexing. Some critics have tried to relate the pictures to proverbs, but many remain obscure. The prints were not published in Goya's lifetime.

No such ambiguity surrounds Goya's most famous set of prints, *The Disasters of War* (1810–20). These record the artist's reactions to the horrors of the Peninsular War. Much of the conflict took the form of a guerrilla war between French troops and civilians, with atrocities on both sides. With graphic candour and without adopting a partisan view, Goya catalogued the violence: unarmed civilians are shot, bayoneted or garrotted; women are raped; soldiers are stoned or beheaded; corpses are stripped, dismembered and impaled on trees.

The unflinching realism of the *Disasters* marked a genuine breakthrough in the field of war art. There were no organized battle scenes, no glorious victories, no individual acts of heroism or patriotism, just a depressing litany of the depths to which humanity can sink. Goya's prints were not commissioned and, unsurprisingly perhaps, they remained unpublished until several decades after his death. IZ

ABOVE LEFT. *Rightly or Wrongly* (c. 1810–13)
This is the second plate from *The Disasters of War*, and underlines Goya's despair. It does not matter who is right or wrong: the fighting is brutal and senseless.

LEFT. *A Way of Flying* (1823)
Why are a group of naked men flying in the dark, wearing strange, bird-shaped hats? This is one of the most baffling prints in Goya's *Los Disparates*.

1820-1830

The Greek War of Independence. The greatest political upheaval of the 1820s is the Greek War of Independence. Greece is regarded as the cradle of Western civilization, so most Europeans feel a natural sympathy for the country's aspirations. This is intensified after the Massacre at Chios, when Ottoman troops land on the island and kill or enslave thousands. The atrocity causes outrage across the Continent, and Greece rapidly becomes the cause célèbre of the Romantic movement. Elsewhere, the taste for Gothic horror reaches a peak. Mary Shelley's *Frankenstein* (1818), Charles Maturin's *Melmoth the Wanderer* (1820) and James Hogg's *The Private Memoirs and Confessions of a Justified Sinner* (1824) are all landmark novels in the genre. The fashion also extends to painting. This is reflected in Louis Daguerre's *Ruins of Holyrood Chapel* and Caspar Friedrich's *Abbey in the Oakwood* (see p.162). IZ

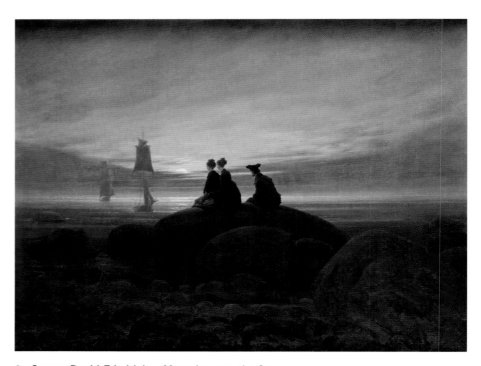

Napoleon dies in exile on the island of St Helena.

The Massacre at Chios by Ottoman troops horrifies Europeans and increases support for the Greek War of Independence.

Caspar David Friedrich – *Moonrise over the Sea*
Friedrich was the greatest of the German Romantic painters. A dour, introspective character, he produced pictures that are hauntingly beautiful. They have a genuine poetic quality, but are also full of Christian symbolism. Here, the figures seen from behind represent Everyman, the ships are tokens of life's long journey, and the distant light is the promise of Christian salvation. The figures are wearing traditional German dress, which was banned at the time. The various German states had not yet been unified but Friedrich, an ardent patriot, supported the growth of this movement.

Lord Byron dies at Missolonghi. He is trying to organize opposition to the Turks, but dies of a fever before seeing action.

| 1821 | 1822 | 1824 |

Louis Daguerre – *The Ruins of Holyrood Chapel*

Together with William Henry Fox Talbot, Daguerre is famed as the inventor of photography; both men revealed their findings to the world in 1839. Prior to this, Daguerre made his living as a painter and stage designer. He had a particular flair for depicting illusory lighting effects, as seen in this atmospheric moonlit scene. The decision to paint a ruined Scottish chapel was probably influenced by the prevailing vogue for the novels of Sir Walter Scott, which were bestsellers throughout Europe.

Nicolas Hüet the Younger – *Study of the Giraffe Given to Charles X*

This charming watercolour provides a record of the first giraffe to be seen in Paris. It was a diplomatic gift, presented to the French king by the Viceroy of Egypt. It was housed at the Jardin des Plantes (the botanical gardens) in Paris, where it attracted 600,000 visitors in the first six months. It remained a popular attraction for the next eighteen years. Hüet came from a family of artists, several of whom specialized in animal painting. He had been part of the scientific and artistic commission that Napoleon had taken to Egypt, and was also the official painter of Empress Josephine's menagerie.

The world's first public railway service using steam-powered trains opens in northern England, on the Stockton–Darlington line.

The Decembrist Uprising takes place in St Petersburg, as a protest against the accession of Tsar Nicholas I.

The Battle of Navarino is a key engagement in the Greek struggle for independence. Here, the combined fleets of Britain, Russia and France defeat the Egyptian–Turkish forces.

c. 1824 **1825** **1827**

1830–1840

The July Revolution. In France the after-effects of Napoleon's fall continue to create instability. He is replaced by the revived Bourbon monarchy. However, Charles X – a younger brother of Louis XVI – soon proves an unpopular leader. He is eventually forced to abdicate after three days of fighting on the streets of Paris. The uprising is celebrated in a famous painting by Delacroix.

In the cultural sphere, a momentous event takes place at the end of the decade, when in 1839 William Henry Fox Talbot and Louis Daguerre reveal details of their experiments with photography. Their two processes – both quite distinct – will soon have an enormous impact on the arts. Photography will prove a useful tool for some painters, while for others it will change the way they look at the world. IZ

Eugène Delacroix – *Liberty Leading the People*

The leader of the French Romantic School, Delacroix addressed the great issues of the day in his art. He made his name with *The Massacre at Chios* – a powerful depiction of an early atrocity in the Greek War of Independence – and gained further high praise for this stirring depiction of the July Revolution. This was a violent uprising, in which the French king, Charles X, was ousted. The figure of Liberty is a curious mixture of allegory and reality. She carries a modern gun, but also has the *bonnet rouge* and the Tricolore flag, which were both potent symbols of the French Revolution. The new regime purchased the painting but did not display it, anxious to damp down the public mood of rebellion.

The July Revolution overturns the unpopular regime of Charles X. He is replaced by Louis Philippe.

1830

1830–33

Karl Bryullov – *The Last Day of Pompeii*

Bryullov was the first Russian painter in the modern era to make an impact in the West. This huge 6-m (20-ft) wide canvas is his masterpiece. The initial commission came from Prince Anatole Demidov, with whom Bryullov visited Pompeii in 1828. Further inspiration came from an opera on the theme by Giovanni Pacini. The painting was exhibited to great acclaim in Italy and in Paris, where it won the much-coveted gold medal at the Salon. It was also feted in Russia, where one commentator asserted that '*The Last Day of Pompeii* is the first day of Russian painting'. Sadly, Bryullov was never able to repeat this success, and his career gradually petered out.

Andō Hiroshige – *Sudden Shower over Shono*

This delightful woodblock print comes from the series that helped to launch Hiroshige's career, namely *The Fifty-three Stations on the Tōkaidō*. This consisted of views along the great imperial road that linked Edo with Kyoto. At the time Japan was in a period of self-imposed isolation, so Hiroshige's work was totally unknown in the West until after the 1850s. When it became available, it proved hugely influential, particularly for the Impressionists. They admired the flat, decorative colouring, the deft economy of the figures and the bold composition. Above all, they were intrigued by the way in which Japanese printmakers created a sense of depth through layered, natural effects, rather than through geometric perspective, which had been the cornerstone of Western art since the Renaissance.

The Spanish Inquisition is finally suppressed, after being in existence for more than 350 years.

The Slavery Abolition Act outlaws the trade of slaves throughout the majority of the British Empire.

Greek independence is finally recognized in the Treaty of Constantinople.

The Battle of the Alamo is a key event in the Texas Revolution. The American defenders of this famous Mission are slaughtered by Mexican troops.

| 1832 | 1833 | 1834 | 1836 |

1840–1850

An age of revolutions. The 1840s are a time of widespread political unrest, culminating in 1848, the so-called 'Year of Revolution'. The problems start in France, where protesters unseat the monarch, Louis Philippe, and set up the Second Republic to replace him. The spirit of rebellion soon spreads, affecting the regimes in Denmark, Italy, the German states and Hungary.

Britain is one of the few nations to avoid a political revolt, but changes are afoot in its art world. In 1848 the Pre-Raphaelite Brotherhood (see p. 187) begins to promote a different style of painting. Led by Dante Gabriel Rossetti, William Holman Hunt and John Everett Millais, the Pre-Raphaelites denounce moribund academic art, arguing instead for a fresh, uncomplicated approach. IZ

J. M. W. Turner – *Snow Storm: Steam-Boat off a Harbour's Mouth*
Turner adored painting the sea, particularly when conditions were at their most treacherous. This is probably his most daring example, veering close to abstraction by the standards of the day. He conveyed the violence of the storm by disguising the horizon (it appears to slope down to the right) and by constructing his composition around a swirling vortex. The paint surface is equally turbulent, with thick slashes of off-white and yellow dragged across the darker areas with a palette knife. Not surprisingly, there were some raised eyebrows, with one critic describing the picture as 'a mass of soapsuds and whitewash'. Turner was unrepentant: 'Soapsuds and whitewash? … I wonder what they think the sea is like. I wish they'd been in it.'

Napoleon's remains are returned to France for a state funeral, and laid to rest in Les Invalides, in Paris.

The Penny Black, the world's first postage stamp, comes into circulation.

1840 ‖‖‖ 1842

Gustave Courbet – *A Burial at Ornans*

This huge painting launched Courbet's career amid a blaze of controversy. It shows a country burial in the artist's birthplace, the town of Ornans, near the Swiss border. The picture caused a stir when it was exhibited at the Salon of 1850, largely because of its size (3.15 by 6.68 m/10 by 22 ft) and tone. A scene of this scale would normally have been reserved for an event of some significance – the burial of a king or a hero, rather than an anonymous peasant. It would also typically have been noble and uplifting, but here the figures seemed to have been made as ugly as possible. In the wake of recent political disturbances, this raised suspicions about the artist's motives in the eyes of many of the critics.

Jean-Auguste-Dominique Ingres – *Comtesse d'Haussonville*

Ingres found fame with his historical paintings, religious scenes and nudes, but he was also a superb portraitist. In common with many great artists, however, he was not fond of this aspect of his work. 'I did not come back to Paris [from Rome] to paint portraits,' he grumbled. Certainly, this painting was a major undertaking. It took three years (with a gap for the countess's pregnancy) and involved around sixty drapery studies. The pose may have been borrowed from a Classical statue – Pudicitia ('Modesty') or Polyhymnia (the muse of sacred poetry) have both been suggested.

The Great Famine starts in Ireland. Over the next few years thousands will die of starvation, while thousands more will emigrate to the United States.

The California Gold Rush begins, when news of the first finds leak out. It gathers pace in the following year, when thousands of 'forty-niners' pour into the area. Most are Americans, but some come from as far afield as Australia and China.

The *Communist Manifesto* is produced by Karl Marx and Friedrich Engels.

| 1842–45 | 1845 | 1848 | 1849–50 |

PRE-RAPHAELITE SISTERHOOD

The first barrier that many female painters faced was finding a decent artistic education. It was an obvious advantage, therefore, to have a relative in the profession. Lucy and Catherine Madox Brown were trained by their father, Ford Madox Brown, while also modelling for him and working as his studio assistants. Similarly, Emma Sandys and Rebecca Solomon were mentored by their brothers (Frederick and Abraham, respectively).

Several painters were linked to the Pre-Raphaelite movement through marriage. The most famous example is Elizabeth Siddal, a former milliner who began working for the Pre-Raphaelites as a model (see *Ophelia*, p. 189), before taking informal lessons with Rossetti and eventually marrying him. *Lady Clare* is probably her best-known work. The cramped space and the stiff figures mimic the primitive qualities of medieval miniatures, while the symbolism of the stained-glass window – showing the *Judgement of Solomon* – was a typical Pre-Raphaelite feature. Several of Siddal's paintings deal with marriage between social unequals – a theme that resonated with her fraught relationship with Rossetti.

Evelyn De Morgan's association with the movement came through her husband, William, best known for his exotic ceramic designs, and who was a close friend of William Morris. Evelyn was influenced by the painting style of Edward Burne-Jones, another Pre-Raphaelite, and she also had a deep affection for early Italian art. Her particular favourite was Botticelli.

Julia Margaret Cameron was another artist, who was friendly with several members of the group. She photographed some of them – her portrait of Holman Hunt in his Middle Eastern costume is especially memorable – and her work (see p. 201) carries strong echoes of Pre-Raphaelitism, in both its style and subject matter.

The Pre-Raphaelite style remained a potent source of inspiration in the early 20th century, right up until the outbreak of the First World War. Kate Bunce was associated with the Birmingham Arts and Crafts circle, and achieved some of her greatest successes with Rossettian pictures of minstrels and lovelorn damsels. *The Keepsake* was acclaimed as 'Picture of the Year' by the *Pall Mall Gazette* in 1901. Significantly, it was executed in tempera, the medium that had flourished before the invention of oil painting. Bunce was a founder member of the Society of Painters in Tempera, believing that this medium suited her medieval themes.

The Austrian artist Marianne Stokes (née Preindelsberger) also worked in tempera at times, and participated in the Society's exhibitions. Her interest in early Italian art is evident in her luminous colouring, particularly in her religious pictures, but the Pre-Raphaelite influence is even stronger in *Honour the Women*. This tapestry was woven by Morris & Co. – William Morris's old firm – and fits perfectly with its house style, particularly in the way in which the figures are set against a profusion of flowers. IZ

RIGHT. Kate Bunce – *The Keepsake* (1898–1901)
Bunce took the subject of this painting from a poem by Dante Gabriel Rossetti, 'The Staff and Scrip'. A pilgrim has died, leaving these items to his lady; a scrip is a small bag.

FAR RIGHT. Elizabeth Siddal – *Lady Clare* (1857)
This impassioned scene is based on a poem by Tennyson. Clare has just learned that she is not of noble birth. Her mother – Alice, the nurse – begs her not to tell her fiancé, in case he rejects her.

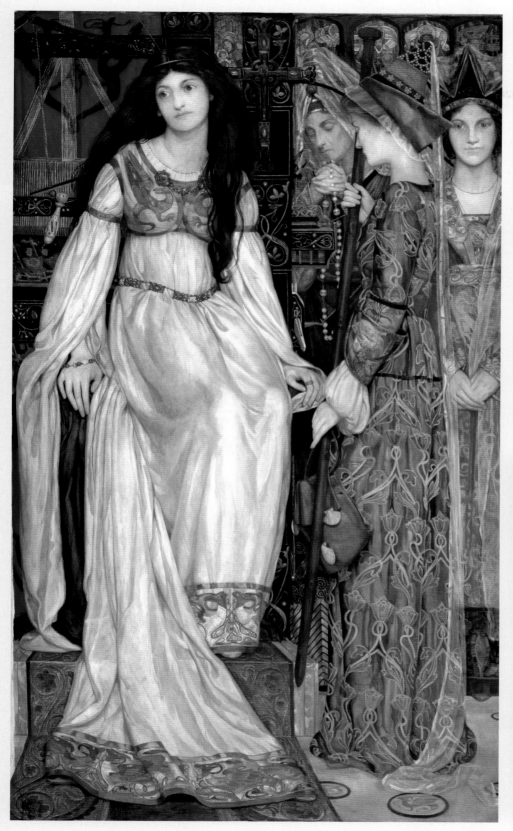

The Pre-Raphaelite Brotherhood

The Pre-Raphaelites arrived on the art scene with an air of mystery. At two exhibitions in 1849, critics noticed that several of the canvases were inscribed with the initials 'PRB'. The 'Brotherhood' was roundly mocked when the secret came out, but their stock rose when the celebrated critic John Ruskin voiced his support. The leading figures in the group were Dante Gabriel Rossetti, John Everett Millais and William Holman Hunt. They chose their name out of admiration for the fresh, natural approach of early Italian art (i.e. before the time of Raphael, 1483–1520). At the time, Raphael was regarded as the world's greatest artist, but he was also the epitome of academic art, which, by the mid-19th century, had come to seem stale and conventional.

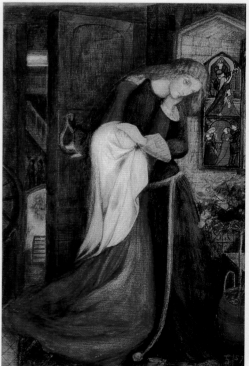

1850-1855

Napoleon III. The political situation in France remains unstable. The Second Republic lasts for just three years (1848–51), before Louis-Napoleon Bonaparte stages a coup and declares himself emperor. As Napoleon III, he will rule until 1870.

In the arts Paul Delaroche is one of a number of artists whose style is described as *juste milieu* ('middle way'). This term, borrowed from politics, suggests a balance between the order of classicism and the fire of Romanticism. For some critics, the term simply means 'bland'. IZ

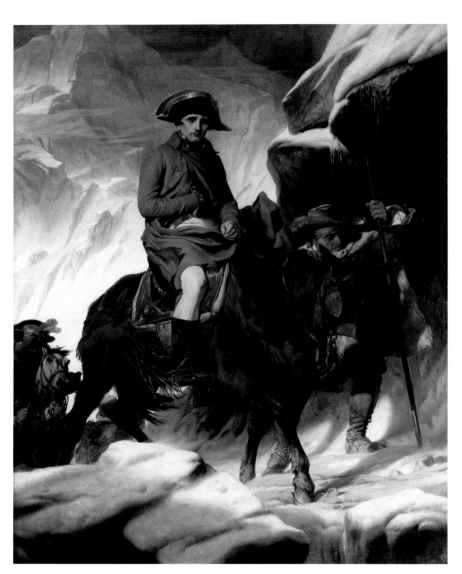

Paul Delaroche – *Bonaparte Crossing the Alps*

This painting illustrates a key episode in Napoleon Bonaparte's campaigns, when he crossed the Alps with his army in May 1800, on his way to defeat the Austrians at the Battle of Marengo. The event was commemorated in a stirring portrait by Jacques-Louis David. Bonaparte had instructed the artist to portray him 'calm, on a fiery steed' and David duly obeyed. The emperor's heroic pose was, however, a Romantic fiction. Napoleon had actually made the crossing on a mule, just as he is portrayed in Delaroche's canvas. There was a resurgence of interest in Bonaparte at this time; his nephew, Louis-Napoleon, had been elected President of France in 1848 and David's painting had recently been put back on public view. Delaroche's commission came from the 3rd Earl of Onslow, who owned a sizeable collection of Napoleonic memorabilia.

The Great Exhibition opens in Crystal Palace, London.

The French President, Louis-Napoleon Bonaparte, stages a coup and declares himself emperor.

1850

1851

Ford Madox Brown – *The Last of England*

Emigration was a major issue in Victorian Britain. Thousands left Ireland because of famine, while the Scots suffered from the clearances (forced evictions, as landowners replaced tenants with sheep). England had its problems too. The Pre-Raphaelite Thomas Woolner emigrated to Australia in 1852, while Madox Brown was thinking of moving to India. At the time of painting this work, he was 'very hard up and a little mad'. The picture shows a grim-faced couple and their tiny child (almost hidden under the woman's shawl) leaving England without a backwards glance. Are they sad to be leaving friends, or bitter at the hand that fate has dealt them? Either way, the rowdy passengers behind them and the row of cabbages at the front indicate that they are travelling economy class. The name of the ship (*Eldorado* – a fabled South American city of riches) is heavily ironic.

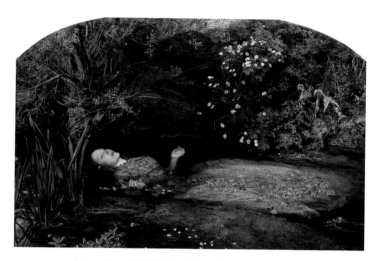

John Everett Millais – *Ophelia*

This is a fine example of the Pre-Raphaelites' brand of poetic realism. It shows Hamlet's tragic lover drowning herself after the death of her father. Millais spent weeks by a riverside in Surrey preparing the setting. The flowers – painted with botanical accuracy – all have symbolic meanings, such as 'love in vain' and 'delusive hope'. The model was Lizzie Siddal, posing in a bath full of water heated by lamps. On one occasion, the lamps went out and Lizzie caught a severe chill. At this stage, her father threatened to sue Millais, unless he paid her doctor's bills.

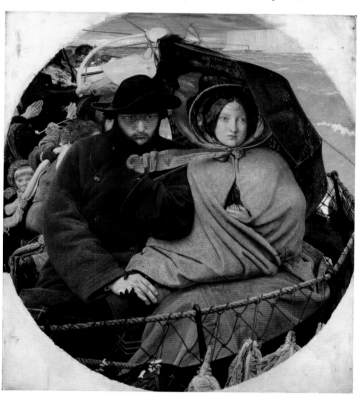

The Crimean War breaks out, pitting Russia against France, Britain and the Ottoman Empire.

Levi Strauss founds the first company to manufacture jeans.

The Convention of Kanagawa, signed between Japan and the United States, finally brings Japanese isolationism to an end.

c. 1851 1852–55 1853 1854

1855–1860

The Realist controversy. Napoleon III has a mixed reputation. He attempts to modernize Paris and, for much of his reign, the capital resembles a huge building site, as Baron Haussmann carries out his renovations. At the same time, he is wary of public opinion. The Realist movement, symbolized by the huge, 'ugly' peasant paintings of Gustave Courbet and Jean-François Millet, seem to carry the threat of another revolution. IZ

Richard Dadd – *The Fairy Feller's Master-Stroke*

Fairy subjects were popular with many Romantic artists, satisfying their taste for fantasy and the irrational. Over the course of the 19th century, the tone of these pictures softened, as the malicious creatures that lurked in the images of Henry Fuseli and John Fitzgerald were replaced by the lovable fairies of children's literature. Dadd's paintings always remained dark, though, partly because most were produced in Broadmoor, the psychiatric hospital in England where the artist was incarcerated after murdering his father. The *Fairy Feller* is his masterpiece. It shows a fairy woodsman attempting to split a hazelnut with a single stroke of his axe, while a strange convocation of characters look on. The proceedings are organized by a patriarchal figure wearing an enormous hat, while the audience includes figures from folklore (Titania, Oberon, Queen Mab) and half-remembered nursery rhymes. The painting is unsettling because of its multiple scales and its complete absence of any rational perspective or narrative.

The Exposition Universelle (World's Fair) opens in Paris. Courbet stages his own one-man show inside it.

William Henry Perkin discovers the first aniline dye, a brilliant mauve colour. This will have a huge impact on the development of synthetic pigments, which will prove a boon for artists.

1855 **c. 1855–64** **1856**

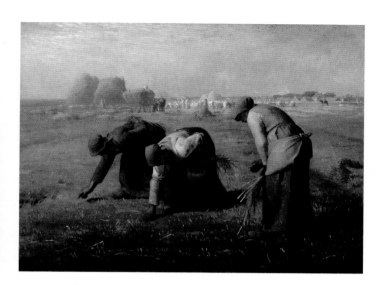

○ Jean-François Millet – *The Gleaners*

Together with Gustave Courbet, Millet was one of the
figureheads of the Realist movement in France. Their large-
scale pictures of peasants provided an unsentimental view
of the hardships of rural life, and these remained highly
controversial throughout the 1850s, as memories of the
1848 revolution were still relatively fresh. Many conservative
critics regarded them as politically motivated, particularly
in view of the controversial nature of Napoleon III's rule.
Gleaners were the poorest of all peasants. They were
authorized to collect the scraps left behind after a harvest.
Here, the pickings seem very thin. Millet makes a pointed
contrast between the meagre stubble of corn on the ground
and the heavily-laden carts in the distance. One reviewer
memorably described the women as 'the Three Fates of
Poverty, scarecrows in rags'.

William Dyce – *Pegwell Bay, Kent – A Recollection of October 5th 1858*

This multi-layered masterpiece combines landscape and portraiture. It shows
Dyce's family collecting seashells and fossils at twilight, while the artist (far right)
gazes up at Donati's Comet. This caused a sensation at the time, and the picture's
very precise title refers to the date when the comet was said to be at its brightest.
The mood of the picture is both solemn and haunting. The figures are painted
with photographic clarity, and most are gazing with interest at something beyond
the confines of the painting. Dyce was a deeply religious man, but he was also a
keen amateur scientist, at a time when the discoveries of Darwin and others were
casting doubts on the accuracy of the Bible. Pegwell Bay had strong Christian
associations (St Augustine had landed nearby), but Dyce's painting also seems
to be a rumination about the immensity of time (emphasized by the painstaking,
geological detail of the cliff-face) and space.

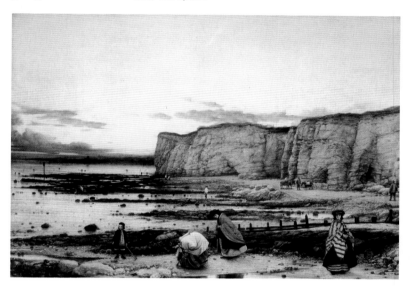

The Indian Mutiny
breaks out in
northern India.

Donati's Comet is first
observed by the Italian
astronomer Giovanni
Battista Donati.

Charles Darwin
publishes his
groundbreaking
study, *On the Origin
of Species*.

| 1857 | 1858 | c. 1858–60 | 1859 |

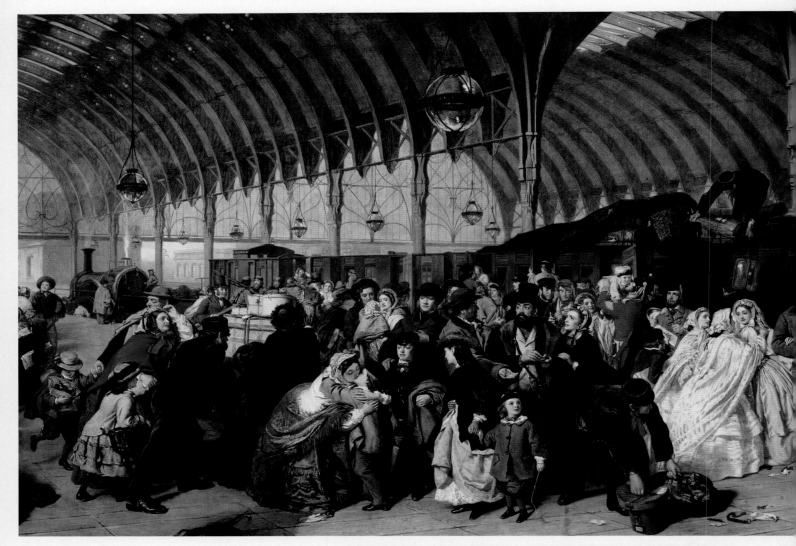

George Pullman
(1831–97)

No one had a greater impact on rail travel in the
United States than George Pullman. He trained as an
engineer in Chicago and worked on the city's sewers,
before designing the sleeping-car that would make
his name. Pullman's aim was to introduce an element
of luxury to rail travel, and his sleeping-cars earned
the nickname of 'palace cars' or 'hotels on wheels'.
They first came to public attention in 1865, after the
assassination of Abraham Lincoln. The president's
body was transported across the country in a Pullman
car, watched by thousands of mourners lining the
route. Orders soon began to roll in, and the success
of Pullman's venture was assured.

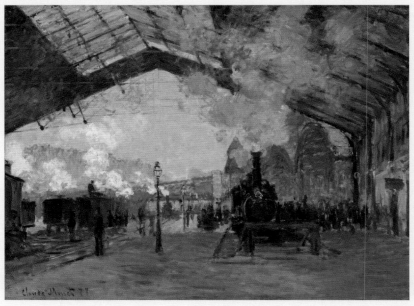

ART AND RAILWAYS

The railways transformed society, enabling greater mobility and bringing commercial opportunities. They changed the way people worked, as well as how they spent their leisure time. With their cast-iron columns and huge glass roofs, the stations were the cathedrals of the age.

Artists were quick to seize on the opportunities afforded by the new phenomenon of rail transport. In Britain, the emphasis was on the passengers. Rail travel brought together different strands of society as never before, providing inspiration for vignettes of everyday life. Perhaps the most celebrated example is *The Railway Station* (1862) by William Powell Frith. Set in London's Paddington Station, which was less than a decade old at the time, the picture is crammed with detail. Frith appeared with his own family at the centre of the canvas, and he used his daughter's tutor as the model for the foreign tourist, who is arguing with a cab driver. On the right, two metropolitan detectives are apprehending a criminal. These policemen – Michael Haydon and James Brett – were local celebrities, and happy to pose for the artist. Even Frith's dealer appears in the picture, chatting to the engine driver. *The Railway Station* proved extremely profitable: Frith exhibited the picture privately for an admission fee, and made a healthy income from engravings of the scene.

The popularity of this venture prompted other artists to tackle railway subjects. George Earle's *Going North, King's Cross Station* (1893) focused on members of the aristocracy, heading north from London to Scotland for the grouse-shooting season. The artist evidently took great pleasure in laying out the paraphernalia associated with their trip, from golf clubs, tennis rackets and fishing gear to fur stoles and boisterous packs of dogs.

On the other side of the English Channel, Honoré Daumier also tackled the theme of rail travel. He portrayed all levels of society but, as a political commentator and satirist, he was chiefly drawn to the poor and the disadvantaged. *The Third-Class Carriage* (*c*. 1862–64) is the finest of his train pictures. The three generations of a family, with no apparent breadwinner, are facing away from the other passengers. This hints at an invisible barrier, which cuts them off financially from the rest of society.

The French Impressionists were also fascinated by the railways. Édouard Manet, Gustave Caillebotte and Claude Monet all painted pictures of the Gare Saint-Lazare in Paris, which was close to their homes. The subject suited their ambition to paint modern life. Significantly, they paid little attention to the trains or their passengers – their main interest lay in the steam from the locomotives. Like ripples in a stream or clouds in the sky, the smoke changed with every passing moment, and the task of capturing this on canvas offered an irresistible challenge. IZ

1860-1865

Fiery revolutionaries. In the art world the revolutionaries of the 1850s – the Realists in France and the Pre-Raphaelites in Britain – are gaining wider acceptance. Meanwhile, the Impressionists are embarking on their careers, while James Abbott McNeill Whistler's paintings, with their musical titles, make a significant contribution to the incipient Aesthetic Movement. In the political arena, there is turmoil in the Americas. The United States is torn apart by a civil war, while the French become embroiled in a disastrous attempt to seize power in Mexico. As so often before and since, political and social upheavals inspire – or at least catalyze – exceptionally high levels of creativity, principally but not exclusively in the visual arts. IZ

Jan Matejko – *Stańczyk*

This brooding masterpiece is one of Poland's most famous paintings. Stańczyk, a famous 16th-century jester, sits alone despondently, having just learned of a terrible national defeat. In the adjoining room, meanwhile, party-goers continue their revels, oblivious to the news. Matejko produced his patriotic, historical scenes at a time when Poland's territories were partitioned between Russia, Prussia and Austria.

Synthetic pigments arrive as chemists rush to emulate William Henry Perkin's discovery of mauve (see p. 190). August von Hofmann's experiments produce synthetic blues, greens and 'Hofmann's violets'.

The International Exhibition in London features displays from thirty-six countries. In the wake of the Treaty of Edo, which ended Shogunate isolationism, it includes the largest display of Japanese art ever seen in the West (623 items, ranging from prints to porcelain). The effect of the exhibits on Western art is quick to appear and is long-lasting.

1861

1862

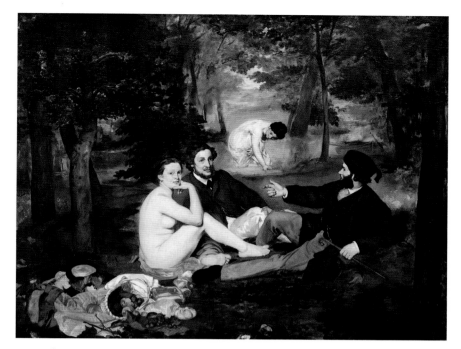

○ **Édouard Manet –** *Le Déjeuner sur l'herbe*

When it was shown at the Salon des Refusés, this painting scandalized Parisians. In part, they were shocked by the nudes, who had previously appeared only in mythological or historical contexts. The modern attire of the men in this picture seemed to suggest a scene of debauchery. This was unacceptable for public display. Manet was playing with conventions, translating a popular theme from the Old Masters into a modern context. It was this passion for modernity that made him such an inspiration for the Impressionists.

The January Uprising sees Polish nationalists attempt to throw off the yoke of their Russian oppressors, but the rebellion fails, and is followed by severe reprisals.

The Salon des Refusés exhibition in Paris displays paintings that had been rejected by the selection committee of the official Salon. Several pioneering artists had work rebuffed, among them Manet, Whistler and Cézanne.

US President Abraham Lincoln delivers the Gettysburg Address, which reaffirms the Union's commitment to freedom and equality.

Mathew Brady – *General Ulysses S. Grant*

The Commander of the Union army poses pensively at Cold Harbor, the scene of one of the bloodiest encounters in the American Civil War.

James Abbott McNeill Whistler – *Symphony in White, No. 2: The Little White Girl*

While his compatriots were engaged in their bitter conflict, American-born Whistler was at the forefront of artistic developments in London and Paris. Here the Japanese fan, the blossoms and the vase reflect the craze for Oriental styles that was sparked by the International Exhibition of 1862. The painting was exhibited at the Royal Academy, London, in 1865, with a poem by Swinburne on the frame.

Algernon Charles Swinburne, a poet closely associated with the Pre-Raphaelite circle, publishes his first major work, *Atalanta in Calydon*. Its binding is designed by Dante Gabriel Rossetti.

1863 **1864** **1865**

1865–1870

The seeds of Impressionism. This is the period when the various strands of the Impressionist movement begin to come together. On the Normandy coast in France, Claude Monet is practising *plein-air* (open-air) painting with Eugène Boudin, while at the Salon, Édouard Manet's paintings continue to cause controversy. From 1866 Manet begins to frequent the Café Guerbois in the rue des Batignolles, and it is here that the future members of the Impressionist group meet and discuss their theories. Initially, the critics actually dub them the Batignolles School.

In the wider world, the American Civil War ends, but Prussia is in the ascendancy. Its president, Otto von Bismarck, engineers a series of conflicts that will ultimately unify the German states. IZ

Abraham Lincoln is assassinated by John Wilkes Booth. The American Civil War ends soon after.

Alice's Adventures in Wonderland is published by Charles Lutwidge Dodgson, using the pseudonym Lewis Carroll.

The Thirteenth Amendment to the US constitution is passed. This formally abolishes slavery and involuntary servitude throughout the country.

Gustave Moreau – *Orpheus*

In Greek mythology, Orpheus played the lyre so sweetly that his songs could charm wild beasts. Unfortunately, he offended the Maenads – the wild, female followers of Bacchus – and they tore him limb from limb, casting his remains into the river. Moreau invented this postscript to the legend himself. A young Thracian girl has retrieved the musician's head from the water and carries it away reverently on his lyre. Her exotic finery and her trancelike expression conjure up an elusive air of mystery. Moreau's painting bears some Italian influences – the face of Orpheus is loosely based on Michelangelo's *Dying Slave*, and the otherworldly landscape is reminiscent of Leonardo da Vinci's work – but it is an outstanding example of his distinctive Symbolist style.

The Austro-Prussian War breaks out between the German Confederation and the kingdom of Prussia.

1865

1866

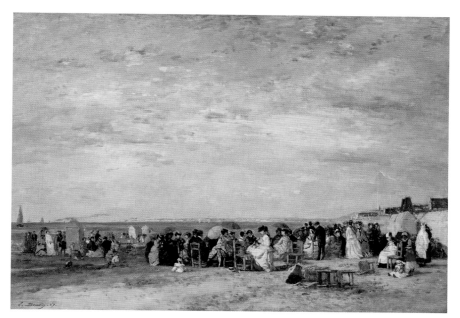

Eugène Boudin – *Beach at Trouville*
One of the key factors in the development of Impressionism was the unlikely friendship between Boudin and Monet. Boudin spent much of his life painting on the Normandy coast. He often worked outdoors, believing that 'everything painted on the spot has a strength and power that cannot be recaptured in the studio'. His figures were far too small and sketchy to have any success at the Salon, but his skies were broad and luminous, with a genuine feeling for the prevailing weather conditions. Monet met Boudin in 1858 – their pictures were displayed at the same shop in Le Havre – and was gradually persuaded to try painting outdoors, alongside his older mentor. Although sceptical at first, he soon had to admit: 'My eyes were opened at last, and I really came to understand nature.'

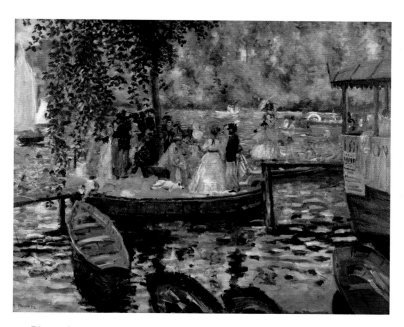

Pierre-Auguste Renoir – *La Grenouillère*
If there was a moment when Impressionism was born, it was at La Grenouillère in the summer of 1869. In their discussions, the group who became the Impressionists had settled on *plein-air* painting as the cornerstone of their approach to art. This required stylistic changes, however, as speed was an issue. Paintings had to be executed quickly, before the light and weather conditions changed. The decisive experiments were made by Renoir and Monet, working side by side at La Grenouillère, a popular bathing and dining spot on the River Seine. Both men produced their 'impressions' using short dabs of bright, complementary colours, often squeezing the paint directly from the tube onto the canvas.

Dynamite is invented and patented by the Swedish chemist Alfred Nobel.

The Alaska Purchase adds new territory to the United States. The land is acquired from the Russian Empire.

1867

1869

The Invention of Photography

There was no single inventor of photography: it was a gradual process. However, the two greatest pioneers both made their discoveries public in 1839. Louis Daguerre (see p. 181) announced his findings with the words: 'I have seized the light, I have arrested its flight.' His invention, the daguerreotype, was a direct positive process, producing a single image on a polished metal plate. This image was astonishingly sharp and detailed, but it had a flaw – there was no way of taking copies from it. Daguerre's rival was William Henry Fox Talbot. His system of 'photogenic drawing' was entirely different, as it entailed the production of a negative. Talbot's calotype (taken from the Greek word for 'beautiful') was not as impressive as Daguerre's photograph, but it won the day, as multiple prints could be taken from the negative.

ART AND PHOTOGRAPHY

The invention of photography shook the art world to its core – opinions were dramatically divided. Some artists were delighted, believing that it would prove an invaluable aid to painters. Others were dismayed, convinced that the new invention would destroy the market for their work. Very few, at this stage, imagined that it could become a major art form in its own right.

ABOVE. Étienne-Jules Marey – *Bird in Flight* (1886)
Experiments in motion photography proved a revelation to many painters. The Futurists in particular found inspiration in Marey's chronophotographs.

LEFT. Gustave Le Gray – *Brig on the Water* (1857)
Le Gray's dramatic seascapes caused a sensation when they were exhibited. *La Lumière* described the show as 'the event of the year'.

Official reactions were equally divided. Daguerre was voted an honorary member of the American Academy and was swiftly offered similar accolades in Edinburgh, Munich and Vienna. By contrast, the more influential academies in Paris and London remained silent. The debate about the status of photography grew more acrimonious as time went on. In 1859 French photographers won a significant victory when they were allowed to show their work at the Salon for the first time, though some critics were scathing. Baudelaire, for example, argued that photographers were failed painters and that their industry was damaging the values of French art.

Two years later the same issues arose again when a famous court case captured the public's attention. Two photographers, Mayer and Pierson, sued for breach of copyright, using the same law that protected artists' rights. This raised the question of whether photographers could be considered artists. When the court eventually found in their favour, a group of painters – led by famous names such as Ingres, Flandrin and Puvis de Chavannes – signed a petition of protest. Photography, they argued, involved a series of 'completely manual operations' that doubtless required some skill, but could never produce genuine artworks.

Photographers were keen to reject this. In England, Henry Peach Robinson achieved considerable success with his imaginative composite pictures. However, his attempt to invite direct comparisons with painting proved less auspicious. In 1861 he produced a version of *The Lady of Shalott*, a perennial favourite with Victorian painters (see p. 209). The result was prosaic, stripping the subject of its romantic pathos, and Robinson admitted as much.

Photographers were more successful when they employed techniques far removed from painting. Gustave Le Gray won high praise for his shimmering seascapes, achieved through his pioneering use of combination printing. The sea and the sky were taken from different photographs and then printed together, appearing slightly unreal and unsettling.

By the end of the century, artists were perfectly happy to acknowledge their debt to photography. Edgar Degas, in particular, drew great inspiration from instant photography, altering the way in which he posed his figures and balanced his compositions. Similarly, the Futurists were fascinated by the experiments of Étienne-Jules Marey. His chronophotographs of birds in flight showed them a way to convey speed and movement in their paintings. IZ

1870–1875

The Franco-Prussian War. Northern Europe is torn apart by a new conflict when, as part of his plan to unify Germany, Bismarck provokes France into an ill-advised attack. This leads to a humiliating defeat; the French forces are crushed at Sedan, and Napoleon III abdicates. Paris is besieged, and the new German Empire is finally confirmed at Versailles in January 1871. The city's suffering is not over, however, as a new revolutionary uprising – the Paris Commune – erupts into violence.

There is happier news in the art world. In Russia, a new exhibiting body is formed, which will take progressive art to the provinces, while in Paris the Impressionists hold their first group exhibition. IZ

Ilya Repin – *Barge Haulers on the Volga*

Repin was the greatest Russian artist of his age, winning international fame with his powerfully realistic paintings. This is one of his most famous works, illustrating the brutal system of using teams of men to pull riverboats. Repin met some of the haulers, using them as models, though the practice was already dying out by this time. Steam power was taking over, as indicated by the smoking funnel of the boat in the distance. *Barge Haulers* was commissioned by the Tsar's second son, Vladimir Aleksandrovich, and was featured as a showpiece in the Russian Pavilion at the International Exhibition in Vienna (1873), where it was awarded a bronze medal.

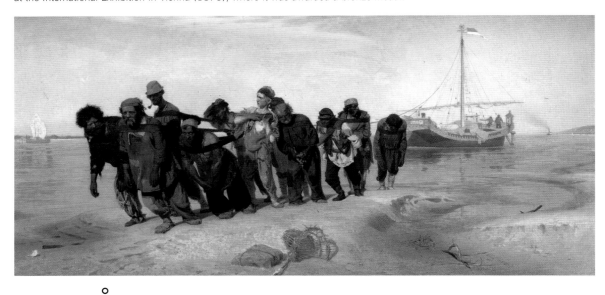

The Association of Travelling Exhibitions is founded in Russia, offering progressive artists a new outlet for their work.

The Franco-Prussian War sends France into turmoil.

The Unification of Italy is completed, and Rome is confirmed as its capital.

| 1870 | 1870–73 | 1871 |

Claude Monet – *Poppy Field*

Monet was living at Argenteuil, on the outskirts of Paris, when he painted this delightful image of a gentle afternoon stroll. His primary source of interest lay in the glorious bank of poppies. The individual flowers are often little more than blobs of red paint, but the ones in the foreground are disproportionately large – some even larger than the child's head. The function of the figures was to emphasize the diagonal structure of the picture. Their faces are virtually blank, but the pair on the right are probably the artist's wife, Camille, and his son Jean. Monet showed the painting at the first Impressionist exhibition, in the following year.

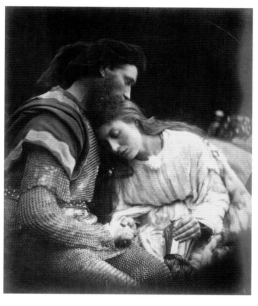

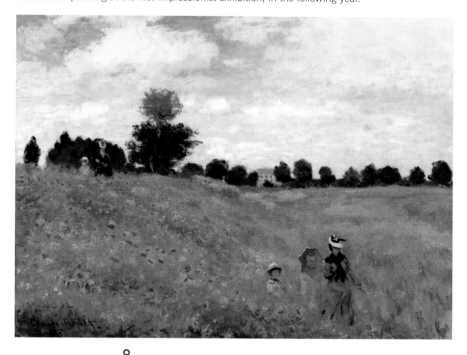

Julia Margaret Cameron – *The Parting of Sir Lancelot and Queen Guinevere*

When photography was invented, painters often used it as an artistic aid, but by the 1870s it was gaining acceptance as an independent art form. Cameron was one of its finest exponents, specializing in romantic, soft-focus shots. In 1874 she was commissioned by Lord Tennyson, her friend and neighbour on the Isle of Wight, to provide a series of illustrations for his epic poem, *Idylls of the King*. She experimented with different exposures, taking more than forty shots before settling on this definitive version. The photos were reproduced as wood engravings in Tennyson's book, while Cameron published her own deluxe edition of the photographic prints. Her illustrations of the *Idylls* were heavily influenced by Pre-Raphaelite painting, and were later acknowledged as important precursors of the Pictorialist style that became popular at the end of the 19th century.

The Impressionists stage their first group exhibition in Paris.

The opera *Carmen* has its premiere in Paris.

1873 1874 1875

1875–1880

The Russo-Turkish War. On the eastern borders of Europe, a serious conflict breaks out in 1877 that will have long-term consequences for the rest of the world. The war pits Russia and its allies against the Ottoman Empire, now in political decline. Russia hopes to recover some of the territory lost in the Crimean War, while its Balkan allies – Serbia, Bulgaria, Romania and Montenegro – have nationalist aspirations. Many of these issues are resolved at the Congress of Berlin in 1878, but some resentments continue to fester and will ultimately resurface in the First World War. IZ

Edgar Degas – *Ballet at the Paris Opéra*

More than any of the other Impressionists, Degas was influenced by the advent of photography. He loved to give his compositions freshness and immediacy by adopting unusual viewpoints and cropping his figures. Here, he deliberately mimics the effect of a clumsily composed photo. The spectator is placed in the orchestra pit, peering over the heads of some of the performers, with his or her view partially obscured by the necks of two double basses glimpsed in the foreground. The dancers' free-flowing hair suggests that this is a rehearsal. Degas was also the most inventive of the Impressionists in terms of technique. Here he combines monotype – an unusual printing medium – with pastel. This gives the picture its delicate, feathery appearance.

Gustave Caillebotte – *Paris Street, Rainy Day*

The Impressionists celebrated modern life in their paintings. This included the latest entertainments and technological advances, but also the city of Paris itself. During the 1850s and 1860s, much of the capital was redeveloped by Baron Haussmann, who swept away the narrow medieval streets, replacing them with wide boulevards and new street-lighting. Caillebotte's painting documents a district that had recently been transformed. Caillebotte was one of the lesser-known Impressionists, but he played an important role in the success of the movement. He came from a wealthy background and was able to help out financially in the early days, when some of his colleagues were penniless. He later bequeathed his own collection of Impressionist paintings to the French state.

Alexander Graham Bell patents the telephone.

The April Uprising in the Ottoman Empire leads eventually to the creation of the Bulgarian state.

The Battle of the Little Bighorn, also known as 'Custer's Last Stand', takes place in eastern Montana.

1876 1877

Vasily Polenov – *Moscow Courtyard*

Born and trained in St Petersburg, Vasily Polenov was a versatile artist who produced historical paintings, portraits, landscapes and stage designs. However, he is best known for his *plein-air* paintings, which brought a flavour of Impressionism to the East. This delightful scene is an early piece, produced when Polenov was beginning his association with the Wanderers (a group of Russian Realists). Initially, he had intended only a brief stay in Moscow, before making a lengthy tour of eastern Russia and the Volga, but he was entranced by the subjects that he found there. These tranquil gardens gave him the opportunity to fulfil his aim of capturing 'the poetry of everyday life'. He took as much pleasure in depicting the details of overgrown foliage, a harnessed horse and children playing by a covered well as the Impressionists did in celebrating their modern city.

Eadweard Muybridge carries out his groundbreaking photographic tests, analyzing the motion of horses.

The Ruskin–Whistler Libel Trial rocks the art world in England. American-born painter James Abbott McNeill Whistler sued British critic John Ruskin for libel after Ruskin published a letter in 1877 describing the artist's *Nocturne in Black and Gold: The Falling Rocket* (1875) as 'flinging a pot of paint in the public's face'. Whistler won the case, but was awarded only a farthing in damages.

Thomas Edison produces the first commercially viable incandescent light bulb.

1878

1879

WILLIAM MORRIS AND CRAFTSMANSHIP

William Morris was a pioneer of the Arts and Crafts Movement, which flourished primarily in Britain and the United States in the late 19th century. It revolutionized the philosophy and practice of design in an age when standards had slipped as a result of commercial pressures surrounding mass production.

Morris began his artistic career in the circle of the Pre-Raphaelites. In the early 1850s he was a student at Oxford University with Edward Burne-Jones, who became a lifelong friend. Together, they were recruited by Dante Gabriel Rossetti when he came to paint a series of murals in the Oxford Union in 1857. Rossetti gave Morris a few informal lessons in painting at this time, but it was soon obvious to Morris that this was not

where his future lay. Instead, he was attracted to the decorative arts and had already begun experimenting with furniture design. One of his first efforts was a magnificent medieval settle, which he created for his own studio.

Design was a very topical issue in the 1850s. The Great Exhibition of 1851 had placed British design in the spotlight, but had also shown that it was lagging behind other countries. This sparked

ABOVE LEFT. Opening text of the Kelmscott Chaucer (1896)
This edition of Geoffrey Chaucer's works is the greatest product of Morris's Kelmscott Press, and by common consent one of the most beautiful books of the 19th century. It has eighty-seven woodcut illustrations by Burne-Jones.

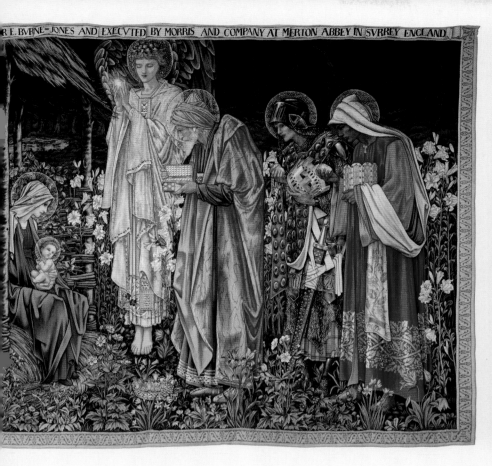

ABOVE CENTRE. *Adoration of the Magi* **tapestry (1886–90)**
Morris produced ten versions of this tapestry (designed by Burne-Jones), his most famous work in this medium. The first version was made for the chapel of Exeter College, Oxford, where Morris and Burne-Jones had met as students.

ABOVE RIGHT. 'Pimpernel' wallpaper (1876)
Named after the small five-petalled flower that forms part of the pattern, this is one of Morris's most popular designs, still in commercial production today for wallpaper, textiles and other goods.

off a number of initiatives, most notably Prince Albert's new museum in South Kensington (now the Victoria and Albert Museum), London. Morris was also inspired by the ideas of John Ruskin – the critic who championed the Pre-Raphaelite cause – who loathed the effects of the Industrial Revolution and lamented the demise of the medieval guild system.

Ruskin would eventually crystallize his ideas in the Guild of St George, which he founded in 1871 but, by this stage, Morris had already put his own plans into operation. In 1861 he set up the firm of Morris, Marshall, Faulkner & Co., which designed and manufactured a broad range of products. These included furniture, stained glass, wallpaper and textiles. Many of the items had a medieval flavour, echoing Morris's passion

for the period, but his priority was for fine quality goods, hand-made wherever possible, and the use of natural pigments.

After a shaky start the firm prospered, gaining an important commission from the architect G. F. Bodley for a series of stained-glass windows for his churches. In the long term, though, it was the textile and wallpaper designs that fared best – the wallpapers are still in production today. In many cases, Morris collaborated with Burne-Jones, who would provide the figurative elements, while Morris concentrated on the floral patterns. They maintained this arrangement in the sumptuous books produced by the Kelmscott Press. Founded in 1890, this was Morris's last great project, inspiring the private press movement that sprang up in its wake. IZ

1880-1885

The Aesthetic Movement. This movement is at the peak of its popularity, affecting painting, literature and the decorative arts. In literature, its chief exponent is Oscar Wilde, who tours the United States to great acclaim in 1882. In painting, the leading lights are James Abbott McNeill Whistler and Albert Moore, who compose their pictures like musical arrangements. The cult of beauty surrounding the movement is satirized in Gilbert and Sullivan's comic opera *Patience* (1881) and in the cartoons in *Punch* magazine. IZ

Max Liebermann – *Recreation Period in the Amsterdam Orphanage*
By the 1880s, the taste for Impressionism had spread beyond France, though the style was often modified in the process. In Germany, Max Liebermann was one of the keenest converts. He had travelled to Paris in 1872, when he was chiefly impressed by the Realists Courbet and Millet. Liebermann's earliest paintings of the Amsterdam Orphanage – which date to the mid-1870s – were in a Naturalist vein. It was only in his 'recreation period' that the Impressionist influence shows through. For this picture, Liebermann added the trees – which did not exist in the actual courtyard – precisely so that he could create the impression of sunlight filtering through the leaves. This dappled sunlight effect became a regular feature in Liebermann's paintings during his Impressionist phase.

Ned Kelly, the Australian outlaw, is captured after a shoot-out with the police and is executed in Melbourne.

Tsar Alexander II of Russia is assassinated in St Petersburg, when a bomb is thrown at his carriage.

1880 **1881**

Albert Moore – *Dreamers*

Along with Whistler, Moore was the most important painter in Britain's Aesthetic Movement. Both men followed its central creed of 'art for art's sake', producing pictures that had no social, moral or political purpose. Their only aim was beauty, and *Dreamers* is typical of Moore's approach. A row of attractive women are draped decorously over a long wall-seat. The spectator looks for some narrative content to explain their situation, but there is none – Moore's paintings are deliberately subjectless. The women have no more meaning than the rich fabrics that surround them. A number of stylistic influences can, however, be detected. The figures with their togalike gowns resemble Classical sculptures; the patterns, the screens and the fan reflect the contemporary vogue for Japanese goods; while the wallpaper is reminiscent of the Arts and Crafts designs produced by William Morris.

Georges Seurat – *Sunday Afternoon on the Island of La Grande Jatte*

This huge masterpiece is Seurat's most famous painting. It was shown at the final Impressionist exhibition in 1886, where it caused a sensation. Viewers could appreciate that it was a great achievement and that it marked a revolutionary development in art, but some also suspected that it heralded the end of Impressionism. Seurat wanted to retain the freshness and vitality of the Impressionist technique, but he was also keen to create something that was more significant than a momentary impression. So, using the latest scientific theories, he built up his picture through tiny dots of pure complementary colours. The idea was for the optical mixture to take place in the eye, rather than on the palette. Seurat's pointillist method was a great success and was much-copied for a time, but the process itself ultimately proved too slow and laborious to prevail.

The Siege of Khartoum in Sudan begins. General Gordon is killed there the following year.

The Salon des Indépendants is formed, and holds its first exhibition in Paris.

The Statue of Liberty, a gift from the French people, arrives in New York Harbor.

1882 **1884** **1884–86** **1885**

1885–1890

End of the Impressionist era. There is a festive mood in the West, as Paris glories in the success of its World's Fair (1889), centred on the newly constructed Eiffel Tower, while in Britain there have been celebrations for Queen Victoria's Golden Jubilee (1887). To the east, the tragic events at Mayerling in Austria strike a more sombre note, as the sudden death of the liberal Crown Prince destabilizes relationships between the nationalist factions within the Austro-Hungarian Empire.

Change is also in the air in the art world, where the final Impressionist exhibition takes place in Paris (1886). Many of the members have been following different paths for some time, and these new trends will eventually be classified as Post-Impressionism. Two of its leading exponents – Vincent Van Gogh and Georges Seurat – produce their greatest masterpieces in these years. IZ

The Canadian Pacific Railway is completed. The first transcontinental train leaves Montreal on 28 June and arrives at Port Moody on 4 July.

Vincent Van Gogh – *Sunflowers*
In 1888 Van Gogh moved from Paris to Arles, in the south of France, and was immediately inspired by the brighter light he found there. Most of his greatest masterpieces were produced in the frenzied two-year period at the end of his life. He painted a series of sunflowers in August, working at great speed to capture the blooms before they died. The pictures were intended to decorate his home, prior to the arrival of Paul Gauguin. They are almost entirely yellow. This was Van Gogh's favourite colour, which he regarded as a symbol of friendship.

Construction begins on the Eiffel Tower. It will be finished in time for the opening of the World's Fair, two years later.

1886 1887

Charles Conder – *A Holiday at Mentone*

Pioneers of Impressionism in Australia included Tom Roberts, Charles Conder and Arthur Streeton. Their breakthrough show was the '9 by 5 Impression Exhibition' held in Melbourne in 1889. Conder's picture was produced at the nearby resort of Mentone. It is a genuine *plein-air* painting (there are grains of sand trapped in the paint surface), while the structure of the composition, with its prominent bridge, was influenced by Japanese prints and the work of James Abbott McNeill Whistler.

John Waterhouse – *The Lady of Shalott*

The influence of the Pre-Raphaelites remained strong in England until the end of the 19th century. Here Waterhouse tackled one of their favourite themes – an Arthurian subject made famous by one of Lord Tennyson's poems. The Lady of Shalott is the victim of a strange curse – she is trapped in her castle, forbidden to look directly at the world outside. So she sits in her room, weaving a tapestry of the events that she sees reflected in a mirror. Then, one day, she accidentally sees Sir Lancelot riding by and her life is forfeit. She climbs into her boat and drifts downstream to meet her fate. Waterhouse depicts these final moments, as she sits on her tapestry, watching the candle that represents her life ebbing away. There are echoes of Millais's *Ophelia* (see p.189) in this picture, but Waterhouse was practising *plein-air* painting at this time, so the landscape has a fresher, more spontaneous feel.

The tragedy at Mayerling shocks Europe. Crown Prince Rudolf of Austria and his young lover are found dead, after apparently committing suicide.

Jack the Ripper begins his reign of terror, murdering several prostitutes in the Whitechapel district of London. He is never caught.

John Dunlop patents the pneumatic tyre. He develops this initially for his child's tricycle.

Van Gogh dies at Auvers-sur-Oise. He commits suicide by shooting himself in the chest.

| 1888 | 1889 | 1890 |

ART COLONIES

For a brief period in the 1880s and 1890s the village of Pont-Aven in Brittany was one of the most innovative centres of art in Europe. It was there that Paul Gauguin achieved the breakthrough in his work that made him such an influential figure among his contemporaries and successors.

Many artists' colonies flourished during the late 19th century and into the early 20th century – in numerous European countries and also in the United States. They were usually located in attractive villages or small towns, and were part of a widespread urge to escape urban society in favour of a romanticized ideal of simple pastoral life. Such colonies typically offered artists relatively cheap living costs, the company of like-minded people, an abundance of picturesque local subjects and a mild climate suitable for outdoor work. Many were in coastal locations, where the quality of light appealed to painters. Pont-Aven, in Brittany, north-west France, is a famous example. It first attracted artists in the 1860s, after a new railway line made it more easily accessible from Paris, and it played a key

role in the life of Paul Gauguin. He worked there several times in the 1880s and 1890s, and the term 'Pont-Aven School' refers to a short-lived but significant group of artists in which he was the dominant figure.

During his first stay in Pont-Aven (July to October 1886), Gauguin still worked in a style that was essentially Impressionist. However, his second visit, in 1888, marked the decisive turning point of his career, as he broke away from a naturalistic outlook to one in which he used form and colour for decorative and emotional effect. This is seen most clearly in his celebrated *Vision after the Sermon* (1888), in which a group of peasant women in a churchyard experience an apparition of the biblical story of Jacob wrestling with the angel. At this time Gauguin had a brief but fruitful collaboration with a

ABOVE LEFT. Émile Bernard – *Breton Women with Umbrellas* (1892)
Bernard's bold simplification of forms was partly inspired by his love of medieval art.

ABOVE CENTRE. Paul Gauguin – *Vision after the Sermon* (1888)
In a letter to Van Gogh, Gauguin wrote: 'For me the landscape and the fight exist only in the imagination of the people praying after the sermon.'

ABOVE RIGHT. Paul Sérusier – *The Talisman* (1888)
Sérusier was encouraged by Gauguin to use colour to express his feelings rather than realistically depicting the world.

much younger artist, Émile Bernard. In spite of his youth (and his relatively modest talent), Bernard was a stimulating companion, and he shares with Gauguin the credit for creating a new, anti-naturalistic approach to painting.

There was never a fixed group associated with Gauguin in Pont-Aven, but rather a fluctuating number of artists, of various nationalities, among them Roderic O'Conor (Irish), Paul Sérusier (French) and Jan Verkade (Dutch). Gauguin's last visit to Pont-Aven was in 1894, and subsequently it was no longer a major centre of creativity. However, the flattening of forms, unnaturalistic colour and vaguely mystical atmosphere seen in the paintings of Gauguin and Bernard helped to shape the Symbolist movement that was such a powerful force in avant-garde art around the turn of the century. IZ

Émile Bernard (1868–1941)

Bernard did most of his best work as a painter early in his career, and in later years he was more important for his writings about the art of his time, notably in promoting the reputations of Van Gogh and Cézanne (he organized an exhibition of Van Gogh's work in 1892, two years after his death; and his correspondence with Cézanne is a rich source of information). However, Bernard's close association with Gauguin ended acrimoniously in 1891, as he thought Gauguin was trying to take all the credit for the new aesthetic outlook they had pioneered together at Pont-Aven.

1890-1895

Belgian Symbolism. The Symbolist movement is in full bloom. It starts in France, where Jean Moréas writes its Manifesto (1886), but by the 1890s it has spread to many other countries. Some of the finest examples are produced in Belgium, under the auspices of Les Vingt ('The Twenty'; 1884–93). This avant-garde exhibiting body attracts an international array of talent. Jan Toorop and Fernand Khnopff are prominent members.

Belgium itself is going through a period of turmoil. There are numerous strikes and demonstrations, partly as a result of the economic depression and partly in support of greater voting rights. Meanwhile, King Leopold II's controversial enterprises in the Congo Free State (now the Democratic Republic of the Congo) are storing up problems for the future. IZ

The Wounded Knee Massacre takes place on the Great Sioux Reservation. More than 150 Native Americans die at the hands of the US cavalry.

Mary Cassatt – *In the Omnibus*
Cassatt entered the Impressionists' inner circle through her friendship with Degas, eventually contributing to four of their exhibitions. Like him, she was a superb printmaker. This comes from her *Set of Ten*, a magnificent series of drypoint and softground etchings ('softground' means that the metal plate was covered with wax). The key influence was from Japanese prints. There was a major exhibition of these in Paris in 1890 and, from them, Cassatt derived her taste for daringly sparse compositions, unusual viewpoints and bold colouring.

1890 1890-91

Fernand Khnopff – *I Lock My Door Upon Myself*

The aim of the Symbolists was to transport the viewer into a world of mystery, helping their imagination to take flight. Their 'symbols' do not have precise meanings. Rather, they are meant to evoke feelings, moods or ideas. Khnopff's painting takes its title from a line in a poem by Christina Rossetti ('Who Shall Deliver Me?'). The winged head is a sculpture of Hypnos, the god of sleep, and, aptly enough, the woman seems immersed in her own private reverie. Tiny details are there to intrigue us. What is the significance of the arrow on the left, or the tiny golden crown that dangles from a slender thread by her left elbow? Khnopff leaves the viewer to draw their own conclusions.

Jan Toorop – *The Three Brides*

Born in Java but resident in Holland, Toorop was a prominent member of Les Vingt. He developed a distinctive style, which blended elements of Symbolism and Art Nouveau and that would later have a significant influence on Gustav Klimt. Here, the innocent bride in the centre must choose between the path of purity or that of sensuality and evil. The figures are derived from the Javanese shadow puppets that Toorop remembered from his childhood, while the imagery is typically Symbolist. The figures are enveloped in swathes of human hair and thorns. Much of the hair flows out of silent bells. The largest of these (in the upper corners) are attached to nailed hands, with blood trickling down over their surface.

Georges Seurat dies at the age of thirty-one, following an attack of meningitis.

Finger Prints is published: Francis Galton's groundbreaking study establishes the scientific basis for using fingerprints in detective work.

The Dreyfus Affair begins with the conviction of Captain Alfred Dreyfus for treason. The scandal will divide opinion until 1906.

The French President, Sadi Carnot, is assassinated. He is stabbed by an Italian anarchist after a banquet.

The First Sino-Japanese War breaks out, largely over the control of trade with Korea. The conflict is swiftly settled in Japan's favour through the Treaty of Shimonoseki (1895).

1891　**1892**　**1892-93**　**1894**

1895–1900

Scandinavian resurgence. Nordic art is entering a golden phase at the end of the century. It displays a vigour and freshness sometimes lacking elsewhere. In part, this is due to the number of new exhibiting bodies that emerge, challenging the authority of older, conservative institutions. In Denmark, there is the Free Exhibition; in Finland, the first independent Exhibition of Finnish Artists; and the Swedish Artists' Association also stages its inaugural exhibition.

This takes place against a background of political uncertainty. The union of Sweden and Norway is coming under increasing pressure. The joint commercial treaty is allowed to lapse in 1897 and the two nations will eventually separate after a referendum in 1905. Meanwhile in Finland – which is ruled as a Grand Duchy within the Russian Empire – there are growing calls for independence. IZ

The first Olympic Games of the modern era take place in Athens. The contest is attended by 241 athletes from 14 nations, competing in 43 separate events.

Guglielmo Marconi gives the first public demonstration of his radio equipment.

Anders Zorn – *Midsummer Dance*

Zorn remarked on several occasions that 'I regard this work as containing all my deepest feelings'. The Swedish artist was proud of his country's ancient traditions, which were undergoing a revival at the time. On Midsummer Night, when the sky barely grew dark, the peasants in some regions would raise a festive pole (seen here on the right) and dance until dawn. Zorn captured both the exuberance of the event, with couples swirling around in their traditional costumes, and the unique pearly quality of the northern light.

The Diamond Jubilee of Queen Victoria is celebrated throughout the British Empire.

1896 **1897**

Henri Rousseau – *The Sleeping Gypsy*

Rousseau was a self-taught naïve painter, who spent much of his career working as a customs official. He frequently painted wild animals, claiming that he had witnessed these on exotic travels, though he actually just copied them from books or saw them in the local zoo. Rousseau's style may have been child-like, but his compositions often had a genuinely poetic quality, which was much admired by members of the avant-garde, and he was a regular exhibitor at the Salon des Indépendants.

Laurits Andersen Ring – *June: Girl Blowing Dandelion Seeds*

Ring was one of the leading Danish painters of his age, developing an unusual style that blended Naturalism and Symbolism. This idyllic scene was painted during one of the happiest periods of his life. A young girl sits blowing a dandelion clock, perhaps playing the old children's game (the number of breaths taken equates to the number of years until you find true love). Certainly, Ring linked the blowing of the seeds with fertility and the creation of new life. He had recently been married (1896) and this painting was produced just after the birth of the couple's first child.

The Spanish-American War breaks out, as the two powers compete over control of Cuba. It is resolved with the Treaty of Paris, signed in December.

Marie and Pierre Curie discover radium. They announce their findings to the French Academy of Sciences in December.

The Boer War begins in South Africa. The conflict pits Britain against the Boers, the descendants of Dutch settlers.

1898　　**1899**

5
—

THE
MODERN
ERA

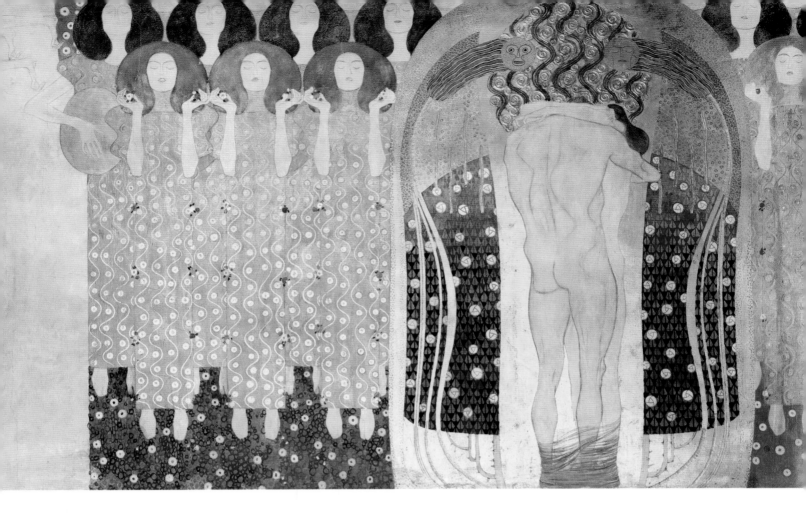

The period leading up to the First World War was one of the most fertile and inventive in the history of art. This was perhaps due to the newfound liberty which painters gained by organizing their own exhibitions. The Impressionists had been one of the first groups to go down this route, but the trend increased in the 1890s and early 1900s.

In France, the new bodies often retained the word 'Salon' in their title – the Salon d'Automne, the Salon de la Rose + Croix, the Salon des Indépendants and so on. Each of these catered for slightly different artistic interests and, in some cases, they have become associated with specific movements. The Salon d'Automne (so called because it was held in the autumn), for example, is chiefly famous because of its association with the Fauves. This group, led by Henri Matisse and André Derain, burst on to the scene when it exhibited at the Salon d'Automne in 1905. While painting in the brilliant light of St Tropez and Collioure in the south of France, these artists had begun to explore the potential of using intense colour as an independent element in their pictures. By removing colour's more usual descriptive role, the artists' vivid tones acquired an emotional and expressive power. The critics were shocked and dubbed the group les fauves ('the wild beasts').

Outside France, the breakaway exhibiting bodies were often known as 'secessions'. The leading examples were the Munich Secession (founded 1892), the Vienna Secession (founded 1897) and the Berlin Secession (founded 1899). The most important of these was the Vienna Secession, which was headed by Gustav Klimt. During his brief association with the group he established himself as the leader of the Austrian avant-garde. His Beethoven Frieze caused a scandal when it was exhibited at the Secession Building in 1902, and was dubbed 'painted pornography' by one critic. It culminates in A Kiss for the Whole World, which includes a naked couple embracing, prefiguring his most famous work, The Kiss (1907–8; see p. 225).

Paris remained the centre of the art world, a honey pot that attracted major artistic talents from every corner of Europe. This loose-knit community became known as the École de Paris (School of Paris), even though there was no teaching and no overall style. Some of the leading figures included Pablo Picasso (Spanish), Amedeo Modigliani (Italian), Marc Chagall (Russian),

PREVIOUS PAGE. Robert
Delaunay – *La Ville de Paris*
(c. 1911)

LEFT. Gustav Klimt – *A Kiss
for the Whole World* from the
Beethoven Frieze (1902)

BELOW. Umberto Boccioni
– *Plastic Forms of a Horse*
(1913–14)

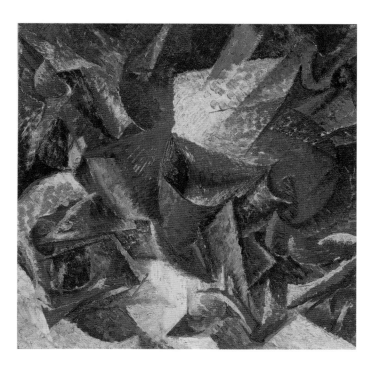

Chaim Soutine (Lithuanian) and Jules Pascin (Bulgarian).
Many of these incomers settled at La Ruche ('The Beehive'), a
ramshackle, twelve-sided pavilion that had been rescued from the
Exposition Universelle of 1900, in Paris. With the stench of the
nearby slaughterhouses hanging in the air, this place lived up to
its name, becoming a hive of industry where different cultures
and styles thrived alongside one another.

The great artistic talking point of the day was Cubism.
This revolutionary new style was developed in Paris by Georges
Braque and Picasso. When the pair met in 1907, Braque was
processing the influence of Cézanne's later paintings, which he
had witnessed at the latter's memorial exhibition at the Salon
d'Automne. Picasso, meanwhile, was working on *Les Demoiselles
d'Avignon* (1907; see p. 225), which reflected his interest
in African and ancient Iberian art. The combination of these
different factors sparked the inspiration of the two painters,
as they began to explore new ways of representing form and
spatial relationships. Over the next few years (1907–14), they
collaborated closely – 'like mountaineers roped together', as
Braque put it – creating a new way of looking at the world.

Cubism rejected the need for a single, fixed viewpoint, which
had been a lynchpin of Western art since the Renaissance. It also
undermined the use of perspective, modelling and foreshortening.
Instead, forms were broken down and their various different sides
were shown simultaneously. The name of the movement came
from a jibe directed at an exhibition of Braque's paintings of
L'Estaque in 1908: 'He despises form and reduces everything
… to geometrical patterns, to little cubes'. This early, geometric
phase, which stemmed from the influence of Cézanne, did
not last long. Soon, the fragmented forms were depicted as
overlapping planes. Colour was virtually eliminated, but gradually
other elements, such as stencils and collage, were introduced.

The ramifications of Cubism were huge, opening the doorway
to a number of other movements. These included Futurism,
Orphism, Vorticism and Constructivism. Orphism, pioneered by
Robert and Sonia Delaunay, along with František Kupka, injected
colour and lyricism into the austere domain of Cubism (the term
comes from Orpheus, the legendary musician). Many Orphic
works were abstract, although the Delaunays had a fondness
for incorporating images of the Eiffel Tower into their pictures.

The Futurists celebrated the power and dynamism of the
modern age. Founded in Italy, where it was spearheaded by
artists such as Umberto Boccioni, Carlo Carrà, Gino Severini and
Giacomo Balla, the movement has been described as 'animated
Cubism'. It used the latter's fractured forms to convey a sense
of speed, often focusing on moving cars and trains. However,
the spirit of the movement was very different. Where the Cubism
of Braque and Picasso was inward-looking, almost hermetic,
the Futurists gloried in their brashness. Filippo Marinetti – author
of the *Futurist Manifesto* – famously declared: 'a roaring motor-
car, which seems to run on machine-gun fire, is more beautiful

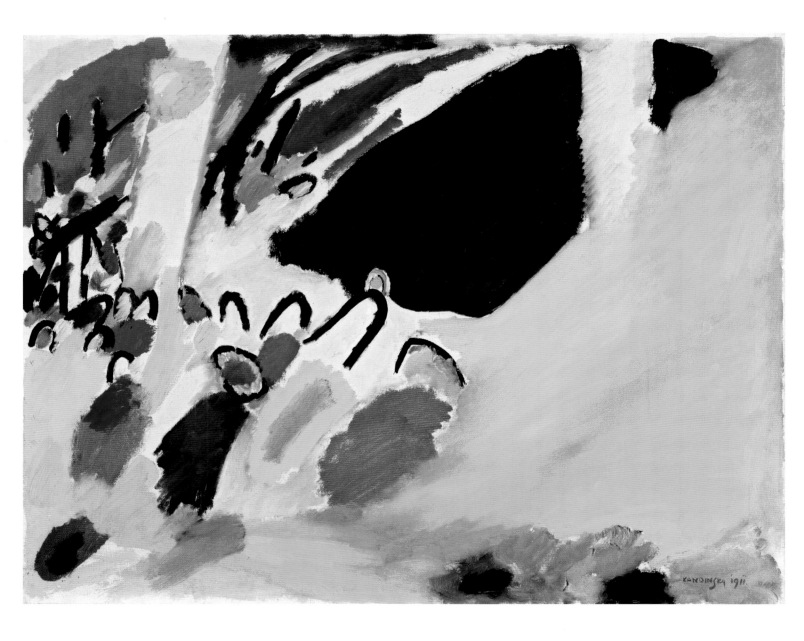

than the *Victory of Samothrace* (a famous Classical statue). He also gloried in the prospect of war, describing it as 'the Sole Hygiene of the World', and it may be no accident that the Futurists produced some of the most stirring scenes of the conflict.

The other great movement of the pre-war era was Expressionism. This had its roots in the work of two masters, Vincent van Gogh and Edvard Munch, who both used powerful, symbolic colours and linear distortions as a way of channelling their neuroses. The movement had the greatest impact in Germany, where it gained momentum from two important groups: Die Brücke (The Bridge), which was founded in Dresden

in 1905, and Der Blaue Reiter (The Blue Rider), which was formed in Munich in 1911. The latter harnessed the formidable talents of Wassily Kandinsky, Franz Marc and August Macke. The group offered a more spiritual, almost mystical slant on Expressionism, but it was also highly experimental. Kandinsky in particular pushed back the boundaries with his *Impressions*, *Improvisations* and *Compositions*.

The First World War put an end to many avant-garde groups, as so many of the leading participants were killed. Some elements of Expressionism, however, did survive. They can be seen in the Neue Sachlichkeit (New Objectivity) paintings of the

1920s. Led by Otto Dix, Christian Schad and George Grosz, the exponents of this style rejected the abstract tendencies of Der Blaue Reiter, but still used distortions to express the bitterness and cynicism of the post-war period in Germany. Dix, for example, went out of his way to make his figures appear ugly. Thus, in his *Portrait of the Journalist Sylvia von Harden* (1926), he emphasized the woman's enormous, claw-like hands and her sagging stockings. The legacy of Expressionism also played a part in the later movements of Neo-Expressionism and Abstract Expressionism.

Kandinsky's experiments with abstract art were echoed elsewhere. The most radical approach was that of Kazimir Malevich. In his Suprematist paintings, he restricted himself solely to geometrical shapes – rectangles, circles, triangles – but still managed to create a sense of movement and lyricism with these limited means. Malevich produced his first abstract Suprematist composition in about 1913 and experimented freely with the style for the next few years. He eventually reached an impasse with his *White on White* paintings of 1917–18, where the differences between the forms could be discerned only by slight differences in the brushwork. Malevich realized he could take the style no further, although Suprematist designs did have a longer shelf-life, as they were easily adapted for use on ceramics and textiles.

In the middle years of the century, the most important movements were Abstract Expressionism (see p. 244) and Pop art (see p. 253). Centred on figures such as Jackson Pollock, Mark Rothko and Andy Warhol, they signalled a decisive shift in creative circles as New York replaced Paris as the capital of the art world. In time, however, focus began to turn away from the implicit commercialism of the collectable art object. Artists looked instead for more dynamic interactions with the spectator. One of the most popular forms was the installation. This is generally a type of assemblage, which has its roots in the experiments of Marcel Duchamp and Kurt Schwitters. It is at its most effective when it is site-specific and temporary. The inspired creations of Joseph Beuys and Daniel Buren are fine examples.

The shift away from the collectable physical object took many forms. Sometimes there was an element of theatre (Performance art, Happenings, Body art); sometimes the materials were intangible or worthless (Land art [see p. 261], Arte Povera); and sometimes the idea itself was more important than the end product (Conceptual art). For some commentators, the growing emphasis on shock value and avant-garde effects amounted to little more than navel-gazing. However, great art still has the power to move and excite. Antony Gormley's *Angel of the North* (1998) regularly tops polls as Britain's favourite sculpture, David Hockney's exhibitions of his ipad paintings have proved both a popular and a critical triumph, and Paul Cummins' installation of poppies at the Tower of London – his tribute to the victims of the First World War – attracted millions of visitors.

LEFT. Wassily Kandinsky
– *Impression III (Concert)* (1911)

BELOW. Kazimir Malevich
– *Supremus 56* (1915)

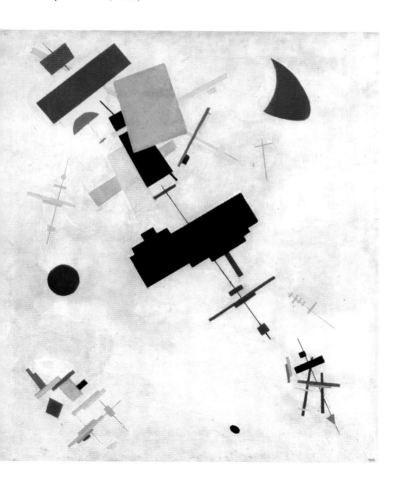

1900–1905

The turn of the 20th century. This is a period defined by modernity. The 1900 Exposition Universelle (World's Fair) in Paris showcases the latest advancements. The late 19th-century rise of the avant-garde continues to affect visual innovations. Representation is increasingly freed from traditional artistic conventions. The Viennese doctor Sigmund Freud publishes treatises that explore the human psyche, and artists start to turn inwards to explore these psychological intensities, and to visualize their experiences of the modern world. In 1905 a school of painting known today as Fauvism starts in Paris, with Henri Matisse at its helm. The Fauvists' forceful innovations with colour set them apart from their predecessors. ED

Edvard Munch – *Kiss IV*

The Norwegian artist Edvard Munch depicted the 'kiss' motif many times in his primary two media of print and paint. This is the final woodcut in a series of four that he produced on the theme. Munch was an important figure in the Symbolist movement and concerned with internal and psychological worlds, exemplified in his most famous canvas, *The Scream* (1893). The simplicity of Munch's woodcut here would later be taken to extremes in Gustav Klimt's Art Nouveau rendering of the same theme (see p. 225).

George Eastman's Kodak Company releases its Kodak Brownie hand-held camera, sold for $1. The model makes snapshot photography available to the masses.

The World's Fair or Exposition Universelle is held in Paris from 14 April to 12 November 1900, showcasing Art Nouveau to all.

Sigmund Freud, Viennese doctor and hugely influential thinker in the development of modern psychology, publishes *The Interpretation of Dreams*, his first treatise on the unconscious and inner worlds of human behaviour.

1900 | 1902

Hugo Simberg – *The Wounded Angel*

When Simberg first exhibited this piece at the Finnish Art Society in 1903, he deliberately withheld a title to encourage viewers to make up their own minds about its meaning. The mysterious scene pictures three life-like figures, one a fallen angel being carried across the bleak landscape of Helsinki's Eläintarha Park. Though Simberg originally intended the two attendants to be painted as devils, the more realistic portrayal of two morose boys carrying the wounded angel is particularly harrowing.

André Derain – *L'Estaque*

André Derain was one of the founding members of the modernist style known as Fauvism. The artists participating in this movement rejected the tenets of the Impressionists who came before them, and were instead interested in the innovative use of colour. A close friend of fellow Fauvist Henri Matisse, Derain used colour broadly and boldly. He applied this innovation to his multiple depictions of L'Estaque in southern France, in which the use of colour overtakes any attempt at realism.

Mary Cassatt is awarded the Légion d'Honneur in 1904 for her contributions to art. She is one of the few female Impressionists to have enjoyed success during her lifetime.

Photo-Secessionist Alfred **Stieglitz** opens his Gallery 291, also referred to as the 'Little Galleries of the Photo-Secession', in New York City.

1903　　**1904**　　**1905**

1905–1910

Early 20th century. Paris is the centre of intellectual and artistic activity. Gertrude Stein's famous Saturday evening salons bring together the giants of the avant-garde, including artists Henri Matisse and Pablo Picasso and writers Ernest Hemingway and F. Scott Fitzgerald. Intellectual elites meet and discuss the state of the arts, pushing ideas to new levels. Visual artists are as fearless as ever in their representational strategies. Picasso and Georges Braque are in the early stages of developing an abstracted visual language later known as Cubism. The impact of Art Nouveau continues, with Gustav Klimt exploring the potential of the decorative in visual art. Meanwhile, Italian Futurists are developing their own manifesto in response to industrialization of the modern world. ED

Albert Einstein publishes his Theory of Special Relativity, a foundational concept in modern physics.

The Fauvists, a group of artists that included Henri Matisse and André Derain, exhibit for the first time at the Salon d'Automne in Paris's Grande Palais.

Die Brücke, the German Expressionist group, is founded in Dresden.

Osman Hamdi Bey – *The Tortoise Trainer*

Osman Hamdi Bey was one of the rare painters to depict the Ottoman Empire from the point of view of an insider. Here he depicts a dervish who is tasked with training the roaming tortoises before him using the kettle drum he has strapped to his back, and the long hollow stick he clings to. Hamdi's detailed treatment of his figure, including the *araqiyya* he wears on his head and the Moroccan goatskin leather slippers that he wears on his feet, reinforces this authentic portrayal. The choice of subject is thought to be a satire on the slow pace of reform within the Ottoman empire.

Auguste and Louis Lumière launch the Autochrome Lumière, the first commercially successful colour photography process.

1905

1906

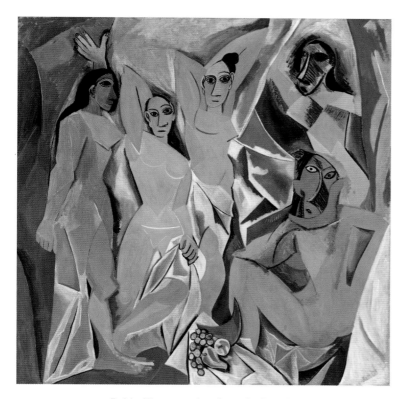

Gustav Klimt – *The Kiss*

Unlike Munch's simplified portrayal of *The Kiss* (see p. 222), Klimt's version is an exercise in visual decadence. Criticized for the blatant eroticism of his works, Klimt here portrays a couple locked in an embrace at the centre of the shimmering gold canvas. The rich clash of textures and colours reinforces the excess typical of Art Nouveau and the Viennese Secession. Inspired by the Byzantine mosaics he saw on a trip to Ravenna, Klimt's innovative use of gold and silver leaf in his canvases is iconic.

Pablo Picasso – *Les Demoiselles d'Avignon*

This painting is one of the most important in modern art. Picasso's fragmented depiction of a series of female figures from Barcelona's red-light district on Avignon Street was an important step towards his development of Cubism. The women's bodies appear as a series of jagged planes, and their faces fuse with the African masks that Picasso turned to throughout his career. The sexually charged scene is here approached through asymmetrical and abstracted planes that had a profound impact on the visual language of modern art.

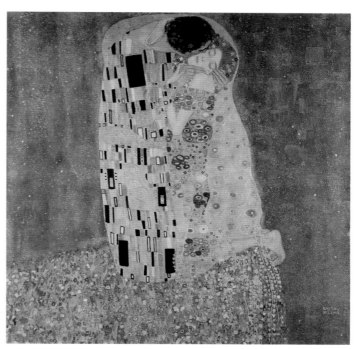

The *Futurist Manifesto* is published by the Italian poet Filippo Tommaso Marinetti in February, championing a break from the artistic traditions of the past.

Georges Braque and Pablo Picasso develop their first attempts at the new and influential visual style later known as Cubism.

1907 1907-8 1909

1910–1915

Energetic optimism. With developments in science, technology and engineering, new artistic movements emerge, including Expressionism, Cubism, Orphism, Futurism and Suprematism. Suffragettes fight for women's rights, the divide between rich and poor becomes more apparent and there are strikes, and the world hurtles towards war. In Germany Expressionism has started, stressing emotion rather than realism, and Futurism has begun in Italy, emphasizing speed, technology and violence. In 1911 in Germany the group Der Blaue Reiter (The Blue Rider) forms, emphasizing creative freedom, and in France, Cubists depict objects from different viewpoints simultaneously. In 1913 in Russia, Kazimir Malevich invents Suprematism: a form of pure abstraction. Meanwhile, The Armory Show opens in New York City, launching modern art in America. SH

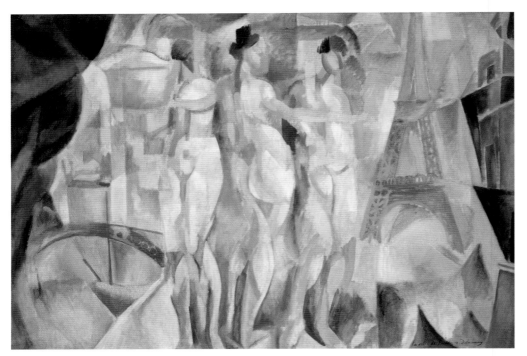

Robert Delaunay – *La Ville de Paris*

Robert Delaunay painted several works on this theme during the period in which he began to break away from Cubism and move toward Orphism – the movement that linked art and music through expressive colours and geometric shapes. Delaunay juxtaposed elements to convey contradictions of the city of Paris, such as history with modern life, figures alongside architecture, and stillness beside movement. He favoured bright, expressive colours and shard-like prisms. Adapted from a Pompeiian wall painting, the mythological Three Graces personify the city's elegance. The Quai du Louvre represents its heritage, while the Eiffel Tower symbolizes its modernity.

Slavery in China is made illegal.

King Edward VII dies in Britain.

The Firebird ballet, the first major work by the Russian composer Igor Stravinsky, commissioned by Serge Diaghilev's Ballets Russes, is premièred in Paris, bringing the composer international fame.

The term 'Expressionism' is first used by the German art and literary magazine *Der Sturm*.

The Republic of China is proclaimed.

The White Star liner RMS *Titanic* departs from Britain for America with 2,225 passengers and crew on her maiden voyage. Four days later she strikes an iceberg in the northern Atlantic Ocean and sinks; 1,517 die.

1910 **c. 1911** **1912**

Jacob Epstein – *Rock Drill*

Originally over 3 m (10 ft) high, this sculpture was a plaster figure on top of an actual industrial rock drill, expressing the advancements of 20th-century technology. After the First World War began, however, and the reality of trench warfare was known, Jacob Epstein removed the drill and the legs, changed the arms and cast the object in bronze. Immediately, it became a vulnerable symbol of war. With its beaklike head, the angular torso appears to wear armour, but the soft abdomen is exposed.

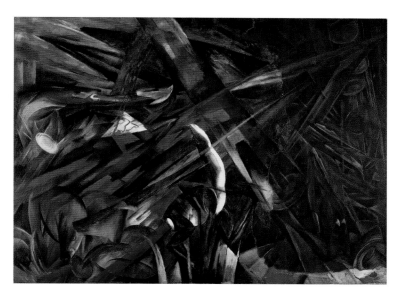

Franz Marc – *Fate of the Animals*

Sharp angles and jagged shapes convey devastation of the natural world seen through the eyes of animals: a premonition of the First World War. A pioneer of German Expressionism, Franz Marc was interested in spirituality and primitivism, as well as colour symbolism. For him, blue was masculine, yellow was feminine, and red embodied the increasingly powerful material world. Here the animals are trapped in a raging forest fire caused by humans that is destroying their environment. Dagger-like flames provoke terror, and the animals contort as they try to escape. In the centre, however, a blue and white deer symbolizes hope as it twists away from a tree that is about to fall on it.

The rebuilt Grand Central Terminal in New York City opens as the world's largest railway station.

In Michigan, near Detroit, the Ford Motor Company becomes the first car production facility in the world to implement a moving assembly line.

The assassination of Archduke Franz Ferdinand of Austria and his wife in Sarajevo triggers the First World War, as Austria-Hungary declares war on Serbia, Russia mobilizes against Austria-Hungary, German and French troops mobilize, and Germany also invades Belgium. Britain declares war on Germany for violating Belgian neutrality.

1913

1913–16

1914

THE ART OF THE POSTER

In the closing years of the 19th century, a new art form emerged, as scores of colourful posters began to brighten up the boulevards of Paris. This phenomenon was dubbed 'the art gallery of the streets', attracting some of the most talented designers of the period.

The pioneer of the genre was Jules Chéret. He began producing posters in the late 1860s, exploiting the latest technical developments in the field of colour lithography, which enabled him to print large numbers of his designs quickly and cheaply.

From the outset, posters were regarded as ephemera. They were mainly used to publicize temporary events – the latest play or concert – or to advertise new commercial products. This did not require the same detail or complexity as a painting, but it did need images that were bold and eye-catching. Henri de Toulouse-Lautrec became the first great master of poster design

because he excelled at all these features. He liked basing his compositions around a large, striking silhouette, and there is often an element of caricature in his figures. He used a limited range of colours (only four in *Divan Japonais*), but added a degree of texture through a technique called *crachis* ('spitting') – plainly visible on the man's gloves and trousers – which he achieved by flicking ink onto the lithographic stone with a toothbrush.

Lautrec's career coincided with the boom in the popularity of posters. The first book on the subject appeared in 1886, and there were exhibitions in Paris and New York. Some

Alphonse Mucha
(1860–1939)

Mucha was one of the greatest poster designers of the Belle Epoque – the glittering period of French culture at the end of the 19th century. His images of pretty young women with long, cascading hair, surrounded by flowers, have become regarded as the epitome of the Art Nouveau style. Mucha was born in Moravia (in the present-day Czech Republic), but spent much of his career in Paris. His breakthrough came in 1894, when he produced his first theatrical poster for the celebrated actress Sarah Bernhardt. She was so happy with that she gave him a contract to produce several more, over the next few years. In later years, Mucha returned to his roots, producing a monumental series of paintings entitled *The Slav Epic* (1909–28).

ABOVE LEFT. Henri de Toulouse-Lautrec – *Divan Japonais* (1893)
Lautrec's poster features several of his friends. The lady in black is the can-can dancer Jane Avril and next to her is the art critic Édouard Dujardin. The singer, recognizable despite her missing head, is Yvette Guilbert.

ABOVE CENTRE. Cassandre – *Nord Express* (1927)
Cassandre was the greatest poster artist of the Art Deco era. He captured the sensation of speed with economy of means.

ABOVE RIGHT. Martin Sharp – *Explosion* (1968)
Sharp's psychedelic tour-de-force conveys the power and ferocity of Jimi Hendrix's music.

designers even produced special editions for collectors. Alphonse Mucha, for example, created sets of posters on specific themes, such as 'The Four Seasons' and 'Times of the Day'.

The style of Lautrec's posters owed much to recent artistic developments. He was particularly influenced by Japanese prints and by Degas's brand of Impressionism. The notion of cropping the singer's head at the top of *Divan Japonais* was a device borrowed directly from Degas (see p. 202).

In the same way, Art Deco designers drew inspiration from the avant-garde art movements of their era. From the Cubists they borrowed ideas about fragmentation, overlapping images and bold use of typography, while from the Futurists they gained a preoccupation with speed and power. No one utilized these themes more effectively than Cassandre (Adolphe Mouron),

who added a dash of glamour that was all his own. He is remembered for his advertising posters for railways and ocean liners, where he stripped away superfluous detail, letting his sleek stylizations of mechanical power shine through.

The poster revival of the psychedelic era had similar roots, deriving some of its ideas from the visual ambiguities of Op art and the irreverent attitudes of the Pop artists. Members of the general public may have had little contact with the original art movements, but they could enjoy popularized versions of their forms in posters of rock concerts and venues. Martin Sharp's celebrated poster of Jimi Hendrix, for example, was loosely based on a photograph by Linda Eastman, but the artist conjured up the energy of a live performance by dissolving the image, echoing the frenzied abstraction of a Jackson Pollock painting. IZ

1915–1920

Destruction and conflict. This is a period of conflict, as the Great War tightens its grip on the world's political powers. As technology develops, so too do deadly warfare tactics, including the introduction of mustard gas and machine guns. The devastation of war results in a period of major social, economic and political turmoil. To add to the chaos, the Russian Revolution sets off its own upheaval when it erupts in 1917. Artists during this period are no longer concerned with beauty or the sublime; such artistic principles no longer seem relevant amidst the extreme destruction and absurdity of war. The anti-war artists known as Dada emerge as a force to be reckoned with in Berlin, Zürich, New York, Paris and Cologne. The artistic innovations that come out of Dada – photo-montage, collage and readymades – address the disaster of the war and approach art making as a 'state of mind'. ED

Kazimir Malevich – *Painterly Realism of a Football Player*

With his manifesto *From Cubism to Suprematism: The New Realism in Painting*, Kazimir Malevich founded the Suprematist movement in 1915. This painting demonstrates the major tenets of Malevich's manifesto: geometric abstraction, anti-pictorialism, and compositions governed by the formal rules of line, colour and shape. Here Malevich's approach to 'painterly realism' reduces his subject to its very core, and is one of his first efforts at Suprematist painting.

The Easter Rising in Dublin against British rule begins on 24 April, with some 1,250 rebels seizing the General Post Office and other strong points of command. Six days of fierce fighting end with the execution of the leaders of the rising, fuelling a wave of public sympathy and setting the course for Irish independence.

The Battle of the Somme begins on 1 July. The British offensive against German positions north of the Somme is an almost total failure, with 57,000 casualties – more than 19,000 of them dead – on the first day alone.

Cabaret Voltaire, the famous nightclub and home of Dada, opens its doors in Zürich.

1915

1916

Mark Gertler – *Merry-Go-Round*

Mark Gertler described his large-scale painting of the merry-go-round mounted annually near Hampstead Heath as 'unsaleable'. Nevertheless, he persisted with this dystopian scene of men and women in uniform riding their unmoving synthetic horses. The unsettling juxtaposition of war and merriment is a scathing portrayal of war-torn Europe. Interpreted as a harrowing response to this, Gertler's disturbing and modernist treatment of his subject was admired by audiences who viewed it when it was exhibited in 1917.

John Singer Sargent – *Gassed*

John Singer Sargent's portrayal of the aftermath of a gas attack on soldiers in 1918 depicts them being blindly led to medical tents. Their eyes, badly damaged from the attack, are covered as they rely on one another for balance and direction. Sargent had been shocked by the gassed soldiers he saw on a trip to France. This sobering piece was commissioned by the British government for a Hall of Remembrance, and was received with great acclaim by the Royal Academy when it was exhibited in London.

Marcel Duchamp, one of Dada's most prominent members, famously produces his work *Fountain* – a urinal – and insists that it is art.

The October Revolution, or Red October, is a planned insurrection against the Provisional Government in Petrograd organized by the Bolsheviks. It is an important event in the larger 1917 Russian Revolution.

The First World War ends: the armistice is signed on 11 November.

The Suffragette movement wins an important battle when the Representation of the People Act 1918 grants the vote to British women over the age of thirty. In 1928, further legislation extends this to women over the age of twenty-one.

1917 | **1918** | **1919**

1920-1925

A period of rebuilding. There is a period of regeneration in the aftermath of the First World War. In the United States, the Roaring Twenties are a period of unprecedented economic prosperity as consumerism thrives in a modern capitalist economy. However, for others, poverty and prejudice prevail. This tension creates an exciting time for art in the 1920s, with major movements including the Bauhaus and Dada taking form and spreading their influence across literature and the visual arts. Dada emerges across cities internationally, with unnerving works that attempt to mimic the absurdity of war. Dada takes many forms, and defies any easy categorization, but its anti-war thrust pervades its worldwide iterations. In the United States the Harlem Renaissance takes a stand of its own, resulting in work from some of the country's most celebrated artists and intellectuals, including Langston Hughes and W. E. B. Du Bois. ED

The **Prohibition era** in the United States begins on 16 January, with the coming into effect of the 18th Amendment to the American Constitution. It lasts until 1933, when the 21st Amendment legalizes the sale and consumption of alcohol.

The **right to vote** is granted to American women on 18 August, with the 19th Amendment to the American Constitution.

The **first International Dada Fair** is organized in Germany, featuring work by Otto Dix, Max Ernst and Hannah Höch.

Francis Campbell Boileau Cadell – *Portrait of a Lady in Black*
Cadell was one of the founding members of the Scottish Colourists, who pioneered the development of modern art in Scotland. He lived in Edinburgh for most of his life, with the exception of the time he spent in Paris learning how to paint. This portrait of the popular model Bertha Hamilton Don-Wauchope, or the 'Lady in Black', marks a break from his previous Impressionist-style painting. He painted Bertha a number of times; here she appears in the interior of his beloved studio in Ainslie Place, Edinburgh.

1920

1921

Max Ernst – *Ubu Imperator*

Max Ernst was one of the most influential practitioners of Dada and Surrealism, and here he combines the two. The Surrealists were interested in the world of dreams and the subconscious, while Dada was concerned with the absurd brutalities of war. As Ernst's bizarre juxtaposition of human hands on a machine-like figure demonstrates, his Surrealist leanings encouraged a relinquishment of control over the reasoning of the conscious mind, allowing the subconscious to take over.

Paul Klee – *Fish Magic*

Paul Klee completed his abstract canvas *Fish Magic* in 1925. There are a number of influences at play here, including most obviously Expressionism and Surrealism. Klee was born in Germany to Swiss and German parents, so his participation in the German-born Expressionist movement comes as no surprise. The evocative intrigue of Klee's 'magic' aquatic scene is particularly Expressionistic, while the strange juxtaposition of the clock tower and the waving figure in the foreground suggests Surrealist undertones.

The USSR, or Soviet Union, is formally proclaimed in Moscow. It is initially composed of four republics – Russia, Ukraine, Belorussia and Transcaucasia – but goes on to encompass Armenia, Azerbaijan, Georgia, Kazakhstan, Moldova, Uzbekistan, Tajikistan, Turkmenistan, Estonia, Latvia and Lithuania.

The Freer Gallery opens in Washington, D.C., boasting impressive collections of Asian and 19th-century American art.

1922 1923 1925

1925–1930

Surrealism's first exhibition. This takes place in Paris in the same year that Art Deco is established at an exhibition put on by the French government. Angular and elegant, Art Deco assimilates aspects of other contemporary movements and the ancient Egypt craze inspired by Howard Carter's discovery of Tutankhamun's tomb in 1922. Adolf Hitler's *Mein Kampf* (My Struggle; 1925) is published in Germany, and the Bauhaus moves from Weimar to Dessau. In Mexico City, Frida Kahlo is seriously injured when her school bus collides with a tram, while in the United States the phrases Jazz Age and Roaring Twenties describe the freer attitudes surrounding popular music, dances and fashions. All this ends in 1929, when the New York stock market crashes, leading to the Great Depression, the worst economic downturn in the history of the industrialized world. SH

Otto Dix – *Big City Triptych*

In the 1920s Otto Dix and George Grosz founded Neue Sachlichkeit (New Objectivity), a movement that emphasized many German artists' cynicism towards the First World War and its repercussions. Dix's triptych, alternatively called *Metropolis*, blatantly illustrates the situation. Oblivious to the suffering around them, the wealthy couple in the centre enjoy themselves in a jazz club. On the right-hand side, high-class prostitutes wear similar clothing to the rich women in the centre, while on the left, low-class prostitutes loiter under a bridge.

The capital of Norway, Kristiania, returns to its original name of Oslo.

Benito Mussolini makes a crucial speech in the Italian Chamber of Deputies.

Adolf Hitler publishes the first part of his autobiography, *Mein Kampf*.

F. Scott Fitzgerald publishes *The Great Gatsby*.

Germany and the Soviet Union pledge neutrality for the next five years in the event of an attack on the other by a third party.

A general strike occurs in Britain involving 1.7 million workers.

Charles Lindbergh makes the first solo non-stop transatlantic flight from New York City to Paris.

Leon Trotsky is expelled from the Soviet Communist Party, leaving Joseph Stalin in control.

1925	1926	1927	1927–28

○ **Alexander Deineka – *The Defence of Petrograd***

After the Russian Revolution of 1917, the new Soviet Union used art to reinforce the aims of Communism. Artists such as Deineka had to use conventional realistic techniques, and the style became known as Socialist Realism. An important example of early Socialist Realism, this depicts events of 1919 during the civil war, when the White Army reached Petrograd (now St Petersburg), and Leon Trotsky organized the city's defence. Deineka creates a circular rhythmical composition, conveying the incessant stream of those prepared to die for the Soviet state. Colour is used sparingly.

Tamara de Lempicka – *Autoportrait (Tamara in a Green Bugatti)*

'Baroness with a Brush' and 'Modern Venus' are just two of the many terms that were applied to Tamara de Lempicka. Her Polish background and life of wealth, travel and love affairs enhanced her enigmatic allure, while her art blended elements of Neoclassicism, Cubism and Futurism to create an overt Art Deco style that embraced modernism. With smooth contours and powerful chiaroscuro, this self-portrait appears almost sculptural.

The British inventor John Logie Baird broadcasts a television signal from London to New York and later demonstrates the first colour television transmission.

Amelia Earhart becomes the first female aviator to make a successful transatlantic flight.

The St Valentine's Day Massacre occurs when five gangsters plus two civilians are shot dead in Chicago.

On Black Tuesday, 29 October, the New York stock market crashes and the world economy is plunged into the Great Depression.

1928

1929

Clarice Cliff
(1899–1972)

Affectionately known as 'The Sunshine Girl', Clarice Cliff was one of the most prolific designers of the Art Deco era, a remarkable achievement for a female in a male-dominated industry. She began working in the potteries of Stoke-on-Trent, Staffordshire, in her early teens, and visited the Exposition Internationale des Arts Décoratifs et Industriels Modernes in Paris in 1925. Having been given her own studio at A. J. Wilkinson Potteries, she released her first range of bright, bold designs called 'Bizarre' in 1927, inspired by the Exposition in Paris, the Bauhaus in Germany and the Wiener Werkstätte in Austria. Hand-stencilled *pochoir* prints of the French artist and chemist Édouard Benedictus also influenced her colour choices.

ART DECO

Named after an exhibition held in Paris in 1925, Art Deco was interpreted in fine art, design and architecture. It was both a reaction against Art Nouveau, and a blend of ideas from Cubism, Futurism, De Stijl, the Bauhaus, Orientalism, Constructivism, the Ballets Russes, and ancient Egyptian, Aztec and African tribal art. These were combined with an emphasis on the sleek shapes of the Machine Age.

ABOVE LEFT. René Lalique – *Victoire (Spirit of the Wind)* (1920–31)
Famed for glass art, bottles, jewelry, chandeliers and clocks, Lalique embraced modernism here in one of his many innovations: car mascots.

LEFT. Clarice Cliff – *Age of Jazz* (1930)
This flat-sided, angular group of figures was designed either to be a table centrepiece or displayed around a wireless playing popular dance-band music. Nicknamed 'happy china', the small, colourful figures were created in five different designs, including a dancing pair, a drummer, a pianist, and an oboe and a banjo player.

More angular and geometric than the curving undulations of Art Nouveau, Art Deco began as a total design and art style intended to challenge the hierarchy of the visual arts that for so long had given crafts and decorative arts lower status than fine art. The first use of the term 'Art Deco' is usually attributed to the architect Le Corbusier in a series of articles in his journal *L'Esprit Nouveau* ('The New Spirit'), entitled '1925 Expo: Arts Déco'. He was referring to the Exposition Internationale des Arts Décoratifs et Industriels Modernes (International Exposition of Modern Decorative and Industrial Arts) held in Paris in 1925, although the term did not come into general use until after another exhibition had been held in Paris over forty years later in 1966: 'Les Années '25': Art Déco/Bauhaus/Stijl/Esprit Nouveau'. Yet ideas for the new movement had initially arisen soon after the Exposition Universelle of 1900, when a group of artists and designers formed an organization called La Société des Artistes Décorateurs (The Society of Decorative Artists) to promote French crafts.

Among members of the group were the architect Hector Guimard, designer Eugène Grasset, ceramicist Emile Decoeur and painter and designer Francis Jourdain. They planned a major exhibition for 1914 to show their new ideas for decorative art, but when the First World War broke out it was postponed. Then, from April until October 1925, over 15,000 artists, architects and designers displayed their work, seen by more than 16 million visitors. The two most influential displays were the interiors for the Pavilion du Collectionneur (House of a Collector) designed by Émile-Jacques Ruhlmann, and the Pavilion de l'Esprit Nouveau designed by Le Corbusier. The styles seen there spread rapidly and extensively, as the exhibition became the catalyst for the Art Deco movement. Expressing the glamour of Hollywood, the energy of the flapper era and the enthusiasm of the Harlem Renaissance, Art Deco also celebrated the sense of progress and modernism of the period, including the mass production and subsequent affordability of many domestic appliances; the production of more cars, trains and ships; the building of new high-rise buildings; and women being allowed to vote for the first time in many countries. While also evading the anxieties of the Great Depression and another war looming, Art Deco practitioners optimistically embraced and celebrated the Machine Age, in particular, technological innovation, modern materials and streamlined contours. SH

1930–1935

The Great Depression. Following the economic prosperity of the 1920s, the 1930s sees the United States fall into the throes of the Great Depression. In the aftermath of the historic stock market crash of 1929, America experiences its greatest period of economic decline. In Europe, fascism is on the rise, with Mussolini and Hitler taking the helm in Italy and Germany. The unsettling lead-up to the Second World War is reflected in the art produced in this interwar period. Surrealism starts to take shape across Europe, for instance. The French poet André Breton, who is heavily involved with Dada, published the *Surrealist Manifesto* in 1924, encouraging artists to engage in free association or 'automatism' – a concept borrowed from Freudian psychology. By the 1930s Surrealism has matured into one of the most important movements in modern art. ED

Grant Wood – *American Gothic*
The stoic, unsmiling figures in Grant Wood's masterpiece are some of the most recognizable in American art. Inspired by the architecture in the state of Iowa where he grew up, known as 'Carpenter Gothic', Wood applied the architectural term to his depiction of a farmer and his daughter. Their exaggeratedly long facial features echo the architecture of their small wood-frame house standing in the background. Inspired by early Flemish portraiture, Wood's figures are brought to the foreground of his canvas, confronting their viewers with the resolve of the rural Midwest.

Amy Johnson successfully completes a solo flight from Britain to Australia in nineteen days, making her a household name.

The Empire State Building emerges on Manhattan's famous skyline. Formally opened on 1 May, it becomes one of the world's most recognizable skyscrapers and holds the title of the world's tallest building from 1931 to 1970.

1930

1931

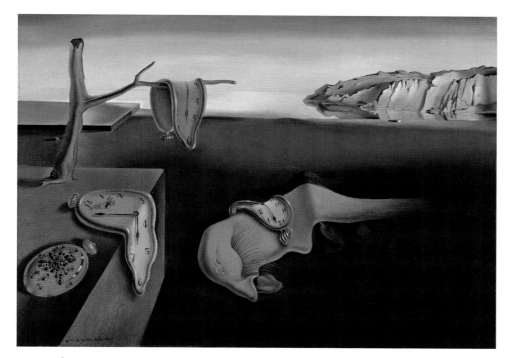

Salvador Dalí – *The Persistence of Memory*

The threshold between sea, shore and sky sets the scene for this iconic Surrealist painting. Dalí's melting clocks appear to be hanging and sliding down the bizarre fixtures that are sparingly featured in this canvas. The strange, flesh-coloured figure at the centre lies on its side, with its vaguely discernable eyelids and snout giving way to a body that blends into the flat landscape. Time and decay create an unnerving context for this exploration of the world of dreams and the subconscious. The swarming ants contained on the reverse side of the flipped watch allude to the underbelly of the conscious mind as the central figure – often interpreted as Dalí himself – lies sleeping.

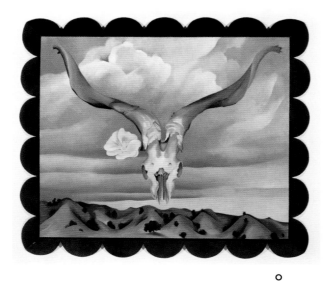

Georgia O'Keeffe – *Ram's Head with Hollyhock*

Georgia O'Keeffe was one of the most innovative painters of American modernism. Her imaginative way of combining elements from nature was both lyrical and highly original. O'Keeffe made frequent trips in the 1930s to New Mexico, where she was inspired by the rich landscape and surroundings. This painting encapsulates the rhythms of the rolling hills, and brings life and mortality together in the juxtaposition of the skull and the blooming flower.

Adolf Hitler comes to power as the chancellor of Germany on 30 January, transforming the German state into a fascist dictatorship.

Franklin D. Roosevelt is inaugurated as US president, beginning a period of bold action that would lead the United States to prosperity after the Great Depression.

Benito Mussolini's Italian forces embark upon the conquest of Haile Selassie's Ethiopia, forcing the African leader into exile.

1933

1935

1935–1940

Build-up to war. The years leading up to the Second World War are characterized by mounting anxiety. The Nazi party continues its reign of terror in the immediate lead-up to Hitler's invasion of Poland in 1939. With the Nuremberg Laws passed in 1935, Germany is on the brink of the largest genocide in modern history. The conservatism of the Nazi party is reflected in two exhibitions that are staged in 1937: 'The Great German Art Exhibition', and its intended antithesis, 'The Degenerate Art Exhibition'. The latter features works by some of the greatest modernist artists, including Paul Klee, Max Ernst and Wassily Kandinsky, whose work is condemned by Hitler as corrupt. Spain is in the throes of a civil war that divides the country between military Nationalists and the Republican government. Among the artistic responses to the war is one of the most powerful anti-war images in modern art. In 1937, one year after Spain's initial military revolt, Picasso paints *Guernica*, bereft of colour but overwhelming in its portrayal of the atrocities of war. ED

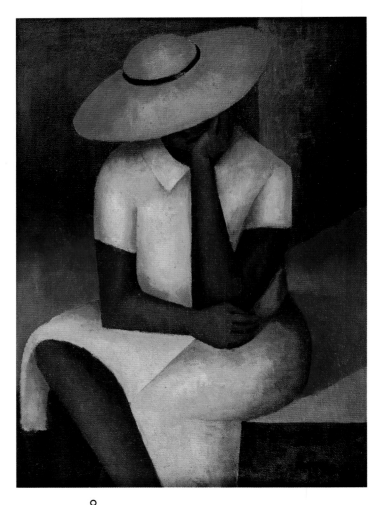

Norman Lewis – *Girl with Yellow Hat*

In his later work, Norman Lewis was associated with American Abstract Expressionism. In his earlier work, however, he was engaged in the Social Realism that tackled the classist and racial tensions of interwar America in the decades leading up to the Civil Rights Movement. His earlier style borrows from European modernism, as is evidenced in *Girl with Yellow Hat*, a figurative rendering of a young African-American woman seated pensively on her own.

The 'Cubism and Abstract Art' exhibition is organized by Alfred Barr, founding director of the Museum of Modern Art in New York, and opens to the public in March.

The Spanish Civil War erupts in July, following a military uprising. The war polarizes the country between military Nationalists and the Republican government.

The 'Degenerate Art Exhibition' is organized by the Nazi party in July to condemn the supposed corruption of modern art. It is mounted in Munich, a short distance from its counterpart in the 'Great German Art Exhibition'.

1936

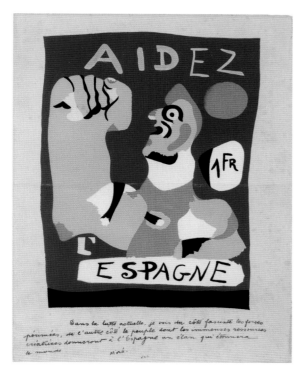

Dans la lutte actuelle, je vois du côté fasciste les forces
périmées, de l'autre côté le peuple dont les immenses ressources
créatrices donneront à l'Espagne un élan qui étonnera
le monde. Miró.

Edward Hopper – *New York Movie*

Edward Hopper's canvases heartbreakingly capture the melancholy of the modern world. Though Hopper was interested in some of the same developments that motivated the Surrealists – especially when it came to modern psychology and the workings of the inner psyche – he arrived at the canvas with a drastically different approach. *New York Movie* encapsulates his starkly Realist style, wherein the theatricality of cinema is sidelined and the lone musings of a contemplative usher thinking to herself are the real drama.

Joan Miró – *Aidez l'Espagne*

This striking poster was designed to raise funds for the Republican cause during the Spanish Civil War. With its graphic message – 'Help Spain' – it shows a muscular peasant, wearing the colours of the Spanish and Catalan flags, raising his massive fist in defiance. Miró originally produced this design for a French postage stamp, but the stamp never materialized. Instead, it was used for a limited-edition poster, which was sold outside the Spanish Republican Pavilion at the 1937 International Exhibition in Paris.

Pablo Picasso completes his monumental work *Guernica* in the summer, in response to the bombing of the city of Guernica in northern Spain. After touring Europe and America, the painting returns to Spain in 1981 and is today held by the Museo Reina Sofia in Madrid.

Germany invades Poland on 1 September. This event is considered the catalyst for the outbreak of the Second World War.

1937

1939

1940–1945

Shift to the States. The 1940s sees artists increasingly unconvinced by traditional approaches to art production. The allure of classical and idealized subjects diminishes as new visual languages and philosophies develop and adapt to the violence of war. The art world also begins a historic shift from its roots in Europe over to the United States, where New York becomes entrenched as a centre for art. Influential figures such as Peggy Guggenheim are instrumental in promoting and exhibiting the new modern art to an international audience. Abstract Expressionism produces such significant painters as Mark Rothko and the legendary Jackson Pollock, whose 'drip paintings' completely change the painterly process for a new generation of artists. Indeed Peggy Guggenheim's Art of This Century gallery gives many of the best-known players in American modern art their first shows. She also mounts 'The Exhibition of 31 Women' in 1943, showcasing the work of women modernists including Frida Kahlo, Dorothea Tanning and Méret Oppenheim. ED

Paul Nash – *Totes Meer (Dead Sea)*

Paul Nash was one of the most important figures in the development of modern British art. In August 1940, the year after the outbreak of the Second World War, he saw the wreckage of abandoned aircraft in Cowley, Oxfordshire. Nash was especially struck by the fact that the pile of rubble – the 'vehicles of destruction' – were once 'directed by human agency'. The vastness of the destruction was such that it looked to him almost like a seascape – hence his chosen title.

The American art critic Clement Greenberg publishes his treatise 'Towards a Newer Laocoön' in a 1940 issue of the *Partisan Review*. Following his essay 'Avant-Garde and Kitsch' published the previous year, this is one of Greenberg's most famous and influential writings.

The American naval base at Pearl Harbor is attacked by the Japanese. Historians see this as the catalyst to the United States' participation in the Second World War.

1940 ‖‖‖‖‖‖‖‖‖‖‖‖ **1940–41** ‖‖‖‖‖‖‖‖‖‖ **1941**

Piet Mondrian – *Broadway Boogie Woogie*

Piet Mondrian was one of the many artists who fled Europe during the war. He made his way to the United States, infiltrating the New York art world and bringing a strong dose of European modernism with him. This canvas is quintessentially New York: inspired by the rhythms of jazz and the bright lights of Broadway, Mondrian's brightly coloured grid maps out the countless forms of 'boogie woogie' that make the city come alive.

Laura Knight – *Ruby Loftus Screwing a Breech Ring*

During the Second World War women participated actively in the world of work and industry. Laura Knight's powerful depiction of an industrial factory in Newport, Wales, filled with women labouring, is testament to this. This painting was commissioned by the War Artists' Advisory Committee in 1943, and honours the twenty-one-year-old factory engineer Ruby Loftus. She appears here performing one of the most complex tasks at the Royal Ordnance Factory – a feat that brought her instant fame and recognition.

Peggy Guggenheim opens her famed Art of This Century gallery on 20 October, at 30 West 57th Street in New York City.

The Surrealist artist Salvador Dalí publishes his autobiography, entitled *The Secret Life of Salvador Dalí*.

Piet Mondrian, the Dutch painter and member of the influential De Stijl movement, dies in New York.

The D-Day landings, in which more than 125,000 US, British and Canadian soldiers assault the German-held coast of France along the bay of the River Seine in Normandy, occur on 6 June.

1942–43 **1942** **1943** **1944**

ABSTRACT EXPRESSIONISM

The most important movement in modern American painting, Abstract Expressionism made such an impact that it led New York to replace Paris as the world's leading centre of contemporary art. It flourished in the 1940s and 1950s, and involved some of the most remarkable personalities in the history of American culture.

The Abstract Expressionists were not a formal group, but a loose association of artists who shared certain attitudes – notably a belief in freedom of expression and the conviction that abstract art could have a moral purpose and make statements about the human condition. These artists worked mainly in New York (they are sometimes known as the New York School) and were influenced by the avant-garde European artists who took refuge there during the Second World War. In particular they were stimulated by the ideas of the Surrealists, who often used unconventional techniques to release the creative forces of the unconscious mind.

The leading Abstract Expressionists included Jackson Pollock, Willem de Kooning, Mark Rothko, Barnett Newman, Clyfford Still and Robert Motherwell. All except Motherwell began as figurative painters, but during the late 1930s and early 1940s they moved into abstraction. Pollock, the most powerful personality, created a highly distinctive, energetic style, splashing and dribbling paint on the canvas. Rothko evolved a very different style – contemplative, with soft, hazy shapes and subtle variations in relatively flat colour. De Kooning was different again, as he often retained figurative elements in his work, which is characterized by violent brushwork. Most liked to work on very large canvases, underlining the scale of their ambitions.

Initially Abstract Expressionism was greeted with bewilderment or shock by many people, but during the 1950s it became a huge success critically and financially. Previously abstraction had always been a fairly highbrow taste, but now it occupied centre stage in world art. This success had a political dimension, for at the time of the Cold War, Abstract Expressionism was promoted as an embodiment of the American values of freedom and individuality, in contrast with the totalitarianism of Communist countries, where avant-garde art was banned.

By about 1960 Abstract Expressionism had passed its peak, but it continued to influence younger artists (for example in the taste for working on a huge scale) and it inspired reactions against its emotionalism, in the form of cooler idioms such as Minimal art and Pop art. IC

1945–1950

The immediate post-war period. Europe lives in the wake of the chaos of war, while changes are happening the world over: Korea is divided; the newly independent nations of India and Pakistan are at war; Communist China is on the rise after Mao Zedong declares the establishment of the People's Republic of China in 1949; the first apartheid policies in South Africa are introduced. The United States drops the world's first atomic bombs on the Japanese cities of Hiroshima and Nagasaki, killing more than 120,000 people. This event positions the United States as a rising superpower in the aftermath of the war. In art, New York is the new centre of the Western art world, and the 19th-century search for a distinctive American aesthetic is maturing. ED

Henri Matisse – *Icarus*

This is one of Matisse's most recognizable images. The artist is best known for his innovations as a colourist, and as the leader of the Fauvist movement in France. The Fauvists were interested primarily in colour, and broke away from the Impressionist avant-garde early on in the 20th century. Matisse was consistent with his approach to colour, and created a series of plates for an artist's book entitled *Jazz*, published in 1947. Icarus appeared for the first time in this limited-edition publication.

The United States drops atomic bombs on the Japanese cities of Hiroshima (6 August) and Nagasaki (9 August), forcing Japan to surrender on 15 August.

The United Nations is officially founded on 24 October, with fifty participating countries.

India gains its independence, as the British Empire starts to disintegrate after the end of the Second World War.

Mark Rothko, Barnett Newman and Robert Motherwell help co-found The Subjects of the Artist School in New York, devoted to promoting meaning in abstract art.

1945 **1947**

Andrew Wyeth – *Christina's World*
This unsettling painting pictures a young woman dragging her body across a seemingly endless rural landscape towards the farmhouse in the distance. Though the unnerving scene invites comparisons with the Surreal, Wyeth's execution is Magical Realist. The exactitude of each grass blade echoes the strands of hair being rustled in the gentle wind. The subject of the painting, Anna Christina Olson, suffered from a degenerative muscle condition that prevented her from walking. She preferred crawling around rather than using a wheelchair.

Jackson Pollock – *Autumn Rhythm (Number 30)*
Jackson Pollock was the most famous of the group of Abstract Expressionist painters that came to be known as the New York School. Peggy Guggenheim gave him his first solo exhibition at her Art of This Century gallery in 1942, and soon after he rose to prominence in the art world. *Autumn Rhythm* is an example of his revolutionary 'drip' technique, in which he focused on the spontaneity and immediacy of the artistic process.

The 'Big Bang Theory' is formulated by the physicists George Gamow and Ralph Alpher.

The Abstract Expressionist Jackson Pollock paints one of his most famed 'drip paintings', entitled *Number 1, 1950 (Lavender Mist)*.

1948

1950

1950–1955

The American Dream. The early 1950s saw Abstract Expressionism reach the height of its popularity. Led by Willem de Kooning and Jackson Pollock, the movement dominated Western art but would come to an end with Pollock's death in a car crash in 1956. Their supporter, the art critic Harold Rosenberg, added intellectual weight to the movement with his December 1952 essay 'The Action Painters', which redefined art as an act rather than an object. Rosenberg coined the term 'action painting', which came to describe the gestural style of artists such as de Kooning, Pollock and Franz Kline. The world was looking to the United States for inspiration and leadership, as the country was regarded as a beacon of democracy, liberalism, affluence and invention. CK

Willem de Kooning – *Woman I*

This is one of a series of six paintings of single female figures that the Abstract Expressionist painter Willem de Kooning completed between 1950 and 1953. Although the fluid brushstrokes and drips of paint suggest that the portrait was created quickly and spontaneously, in fact it is estimated that the artist created some 200 images in preparation for *Woman I*. The artwork challenged conventional stereotypes and subverted common notions of femininity, as de Kooning painted his figure with wild eyes, her teeth bared and huge breasts that appear almost trussed, as if in either armour or a brassiere.

Two murals based on sketches by Fernand Léger are painted on the east and west walls of the Plenary Hall of the United Nations General Assembly Building in New York.

Jackson Pollock first exhibits *Blue Poles* (see p. 244) at his solo show at Sidney Janis Gallery in New York, where it was titled *Number 11*. The large-scale, colourful stain painting prefigures colour field painting and lyrical abstraction.

The Korean War breaks out. It starts as a civil war between North and South Korea but escalates to involve Western powers led by the United States under United Nations command.

1950	**1950–52**	**1951**	**1952**

○ **John Armstrong – *Design for a mural in the foyer of the Telecinema at the Festival of Britain***

The Festival of Britain was an exhibition held in 1951 at the South Bank in London to celebrate British industry, arts and science. British artist John Armstrong had extensive experience designing for film and theatre productions, making him the perfect choice to create a mural for the entrance of the Festival's Telecinema. The end result was a lighthearted kaleidoscope of cinematic references, framed by lengths of film. The mural was later destroyed when the festival site was dismantled.

Jasper Johns starts his encaustic painting *Flag*, inspired by a dream of the US flag, two years after he leaves the US Army. He went on to make more than forty works based on the Stars and Stripes.

The Army–McCarthy hearings end on 17 June. Although US Senator Joseph McCarthy is acquitted of misconduct, his popularity suffers and he is later censured by the Senate, signalling the beginning of the demise of McCarthyism and the Communist witch-hunt in the United States.

Joseph Stalin, the leader of the Soviet Union, dies. He is succeeded by Nikita Khrushchev, who pursues a more liberal domestic and foreign policy, seeking a less hostile relationship with the West.

○ **Fernand Léger – *Two Women Holding Flowers***

This was painted towards the end of the life of the French artist Fernand Léger, at a time when he had found success internationally and gained prestigious commissions. It shows two women holding some flowers painted in a very stylized manner, and their forms appear to merge. Painting at a time of longed-for peace, Léger elevates the conventional nude to almost heroic status, and an ordinary bouquet becomes a symbol of gentle prosperity. The painting's dynamic shapes and bright primary colours celebrate femininity, peacetime and harmony.

1953　　**1954**

1955–1960

The demise of the bowler hat. The late 1950s sees the rise of rock 'n' roll as the world stands on the cusp of the sexual revolution of the 1960s. The liberal mood is a reaction against austerity and the stuffy restrictions of the old world order. Countries in Europe are losing their colonies as power shifts to the chief Cold War rivals, the United States and Soviet Union. In the West, US values spread, as does the goods it sells to a Europe that is recovering economically. Artists reflect the rise of consumerism and the desire for civil rights in their work, as people want more of everything: cars, white goods, canned foods, dignity and freedom. The restoration of order is no longer enough to satisfy the masses: they want fun, and they want to be heard. CK

Edward Burra – *Izzy Orts*

The English painter Edward Burra flirted with Surrealism, but his style was his own. The figure in the foreground on the left is thought to be a self-portrait. The African-American sailor to the right stares at the viewer with blank eyes in a post-war world where protests against racial segregation by the Civil Rights Movement in the United States had begun. The Izzy Orts jazz club represents a melting pot where revellers appear indifferent to race.

Rosa Parks initiates a bus boycott in Montgomery, Alabama, after refusing to give up her seat to a white passenger. This campaign, which forces the city to desegregate its buses, is a key incident in the African-American civil rights movement.

Richard Hamilton uses images from mass-media sources to create his collage *Just what is it that makes today's homes so different, so appealing?*, which is a commentary on popular culture and post-war consumerism.

Israeli armed forces push into Egypt, initiating the Suez Crisis. The UK and France are humiliated when they withdraw under pressure from the US and USSR. Britain's status as a world power is forever damaged.

1955 **1956**

○ **L. S. Lowry – *Industrial Landscape; Stockport Viaduct***
Lowry is famous for painting scenes of industrial life in north-west England. His work often contains crowds of small figures swarming across a busy canvas, as seen in this example. The Stockport Viaduct was a favourite structure of Lowry's and is a recurring feature in his paintings. The repetitive nature of Lowry's paintings led him to be dismissed by some as a 'Sunday painter', but in recent years his work has been reappraised as an important chronicle of British working-class life in the industrial city.

René Magritte – *The Intimate Friend*
The Belgian painter Magritte was a leading Surrealist. Unlike many of the flamboyant personalities in the movement Magritte lived quietly in middle-class Brussels. He often painted an anonymous, bowler-hatted figure seen as his alter ego. Here the figure has his back to the viewer as he stares at an idealized blue sky with fluffy clouds. The baguette and empty glass shown floating behind him may refer to the bread and wine of the Christian Mass.

The Treaty of Rome is signed
by Belgium, France, Italy, Luxembourg, the Netherlands and West Germany to establish the European Economic Community, the precursor of the European Union. It proposes a single market for goods, labour, services and capital across member states.

The term 'Pop art' is coined
by influential British art critic and member of the Independent Group Lawrence Alloway in his essay 'The Arts and the Mass Media' in *Architectural Design* magazine.

Cuban revolutionary leader Fidel Castro, aided by Ernesto 'Che' Guevara, overthrows the right-wing authoritarian government of Cuban president Fulgencio Batista. Castro goes on to head the first Communist government in the West.

1957　　　1958　　　1959

Andy Warhol
(1928–87)

Andy Warhol is the most famous exponent of Pop art. He worked as a highly successful commercial illustrator in New York before becoming an artist, working for clients such as Columbia Records, *Harper's Bazaar* and *Vogue*. He used commercial-art processes to create prints, paintings, photography and sculpture. Warhol worked out of a New York studio nicknamed The Factory, which became a hangout for artists, musicians, socialites and free-thinkers. He pioneered the use of video and film in art in the early 1960s, and his artistic practice grew to encompass performance, music, fashion and multimedia throughout the decade. He embraced and influenced popular culture, founding *Interview Magazine*, designing record covers for the Rolling Stones and producing TV programmes for MTV.

POP ART

Pop art was the reaction to the Abstract Expressionism of the 1950s. It cast aside the style's painterliness in favour of a witty, hard-edged representational art that celebrated popular culture. The movement highlighted the materialism of a post-war world where people could buy cars and decorate their homes, thanks to peacetime prosperity.

ABOVE LEFT. Claes Oldenburg – *Ice Cream Being Tasted (Glace en dégustation)* **(1964)**
Oldenburg's sculptures elevate common objects found in everyday life to art. This plaster ice cream on a porcelain plate is shellacked in brightly coloured enamel to emulate cheap comfort food.

LEFT. Andy Warhol – *Marilyn Monroe* **(1967)**
When Andy Warhol started creating silk-screen portraits in the 1960s it was ground-breaking, as the process had not been used in fine art before.

The term 'Pop art' was coined in 1958 for an Anglo-American art movement that lasted from the 1950s to the 1970s, inspired by popular cultural forms such as Hollywood films, advertising, comics and mass-produced packaging. Leading practitioners included Andy Warhol, Claes Oldenburg and Roy Lichtenstein.

However, the word 'pop' was first used in a visual arts context in 1956 when it appeared on an oversized red lollipop in a collage, *Just what is it that makes today's homes so different, so appealing?*, by British artist Richard Hamilton. He created the collage using images from US magazines to parody the growth in consumerism after the war. It was used for the poster and catalogue accompanying the 'This Is Tomorrow' exhibition held by the Independent Group at London's Whitechapel Gallery. A year later Hamilton listed the 'characteristics of pop art' in a letter: 'Popular (designed for a mass audience), Transient (short-term solution), Expendable (easily forgotten), Low cost, Mass produced, Young (aimed at youth), Witty, Sexy, Gimmicky, Glamorous, Big business'.

Pop art employed imagery that reflected mass consumerism such as Warhol's *Green Coca-Cola Bottles* (1962) and *Brillo Box (Soap Pads)* (1964). It also treated subjects as if they were consumer items, such as Warhol's portraits of popular icons including Marilyn Monroe and Elvis Presley, and the paintings of US flags by Robert Rauschenberg and Jasper Johns in the 1950s.

Pop artists used the techniques of graphic design and advertising to give works the Pop treatment. Lichtenstein drew on 'low' art comic-book culture to create 'high' art by adapting images from cartoon strips complete with speech balloons and Ben-Day dots in large-scale paintings that reference the art historical traditions of history painting and portraiture.

At the same time, Oldenburg outlined his vision in *I Am for an Art* (1961), which begins: 'I am for an art that … does something other than sit on its ass in a museum.' Oldenburg and fellow Pop artists embraced the ordinary. They did not look to esoteric philosophies or highbrow art for inspiration; rather they revelled in the lowbrow. Oldenburg showed that it was possible to make anything art with his huge soft sculptures of everyday items such as his *7-foot-wide Floor Burger* (1962), which portrays a hamburger. Critics were aghast at the use of such 'low' subject matter, yet as the 1960s wore on Pop art appealed to a young audience that was creating a postmodern world. **CK**

1960–1965

Perception is all. The Swinging Sixties are born to the fresh sound of revolution in Cuba, and the decade sees the world turned on its head when the small island repels the Bay of Pigs invasion. The botched incursion leads to the Cuban Missile Crisis of October 1962, when the United States and Soviet Union come close to nuclear conflict. As the world faces the prospect of the Cold War heating up, people consider how to keep the peace. Artworks aim to help viewers heal from the horrors of the war, the Holocaust, and the bombings of Hiroshima and Nagasaki. Yet art also remains playful. Op art takes abstraction to its extreme, with meticulous works that appear to move. Soon these eye-teasing shapes move to the catwalk, appearing as patterned fabric in the latest fashions such as the miniskirt. CK

A CIA-sponsored military group, **Brigade 2506,** enters the Bay of Pigs on the southern coast of Cuba and attempts to invade the island. The invading force is defeated in three days in a humiliating climbdown for the United States.

The 'Young Contemporaries' **exhibition in London** showcases the work of British Pop artists David Hockney, Derek Boshier, Allen Jones, Peter Phillips and Peter Blake.

Andy Warhol holds his first fine-art exhibition. He shows thirty-two canvases of Campbell's soup cans in Los Angeles. The sales are dismal and the critical response derisory. Yet the show introduces Pop art to the US West Coast and launches his artistic career.

Marc Chagall – *The Tribe of Benjamin*

The Tribe of Benjamin is one of twelve designs for a series of stained-glass windows depicting the Twelve Tribes of Israel in the synagogue at the Hadassah-Hebrew University Medical Center in Jerusalem by the French-Russian artist Marc Chagall. The jewel-like windows have come to be regarded as Chagall's greatest accomplishment, and he said: 'All the time I was working, I felt my mother and father looking over my shoulder; and behind them were Jews, millions of other vanished Jews – of yesterday and a thousand years ago.'

1961

1962

Gerhard Richter – *Uncle Rudi*

Gerhard Richter grew up in Germany with direct experience of the Nazi and Socialist regimes. This work is based on a photograph of his uncle Rudi, who was killed fighting in the Second World War. Richter painted the image in realist detail and then drew a dry brush across the surface of the paint to blur it. He uses this effect to explore the relationship between images and meaning, and the layers through which we experience the things we see.

Bridget Riley – *Blaze I*

The British artist Bridget Riley began producing black and white paintings like this that explore optical phenomena in the early 1960s. She never studied optics but creates her works through a combination of precise technical skill and intuition regarding what will evoke sensations of movement for the viewer. She became the focus of the Op art movement when her painting *Current* (1964) was used for the catalogue of the landmark show 'The Responsive Eye' at the Museum of Modern Art in New York.

Roy Lichtenstein holds his first solo show at the Leo Castelli Gallery in New York. His comic-book-style illustrations provoke horror and amusement. The same year he features in *Time* magazine alongside Andy Warhol, Wayne Thiebaud and James Rosenquist in the first article on US Pop art.

The phrase 'Op art' is used for the first time in an article in the 23 October issue of *Time Out* magazine titled 'Op Art: Pictures that Attack the Eye'.

New York's Museum of Modern Art holds a major exhibition of Op art called 'The Responsive Eye'. Featuring more than 120 paintings and constructions by 99 artists from 15 countries, it aims to document a 'powerful new direction in art'.

1964　　**1965**

1965–1970

Counterculture explosion. The late 1960s see young people challenge convention. Peace campaigners use publications, marches and songs to promote their message, while protesters commit acts of civil disobedience to oppose nuclear weapons and war. Revolution is in the air, and this fervour for change is reflected in the art and music of the time. Rainbow-hued imagery finds a home in paintings that nod to graphic design with their clean lines and simple shapes. People also look inwards, as they are drawn to Eastern philosophies and religions, experimenting with yoga, meditation and drugs such as LSD. Art sometimes reflects that psychedelic experience with its altered consciousness and a desire for a brave new world. CK

Roy Lichtenstein – *Grrrrrrrrrr!!*

This work is typical of Pop artist Roy Lichtenstein, famous for his comic-strip-style paintings that use closely spaced spots known as Ben-Day dots and are often adaptations of images from DC Comics titles. This painting was inspired by a frame from the February 1962 edition of the war anthology *Our Fighting Forces*. The military dog's aggression references American might, at a time when the country was in the throes of the Vietnam War (1955–75).

Peter Max – *1 2 3 Infinity, The Contemporaries*

The psychedelic art of Peter Max came to symbolize the counterculture explosion of the mid-1960s. His brightly coloured posters were ubiquitous in college dorms across the United States – at the peak of his popularity he sold several million in nine months. Max's work became such a part of the zeitgeist that he was asked to create an art installation for the 180-m (600-ft) stage at the Woodstock Festival in New York in 1969.

1965

Frank Stella – *Harran II*

Harran II forms part of the
Protractor Series (1967–9)
by Frank Stella. The series
was based on the semicircular
instrument used for constructing
and measuring angles. *Harran
II* is named after an ancient city
in Upper Mesopotamia, now in
modern-day Turkey, as Stella
evokes the decorative forms
and patterns found in ancient
architecture. The painting's
curved shapes and psychedelic
colours recall a rainbow, and
so Stella was able to create an
abstract work that references a
countercultural symbol favoured
by hippies of the time.

The Beatles release their ground-breaking
album Sgt P*epper's Lonely Hearts Club Band*
in May. It is hailed for bridging the gap between
popular culture and high art. The cover artwork
was designed by Pop artists Peter Blake and
Jann Haworth.

100,000 people, most of them young hippies,
converge on San Francisco's Haight-Ashbury
neighbourhood in June, instigating what
became known as the Summer of Love,
which celebrated a countercultural lifestyle
promoting peace, love and the arts.

**The Argentine revolutionary Ernesto 'Che'
Guevara** is captured and executed in October
by the Bolivian army as he campaigns to spread
revolution worldwide. He becomes an iconic
figure for the left-wing and the young.

The Prague Spring begins in January when Alexander
Dubček becomes First Secretary of the Communist Party
and aims to liberalize Czechoslovakia. Hope ends for
the reformers when the Soviet Union invades in August.

Civil unrest in France causes chaos in May, as student
protests in Paris, demonstrations and strikes bring the
country to a halt. President Charles de Gaulle briefly
leaves France in secret.

Colonel Muammar Gaddafi leads a small
group of military officers to overthrow
the monarchy in Libya in September.
He seizes power and promises to lead a
radical, revolutionary socialist government.

1967 **1968** **1969**

1970–1975

Colour is king. The early 1970s sees artists create Minimalist works. The hard lines of geometric abstraction dominate as artists not only spurn any attempt to make works that relate to reality, but also eschew the gestural mark-making of Abstract Expressionists. Painters explore the effect of colour and the relationships between colours. Viewers are encouraged to stand close to paintings, to enjoy their colours, flatness and surfaces, as artists seek to elicit an emotional and metaphysical response from their work. This shift away from the pictorial and illusionistic is accompanied by a movement towards the sculptural, but in the shape of installations that reinvent notions of space with Light art and Land art. CK

Barnett Newman – *Who's Afraid of Red, Yellow, and Blue IV*

This is one of a series of four colour field works Barnett Newman painted between 1966 and 1970. Each uses a solid ground with thin vertical strips of colour, called zips, which divide the canvas. The title is a reference to Edward Albee's play *Who's Afraid of Virginia Woolf?* (1962). Newman's use of primary colours references the history of abstract art, particularly the work of the Russian painter Kazimir Malevich and De Stijl artist Piet Mondrian, as he sought a new direction for abstract art with large-scale works like this that envelop the viewer.

Terrorists kill two Israelis and take nine hostages at the Olympic Games in Munich. A firefight ensues in which all nine Israelis are killed along with five of the terrorists.

Alexander Calder is hired by Braniff International Airways for $100,000 to paint a DC-8-62 jet airplane as a 'flying canvas'. For the next five years, he works on two multicoloured planes he calls 'flying mobiles'.

Abortion is legalized in the United States when the Supreme Court reaches its landmark *Roe v. Wade* decision. The ruling sparks an ethical debate nationally and reshapes politics as it divides the country into pro- and anti-abortion camps.

1970　1972　1973

Kenneth Noland – *Inweave*
Kenneth Noland was one of the first proponents of hard-edge painting in the 1960s, a style notable for the abrupt transitions between areas of colour. Initially, he used concentric circles on a square canvas, while in later works such as this he adopted a diamond-shaped canvas. His work avoids references to the external world as he employed simplified abstract forms such as lines, chevrons and diagonals painted in complementary colours as a way of exploring colour relationships.

Dan Flavin – *Untitled (to Ellen aware, my surprise)*
The US sculptor Dan Flavin was the most renowned practitioner of Minimalist Light art, and this is typical of his works consisting of arrangements of commercially available fluorescent tubing that nod to the readymades of Marcel Duchamp. The pink, blue and green lights create a square of intense light that illuminates the surrounding area to make an inviting portal. This installation occupies a large space, and the coloured bands of light bathe the viewer as they become part of the artwork.

Richard Nixon is forced to resign as US president to avoid impeachment following the Watergate scandal. He is succeeded by the vice president, Gerald Ford, who issues him a full pardon.

Saigon falls to the North Vietnamese, bringing the Vietnam War to a close and ending years of US presence in South Vietnam.

The Night Watch (1642; see p. 126) by Rembrandt is slashed a dozen times with a bread knife by an unemployed school teacher at the Rijksmuseum in Amsterdam.

1974

1975

Robert Smithson
(1938–73)

It was after Land artist Robert Smithson published his essay 'A Sedimentation of the Mind: Earth Projects' in 1968 that the movement really took off, when artists joined to mount the Earthworks exhibition at the Dwan Gallery in New York. Smithson is famous for his huge constructions designed to highlight man's relationship with nature. In works such as *Spiral Jetty* he aimed to raise public awareness of how urbanization and industrialization were damaging the environment. He created works in harmony with their surroundings, wanting to show how humanity can work alongside nature rather than destroy it.

LAND ART

Land art grew out of the Conceptual art movement of the 1960s and 1970s. Artists create earthworks, a form of sculpture which explore humankind's relationship with the environment. Works are often built from natural materials such as stone, berries, moss or sticks. The effect of erosion on a piece of Land art is integral to the work.

ABOVE. Richard Long –
***Full Moon Circle* (2003)**
Made from Cornish slate, this was commissioned for the landscape of Houghton Hall in Norfolk. Richard Long works with natural materials to accentuate nature's beauty.

LEFT. Will Maclean – *Land Raiders Monument* **(1994)**
This stone archway at Gress Cairn on the Isle of Lewis in Scotland is a memorial to the historic land clearances on the island. It also celebrates traditional local skills with its use of drystone walling techniques.

Land art has been practised since 1967. It was spearheaded by a group of US artists that included Carl Andre, Walter De Maria and Robert Smithson. The movement began as a reaction against modernism: a protest against the utilitarianism of much contemporary art and its commodification via the gallery system. Land artists were also responding to the zeitgeist in which countercultural groups found a voice, whether they were hippies, the women's liberation movement or environmentalists. Practitioners highlighted the constricting nature of the gallery space by creating works outside, sometimes in cities and often in the wild. The arrival of Land art is a profound shift in art history, as artists choose not to represent nature by painting landscapes but use the land as their raw material: making mounds of rocks, drawing lines by spreading lime on earth or digging trenches.

Artists often create their works in remote parts of the world, sometimes in hostile environments such as dried-up lakes and riverbeds, or even desert as in De Maria's *The Lightning Field* (1977), a collection of 400 polished stainless-steel poles installed in a grid array measuring 1 mile by 1 kilometre in a remote area of the high desert of western New Mexico. There does not need to be lightning for viewers to appreciate the work; rather, they are encouraged to walk among the poles, which are planted so that their tips create a perfect horizontal plane despite the gently undulating landscape.

Land art earthworks are often inspired by and similar in appearance and scale to ancient works such as Native American mounds and the Stonehenge prehistoric monument in Wiltshire, England. Smithson's *Spiral Jetty* (1970) is a massive earthwork formed of a coil of rock that resembles the triskelion motif of ancient European cultures, while the work of the Scottish artist Will Maclean draws heavily on traditional skills to create structures such as the *Land Raiders Monument* (1994). This is a reflection on social history, Scottish culture and the relationship of Highland communities with their environment, perhaps as crofters or fishermen.

The vast or small scale of earthworks, changing forms with the passage of time, and even their impermanence mean that the photographic documentation of Land art is as much a part of the work as the construction or intervention on site. The aesthetic configurations of works by the British artist Richard Long are often best appreciated via aerial shots. These reveal their careful patterning and the contrasts in texture between stones, rocks, sticks, mud and the surrounding location. Sometimes artists make Land art in galleries by bringing material in from the landscape to create installations. **CK**

1975–1980

It's getting personal. The women's liberation movement that grew out of the protests and counterculture of the 1960s begins to bear fruit, as female achievements in art gain recognition. This new appreciation is not only for the work of contemporary artists such as Eva Hesse, Judy Chicago and Ana Mendieta; the critical gaze looks to reassess the work of women throughout art history. Feminist artists are not alone in shattering the glass ceiling as women become more visible in politics, music, sport and industry. Along with Feminist art, the Photorealist movement that emerges in the United States in the 1960s goes mainstream; artists take photographs as a primary source to create detailed paintings and sculptures. In some instances, they make subtle changes to depth of field, perspective and colour to compose works of hyper-realistic clarity that emphasize a socially conscious message. CK

Richard Estes – *Double Self-Portrait*

Richard Estes is one of the most respected practitioners of Photorealism. He takes photographs of his subjects from different angles, focusing on architectural elements that he uses to create realistic compositions, often urban environments devoid of figures. This painting is typical of his work in that it features reflections and distortions of perspective that cause the viewer to question spatial relationships despite the fact the street scene is depicted with exacting precision and close attention to detail. The work is unusual in its inclusion of the artist's repeated self-portrait.

Steve Jobs and Steve Wozniak found Apple Computers. They launch the company's first product, the Apple I desktop computer. A year later the duo introduce the Apple II, which spearheads the revolution in personal computing.

'Women Artists: 1550–1950' opens in Los Angeles County Museum of Art. Curated by the art historians Linda Nochlin and Ann Sutherland Harris, it is the first international female-only exhibition and aims to familiarize the public with the work of eighty-three artists that had gone unrecognized.

The Centre Georges Pompidou opens in Paris. Designed by Renzo Piano and Richard Rogers, its bold scheme receives a mixed reception – critics describe the building as having been turned inside out, while admirers praise its radicalism.

1976

1977

Audrey Flack – *Marilyn (Vanitas)*

This painting by Photorealist Audrey Flack is one of three
monumental paintings in her *Vanitas* series (1976–78)
that alludes to the vanitas genre of art that was especially
popular in 17th-century Dutch paintings, which suggest
the transience of beauty and futility of vanity. Her work
is an homage to Marilyn Monroe, featuring a portrait of
the Hollywood actress and its mirror image. The work
contains objects traditional to vanitas such as a candle
that will burn quickly and an hourglass to show that time
is short, as well as items specific to the idol such as her
signature ruby-red lipstick.

Georg Baselitz – *The Gleaner*

The German artist Georg Baselitz has been painting
figures upside down since 1969 to subvert how
works are viewed and to suggest that the subject
is less important than the mark-making of the
painting itself. Initially, *The Gleaner* appears an
abstract work; however, on closer examination it
shows an inverted figure of a gleaner bent to the
ground gathering the leftover grain after a harvest,
working under a square-shaped beating sun while
a small bonfire flickers at the worker's side.

Sony introduces the Walkman portable
audio cassette player. The personal stereo
is revolutionary because its compact size and
lightweight headphones enable users to listen
to their favourite music on the move, anywhere.

Margaret Thatcher becomes the first
female prime minister of the United Kingdom.
The Conservative Party leader serves three
consecutive terms (until 1990), the longest of
any British prime minister in the 20th century.

Feminist artist Judy Chicago exhibits *The Dinner
Party* (1974–79) for the first time at the San
Francisco Museum. The installation uses traditionally
feminine crafts to celebrate 1,038 women from
history. It attracts more than 5,000 visitors.

1978

1979

1980-1985

Earth wars and Star Wars. The early 1980s witness violence in the Middle East, with attention shifting from the Palestinian–Israeli conflict to the Gulf. The effect on oil prices changes the geopolitical map, as does US President Ronald Reagan's aggressive stance towards the Soviet Union. In Britain, the Troubles in Northern Ireland take on a new dimension; artists seek to comment on the bloodshed around them, and painting makes a comeback. The return of saleable art pieces encourages the growth of auction houses and galleries. As the art world experiences a renaissance, contemporary art attracts more attention. The idea of Installation, Conceptual art and Video art begins to enter the mainstream consciousness, prompting a debate on what constitutes art. CK

Richard Hamilton – *The Citizen*

Richard Hamilton said he painted this diptych after watching two TV documentaries broadcast in 1980. The shows featured the Troubles in Northern Ireland and focused on the 'dirty protest' enacted by Irish Republican Army (IRA) inmates held at the Maze prison as they sought to be treated as political prisoners rather than criminals by refusing to obey any prison regulations. The left panel shows excrement smeared on the walls of a cell and the right a Christ-like figure wearing a blanket.

Iraq invades Iran on 22 September. The ensuing war lasts until August 1988. Iraq uses home-produced chemical weapons against the Iranian Army and Kurdish civilians. The war affects oil production all over the Gulf area.

Ten republican prisoners in Northern Ireland die of starvation during a hunger strike. Sinn Féin, the Provisional IRA's political wing, contests elections in Northern Ireland and the Republic of Ireland.

1980 1981-83 1981

Nabil Kanso – *Lebanon Summer*

Israel invaded Lebanon in June 1982 after the attempted assassination of the Israeli Ambassador to Britain by a Palestinian splinter group. In September of that year, the pro-Israeli Lebanese leader and president-elect Bachir Gemayel was assassinated. Israel occupied West Beirut, where the Phalangist militia killed thousands of Palestinians in the Sabra and Shatila camps. Nabil Kanso painted this mural in response to the massacre and the ongoing violence of the Lebanese Civil War (1975–90).

Joseph Beuys – *Capri Battery*

Joseph Beuys used unconventional, non-art materials in his work to challenge viewers' notions of reality, representation and art. He created this a year before he died, while recovering from an illness on the island of Capri. By attaching the fruit to a light bulb, he suggests nature's energizing and healing properties – and perhaps even the warmth and sunshine of the Mediterranean island. The instructions that accompany the work read: 'Change battery every 1,000 hours.' Beuys was being ironic given that the bulb will never run out because it can never be switched on.

Argentina invades the Falkland Islands, a British overseas territory in the South Atlantic, on 2 April. The Argentine military junta hopes to regain sovereignty over the islands and restore support at a time of economic crisis. The UK government sends a naval task force to reclaim the islands. Argentina surrenders on 14 June. More than ninety military personnel from both sides die in the conflict.

President Ronald Reagan takes the Cold War to the stars when he unveils plans to combat nuclear war in outer space with the launch of the Strategic Defense Initiative. Critics dub it 'Star Wars'.

The Turner Prize is awarded in Britain for the first time. It was founded to encourage wider interest in contemporary art.

1982 1982–85 1983 1984

1985–1990

Fall of the Iron Curtain. The late 1980s brings an end to the Cold War. In 1985 Mikhail Gorbachev becomes leader of the Soviet Union and introduces his policies of *Glasnost* (openness) and *Perestroika* (restructuring) that will transform global politics forever. In 1987 US President Ronald Reagan visits Berlin and urges the Soviet Union to tear down the Berlin Wall, which finally occurs two years later. Governments across Eastern Europe start to fall as the Iron Curtain disappears. The geopolitical map is changing at its most rapid pace since the Second World War. But liberty is not for all – that same year, China crushes dissent in the Tiananmen Square Massacre. The death of the US artist Andy Warhol signals an end to Pop art. Yet his prediction that 'in the future, everyone will be world-famous for 15 minutes' becomes more likely when the British scientist Tim Berners-Lee invents the World Wide Web in 1989. ED

Andy Warhol – *Camouflage Self-Portrait*
Andy Warhol changed the face of artistic production with his contributions to Pop art in the 1960s. Borrowing popular tropes from advertising and mass-produced imagery, Warhol transformed such mundane subjects as Brillo soap pad boxes and Campbell's soup cans into high art. He also worked in prints, exploring the infinite potential for reproducibility in this medium to make a comment on the mass-media machine. Warhol's self-portraits are iconic, and this one was produced shortly before his death.

Andy Warhol dies following surgery on his gallbladder. In accordance with his will, his estate goes to create a foundation dedicated to the 'advancement of the visual arts'.

The Saatchi Gallery for contemporary art opens in London, based on the collection of the art collector and advertising agency founder Charles Saatchi. Its first show features work by the US abstract painters Cy Twombly and Brice Marden.

A disastrous explosion occurs at the Chernobyl Nuclear Power Plant in the Ukraine on 26 April. The global environmental and health impacts resulting from this historical event continue to be assessed.

1985 **1986** **1987**

Peter Corlett – *Man in the Mud (Diorama)*

This work was commissioned in 1986 for the First World War gallery of the Australian War Memorial. It consists of a photographic diorama picturing the war-torn landscape of the Western Front and a sculpted soldier sitting with his head in his hands – literally stuck in the mud. The bravery and helplessness of the young soldier make a powerful statement about the effects of war and commemorate the Australian soldiers who served. This was one of many commemorative works that Corlett was commissioned to produce, including works honouring the Australians John Simpson Kirkpatrick and Sir Edward Dunlop.

Paula Rego – *The Dance*

The Portuguese-born artist Paula Rego is known for her dreamlike narrative canvases. Her work is often described within the context of Magic Realism, a style that emerged in literature and the visual arts and explored the combination of Realist subject matter with a Surrealist or 'magic' touch. Here, a series of 'lifecycles' are depicted, symbolically exploring traditional feminine roles: young lovers, an expecting couple, and a trio of child, young woman and elderly woman all dance together in Rego's three figural groups. A large female figure stands alone off to the side of her canvas, perhaps contemplating what is ahead of her.

Famed artist Jean-Michel Basquiat dies in his loft in New York City at the age of twenty-eight. In 2017 his painting *Untitled* (1982) set the record for the highest price achieved at auction for an American artist.

'Freeze', the first exhibition of the Young British Artists, is organized in 1988 by the now-celebrity artist Damien Hirst. The Frieze Art franchise is now one of the world's biggest commercial art fairs.

The Berlin Wall falls in November. Erected in 1961 to divide Germany between East and West, it was a symbolic division that mirrored the greater socio-political tensions in the country.

1988

1989

Jenny Saville
(b. 1970)

British artist Jenny Saville graduated from the Glasgow School of Art in 1992. She
is known for her massive oils of fleshy female figures that verge on the grotesque.
Her masterly handling of thick paint, use of extreme perspective and unusual subject
matter brought her to the attention of the art collector Charles Saatchi, and her work
appeared in 'Young British Artists III' at the Saatchi Gallery, London, in 1994. Her
innovative explorations of the flesh, the nature of femininity and the architecture of
the body have led to her recognition as one of the foremost painters of her generation.

ABOVE LEFT. Jenny Saville –
Prop (1993)
The extreme foreshortening, heavy
build, sullen expression and thickly
applied, pink flesh colours make this
nude study by Jenny Saville appear
threatening. The woman towers
above the viewer, perched on a
stool, and ready to slide off it.

THE FIGURATIVE TRADITION

The 20th century saw art undergo rapid change as artists responded to the new media of photography and film. Many countered by creating works that challenged convention by their abstract nature. However, others chose to continue within the figurative tradition and reinvent it for a modern age.

ABOVE RIGHT. Stephen Conroy – *The Healing of a Lunatic Boy* (1986)
Scottish artist Stephen Conroy rose to fame with paintings of haunting figures in strange settings that hint at the macabre. The open-mouthed figures and man with blank glasses here reek of mystery and menace, serving to confuse and alienate the viewer.

Despite the acceptance of abstract art in the 20th century, artists' interest in the formal possibilities of portraying the body did not wane, and figurative artists opted to continue depicting people and objects in a recognizable way.

For some, this enabled them to comment on the world that surrounded them, particularly between the two world wars. The portraits of German artists Otto Dix and George Grosz acted as commentaries on the brutality of war and the harshness of life in the Weimar Republic. After the Second World War the contorted portraits of the British painter Francis Bacon and elongated figures of the Swiss artist Alberto Giacometti tackled its horrors with challenging works that allude to violence and trauma.

Subsequent figurative artists have experimented with ways to depict the body in a world where people were physically healthier than they have ever been. The nudes of artists such as Lucian Freud, Ron Mueck and Jenny Saville work within the figurative tradition in terms of their representation, yet each artist plays with scale, mass and the tactile surface of flesh in ways previously unseen. Freud's penetrating studies in unsettling interiors focus on the materiality of flesh as well as the psychological relationship between artist and model. Mueck's hyper-realistic sculptures made from acrylic, fibreglass and silicone shock

because of varying sizes and their level of detail – from wrinkled skin and yellowing toenails to stubble – that reveals the nature of being human in an intimate, grisly and unforgiving fashion. Saville's monumental canvases of obese females are far removed from those of idealized women painted by men throughout art history and challenge conventional notions of beauty.

Other figurative artists cast their subjects in fantastical worlds in a Magical Realist style. Their figures are recognizable yet they are in an improbable situation that appears like a dream or even a nightmare. Portuguese artist Paula Rego creates works that reference fairy stories and folk tales while examining the relationships between men, women and children. Her series *Dog Woman* (1994), which shows vigorous women positioned like dogs, and *The Ostriches* (1995), which features stocky middle-aged women in ballet tutus attempting to dance, explore female physicality via unusual poses.

In the 21st century there is much debate over gender and sexuality. The discussion of what it means to be a human in one kind of body or another lends itself to figurative art and is seen in works such as Saville's piece *Passage* (2004), which portrays a trans woman with a natural penis and false silicone breasts. **CK**

1990–1995

Activist art. Art produced in the 1990s continues to explore the dynamics of power and visibility set in motion in previous decades. The social collective ACT UP, or the AIDS Coalition to Unleash Power, persists with its important work in advocating for better legislation, research and rights for those living with AIDS. The work of this organization eventually led to the establishment of Gran Fury, an activist art collective that champions AIDS activism by creating powerful images and slogans in the popular media. This marriage of art and activism is a defining feature of art production in the 1980s and 1990s. The language and culture surrounding art-making are becoming increasingly bold. In the United Kingdom, the Young British Artists (YBAs) are gaining recognition and notoriety for the shock value and entrepreneurial spirit of their work. This era produces such celebrity artists as Damien Hirst, Tracey Emin and Sarah Lucas. ED

The Gardner Museum Heist, the biggest art theft in museum history, is carried out in March at the Isabella Stewart Gardner Museum in Boston. Two individuals disguised as police officers steal works with a total value of $500,000,000.

The French artist Orlan embarks on her performance series *The Reincarnation of Saint Orlan*, in which she undergoes surgery to explore the boundaries and limitations of beauty in art.

Nelson Mandela is freed after twenty-seven years on Robben Island, and goes on to become President of South Africa in 1994.

○ **Helen Frankenthaler – *Overture, 1992***
A second-generation Abstract Expressionist who established her reputation with the landmark 1952 painting *Mountains and Sea*, Helen Frankenthaler continued to develop a distinctive and influential body of abstract work into the early years of the 21st century. Her pioneering soak-stain technique of pouring thinned paint onto the surface of a canvas spearheaded the Color Field movement. *Overture*, a key late work, represents her more mature approach to painting. Filled with pictorial incident through richly variegated hues of green and other colours and vigorous brushwork ranging from broad, sweeping strokes to more finely detailed passages, it is a prime example of Frankenthaler's expressive language of abstract painting.

1990 **1992**

Gillian Wearing – *I'm Desperate*

For her landmark series *Signs that say what you want them to say and not Signs that say what someone else wants you to say*, the British conceptual artist Gillian Wearing approached strangers on the streets of London and asked them to write what they were thinking or feeling at that moment on a sheet of A3 paper. She then photographed them holding this statement. Wearing took about 600 portraits in this way, covering a broad cross-section of London society. The images highlight the tension between appearance and inner life, as epitomized in this photograph where the man's suit and self-assured expression provide a sharp contrast to the words written on the sign that he is holding.

Hans Haacke – *Germania*

The German-born artist Hans Haacke has incited a great deal of controversy – in large part due to his directed criticism of the art-world structures in which his work circulates. Haacke made a name for himself in outing the underlying corporate structures of the art world, with particular reference to the corporate money that is an integral component of most major art institutions. His controversial work *Germania* for the German Pavilion of the 1993 Venice Biennale took this to an extreme, echoing Hitler's name for Nazi Berlin, and exploring Hitler's involvement in the modelling of the German Pavilion during his rise to power.

The first White Cube gallery, established by Jay Jopling, opens in London's Duke Street.

The Rwandan Civil War leads to the genocide of Tutsi Rwandans by the Hutu majority government over a three-month period.

1992–93 1993 1994

1995-2000

Diversification. Contemporary art continues to evolve and diversify, moving towards large-scale installations. British artists lead the way in artistic innovations, with Chris Ofili, known for his paintings incorporating elephant dung, winning the Turner Prize in 1998. In sculpture, the British artist Rachel Whiteread develops her controversial public sculptures for new audiences in New York City, while the Australian artist Ron Mueck shocks viewers with his jarring hyper-realist sculptures. Charles Saatchi continues to invest heavily in the YBAs, and exhibits choice pieces from his collection at the famed 'Sensation' exhibition at London's Royal Academy in September 1997, including Tracey Emin's *Everyone I Ever Slept With* and Damien Hirst's formaldehyde shark. ED

Yayoi Kusama – *Nets 40*

Avant-garde Japanese artist Yayoi Kusama has been painting motifs such as dots and nets since childhood. Composed of individually applied, curved brushstrokes of thick paint, she has described her net paintings as 'without beginning, end or center', causing 'a kind of dizzy, empty, hypnotic feeling'. Kusama has suffered from depersonalization disorder since early childhood, which has had a direct influence on her works.

Damien Hirst's installation *Mother and Child (Divided)*, featuring two halves of a cow and calf preserved in large glass tanks filled with formaldehyde, becomes the focal point of the Turner Prize exhibition. This winning approach soon becomes Hirst's go-to aesthetic.

Diana, Princess of Wales, dies in August of severe injuries sustained in a car crash in Paris.

Johnny Warangkula Tjupurrula sets an Aboriginal art record when his painting *Water Dreaming at Kalipinypa* is sold by Sotheby's for $210,000.

1995

1997

Chuck Close – *Self-Portrait*

The American artist Chuck Close is a master innovator in the art of the portrait. Working to reconcile the disparate media of painting and photography, Close's work suggests that their underlying philosophies may not be as different as they seem. Starting in Photorealism, Close later focused his full attention on portrait painting, applying some of the philosophical tenets of photography – such as its meticulous documentary function, for instance – to painted portraiture. Close's self-portraits are some of the best-known works in contemporary painting.

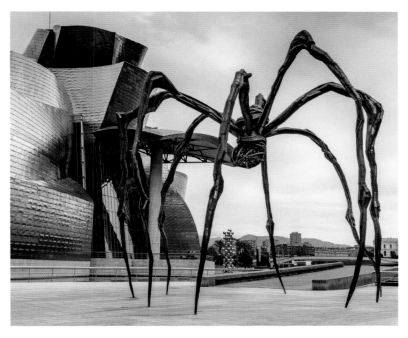

Louise Bourgeois – *Maman*

Louise Bourgeois's monumental, larger-than-life spiders have become an iconic global presence. The grande dame of 20th-century art created a series of spiders entitled *Maman* for installation in select international locations, including the National Gallery of Canada in Ottawa, Tate Modern's Turbine Hall in London and the Guggenheim Museum in Bilbao (as shown above), among others. The artist described her spiders as monumental representations of the mother figure. Clever, calculating but also protective, the bronze spiders loom large in some of the world's most important art institutions.

The euro is launched as the new single currency of the European Monetary Union. It is first introduced as an electronic currency used by banks, foreign exchange dealers and stock markets, with notes and coins becoming legal tender in 2002.

George W. Bush narrowly defeats Al Gore to become president of the United States.

1999

2000

2000-2005

Globalization takes hold. A sense of optimism at the new millennium soon turns to fear after the September 11 terrorist attacks in the United States in 2001. The assault on US soil kills almost 3,000 people, leads to the US wars in Iraq and Afghanistan, and sparks a change in the country's relations with the Islamic world that defines the early 21st century. Thanks to fast-moving digital communication via the internet and mass media, globalization is the norm, so the so-called War on Terror appears to affect everyone, everywhere, in some way – even if that is only a perception. Yet for many artists, the mood on the street provides inspiration. As once artists took to the country to create paintings *en plein-air*, so they observe the urban environment and the convergence of globalized values on ordinary people. Some even take to the street as well as gallery spaces to make their work, as art takes on a prominent role in public life. CK

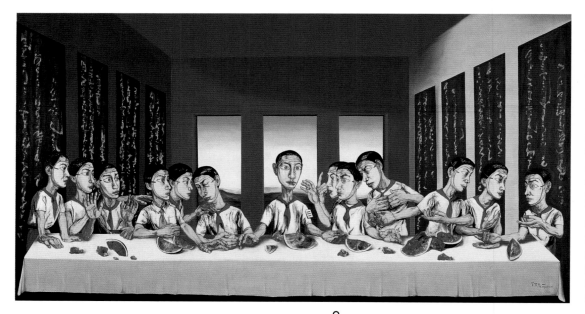

Zeng Fanzhi – *The Last Supper*
In 2013 Zeng Fanzhi became the most expensive living Asian artist following the sale of *The Last Supper* for $23.3 million. A recreation of the 15th-century work of the same name by Leonardo da Vinci, the 4-m (13-ft) wide painting highlights the societal and economic changes that have taken place in China since the 1990s. The religious figures of the original have been replaced by young communists. The red neckties represent communist ideals, while the western-style yellow tie worn by the Judas figure symbolizes China's move toward capitalism.

Tate Modern opens in London. The gallery's collections consist of international works and modern and contemporary art dating from 1900 to the current day. More than 40 million people visit the space over the next seventeen years.

The 9/11 attacks on New York destroy an estimated $100 million-worth of art. Public artwork accounts for about $10 million of this figure, which includes works by Alexander Calder, Joan Miró and Roy Lichtenstein.

2000 **2001** **2002**

Olafur Eliasson – *The Weather Project*

This installation by the Danish-Icelandic artist Olafur Eliasson was commissioned for the Turbine Hall in Tate Modern, London. It consisted of representations of the sky and the sun: a fine mist created by haze machines, a huge semicircular screen backlit by around 200 lights, and a ceiling of mirrors that visually doubled the volume of the hall and created the image of a massive, indoor sunset. The gallery was only a few years old at the time; the vast space of the Turbine Hall lends itself to exciting pieces that capture the public's imagination about what makes a work of art.

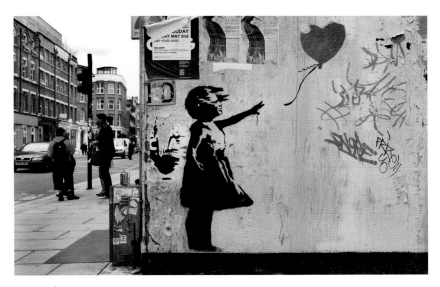

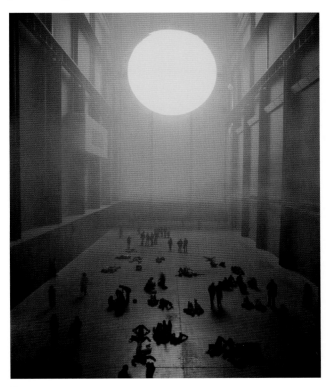

Banksy – *Balloon Girl*

This stencilled mural of a young girl letting go of a red heart-shaped balloon is by the anonymous British-based graffiti artist Banksy. It was originally graffitied onto the wall of a printing shop in Great Eastern Street in London's Shoreditch neighbourhood. However, it fast became an iconic image symbolizing hope – it was replicated numerous times in various printed materials and even as a tattoo by pop singer Justin Bieber. The mural is no longer in situ and was sold for £500,000 in 2014.

The Melbourne Stencil Festival is held for the first time in a former sewing factory in North Melbourne, Australia. The three-day exhibition celebrates international street and stencil art, and visitor numbers far exceed expectations.

A fire in the Momart art storage warehouse in London destroys more than 100 major works by leading contemporary British artists including Tracey Emin, Damien Hirst and Sarah Lucas.

Christo and his wife, Jeanne-Claude, open their public-art project, *The Gates*, in New York. It consists of 7,503 gates made of saffron-coloured fabric placed on paths in Central Park.

Twelve cartoons depicting the prophet Muhammad and Islam are printed in the 30 September edition of the Danish newspaper *Jyllands-Posten*. The drawings cause a controversy: Muslims worldwide protest and the newspaper defends its actions as use of freedom of speech.

2003–4 **2004** **2005**

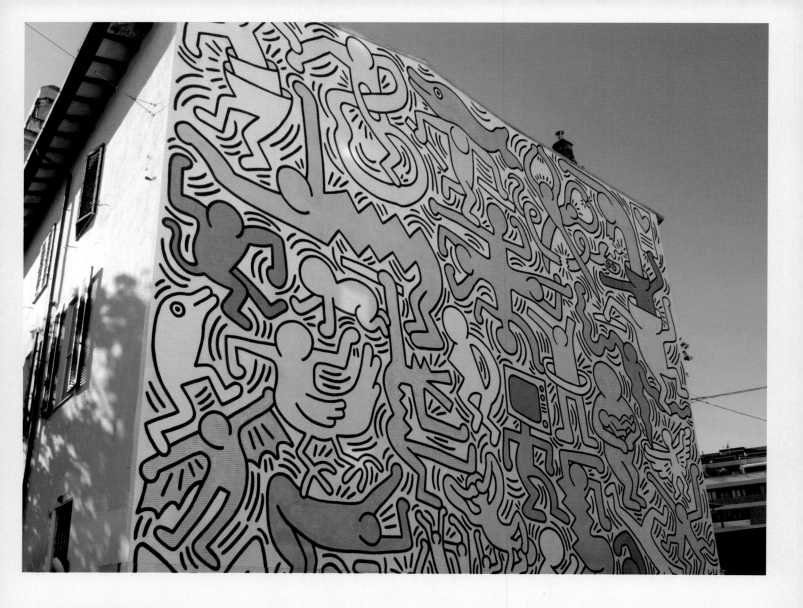

STREET
ART

The graffiti artists of the late 20th century led the way in creating street art. Often a method of protest, what was originally regarded as defacing public property has now gained public acceptance worldwide.

Street art originated in Philadelphia in the late 1960s with the work of graffiti writers Cool Earl and Cornbread. Initially it took the form of tagging, whereby artists used spray paint to create calligraphic works in public spaces. It soon spread to New York, and by the 1970s it had gained notoriety as the local authorities waged a battle against the mushrooming of graffiti on the public transport system, and the subway in particular.

Among the graffiti artists then working in the city was Jean-Michel Basquiat. From 1977 to 1980 he and his friend Al Diaz started a campaign under the name SAMO©, meaning 'the same old shit'. Within a few years his

gestural style of painting, which referenced his Puerto-Rican and Haitian background, caught the attention of the media. Pop artist Andy Warhol admired his style, adopted him as a protégé and promoted his work, helping him to mount a solo show. The impact of Basquiat's transition into the gallery world cannot be underestimated in helping street art gain acceptance and recognition as a legitimate art form.

Another urban artist who pioneered the movement was Keith Haring. Between 1980 and 1985 he created hundreds of drawings on the unused advertising panels covered with matt black paper in New York's subway stations.

Jonesy

The Welsh artist Jonesy started his career as a metalworker. He worked in Ibiza with the Welsh sculptor Barry Flanagan but has spent most of his life in London, where he relocated in the 1980s. His street art first appeared in the capital in about 2010. Working out of a studio near Brick Lane, he creates a range of artworks from pasted posters to small bronzes and hand-carved wooden sculptures. They are found throughout the East End, on brick walls and even the tops of poles used in street signs. His exquisite small bronzes and colourful wooden carvings are easy to miss, yet once one has been located viewers are likely to never walk around the urban streets of the East End without looking high and low in an attempt to spot another.

ABOVE LEFT. Keith Haring –
Pisa Mural (1989)
This mural on the southern exterior wall of the Church of Sant' Antonio in Pisa was executed at the request of the city. Each of its thirty figures represents an image of peace.

ABOVE. Jonesy – *Green Bust*
(c. 2012)
This green wooden head created by Jonesy is located on Sclater Street in Tower Hamlets. Like much of his work around London's East End it uses Celtic imagery.

They proved popular with commuters, and Haring made his solo gallery debut in the city in 1982. He moved on to create public murals internationally in his graphic style, depicting animated figures in bold lines, often with a social message.

By the 1990s street art had become widespread and artists began to explore new techniques. Given that it often occupied public spaces illegally it was essential that practitioners work quickly. Many adopted stencilling, whereby they created stencils out of paper or cardboard and then transferred an image on to a surface using spray paint or roller paint. Stencilling also allows for the easy reproduction of images. The technique was popularized by the French artist Blek le Rat and adopted with great success by the British artist Banksy.

In the 21st century street art has come to encompass a range of work. It includes Lock On sculptures whereby works are attached to public street furniture by bicycle locks, wheat-pasted posters, and yarn bombing in which public spaces are covered with knitting and crochet. Artists are not only installing pieces: British street artist Ben Wilson's work transforms found objects. He paints pieces of chewing gum that have been discarded, first heating them using a blowtorch and then applying lacquer to create tiny pavement paintings. CK

2005–2010

Art is everywhere. Conceptual art, Land art, installations and video are widespread. The acceptance of such artworks by the art world and the public allows artists to explore issues and work in public spaces in a way undreamed of in the previous century. Artists create pieces that invite viewers' participation. Digital devices and internet use become ubiquitous, allowing artists to create, promote and distribute art more cheaply and easily than ever, and the distinctions between high art and popular culture fade. Artists mix media as they seek to use whatever forms best suit their purpose and the message they want to project, whether that is using high-value video-production tools or non-art materials. Advances in technology and changes in methods of communication allow artists to draw on a global range of influences. The art market expands and artists can reach an audience of viewers and buyers worldwide. CK

Daniel Buren – *Le Vent souffle où il veut (The Wind Blows Wherever It Pleases), Le Coq-sur-mer (Ostende), Belgique, March 2009 (detail)*

The French artist Daniel Buren used 100 flagpoles with windsocks to create this installation on a beach at De Haan in Belgium. The windsocks flutter in the wind, creating a forest of bright colour, which viewers can stroll through. They are part of a permanent coastal sculpture park, and their presence challenges perceptions of the nature of coastline space in the 21st century, at a time when sandy beaches have become sites for relaxation and leisure. Buren's work shows that they can also be used as spaces for art, culture, reflection and meditation.

The YouTube video-sharing website is launched. It is quickly adopted as a platform for sharing content by individuals and corporations. It helps change how art, music and news are disseminated globally.

Banksy holds the 'Barely Legal' show in an industrial warehouse in downtown Los Angeles, which aims to address global poverty and injustice. The show includes a model of an elephant painted to match the wallpaper, recalling the phrase 'the elephant in the room' and referencing both the public and governmental ability to ignore social problems.

Apple launches the iPhone smartphone. Its ease of use and portability helps promote the rise of social networking.

| 2005 | 2006 | 2007 | 2009 |

Heatherwick Studio – *Seed Cathedral*

The *Seed Cathedral* is a sculptural structure that served as the UK Pavilion at the 2010 World Expo in Shanghai. The competition to design the pavilion was won by London-based Heatherwick Studio, led by designer Thomas Heatherwick. The *Cathedral* referenced the conservation effort to save seeds from around the world in seed banks. It consisted of more than 60,000 7.6-m (25-ft) long acrylic optic fibres, which formed rods that projected from the structure. The rods contained 60,000 plant seeds.

Isaac Julien – *Hotel (Ten Thousand Waves)*

Ten Thousand Waves is an immersive installation by the British artist and film-maker Isaac Julien that was conceived for an atrium at New York's Museum of Modern Art. Julien's 55-minute film was inspired by the Morecambe Bay tragedy of 2004, in which more than twenty Chinese cockle pickers drowned on a flooded sandbank off the north-west coast of England. The film is projected on to nine double-sided screens. Shot in Shanghai, it features contemporary Chinese culture, as well as poetry and myths based on life at sea.

Michael Landy installs the Art Bin at the South London Gallery. It consists of a 600-sq-m (6,458 sq ft) transparent skip, into which members of the public can throw artworks they are dissatisfied with. Landy describes his installation as 'a monument to creative failure'. It also alludes to how society attributes value to an artwork, and how contemporary art is sometimes treated with derision.

2010

2010–2017

Breaking up. The 2010s see tributes held worldwide to honour the First World War, many of which use art as part of the commemorations. Public involvement in art reaches a new height in the opening ceremony of the 2012 Olympics in London, directed by film-maker Danny Boyle. Known as the Isles of Wonder, it breaks new ground for its use of artistic spectacle encompassing performance, music and film, with a cast of 2,500 volunteers. However, the message of optimism, diversity and inclusion it delivered is soon marred by the British public's vote to leave the European Union in 2016. Some claim the UK is riding on a wave of populism that also sees realtor and reality TV star Donald Trump win the US presidential election that same year. As he sets about reconsidering the US role in the world, an air of unease takes hold. The 'never again' sentiment regarding global conflict sparked by the First World War seems ever more poignant. CK

Gilbert & George – *BANGLA CITY*

Gilbert & George have been the *enfants terribles* of the London art scene for more than forty years. Their pictures are both playful and provocative, challenging the spectator to take offence. This work is from their *SCAPEGOATING* series, which centres on the knee-jerk targets of the tabloid press – young men wearing hoodies, Muslim women in niqabs. The images are littered with bomb-shaped objects that make the subjects appear more sinister, but these are actually harmless 'whippets' – tiny canisters of nitrous oxide, a popular drug amongst party-goers, which the artists found discarded on the streets near their home.

Apple Inc. debuts its first tablet computer, the iPad. The device sits between a smartphone and laptop in functionality, and uses a multi-touch screen and a virtual keyboard. Over 250 million iPads are sold over the next five years.

Rhein II (1999) by the German photographer Andreas Gursky sells for $4.3 million at Christie's, New York, to become the most expensive photograph ever sold. The print is one of a set of six depicting the River Rhine.

A trove of 1,406 artworks looted by the Nazis in the Second World War is found in an apartment in Munich rented to Cornelius Gurlitt, the son of art dealer and historian Hildebrand Gurlitt. The press reports the find a year later. It includes works by Henri Matisse, Marc Chagall, Otto Dix, Franz Marc, Claude Monet and Pierre-Auguste Renoir. As many as 300 pieces had appeared in the 'Degenerate Art' exhibition in Munich in 1937.

2010	2011	2012	2013

Paul Cummins – *Blood Swept Lands and Seas of Red*

Members of the public volunteered to participate in creating this installation of ceramic poppies by artist Paul Cummins and designer Tom Piper to commemorate the centenary of the outbreak of the First World War. Volunteers gathered over the summer and autumn to assemble 888,246 poppies – each representing one of the people who died in the conflict – at the Tower of London. Over 5 million people visited the site before it was dismantled on 11 November that year. A Yeoman Warder read aloud names of the fallen each evening for the duration of the installation.

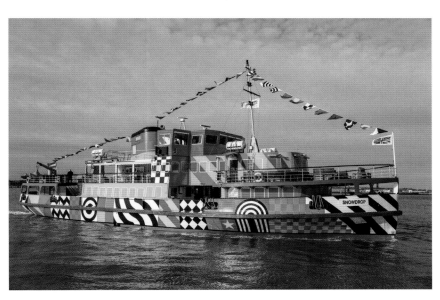

Peter Blake – *Everybody Razzle Dazzle*

British Pop artist Peter Blake used dazzle painting to transform *Snowdrop*, a Mersey Ferry, as part of commemorations in Liverpool for the First World War. The concept of dazzle painting was first suggested in 1914 by the scientist John Graham Kerr to the then First Lord of the Admiralty, Winston Churchill. The technique was developed by marine painter Norman Wilkinson during the war to camouflage ships, distorting their appearance and making it difficult for enemy submarines to target them.

Same-sex marriage becomes legal in England and Wales. The first same-sex marriages take place in March.

Cartoonists at the French satirical newspaper *Charlie Hebdo* are killed by two Al-Qaeda gunmen.

The formal Brexit withdrawal process begins as the United Kingdom invokes Article 50 of the Treaty on the European Union, after the public voted to leave in a referendum the previous year.

2014

2015

2017

Glossary

Abstract Art
Style that does not imitate real life but consists of forms, shape and colour, independent of subject matter.

Abstract Expressionism
Post–Second World War American art movement characterized by a desire for freedom of expression and the communication of strong emotions through the sensual quality of paint. Chief artists include Jackson Pollock, Willem de Kooning and Franz Kline.

Art Nouveau
Decorative style in the art, design and architecture of Europe and the USA, popular from 1890 through the First World War. Often consisting of organic, asymmetrical and stylized flora and foliage forms.

Arts and Crafts Movement
A broad movement in architecture and the decorative arts initiated by William Morris in 1861. It aimed to raise craftsmanship and design to the level of art.

Avant-garde
Term used to describe any new, innovative and radically different artistic approach.

Baroque
Style of European architecture, painting and sculpture, from 1600 to 1750, that peaked around 1630 to 1680 in Rome, Italy, and is typically dynamic and theatrical. Its chief exponents included Caravaggio and Peter Paul Rubens.

Bauhaus
German school of art, design and architecture founded in 1919 by Walter Gropius and closed by the Nazis in 1933. Artists such as Wassily Kandinsky and Paul Klee worked there, and its trademark streamlined designs became influential worldwide.

Blaue Reiter, Der
German for 'The Blue Rider'. A group formed in Munich, in 1911, by artists who epitomized German Expressionism, with a particular focus on abstraction and the spirituality of nature. The name comes from a drawing by Wassily Kandinsky, the leader of the group.

Brücke, Die
German for 'The Bridge'. A group founded in Dresden in 1905 by German Expressionist artists, which had disbanded by 1913. The group espoused radical political views and sought to create a new style of painting to reflect modern life. Noted for their landscapes, nudes, vivid colour and use of simple forms.

Byzantine
Term for orthodox religious art created during – or influenced by – the Byzantine (Eastern Roman) Empire, from 330 BC to AD 1453. Icons are a common feature in the art of this era, which is also typified by exquisite mosaic church interiors.

Chiaroscuro
Italian for 'light-dark'. The dramatic effect created by balancing or strongly contrasting light and shade in a painting.

Classicism
Term describing the use of the rules or styles of classical antiquity. Renaissance art incorporated many classical elements, and other eras, such as the 18th century, have used ancient Greece and Rome as inspiration. The term can also be used to mean formal and restrained.

Collage
Style of picture-making in which materials (typically newspapers, magazines, photographs, etc.) are pasted together on a flat surface.

Commedia dell'Arte
Italian for 'comedy of professional artists'. Term used to describe comic plays performed in masks popular in 16th- to 18th-century Italy and France.

Constructivism
Art movement founded by Vladimir Tatlin and Alexander Rodchenko in Russia around 1914, spreading to the rest of Europe by the 1920s. Notable for its abstraction and use of industrial materials such as glass, metal and plastic.

Contrapposto
Italian term used to describe the way in which a human figure is shown standing with most of its weight on one foot so the shoulders and arms twist away from the hips and legs.

Cubism
Highly influential and revolutionary European art style invented by Spanish artist Pablo Picasso and French artist Georges Braque, developed between 1907 and 1914. Cubists abandoned the idea of a fixed viewpoint, resulting in the object portrayed appearing fragmented.

Dada
Art movement started in 1916 in Switzerland by writer Hugo Ball as a reaction to the horror of the First World War. It aimed to overturn traditional values in art, and was notable for its introduction of 'readymade' objects as art, and its rejection of the notion of craftsmanship.

De Stijl
Dutch magazine (1917–32) edited by Theo van Doesberg and used to champion the work of cofounder Piet Mondrian and the ideas of Neoplasticism. The term is also applied to the ideas it promoted, which influenced the Bauhaus movement and commercial art in general.

Expressionism
Term used to describe a 20th-century style that distorts colour, space, scale and form for emotional effect and is notable for its intense subject matter. Adopted particularly in Germany by artists such as Wassily Kandinsky.

Fauvism
Derived from the French fauve, meaning 'wild beast'. Art movement from about 1905 to 1910 characterized by its wild brushwork, use of bright colour and flat patterns.

Fresco
A painting that is applied to wet plaster – as distinct from a mural, which is painted onto a dry surface.

Futurism
Art movement launched by the Italian poet Filippo Tommaso Marinetti in 1909. Characterized by works that expressed the dynamism, energy and movement of modern life.

Genre painting
Painting that shows scenes from daily life. The style was popular in the Netherlands during the 17th century.

Gothic
European style of art and architecture from the 1300s to the 1600s. Work produced during this period is characterized by an elegant, dark, sombre style, and by a greater naturalism than the earlier Romanesque period.

Grand Tour
A journey around Europe generally taken by wealthy and aristocratic young men as part of their education during the 17th to early 19th centuries. The itinerary was designed to educate travellers in the art and architecture of classical antiquity.

Harlem Renaissance
A flowering of African-American art, literature, music and social commentary that primarily took place in Harlem, New York, in the 1920s. It aimed to challenge prejudice, promote racial pride and social integration, and break down white European distinctions between 'high' and 'low' culture.

Iconography
Derived from ikon in Greek, meaning 'image'. Term used to describe imagery in a painting. Originally a picture of a holy person on a panel used as an object of devotion. In art, the word icon has come to be used to describe any object or image with a special meaning attached to it.

Impressionism
Revolutionary approach to painting landscape and scenes of everyday life pioneered in France by Claude Monet and others from the early 1860s, and which was later adopted internationally. Often created outdoors (en plein air) and notable for the use of light and colour as well as loose brushwork. The first group exhibition held in 1874 was dismissed by critics, particularly Monet's painting Impression, Sunrise, which gave the movement its name. Chief artists include Camille Pissarro, Pierre-Auguste Renoir and Edgar Degas.

International Gothic
A type of Gothic art developed in Burgundy, Bohemia and northern Italy in the late 14th and early 15th centuries, characterized by rich, decorative patterns, colourful settings, classical modelling, flowing lines and use of linear perspective.

Mannerism
Derived from maniera, meaning 'manner', in Italian. A loose term to describe Late Renaissance art from around 1530 to 1580 in which altered perspective, vibrant colour, unrealistic lighting and exaggerated or distorted figures in complex, elongated poses resulted in theatrical and sometimes disturbing images. It was based on the ideals of Raphael and Michelangelo.

Modernism
A broad term used to describe Western artistic, literary, architectural, musical and political movements in the late 19th and early 20th centuries. Applied to that which is typified by constant innovation, formal experimentation and rejection of the old, and works in which the adoption of the new is seen as being more appropriate to the modern age.

Naturalism
In its broadest sense, a term used to describe art in which the artist attempts to portray objects and people as observed rather than in a conceptual or contrived manner. More generally, it can also be used to suggest that a work is representational rather than abstract.

Neoclassicism
Prominent late 18th and early 19th century movement in European art and architecture, motivated by the impulse to revive the style of ancient Greek and Roman art and architecture. In modern art, the term has also been applied to a similar revival of interest in classical style during the 1920s and 1930s.

Netherlandish
Term used to describe art produced in Flanders – now Belgium – andthe Netherlands, and developed by artists such as Jan van Eyck, Hans Memling and Hieronymous Bosch. The style, also known as 'Flemish', arose in the 15th century, and evolved separately from the art of the Italian Renaissance, especially in the use of oil paint instead of tempera. The early Netherlandish period ended around 1600; the late period lasted until 1830.

Neue Sachlichkeit, Die
German for 'The New Objectivity'. German art movement of the 1920s that lasted until 1933. It opposed Expressionism and is noted for its unsentimental style and use of satire. Included artists such as Otto Dix.

Northern Renaissance
The influence of the Italian Renaissance in northern European painting from around 1500, incorporating the use of human proportion, perspective and landscape. It was influenced by Protestantism as opposed to the Catholic themes of Italian painting.

Op Art
Abbreviation of 'Optical Art'. Style of abstract art of the 1960s that used optical illusion, employing a range of optical phenomena to make artworks appear to vibrate or flicker.

Orphism
French abstract-art movement originated by Jacques Villon and characterized by its use of bright colour. The term was first used in 1912 by the poet Guillaume Apollinaire to describe the paintings of Robert Delaunay, which he related to Orpheus, the poet and singer in Greek mythology. Its practitioners introduced a more lyrical element to Cubism.

Plein-air
See Impressionism.

Pochoir
A refined stencil-based technique for making coloured prints or adding colour to pre-existing prints. Notable for its crisp lines and brilliant colours.

Pop Art
Term coined by British critic Lawrence Alloway for an Anglo-American art movement that lasted from the 1950s to the 1970s. It is notable for its use of imagery taken from popular cultural forms such as advertising, comics and mass-produced packaging.

Pre-Raphaelite Brotherhood
British society of artists founded in London in 1848 that championed the work of artists active prior to Renaissance master Raphael. Members included William Holman Hunt, John Everett Millais and Dante Gabriel Rossetti. Their work is characterized by its realistic style, attention to detail and engagement with social problems and religious and literary themes.

Primitivism
Art inspired by the so-called 'primitive' art that fascinated many early modern European artists. It included tribal art from Africa and the South Pacific, as well as European folk art.

Putto (plural, putti)
Italian for 'cherub'. Winged, naked infant figure, usually male. Commonly found in Italian Renaissance works.

Realism
1. Mid-19th-century art movement characterized by subject matter depicting peasant and working-class life.
2. Term for a style of painting that appears photographic in its representational accuracy, irrespective of subject matter.

Renaissance
French for 'rebirth'. Used to describe the revival of art in Italy from 1300, under the influence of the rediscovery of classical art and culture. The Renaissance

reached its peak from 1500 to 1520 with the work of Michelangelo, Leonardo da Vinci and Raphael.

Rococo
From the French *rocaille*, meaning 'rock-work', referring to carvings in grottoes and on fountains. The term is used to describe the 18th-century French style of visual arts that was decorative in nature and often used shell-like curves and shapes.

Romanesque
Initially a term to describe the architecture of 11th- and 12th-century Europe, but extended to cover painting and sculpture of the era. Typified by stylized devotional works, such as illustrated manuscripts.

Romanticism
Artistic movement of the late 18th and early 19th centuries. Broadly characterized by an emphasis on the experience of the individual, instinct over rationality, and the concept of the 'sublime'.

Salon
Refers to exhibitions held by the French Royal Academy of Painting and Sculpture – and later the Academy of Fine Arts – in Paris from 1667 to 1881. Known as the 'Salon de Paris' in French. Named for the Salon Carré in the Louvre, where the exhibition was staged from 1737 onwards.

Secession
Name used by groups of artists in Germany and Austria in the 1890s who 'seceded' from art institutions that they deemed excessively conservative. Led by Gustav Klimt in Vienna, Franz von Stuck in Munich and Max Liebermann in Berlin.

Street Art
Style inspired by spray-painted graffiti – particularly that which became prevalent in the 1980s in New York. Its most famous practitioner was Jean-Michel Basquiat, though Banksy may well be the best-known contemporary graffiti artist.

Suprematism
Russian abstract-art movement. Its chief proponent was the Russian artist Kasimir Malevich, who invented the phrase in 1913. Paintings are characterized by a limited colour palette and the use of simple geometric forms such as the square, circle and cross.

Surrealism
Movement in art and literature launched in 1924 by French poet André Breton with his 'Manifesto of Surrealism'. The movement was characterized by a fascination with the bizarre, the illogical and the dreamlike and, like Dada, sought to shock the viewer. Its trademark emphasis on chance, and gestures informed by impulse rather than conscious thought, was highly influential.

Symbolism
Term invented in 1886 by French critic Jean Moréas to describe the poetry of Stéphane Mallarmé and Paul Verlaine. Applied to art, it describes the use of mythological, religious and literary subject matter, and art that features emotional and psychological content, with a particular interest in the erotic, perverse and mystical.

Tempera
Derived from *temperare*, meaning 'to mix' in Latin. Paint made of powdered pigments, egg yolk and water. Primarily associated with European art produced from the 13th to 15th century.

Vorticism
British art movement founded in 1914, which promoted a Cubist style combined with a Futuristic emphasis on the mechanistic dynamism of the modern world, as a reaction against perceived complacency in British culture.

YBA
Abbreviation of Young British Artists. Used to describe a group of avant-garde British artists, including Rachel Whiteread, Sarah Lucas and Damien Hirst, prominent from the 1990s.

Contributors

Ian Chilvers (IC) studied at the Courtauld Institute of Art, where Anthony Blunt was among his teachers. He has spent most of his career in publishing, devoting many years to writing and editing a series of major reference books for Oxford University Press, including *The Oxford Dictionary of Art* and *A Dictionary of Twentieth-Century Art*.

Emma Doubt (ED) is an art historian with a research specialization in the 19th century. She holds a BA and MA in Art History from McGill University, and is completing an AHRC-funded PhD in Art History with the University of Sussex. She teaches courses on women artists, modern and contemporary art, and the history of interiors at the college level.

Anne Hildyard (AH) is a London-based editor and writer who has produced several books relating to fine art, as well as working on many other publications on subjects including videogames, paper crafts and cooking. She has written two craft books for children and co-authored a book about healthy eating for children.

Susie Hodge (SH) MA, FRSA, is an art historian, author and artist with more than 100 books in print on art history, practical art and history. She also contributes to TV and radio news programmes and documentaries, writes magazine articles, web resources and booklets for museums and galleries, and runs workshops and gives talks on art around the world.

Ann Kay (AK) is an editor and writer who specializes in art, literature and social/cultural history, and has an MA in art history from Bristol University. Her writing credits include contributions to *Art: The Whole Story* and to titles in Dorling Kindersley's 'Definitive' series.

Carol King (CK) studied Fine Art at St Martin's School of Art in London. A writer and editor, she has contributed to many books on art including *Art: The Whole Story*.

Iain Zaczek (IZ) was educated at Wadham College, Oxford and the Courtauld Institute of Art. His many books on art and design include: *The Impressionists*; *Essential Art Deco*; *Celtic Art and Design*; and *The Art of Illuminated Manuscripts*.

Index

Page references to illustrations are in **bold**.

Picture Credits

The publishers would like to thank the museums, artists, archives and photographers for their kind permission to reproduce the works featured in this book.
Every effort has been made to trace all copyright owners but if any have been inadvertently overlooked, the publishers would be pleased to make the necessary arrangements at the first opportunity.

Key: top = t; bottom = b; left = l; right = r; centre = c; top left = tl; top right = tr; centre left = cl; centre right = cr; bottom left = bl; bottom right = br

2 Van Gogh Museum 9 Musee des Tapisseries, Angers, France/Bridgeman Images 10 Neues Museum 11 Hercules Milas/Alamy Stock Photo 12 Heritage Image Partnership Ltd/Alamy Stock Photo 13 Novgorod State Museum 14 Arterra Picture Library/Alamy Stock Photo 15 l Riedmiller/ Alamy stock photo 15 r Fine Art/Corbis Historical/Getty Images 16 Glasshouse Images/Alamy Stock Photo 17 t F. Jack Jackson/Alamy Stock Photo 17 b Art Collection 2/Alamy Stock Photo 18 l Altamira, Spain/Bridgeman Images 18 r Ariadne Van Zandbergen/Alamy Stock Photo 20 Egyptian National Museum, Cairo, Egypt/De Agostini Picture Library/A. Dagli Orti/Bridgeman Images 21 t British Museum 21 b Josse Christophel/Alamy Stock Photo 22 Musee Cernuschi, Paris, France/Bonora/Bridgeman Images 23 l Ageev Rostislav/Alamy Stock Photo 23 r Peter Barritt/Alamy Stock Photo 24 t Photo © Tarker/Bridgeman Images 24 b De Agostini/DEA Picture Library/Getty Images 26 Metropolitan Museum of Art 27 l Iraq Museum, Baghdad/Bridgeman Images 27 r © The British Museum/Trustees of the British Museum 28 imageBROKER/Alamy Stock Photo 29 l PRISMA ARCHIVO/Alamy Stock Photo 29 r adam eastland/Alamy Stock Photo 30 t De Agostini Picture Library/C. Bevilacqua/Bridgeman Images 30 b Sailko/Wikimedia Commons, CC-BY-SA-3.0 31 Louvre, Paris, France/Bridgeman Images 32 l Ny Carlsberg Glyptotek 32 r Naples National Archaeological Museum 33 Mondadori Portfolio/Electa/Sergio Anelli/Bridgeman Images 34 Pictures from History/Bridgeman Images 35 l De Agostini Picture Library/G. Dagli Orti/Bridgeman Images 35 r Altes Museum 36 l British Museum, London, UK/Bridgeman Images 36 tr Heritage Image Partnership Ltd/Alamy Stock Photo 36 br INTERFOTO/Alamy Stock Photo 38 Granger Historical Picture Archive/Alamy Stock Photo 39 l Adam Eastland/Alamy Stock Photo 39 r Dura-Europos Synagogue, National Museum of Damascus, Syria/Photo © Zev Radovan/Bridgeman Images 40 Pictures from History/Bridgeman Images 41 t Capitoline Museums 41 b De Agostini Picture Library/G. Cigolini/Bridgeman Images 42 tl Photo Scala, Florence 42 tr INTERFOTO/Alamy Stock Photo 42 b Catacomb of Domitilla 44 De Agostini Picture Library/Bridgeman Images 45 l De Agostini Picture Library/A. Dagli Orti/Bridgeman Images 45 r De Agostini Picture Library/Bridgeman Images 46 Metropolitan Museum of Art 47 l DEA Picture Library/De Agostini/Getty Images 47 r Jean-Luc Manaud/Gamma-Rapho/Getty Images 48 l Trinity College Library 48 r British Library 49 Cathedral of Trier 50 Photo Scala, Florence/Fondo Edifici di Culto - Min. dell'Interno 51 r Bibliothèque Nationale, Paris 52 David Lyons/Alamy Stock Photo 53 l Kungliga Biblioteket, Stockholm 53 r Trinity College Library 54 Kunsthistorisches Museum, Vienna, Austria/Bridgeman Images 55 l The Morgan Library & Museum 55 r World History Archive/Alamy Stock Photo 56 l mark phillips/Alamy Stock Photo 57 l Universal History Archive/Universal Images Group/Getty Images 57 r De Agostini Picture Library/Bridgeman Images 58 Alinari/Bridgeman Images 59 l Pictures from History/Bridgeman Images 59 r Art Collection 3/Alamy Stock Photo 60 The Art Archive/REX/Shutterstock 61 l The J. Paul Getty Museum 61 r Saint Sophia Cathedral, Kiev 62 The Morgan Library & Museum 63 l Bayeux Museum 63 r Granger Historical Picture Archive/Alamy Stock Photo 64 Museu Nacional d'Art de Catalunya 65 l State Russian Museum 65 r The Print Collector/Alamy Stock Photo 66 Tretyakov Gallery, Moscow 67 l The Morgan Library & Museum 67 r Trinity College, Cambridge 68 l The Morgan Library & Museum 68 r Print Collector/Hulton Archive/Getty images 69 The Morgan Library & Museum 70 The Morgan Library & Museum 71 l San Francisco, Pescia 71 r The Morgan Library & Museum 72 r Prado Museum 72 l British Library 74 l Museu Nacional d'Art de Catalunya 74 r Fondazione Musei Senesi 75 The J. Paul Getty Museum 76 University Library, Heidelburg 77 l Uffizi Gallery 77 r Kimbell Art Museum 78 l The Morgan Library & Museum 78 r University Library, Heidelburg 79 Private Collection/Bridgeman Images 80 Fondazione Musei Senesi 81 l The J. Paul Getty Museum 81 r Gemäldegalerie, Berlin 82 Pushkin Museum 83 l Tretyakov Gallery, Moscow 83 r National Gallery, Prague 84 Musee des Tapisseries, Angers, France/Bridgeman Images 85 l National Gallery, London 85 r Walters Art Museum 87 Christophel Fine Art/Universal Images Group/Getty Images 88 National Gallery, London 89 Royal Collection of the United Kingdom 90 Groeningemuseum 91 Basilica of Santa Maria del Popolo, Rome 92 Städel Museum 93 l Musée Condé 93 r The J. Paul Getty Museum 94 Uffizi Gallery 95 l Tretyakov Gallery, Moscow 95 r De Agostini Picture Library/G. Dagli Orti/Bridgeman Images 96 l Gemäldegalerie Alte Meister 96 r Gemäldegalerie Alte Meister 98 Musée Condé 99 t Galleria Regionale della Sicilia 99 b Musée de l'Hôtel Dieu 100 Austrian National Library/Interfoto/Alamy Stock Photo 101 l National Gallery of Art, Washington, D.C. 101 b Uffizi Gallery 102 Private Collection/Prismatic Pictures/Bridgeman Images 103 l Granger Historical Picture Archive/Alamy Stock Photo 103 r The Morgan Library & Museum 104 Christophel Fine Art/Universal Images Group/Getty Images 105 l Museum Boijmans Van Beuningen 105 r The Cloisters 106 Kunsthistorisches Museum 107 l Museo Thyssen-Bornemisza 107 r National Museum of Western Art, Tokyo 108 Gemäldegalerie Alte Meister, Dresden 108 r Royal Collection of the United Kingdom 109 Uffizi Gallery 110 Wartburg-Stiftung 111 l National Gallery, London 111 r Staatsgalerie Stuttgart 112 Uffizi Gallery 113 l North Carolina Museum of Art 113 r National Galleries of Scotland 114 Musee des Beaux-Arts, Tourcoing, France/Bridgeman Images 115 l Royal Collection of the United Kingdom 115 r Château de Versailles 116 Kunsthistorisches Museum 117 t Château de Versailles 117 b Wellcome Images 118 Pinacoteca di Brera, Milan, Italy/Bridgeman Images 119 l Private Collection/Bridgeman Images 119 r Tate Britain 120 l Royal Collection of the United Kingdom 120 tr Victoria and Albert Museum 120 br Royal Collection of the United Kingdom 122 Uffizi Gallery 123 l National Gallery of Art, Washington, D.C. 123 r Uffizi Gallery 124 Gemäldegalerie, Berlin 125 t Birmingham Museum of Art 125 b National Gallery, London 126 t Amsterdam Museum 126 b Rijksmuseum Amsterdam 128 Walker Art Gallery 129 l Rijksmuseum Amsterdam 129 b Rijksmuseum 130 Château de Versailles 131 t Rijksmuseum Amsterdam 131 b Walker Art Gallery 132 classicpaintings/Alamy Stock Photo 133 l Los Angeles County Museum of Art 133 r National Gallery, London 135 Château de Versailles 136 Musée du Louvre 137 Art Institute of Chicago 138 Wallace Collection 139 Yale Center for British Art 140 Royal Museums of Fine Arts Belgium 141 t INTERFOTO/Alamy Stock Photo 141 b Yale Center for British Art 142 Museum of Fine Arts, Houston 143 t Dulwich Picture Gallery 143 b National Gallery of Scotland 144 l Yale Center for British Art 144 r The National Trust Photolibrary/Alamy Stock Photo 145 Yale Center for British Art 146 The J. Paul Getty Museum 147 l Indianapolis Museum of Art 147 r Pushkin Museum 148 National Gallery of Art, Washington, D.C. 149 t Château de Versailles 149 b Museum of Fine Arts, Houston 150 t National Gallery, London 150 b Library of Congress 152 Bibliotheque Nationale de France, Paris 152 Nationalmuseum, Stockholm 153 t Palazzo Pitti 153 b North Carolina Museum of Art 154 INTERFOTO/Alamy Stock Photo 155 l National Museum, New Delhi 155 r Uffizi Gallery 156 t Städel Museum 156 bl Private Collection/De Agostini Picture Library/Bridgeman Images 156 br Yale Center for British Art 158 Museum of Fine Arts, Boston 159 l Fyvie Castle 159 r Derby Museum and Art Gallery 160 l Frick Collection 160 r Yale Center for British Art 161 l Royal Collection of the United Kingdom 161 r Scottish National Gallery 162 t Alte Nationalgalerie, Berlin 162 b Tate Britain 163 Kupferstichkabinett Dresden 164 Detroit Institute of Arts 165 t Prado Museum 165 b Musée du Louvre 166 Walker Art Gallery 167 t Yale Center for British Art 167 b Photo The Philadelphia Museum of Art/Art Resource/Scala, Florence 169 Musée d'Orsay 170 Philadelphia Museum of Art 171 Private collection 172 Hamburger Kunsthalle 173 The Archives/Alamy Stock Photo 174 Heritage Image Partnership Ltd/Alamy Stock Photo 175 l National Gallery of Art, Washington, D.C. 175 r Musée du Louvre 176 Prado Museum 177 l Philadelphia Museum of Art 177 r Walters Art Museum 178 t Metropolitan Museum of Art 178 b Cooper Hewitt, Smithsonian Design Museum 180 Alte Nationalgalerie, Berlin 181 l Walker Art Gallery 181 r The Morgan Library & Museum 182 Musée du Louvre 183 l State Russian Museum 183 r Suntory Museum of Art 184 Tate Britain 185 l Frick Collection 185 r Musée d'Orsay 187 l Birmingham Museum and Art Gallery 187 r Private collection 188 Walker Art Gallery 189 l Tate Britain 189 r Birmingham Museum and Art Gallery 190 Tate Britain 191 l Musée d'Orsay 191 r Tate Britain 192 t Fine Art Photographic/Corbis Historical/Getty Images 192 b Art Institute of Chicago 194 National Museum, Warsaw 195 tl Musee d'Orsay, Paris, France/Bridgeman Images 195 bl Library of Congress 195 r ART Collection/Alamy Stock Photo 196 Musée d'Orsay 197 t National Museum of Western Art, Tokyo 197 b Nationalmuseum, Stockholm 198 t Granger Historical Picture Archive/Alamy Stock Photo 198 b The Nelson-Atkins Museum of Art 200 State Russian Museum 201 l Musée d'Orsay 201 r The J. Paul Getty Museum 202 l Art Institute of Chicago 202 r Art Institute of Chicago 203 Tretyakov Gallery, Moscow 204 l Iris & B. Gerald Cantor Center for Visual Arts at Stanford University 205 l Art Gallery of South Australia 205 r Museo Nacional de Artes Decorativas, Madrid 206 Städel Museum 207 l Birmingham Museum and Art Gallery 207 r Art Institute of Chicago 208 Van Gogh Museum 209 l Tate Britain 209 r Art Gallery of South Australia 210 l Musée d'Orsay 211 l National Gallery of Scotland 211 r Musée d'Orsay 212 National Gallery of Art, Washington, D.C. 213 t Neue Pinakothek, Munich 213 b Kröller-Müller Museum 214 Nationalmuseum, Stockholm 215 l Museum of Modern Art, New York 215 r National Gallery, Oslo 217 Toledo Museum of Art 218 Heritage Image Partnership Ltd/Alamy Stock Photo 219 Werner and Gabrielle Merzbacher Collection 220 Lenbachhaus 221 State Russian Museum 222 Munch Museum 223 t Ateneum 223 b Photo: Granger Historical Picture Archive/Alamy Stock Photo; copyright: © ADAGP, Paris and DACS, London 2017 224 Pera Museum 225 l Photo: The Museum of Modern Art, New York/Scala, Florence; copyright: © Succession Picasso/DACS, London 2017 225 r Austrian Gallery Belvedere 226 Toledo Museum of Art 227 l Kunstmuseum, Basel, Switzerland/Bridgeman Images 227 r Photo: © 2017. Digital image, The Museum of Modern Art, New York/Scala, Florence; © The estate of Sir Jacob Epstein 228 l Museum of Fine Arts, Boston 228 r Shawshots/Alamy Stock Photo 229 Photo: © 2017. Christie's Images, London/Scala, Florence; copyright: © Estate of Martin Sharp.Viscopy/Licensed by DACS 2017 230 Art Institute of Chicago 231 t Tate Britain 231 b Imperial War Museum 232 Art Gallery and Museum, Kelvingrove, Glasgow, Scotland/Bridgeman Images 233 l Photo: Musee National d'Art Moderne, Centre Pompidou, Paris, France/J.P. Zenobel/Bridgeman Images; copyright © ADAGP, Paris and DACS, London 2017 233 r Philadelphia Museum of Art 234 Photo: akg-images; copyright: © DACS 2017 235 l Photo: Tretyakov Gallery, Moscow, Russia/Bridgeman Images; copyright: © DACS 2017 235 r Photo: akg-images/MPortfolio/Electa; copyright: © ADAGP, Paris and DACS, London 2017 236 t Bournemouth News/REX/Shutterstock 236 b © 2017. Christie's Images, London/Scala, Florence 238 Art Institute of Chicago 239 t Photo: Digital image, The Museum of Modern Art, New York/Scala, Florence; copyright: © Salvador Dali, Fundació Gala-Salvador Dali, DACS 2017 239 b Photo: Brooklyn Museum of Art, New York, USA/Bequest of Edith and Milton Lowenthal/Bridgeman Images; copyright: © Georgia O'Keeffe Museum/DACS 2017 240 Courtesy of Leslie Lewis and Christina Lewis Halpern from the Reginald F. Lewis Family Collection. © Estate of Norman W. Lewis; Courtesy of Michael Rosenfeld Gallery LLC, New York, NY 241 l Photo: www.bridgemanart.com; © Successió Miró/ADAGP, Paris and DACS London 2017 241 r © 2017. Digital image, The Museum of Modern Art, New York/Scala, Florence 242 World History Archive/Alamy Stock Photo 243 l © 2017. Digital image, The Museum of Modern Art, New York/Scala, Florence. © 2017 ES Mondrian/Holtzan Trust 243 r © Imperial War Museum 244 t Photo: National Gallery of Australia, Canberra/Purchased 1973/Bridgeman Images; © The Pollock-Krasner Foundation ARS, NY and DACS, London 2017 244 b Photo: Private Collection/Bridgeman Images; copyright: © 1998 Kate Rothko Prizel & Christopher Rothko ARS, NY and DACS, London. 245 r Photo: Detroit Institute of Arts, USA/Founders Society purchase, W. Hawkins Ferry fund/Bridgeman Images; copyright: © Dedalus Foundation, Inc. /VAGA, NY/DACS, London 2017 246 Photo: National Galleries of Scotland, Edinburgh/Bridgeman Images. Artwork: © 2017 Succession H. Matisse/DACS, London 247 l Photo: © 2017. Digital image, The Museum of Modern Art, New York/Scala, Florence; copyright: © Andrew Wyeth/ARS, NY and DACS, London 247 r © 2017. Image copyright The Metropolitan Museum of Art/Art Resource/Scala, Florence; copyright: © The Pollock-Krasner Foundation ARS, NY and DACS, London 2017 248 Photo: © 2017. Digital image, The Museum of Modern Art, New York/Scala, Florence; copyright: © The Willem de Kooning Foundation/Artists Rights Society (ARS), New York and DACS, London 2017 249 t Private Collection/Bridgeman Images 249 l Photo: Private Collection/Bridgeman Images; copyright: © ADAGP, Paris and DACS, London 2017 250 National Galleries of Scotland, Edinburgh/Bridgeman Images. Estate of the artist and c/o Lefevre Fine Art Ltd., London 251 l Photo: © 2017. Christie's Images, London/Scala, Florence; copyright: © The Estate of L.S. Lowry. All Rights Reserved, DACS 2017 251 r Photo: © 2017. BI, ADAGP, Paris/Scala, Florence; copyright: © ADAGP, Paris and DACS, London 2017 252 t © 2017. Albright Knox Art Gallery, New York/Scala, Florence 252 b Photo: © Bonhams, London, UK/Bridgeman Images; copyright: © 2017 The Andy Warhol Foundation for the Visual Arts, Inc./Artists Rights Society (ARS), New York and DACS, London. 254 Photo: Granger Historical Picture Archive/Alamy Stock Photo; copyright: Chagall ®/© ADAGP, Paris and DACS, London 2017 255 l Peter Horree/Alamy Stock Photo 255 r © Gerhard Richter 2017 256 l © 2017. The Solomon R. Guggenheim Foundation/Art Resource, NY/ Scala, Florence 256 r Digital image, The Museum of Modern Art, New York/Scala, Florence 257 Photo: Solomon R. Guggenheim Museum, New York. Gift of the artist, 1997. 97.4565; copyright: © Frank Stella. ARS, NY and DACS, London 2017 258 Photo: © 2017. Photo Scala, Florence/bpk, Bildagentur fuer Kunst, Kultur und Geschichte, Berlin; copyright: © 2017 The Barnett Newman Foundation, New York/DACS 259 l Photo: Private Collection/Bridgeman Images; copyright: © Estate of Kenneth Noland. DACS, London/VAGA, New York 2017 259 r Photo: © Christie's Images/Bridgeman Images; copyright: © Stephen Flavin/Artists Rights Society (ARS), New York 2017 260 t Holmes Garden Photos/Alamy Stock Photo; copyright: © Richard Long. All Rights Reserved, DACS 2017 260 b Neil McAllister/Alamy Stock Photo 262 © 2017. Digital image, The Museum of Modern Art, New York/Scala, Florence 263 t Collection of The University of Arizona Museum of Art, Tucson; Museum Purchase with Funds Provided By the Edward J. Gallagher, Jr. Memorial Fund. 1982.035.001 263 b Photo: © 2017. The Solomon R. Guggenheim Foundation/Art Resource, NY/ Scala, Florence; copyright: © Georg Baselitz 2017 264 © Tate, London 2017 265 t © Nabil Kanso 265 b Photo: © 2017. Photo Scala, Florence/bpk, Bildagentur fuer Kunst, Kultur und Geschichte, Berlin; copyright: © DACS, London 2017 266 © 2017. Christie's Images, London/Scala, Florence; copyright: © 2017 The Andy Warhol Foundation for the Visual Arts, Inc./Artists Rights Society (ARS), New York and DACS, London. 267 l © Paula Rego. Courtesy Marlborough Fine Art 267 r © Peter Corlett.Viscopy/Licensed by DACS 2017 268 l Photo: Private Collection/Photo © Christie's Images/Bridgeman Images; copyright: © Jenny Saville. All rights reserved, DACS 2017 268 tr National Galleries of Scotland, Edinburgh/Bridgeman Images 270 © Helen Frankenthaler Foundation, Inc./ARS, NY and DACS, London 2017 271 l © Gillian Wearing, courtesy Maureen Paley, London, Regen Projects, Los Angeles and Tanya Bonakdar Gallery, New York 271 r Photo: Roman Mensing, artdoc.de; copyright: © DACS, London 2017 272 © 2017. Christie's Images/Bridgeman Images 273 l Photograph by Ellen Page Wilson, courtesy Pace Gallery; © Chuck Close, courtesy Pace Gallery 273 r Photo: Stefano Politi Markovina/Alamy Stock Photo; copyright: © The Easton Foundation/VAGA, New York, London 2017 274 © 2017 Zeng Fanzhi 275 l Barry Lewis/Alamy Stock Photo 275 r Photo: Andrew Dunkley & Marcus Leith, Courtesy of the artist; neugerriemschneider, Berlin; and Tanya Bonakdar Gallery, New York © Olafur Eliasson 276 Alison Thompson/Alamy Stock Photo 277 dov makabaw/Alamy Stock Photo 278 © DB-ADAGP Paris and DACS, London 2017 279 t Photo: Iwan Baan 279 b Photo: Christie's Images, London/Scala, Florence 280 © Gilbert & George, courtesy of White Cube. 281 t © Historic Royal Palaces and Richard Lea-Hair 281 b Photo: John Davidson Photos/Alamy Stock Photo; copyright: © Peter Blake. All rights reserved, DACS 2017

Front Cover: Detail from *Water Lilies* (1916) by Claude Monet
The Artchives/Alamy Stock Photo

Page 2: *Sunflowers* (1888) by Vincent Van Gogh

First published in 2018 in the United States of America by
Thames & Hudson Inc., 500 Fifth Avenue,
New York, New York 10110

www.thamesandhudsonusa.com

© 2018 Quintessence Editions Ltd.

This book was designed and produced by
Quintessence Editions, an imprint of The Quarto Group
The Old Brewery
6 Blundell Street
London N7 9BH

Senior Editor	Elspeth Beidas
Editor	Liz Jones
Senior Designer	Isabel Eeles
Design Assistance	Michelle Kliem, Dean Martin
Picture Researcher	Emma Brown
Production Manager	Anna Pauletti
Editorial Director	Ruth Patrick
Publisher	Philip Cooper

Library of Congress Control Number 2017947918

ISBN 978-0-500-23981-0

Printed in China